Memoirs of the Life of
John Constable

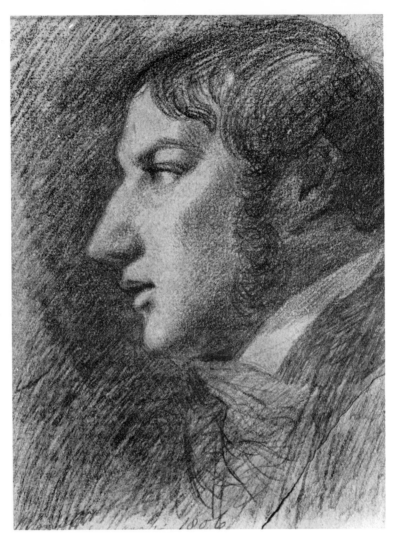

SELF-PORTRAIT OF CONSTABLE.
Pencil, 1806. Collection Colonel J. H. Constable

Memoirs of the Life of
John Constable

Composed Chiefly of his Letters

C. R. Leslie, R.A.

'Heaven and earth, advantages and
obstacles, conspire to educate genius.'
Fuseli

Phaidon · Oxford

Phaidon Press Limited, Littlegate House, St. Ebbe's Street, Oxford, OX1 1SQ

First published 1951
Second edition (photographically reprinted) 1980

The text has been edited and the illustrations chosen and annotated by Jonathan Mayne.

British Library Cataloguing in Publication Data
Leslie, Charles Robert
 Memoirs of the life of John Constable. – New ed. –
(Landmarks in art history).
 1. Constable, John, b. 1776
 2. Painters – Great Britain – Biography
 I. Title II. Series
 759.2 ND497.C7

 ISBN 0-7148-2102-0

Publisher's Note
This volume has been photographically reprinted from the previous Phaidon edition, published in 1951. The locations of some of the works reproduced have changed during the past thirty years; in particular, the pictures reproduced in Plates 6, 18, 51 and 56 are now in the Tate Gallery, London, and some of the pictures and drawings listed as belonging to private owners have changed hands.
Constable's correspondence is now available in six volumes edited by R. B. Beckett and published by the Suffolk Records Society from 1962 to 1968. The most important recent books on Constable's art are *Constable: Paintings, Drawings and Watercolours* (second edition, 1975) by Basil Taylor and *Constable: The Natural Painter* (1965) by Graham Reynolds.

Printed in Great Britain at The Pitman Press, Bath

CONTENTS

EDITOR'S NOTE *page* vii

EDITOR'S PREFACE ix

AUTHOR'S PREFACE xv

CHAPTER I: 1776–1810

Constable's Native Scenery. Parentage. Birth. School Days. His Love of
Painting. John Dunthorne. Constable employed in his Father's Mills.
Introduced to Sir George Beaumont. His first Sight of a Picture by
Claude. Girtin's Drawings. Constable's first Visit to London. Farington.
Antiquity Smith. Constable engaged in his Father's Counting-house.
Returns to the Study of Painting. Becomes a Student of the Royal
Academy. His Drawings at Helmingham. Visits Derbyshire. Anatomi-
cal Studies. Exhibits at the Academy. Samuel Strowger. Mr. West.
Situation of a Drawing Master offered to Constable. Dissuaded by Mr.
West from accepting it. Voyage from London to Deal. Altar-Piece for
Brantham Church. Visits Westmoreland and Cumberland. Introduced
to the Earl and Countess of Dysart. Altar-Piece for Neyland Church.
Jackson. Wilkie 1

CHAPTER II: 1811–1812

West's Picture of 'Christ Healing the Sick'. Constable's Art. Traits of
his Character. His Health affected. Sir George Beaumont's Prescription.
Another Prescription. Attachment to Miss Bicknell. Their Marriage
objected to by her Friends. Visit of Miss Mary Constable to her Brother.
Correspondence with Miss Bicknell. Exhibition at the Royal Academy,
1812. The Rev. J. Fisher. Mr. Stothard. Constable engaged on Portraits.
Fire at his Lodgings 21

CHAPTER III: 1813–1814

Constable's Pictures in the Exhibitions of 1813. Exhibition at the British
Gallery of the Works of Reynolds. Turner. J. Dunthorne, Jun. 'Willy
Lott's House'. Sale of two of Constable's Pictures. His Pictures at the
Academy, 1814. Excursion in Essex. Picture of 'Boat-building'.
Constable's disposition to shun Society 40

CHAPTER IV: 1815–1816

Constable permitted to visit Miss Bicknell. Death of his Mother.
Death of Miss Bicknell's Mother. G. Dawe. Exhibition, 1815. Delicacy
of Miss Bicknell's Health. Lady Spencer. Constable's Studies at Bergholt.
Illness of his Father. Dr. Rhudde. Exhibition, 1816. Death of Constable's
Father. General and Mrs. Rebow. Pictures painted at Wivenhoe Park.
The Rev. J. Fisher. Constable's Marriage. Visit to Osmington. Dr.
Rhudde's Legacy to Mrs. Constable 53

CHAPTER V: 1817–1821

Housekeeping. Birth of a Son. Exhibitions, 1817, 1818, and 1819.
Birth of a Daughter. Constable elected an Associate of the Royal
Academy. Sale of his large Pictures, the 'White Horse' and 'Stratford
Mill', to Archdeacon Fisher. Exhibition, 1820. Matthews' *Diary of an*

Invalid. Stothard's 'Canterbury Pilgrims'. White's *Selborne*. Exhibition, 1821. Excursion in Berkshire and to Oxford. Studies at Hampstead. Criticisms on the 'Stratford Mill'. Constable's Remarks on Skies *page* 71

CHAPTER VI: 1822

Mr. Samuel Lane. Farington. Coxe's *Life of Correggio*. Gold grounds. Constable's fourth large Picture. Stothard's 'Wellington Shield'. Farington's House. The Bishop of Salisbury. Studies of Skies. Illness. System of Copying at the British Gallery. Picture of 'Salisbury Cathedral from the Bishop's Grounds'. David's Picture of the 'Coronation of Josephine'. Constable's dread of a National Gallery 88

CHAPTER VII: 1823

Illness. Picture of 'Salisbury Cathedral'. Sir John Leicester's Pictures. Wilson. Constable's Pictures at the Exhibition. Sir Godfrey Kneller's House. *Life of Correggio*. The Rev. T. J. Judkin. Sir William Curtis. Visit to Archdeacon Fisher. Fonthill. The Diorama. Visit to Cole-Orton Hall. Adventure on the Road. Sir George and Lady Beaumont. Pictures at Cole-Orton. Manner of passing the Day there. Scenery of its Neighbourhood. Southey. Difference of Opinion between Sir George and Constable on Art. Studies at Cole-Orton. Return to London. Illness. Pictures for the Exhibition. Southey and the Church 99

CHAPTER VIII: 1824

Letter from Sir George Beaumont. Picture of the 'Opening of Waterloo Bridge'. Lady Paintress. Sale of two large Pictures to a Frenchman. Picture of a 'Lock on the Stour'. Description of Brighton. Mr. Phillips. J. Dunthorne, Jun. Venetian Secret discovered by a Lady. Mr. Ottley. Washington Irving. Note from Mr. Brockedon. Archibald Constable. French Criticisms on Constable's Pictures 117

CHAPTER IX: 1825

Brighton Sketches. Family Picture at Woodmanstone. Picture of the 'Jumping Horse'. Gold Medal awarded to Constable by the King of France. Duc de Choiseul. Paley. Sharon Turner. Picture of the 'Lock'. Opinion expressed of it by S. W. Reynolds. Constable's Pictures in the Exhibition at the Academy. Sale of two Pictures to Mr. Darby. Exhibition, at the British Gallery, of a Selection of the Works of Living Artists. Illness of Constable's eldest Son. Picture of the 'White Horse' sent to Lisle. Dinner at Lady Dysart's. Northcote. Cat and Chickens. Mr. Bannister. J. Dunthorne's Description of the 'Devil and Dr. Faustus' 136

CHAPTER X: 1826–1827

Return of the 'White Horse' from Lisle. Gold Medal voted to Constable. Letters of N. Poussin. Constable's Picture of the 'Cornfield'. Letter from Mr. Phillips. Mr. Fisher's Description of the Valley of Sutton and Preston. Anecdote of one of Mr. Fisher's Children. Exhibition at the Royal Academy, 1826. Description of a ruined Man. Paul Pry. Ludicrous Occurrence to the Ghost in 'Hamlet'. *The Brighton Gazette*. 'The Glebe Farm'. Mr. Fisher and Bishop Burgess. Northcote. Picture by Ruysdael. Exhibition at the Academy, 1827. Constable removes his Family to a House in Well Walk, Hampstead 151

CONTENTS v

CHAPTER XI: 1828–1829

Illness of Mr. Abram Constable, and of Mrs. Constable. Birth of Constable's youngest Child. Pictures of 'Dedham Vale', and of 'Hampstead Heath'. Death of Mr. Bicknell. His Bequest to Mr. and Mrs. Constable. Exhibition at the Royal Academy, 1828. Death of Archdeacon Coxe. Illness of Mrs. Constable. Her death. Constable ill. Receives a commission to paint a Sign. Elected an Academician, 1829. Congratulations from some of his Friends. Sir Thomas Lawrence and Constable. Picture of 'Hadleigh Castle'. Constable engaged in preparing the *English Landscape* for publication. Mr. David Lucas *page* 165

CHAPTER XII: 1830–1831

Picture of 'Bergholt Churchyard'. Death of Sir Thomas Lawrence. Mr. Shee elected President of the Royal Academy. Notes to Mr. Lucas. Constable on the Committee of Arrangement at the Academy. Picture of 'A Dell in Helmingham Park' exhibited in 1830. Illness of George IV. Jackson. Bannister. Constable Visitor in the Life Academy. Etty. Wilkie. Illness. Large Picture of 'Salisbury Cathedral from the Meadows' exhibited, 1831. Death of Jackson. Death of Northcote. Watteau. Greuze. John Varley. Coronation of King William IV and Queen Adelaide. Lord B——m. Lord Lyttelton and the Ghost. Old Sarum. Illness. Reform Bill. E. Landseer 182

CHAPTER XIII: 1832

Illness. Turner. Claude. Hobbema. Gainsborough. Stanfield. Picture of 'Waterloo Bridge'. Mr. Lawley. Callcott. Constable's Mode of Proceeding with his Pictures. The Palette Knife. Exhibition at the Academy, 1832. Constable's eldest Daughter dangerously ill. Illness of John Dunthorne, Jun. New Apartments for the Academy. Death of Archdeacon Fisher. Copy of De Hooge. Death of J. Dunthorne, Jun. Constable attends his Funeral at Bergholt. Vale of Dedham. E. Landseer. Mr. George Constable. Picture of 'Englefield House' 202

CHAPTER XIV: 1833

Messrs. Chalon. The Palette Knife. Mr. Seguier. Mr. Beauchamp's Establishment. Picture of the 'Cenotaph' erected by Sir G. Beaumont to the Memory of Reynolds. Constable visited by a Connoisseur. Lady Morley. Letters to Mr. George Constable. Stothard. Letter to Mr. Thomas Dunthorne. Exhibition at the Royal Academy. Picture of 'Englefield House'. Allusion to the Loss of the *Abergavenny*, Captain Wordsworth. The Author's Visit to America. Constable's First Lecture on the History of Landscape. Captain Cook. Letters to Mr. George Constable. Notes to Mr. Lucas. Picture of 'Waterloo Bridge' 216

CHAPTER XV: 1834–1835

Illness of Constable and his eldest Son. Death of Lady Beechy. Constable again ill. Mr. Purton. Pictures at the British Gallery and at the Academy, 1834. Visit to Arundel. Mr. George Constable. Petworth. Lord Egremont. Large Picture of 'Salisbury Cathedral'. Lady Dysart. Gainsborough. Ham House. Pictures there. Cuyp. Visit to Petworth. Cowdry Castle. Old Mills, Barns, and Farm Houses. Constable's Habits. Conflagration of the Houses of Parliament. Large Picture of

'Salisbury Cathedral'. Wilkie's 'Columbus'. Picture called the 'Valley Farm' exhibited at the Academy, 1835, and purchased by Mr. Vernon. Cozens. Pictures by David. Second Lecture at Hampstead. Attacks on the Academy. Committee of the House of Commons, etc. Charles Constable. Mr. Vernon's Picture. Bryan's *Dictionary* *page* 229

CHAPTER XVI: 1836–1837

Mr. Vernon's Picture. Contemplated Pictures of 'Arundel Mill' and of 'Stoke'. Description of Stoke Church. Engraving of 'Salisbury'. Breakfast with Mr. Rogers. Lectures at the Royal Institution. Exhibition of 1836. Picture of the 'Cenotaph' erected by Sir George Beaumont to Sir J. Reynolds. Drawing of Stonehenge. Constable's two eldest Sons. Clouds and Skies. Death of Westall. Constable Visitor in the Life Academy. Picture of 'Arundel Mill'. Engraving of 'Salisbury Cathedral from the Meadows'. Probable Causes of the Decline of Constable's Health. His Death. His Funeral 250

CHAPTER XVII

Picture of 'Arundel Mill and Castle', exhibited 1837. Presentation of the Picture of the 'Cornfield' to the National Gallery. Letter from Mr. Andrew Robertson. Constable and Hogarth compared. Traits of Constable's Character described by Mr. George Field. Farther Particulars. Selections from Constable's miscellaneous Memoranda. Note from Mr. Collins. Pictures injured by cutting, enlarging, etc. Forgeries of Constable's Pictures. Recollections of his Sayings and Opinions. The Author's Visit to East Bergholt, in company with Mr. Purton and John Constable, Junior. Mr. Purton's Remarks on Constable's Art. Sketch Books 267

CHAPTER XVIII

Notes of Six Lectures, delivered by Constable, on Landscape Painting 289

SHORT BIBLIOGRAPHY 333

THE PLATES 335

NOTES ON THE TEXT ILLUSTRATIONS 403

NOTES ON THE PLATES 407

WORKS EXHIBITED BY CONSTABLE 421

INDEX 427

EDITOR'S NOTE
AND ACKNOWLEDGEMENTS

THE text printed in this volume is that of the second (1845) edition, which, as the author's preface explains, is considerably fuller than the first (1843) edition. Where it has been possible, I have consulted the original MSS. of the letters quoted in the course of the book, and where it seemed important, I have drawn attention in the foot-notes to differences between the original and the printed texts. I am responsible for all foot-notes, or parts of foot-notes, which are prefixed by an asterisk.

My thanks are due to the following private owners who have kindly given permission to reproduce paintings or drawings in their possession and in some cases have supplied photographs: Lord Ashton of Hyde, T. W. Bacon, Esq., H. A. Benyon, Esq., A. S. Clay, Esq., Col. J. H. Constable, Edward Fisher, Esq., Lord Glenconner, W. L. Lewis, Esq., Major R. G. Proby, Major R. M. P. and the Misses Willoughby. I wish to thank also the authorities of the following Museums and Galleries, from whose collections paintings or drawings are reproduced: the Victoria and Albert Museum, the National Gallery, the National Portrait Gallery, the Tate Gallery, the Royal Academy, the National Gallery of Scotland, the Fitzwilliam Museum, Cambridge, the Lady Lever Art Gallery, Port Sunlight, the National Gallery of Victoria, Melbourne, the National Gallery of Art, Washington (Widener Collection), the Henry E. Huntington Library and Ar Gallery, San Marino, the Frick Collection, New York, and the Toledo Museum of Art, Toledo, Ohio.

<div align="right">

J. M.

</div>

EDITOR'S PREFACE

The history of Constable's development is the history of the sharpening of the eye's focus upon nature, the history of the emancipation of English art from the Claude-glass and from Sir George Beaumont's brown tree. As early as 1802, when he was aged twenty-six, he wrote the letter, which is quoted in this book, with its well-known, underlined remark There is room enough for a natural painture, and its characteristic rebuke that 'the great vice of the present day is bravura, an attempt to do something beyond the truth'. In these two observations one can see at once the essence of a consistent attitude which he maintained throughout his life; they are among the first of those pronouncements on truthfulness and humility with which his letters are henceforward sprinkled. It might be thought that there was nothing in this modest and serious ideal to arouse the suspicion of the Academicians or to mark its professor as a bold innovator; but this would be to forget that naturalism in painting was a new thing, hardly less alarming to contemporary official opinion than the more radical movements are today. When Constable started to paint, the rules for constructing a landscape had already hardened; the new works which he saw round him derived each year a little more remotely from the practice of Richard Wilson and the eighteenth-century classicists, stepped up with an injection of the fashionable 'picturesque'. These—the artificially preserved Nachlässe of an age which was passing—were the models against which Constable was in active revolt from the first.

But in spite of this early formulation of his ideal, Constable proved a slow starter. When we consider the quality of his aim, this is perhaps not surprising, for a deep and precise communion with nature is not a state which can be achieved by merely willing it so. It is particularly unfortunate that the documentary materials for a detailed consideration of his early, formative period—roughly 1800–1812—are lacking. But enough remains to show a very marked access of power and perception in the lake-district drawings and water-colours of 1806 over the more timid, if delicate, Derbyshire drawings of 1801. Even more remarkable developments had taken place by about 1811, to which year are attributed, amongst other oil-

sketches, the 'Lock and Cottages on the Stour' and 'Barges on the Stour' in the Victoria and Albert Museum. Both of these show an intense and personal vision and what amounts almost to an expressionism of gesture for which Constable had no warrant outside nature and himself.

Some of the gaps left by Leslie in his treatment of this early period can be filled from Farington's Diary. Constable first met Joseph Farington in 1798 and he continued thereafter, until the older man's death in 1821, to visit him, to ask his advice and to receive his help. Farington, although he had been a pupil of Wilson's and was himself an important member of the Royal Academy, could feel a genuine sympathy with Constable's ideals, and his advice, as recorded by himself, was perceptive; 'I recommended to him to unite firmness with freedom, and avoid flimsiness' (1801), 'I recommended him to study nature, and particular art less' (1802), 'I recommended to him as he had been studying particular appearances, now to think of atmosphere and general effect . . .' (1811). These suggestions accorded well with Constable's own expressed feelings about his art. But Farington preserved also some of Constable's own observations and states of mind: such are a period of depression in 1801 when 'he had been much discouraged by the remarks of Reinagle, etc., though he did not acknowledge their justness'; a criticism of Turner in 1803, who 'becomes more and more extravagant, and less attentive to nature'; an enthusiastic discovery of Rubens' 'Château de Steen' in 1804, and a sober depreciation of James Ward's 'Bulls Fighting' which was painted in imitation of it.

From 1811 onwards Leslie had fuller materials for the construction of his biography, and from this point it becomes a detailed and worthy portrait of its subject. It was in this year that Leslie returned to England from America and soon afterwards he made Constable's acquaintance; he could write about things which he knew from personal experience, even though the important exchange of letters between him and Constable, which lend such interest to the latter part of his book, did not start until some years later. However, when he came to write, Leslie had before him a large group of letters to and from Constable's intimate friend, Archdeacon Fisher, which more than adequately fill the gap, and from which he made ample

quotation. Indeed the great authority of Leslie's memoir arises from the fact that the story is told almost throughout in the subject's own words. That the result is one of the most attractive self-portraits in English literature, and certainly the most attractive self-portrait of a painter, is but an additional reason for its re-publication. Constable wrote as he painted, with an acute and serious eye on the subject, with a spontaneous precision of imagery; he also showed over and over again a robust wit and a taste for gossip, although this is occasionally obscured by Leslie's too careful editing. The personality which emerges is warm and engaging; Leslie's book can be read as much for its human interest as for its essential art-historical importance.

It was published first in 1843, six years after Constable's death, and was illustrated by a series of mezzotints by David Lucas after Constable's paintings. Its success encouraged Leslie to prepare a second edition, which was published two years later. This second edition, which is reprinted now, contained fewer illustrations, but was considerably enlarged with further quotation from Constable's correspondence. It has ever since remained the standard biography. But its favourable reception cannot be said to have reflected a high contemporary estimate of Constable's genius. During his lifetime he had achieved no resounding worldly success, although it must be admitted that there were seldom lacking a few enlightened friends and critics to encourage and assist him. Such public praise as he received, however, had been grudgingly bestowed, and his posthumous sale (of one hundred and forty items) realised little more than 2,000 guineas. If Leslie's biography stimulated interest and even perhaps helped to create a demand for his works, this was no more than a preparing of the ground for the full revaluation which was to be delayed almost another fifty years. The key-date in the establishing of Constable's reputation in England is 1888; in this year Miss Isabel Constable, the artist's daughter, bequeathed to the Nation over three hundred of his drawings and paintings. Until this time there had been only a very few of Constable's paintings on public exhibition; even 'The Hay Wain', which had created such a stir when it was shown in Paris in 1824, did not reach the National Gallery until 1886. But now at last it was possible for Leslie's

readers to examine for themselves the illustrations to his book and to form their own estimate of Constable's quality—an estimate which has been maintained ever since.

The reasons for the failure of Constable's naturalism to create a tradition amongst English painters, or a contemporary demand with the English public, are involved. The results of this neglect were simple and in a high degree unfortunate; it is possible indeed to attribute to it many of the subsequent weaknesses of nineteenth-century painting in England. For when, ten years after his death, the Pre-Raphaelites arose to extol truth-to-nature, it was with a dry literalness, a fundamental lack of visual emotion, which were as far as possible removed from Constable's own realisation of this ideal. Ruskin, who championed the Pre-Raphaelites, tended more and more to depreciate Constable. His eloquent devotion to Turner, who 'perceives at a glance the whole sum of visible truth open to human intelligence', blinded him to the greatness of a painter who 'perceives in a landscape that the grass is wet, the meadows flat and the boughs shady; that is to say, about as much as, I suppose, might in general be apprehended, between them, by an intelligent fawn and a sky-lark'. Another, and somewhat less disinterested, reason for Ruskin's depreciation was the praise which Leslie bestowed upon Constable in what Ruskin called 'his unadvised and unfortunate réchauffé of the fallacious art-maxims of the last century'—that is to say, the admirably sensible Handbook for Young Painters, *which Leslie published in 1855. Ruskin felt it incumbent upon him to redress the critical balance; and unhappily Ruskin was a far more influential writer than Leslie.*

In France, however, the attitude was different. Constable's own indifference to a Continental reputation, and his almost churlishly slighting remarks about the French, are perhaps responsible for. Leslie's abbreviated account of the success of his paintings in Paris. The fact remains, however, that 'The Hay Wain' and other works which were exhibited at the Salon, made an immediate effect. Delacroix's feelings about them are well known; among French critics the name of Stendhal may be quoted as of one who saw from the first their exciting originality—'I doubt if we have anything to equal them', he wrote. There is a temptation to press this point

somewhat further than the facts will warrant and to regard Constable as the father of the Barbizon School and the progenitor of Impressionism; but even if one does not go so far, it can safely be admitted that it was in France rather than in England that his true stature was first realised and that his methods and his vision were first adopted.

Constable is now regarded as one of the greatest of English painters. His work is widely exhibited and has an immediate appeal for all those who have come to take for granted the principles of Impressionism. The lack of 'finish', for which he was constantly criticised during his lifetime, has if anything enhanced his present-day popularity, and the pendulum has swung so far that some critics now even suggest that the oil-studies, which he made as preliminaries to all his larger paintings, not only are superior to the completed works, but were considered to be so by Constable himself. Such a view is in danger of missing the point. There is no documentary evidence for attributing it to Constable, and those who adopt it themselves tend to lose sight of one of his most remarkable powers—his architectonic ability to carry over into large compositions of an almost classical poise the admired lyricism of the sketches. The small sketches and the full-sized studies show us the substance of his art in its most immediately assimilable form; but they were made with one constantly expressed intention—the construction from them of large, finished pictures; and it is in these, 'The Hay Wain', 'The Leaping Horse', 'The Chain Pier', and the others, that we see the artist's capacities most fully expressed. In the final analysis Constable's genius lies somewhere between the lyric and the heroic; and the fact that he was perhaps the first painter in Europe to strike this balance in terms of romantic naturalism assures him a unique position in the history of art.

London, 1951 JONATHAN MAYNE

AUTHOR'S PREFACE

IN the first arrangement of the papers of which these Memoirs principally consist, many passages were included that, from the fear of making the book too long, were afterwards omitted. The interest, however, with which the retained portions of Constable's correspondence were read, has encouraged me to restore, now, much that had been left out of the first edition. To this I have added a few of his early letters, recently placed in my hands, and by a careful examination of some of his papers, which I had not before seen, I have been enabled to make a few additions to the notes of his Lectures. I have also added to the quotations from the letters of Archdeacon Fisher some passages which assist the narrative and others which appear to me well worthy of preservation on their own account.

In changing the form of the volume to one more adapted to general circulation, while I cannot but hope that its additional pages will be found to add to its value, I regret that it must appear without the beautiful engravings from Constable's works, with which in its first state it was adorned.

I must again offer my thanks to the members of his family and to others of my friends, for their renewed assistance in a task, to me, far less easy than interesting, although, now as before, it has been little else than that of an editor.

July 1845 C. R. LESLIE

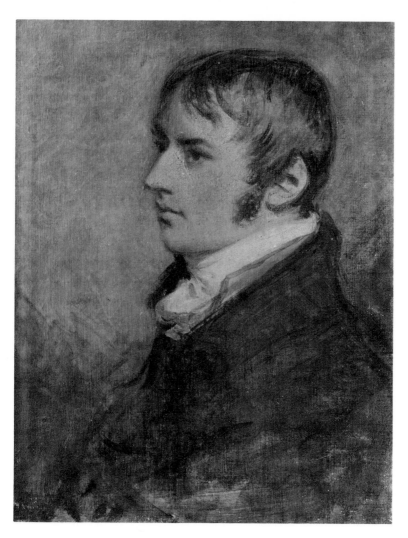

I. DANIEL GARDNER: JOHN CONSTABLE.
Tempera, about 1806. Victoria & Albert Museum

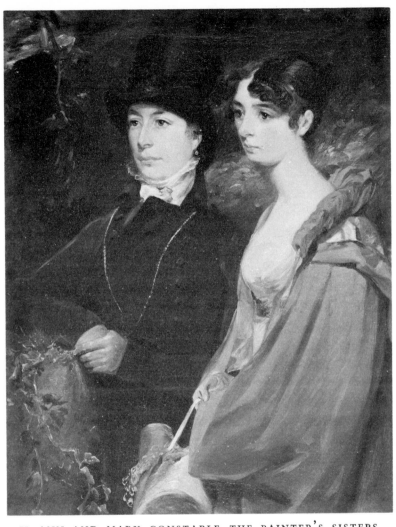

II. ANN AND MARY CONSTABLE, THE PAINTER'S SISTERS.
Collection Colonel J. H. Constable

MEMOIRS OF THE LIFE OF JOHN CONSTABLE

CHAPTER I

1776–1810

Constable's Native Scenery. Parentage. Birth. School Days. His Love of Painting. John Dunthorne. Constable employed in his Father's Mills. Introduced to Sir George Beaumont. His first Sight of a Picture by Claude. Girtin's Drawings. Constable's first Visit to London. Farington. Antiquity Smith. Constable engaged in his Father's Counting-House. Returns to the Study of Painting. Becomes a Student of the Royal Academy. His Drawings at Helmingham. Visits Derbyshire. Anatomical Studies. Exhibits at the Academy. Samuel Strowger. Mr. West. Situation of a Drawing Master offered to Constable. Dissuaded by Mr. West from accepting it. Voyage from London to Deal. Altar-Piece for Brantham Church. Visits Westmoreland and Cumberland. Introduced to the Earl and Countess of Dysart. Altar-Piece for Neyland Church. Jackson. Wilkie.

"EAST BERGHOLT, or as its Saxon derivation implies, Wooded Hill, is thus mentioned in the *Beauties of England and Wales*:—'South of the church is Old Hall, the manor house, the seat of Peter Godfrey, Esq., which, with the residences of the rector, the Rev. Dr. Rhudde, Mrs. Roberts, and Golding Constable, Esq., give this place an appearance far superior to that of most villages.' It is pleasantly situated in the most cultivated part of Suffolk, on a spot which overlooks the fertile valley of the Stour, which river separates that county on the south from Essex. The beauty of the surrounding scenery, its gentle declivities, its luxuriant meadow flats sprinkled with flocks and herds, its well cultivated uplands, its woods and rivers, with numerous scattered villages and churches, farms and picturesque cottages, all impart to this particular spot an amenity and elegance hardly anywhere else to be found."

This is Constable's description of the "scenes of his boyhood", which he was fond of saying "made him a painter". From among them most of the subjects of his pencil were

selected. The frontispiece to the *English Landscape*,[1] a series of engravings published by him late in life, is from a sketch of the house in which he was born, and the passage I have quoted accompanies the plate. Fearful of having said too much, and yet unwilling to say less, he adds, "Perhaps the author, with an over-weening affection for these scenes, may estimate them too highly, and may have dwelt on them too exclusively."

His ancestors[2] were from Yorkshire, where the name is frequent. His great-grandfather, Hugh Constable, carried it into Suffolk, and settled as a farmer at Bures, on the border which separates that county from Essex. Golding Constable, the artist's father, inherited a considerable property from a rich uncle, who was childless, including the water-mill at Flatford; he afterwards purchased a water-mill at Dedham, and two windmills in the neighbourhood of East Bergholt; at the latter place he built the house which has been mentioned, and to which he removed in the year 1774; having before that period married Miss Ann Watts, who brought some accession to his wealth, but more to his happiness, for she possessed in a high degree the virtues best suited to domestic life.

The children of this marriage were three sons and three daughters. John Constable, the second son, was born on the 11th of June, 1776, and baptized on the same day, not being expected to live. He became, however, a strong and healthy child, and when seven years old, was placed at a boarding-school about fifteen miles from Bergholt. He was afterwards removed to a school at Lavenham, the master of which, being in love, left the care of his scholars to an usher, who flogged them so unmercifully as to incur the hatred of them all; and Constable secretly resolved to repay his own share of the castigation in kind, if as men he and the tyrant should ever meet;

[1] Cf. pp. 178-80. The frontispiece is No. 27 in the catalogue by Andrew Shirley in *The Published Mezzotints of David Lucas after John Constable*, Oxford, 1930.

[2] According to the researches of Messrs. Partridge and Sier, Constable's ancestors had been living on the Suffolk-Essex border since the early seventeenth century. His great-grandfather was almost certainly born in this neighbourhood, probably at Boxted. Cf. *The Essex Review*, Oct. 1935.

a resolution he was well qualified to put in practice, unless the usher had been a man of uncommon personal strength. From Lavenham he was removed to the grammar school of the Rev. Dr. Grimwood, at Dedham, where he met with an indulgent master, with whom he became a favourite. Dr. Grimwood had penetration enough to discover that he was a boy of genius, although he was not remarkable for proficiency in his studies, the only thing he excelled in being penmanship. He acquired, however, some knowledge of Latin, and subsequently took private lessons in French, in which he made less progress. He was at this time sixteen or seventeen years of age, and had become devotedly fond of painting. During his French lessons a long pause would frequently occur, which his master would be the first to break, saying, "Go on, I am not asleep: Oh! now I see you are in your painting-room."

But his painting-room was not under his father's roof. He had formed a close alliance with the only person in the village who had any love for art, or any pretensions to the character of an artist, John Dunthorne,[1] a plumber and glazier, who lived in a little cottage close to the gate of Golding Constable's house. Mr. Dunthorne possessed more intelligence than is often found in the class of life to which he belonged; at that time he devoted all the leisure his business allowed him, to painting landscapes from nature, and Constable became the constant companion of his studies. Golding Constable did not frown on this intimacy, although he was unwilling that his son should become a professional artist, and Constable's attempts were made either in the open air, in the small house of his friend, or in a hired room in the village.

It argued no want of affection or of foresight in his father that he opposed his son's choice of a profession in which future excellence cannot with any certainty be predicted from early attempts, and which, even if attained, is less sure than excellence in many other pursuits of securing a competence. He would have educated him for the Church, but finding him

*[1] John Dunthorne, sen. (1770–1844), whose son, John Dunthorne, jun. (1798–1832), was later to become Constable's assistant.

disinclined to the necessary studies, he determined to make a miller of him. For about a year, Constable was employed in his father's mills, where he performed the duties required of him carefully and well. He was remarkable among the young men of the village for muscular strength, and being tall and well formed, with good features, a fresh complexion, and fine dark eyes, his white hat and coat were not unbecoming to him, and he was called in the neighbourhood the "handsome miller".

The windmill in an engraving from one of his sketches entitled 'Spring',[1] is one of those in which he worked; and its outline, with the name of 'John Constable, 1792', very accurately and neatly carved by him with a penknife, still remains on one of its timbers. His acquaintance with the picturesque machinery, both of wind and water-mills, was very useful to him in after life. His younger brother, Mr. Abram Constable, said to me, 'When I look at a mill painted by John, I see that it will *go round*, which is not always the case with those by other artists.' By a windmiller every change of sky is watched with peculiar interest; and it will appear from Constable's description of this plate that the time spent as one was not wholly lost to him as a painter.

'It may perhaps,' he says, 'give some idea of one of those bright and silvery days in the spring, when at noon large garish clouds surcharged with hail or sleet sweep with their broad shadows the fields, woods, and hills; and by their depths enhance the value of the vivid greens and yellows so peculiar to the season. The *natural history,* if the expression may be used, of the skies, which are so particularly marked in the hail squalls at this time of the year, is this:—The clouds accumulate in very large masses, and from their loftiness seem to move but slowly: immediately upon these large clouds appear numerous opaque patches, which are only small clouds passing rapidly before them, and consisting of isolated portions detached probably from the larger cloud. These floating much nearer the earth may perhaps fall in with

★[1] The oil-sketch is in the Victoria and Albert Museum (No. F. A. 144): the engraving is No. 7 in Shirley's catalogue.

a stronger current of wind, which as well as their comparative lightness causes them to move with greater rapidity; hence they are called by wind-millers and sailors, *messengers*, and always portend bad weather. They float midway in what may be termed the lanes of the clouds; and from being so situated, are almost uniformly in shadow, receiving a reflected light only, from the clear blue sky immediately above them. In passing over the bright parts of the large clouds they appear as darks; but in passing the shadowed parts, they assume a grey, a pale, or a lurid hue.'[1]

Mrs. Constable procured for her son an introduction to Sir George Beaumont,[2] who frequently visited his mother, the Dowager Lady Beaumont, then residing at Dedham. Sir George had seen and expressed himself pleased with some copies[3] made by Constable in pen and ink from Dorigny's engravings of the Cartoons of Raphael; and at the house of the Dowager Lady Beaumont the young artist first saw a picture by Claude, the 'Hagar',[4] which Sir George often carried with him when he travelled. Constable looked back on the first sight of this exquisite work as an important epoch in his life. But the taste of a young artist is always the most affected by contemporary art. Sir George Beaumont possessed about thirty drawings in water colours by Girtin, which he advised Constable to study as examples of great breadth and truth; and their influence on him may be traced more or less through the whole course of his practice. The first impressions of an artist, whether for good or evil, are never wholly effaced; and as Constable had till now no opportunity of

[1] Slightly abbreviated from the letterpress to the engraving.

[2] Sir George Beaumont, Bart. (1753–1827), connoisseur, patron of art and literature, and landscape-painter. Constable received help and encouragement from him.

[3] One of these drawings by Constable after Raphael was Lot 2 at Christie's, 17th Dec. 1948. It appeared to be dated —9[5].

[4] This little treasure is now in the National Gallery, where it is called 'The Annunciation'; but the spring by which the female is seated, and the action of the angel who points to the buildings in the distance, leaves little doubt that Claude's intention was to represent the first flight of Hagar from the presence of her mistress. *The painting is No. 61 in the National Gallery, and is now catalogued as *Landscape: Hagar and the Angel*.

seeing any pictures that he could rely on as guides to the study of nature, it was fortunate for him that he began with Claude and Girtin.

In the year 1795, his father consented to his visiting London, for the purpose of ascertaining what might be his chance of success as a painter, and on this occasion Priscilla Wakefield furnished him with a letter of introduction to Farington,[1] of whom, it has been said, he became a pupil. But this was not the case, though he, no doubt, received many valuable hints from a landscape painter who, though not a man of genius, possessed a great deal of good sense, and could tell him much of the practice of Wilson. Farington predicted Constable's future excellence, and said, at an early period of their acquaintance, that his style of landscape would one day 'form a distinct feature in the art'.

Soon after his arrival in London, Constable became acquainted with John Thomas Smith, known then as a clever draughtsman, engraver, and local antiquary; since more generally, I cannot say *better*, known as the writer of the *Life of Nollekins*. Constable's intercourse with 'Antiquity Smith', as he was called, tended, no doubt, to strengthen that fondness for localities which had so much to do with, if indeed it was not the basis of, his art; and it may be inferred that the advice he received from his new friend was generally sound, from the following specimen. 'Do not,' said Smith, 'set about inventing figures for a landscape taken from nature; for you cannot remain an hour in any spot, however solitary, without the appearance of some living thing that will in all probability accord better with the scene and time of day than will any invention of your own.' Often has Constable, in our walks together, taken occasion to point out, from what he saw, the good sense of Smith's advice.

*[1] Leslie is mistaken. According to his Diary, Farington did not make Constable's acquaintance until 25th Feb. 1798. Joseph Farington R.A. (1747–1821) had been a pupil of Richard Wilson. His Diary, the MS. of which is in the Royal Library, Windsor, provides invaluable material for this period of English art. Extracts from the Diary, edited by James Greig, were published 1922–28.

Constable's time was now divided between London and Bergholt; and the following passages from the letters he wrote from the country to Smith show what were some of his occupations for the next two years. "October 27th, 1796. As the evenings are now long, I find great pleasure in reading the books I brought home with me, particularly *Leonardo da Vinci* and *Count Algarotti*. I should feel obliged to you, when you make up the parcel which I mentioned, if you would enclose Gessner's *Essay on Landscape*.[1] I devote all my evenings to the study of anatomy." "January 16th, 1797. You flatter me highly respecting my 'Cottages', and I am glad you have found one or two amongst them worthy of your needle.[2] I am obliged to you for the directions you sent me for etching, but they were not exactly what I meant. What I fear I am deficient in is the biting. I have lately copied Tempesta's large battle, and painted two small pictures in oil, viz. a 'Chymist' and an 'Alchymist', for which I am chiefly indebted to our immortal bard. You remember Romeo's account of an apothecary's shop. I have a great mind to copy one of Ruysdael's etchings. I have seen one at your house where there are two trees standing in the water, and there is one your father copied: either of these I should like very much, but as they are scarce and dear, perhaps you would not like to trust them; if not, send me any others. I want to know if it is possible to take the proofs of the plates myself."

The little pictures of the 'Chymist' and the 'Alchymist'[3] mentioned in this letter have very little merit. Constable probably intended a moral by the ragged and poverty-struck

[1] Salomon Gessner's *Brief über die Landschaftmalerei an Herrn Fuesslin*, Zurich, 1787, was translated and published in English as *On Landscape Painting*.

[2] Smith was publishing a series of etchings of picturesque cottages, and some of Constable's letters to him contained sketches of cottages. ★ J. T. Smith's volume was entitled *Remarks on Rural Scenery, with 20 etchings of Cottages from Nature* (London, 1797). A part of the preceding letter, which Leslie does not quote, contains a reference to a sketch-book with drawings of cottages. Some leaves from such a sketch-book are now in the Victoria and Albert Museum (Nos. 358–358*j*–1888): one of these drawings is dated 1796, and all are much in the style of J. T. Smith's etchings, though there is no direct correspondence.

★[3] Now in the collection of Mrs. C. A. Brookes, Dedham.

appearance of the alchymist, while the chymist is neat and comfortable; but if he had as yet produced nothing better, it is not surprising that his own pursuits were regarded by his friends much in the same light with those of his alchymist. In a letter to Smith, dated March 2nd, 1797, he says, "I must now take your advice and attend to my father's business, as we are likely soon to lose an old servant (our clerk), who has been with us eighteen years; and now I see plainly it will be my lot to walk through life in a path contrary to that in which my inclination would lead me." The next letter is from Mrs. Constable to Smith: "East Bergholt, October 1797. Dear Sir, I have great pleasure in receiving a letter so warm in commendation of my son John, as yours of the 29th ult. His future conduct I trust will ever merit the favour of your friendship, which I know he highly values. Let me assure you that, were you intimately acquainted with his father, you would not wonder at his having so worthy a son. We are anticipating the satisfaction of seeing John at home in the course of a week or ten days, to which I look forward with the hope that he will attend to business, by which he will please his father, and ensure his own respectability and comfort."

How long Constable was engaged in his father's counting-house I know not; but in the year 1799 he had resumed the pencil, not again to lay it aside; as I find him thus writing to Dunthorne. "London, February 4th, 1799. I am this morning admitted a student at the Royal Academy;[1] the figure which I drew for admittance was the Torso. I am now comfortably settled in Cecil Street, Strand, No. 23. I shall begin painting as soon as I have the loan of à sweet little picture by Jacob Ruysdael to copy. Since I have been in town I have seen some remarkably fine ones by him, indeed I never saw him before; yet don't think, by this, I am out of conceit of my own, of

*[1] There is some confusion here. The R. A. Register gives 19th Feb. 1800 as the date on which Constable became a Student at the R. A. Schools. On 4th Dec. 1799 Farington made a list in his Diary of 'Probationers qualified to be students', and Constable's name is among them. Perhaps Constable in the letter quoted above is confusing his terms and really means to say that he has become a Probationer. Or perhaps Leslie misread the date on the letter.

which I have seen a print, 'tis of the same size and reversed. I shall not have much to show you on my return, as I find my time will be more taken up in *seeing* than in painting. I hope by the time the leaves are on the trees, I shall be better qualified to attack them than I was last summer. All the time that you can conveniently spare from your business may be happily spent in this way, perhaps profitably, at any rate innocently. ... Smith's friend, ——, has left off painting, at least for the present. His whole time and thoughts are occupied in exhibiting an old, rusty, fusty head, with a spike in it, which he declares to be the real embalmed head of Oliver Cromwell? where he got it I know not; 'tis to be seen in Bond Street, at half a crown admittance. How goes on the lay figure?[1] I hope to see it finished when I return, together with some drawings of your own from nature."

I have seen no studies made by Constable at the Academy from the antique, but many chalk drawings and oil paintings from the living model, all of which have great breadth of light and shade, though they are sometimes defective in outline.

On the 18th of August he writes to Smith from Ipswich: "I believe I may be here a fortnight longer. It is a most delightful country for a painter. I fancy I see Gainsborough in every hedge and hollow tree."[2]

In a letter to Dunthorne from London, without date, but probably written in the winter of this year, Constable says: "I paint by all the daylight we have, and that is little enough. I sometimes see the sky, but imagine to yourself how a pearl must look through a burnt glass. I employ my evenings in making drawings and in reading, and I hope by the former to clear my rent. If I can I shall be very happy. Our friend Smith has offered to take any of my pictures into his

[1] Mr. Dunthorne, who was a man of much ingenuity, had undertaken to make a lay figure.

[2] Gainsborough was a native of the southern border of Suffolk. He was born at Sudbury, about fourteen miles from Bergholt; and his earliest studies, like those of Constable, were from the pastoral scenery of the Stour. Before he settled in London he resided for some time at Ipswich.

shop for sale. He is pleased to find I am reasonable in my prices."[1]

In another letter, to the same correspondent, without date, he says: "I have copied a small landscape of A. Caracci and two Wilsons, and have done some little things of my own. I have likewise begun to copy a very fine picture by Ruysdael which Mr. Reinagle[2] and myself have purchased in partnership for £70. . . . I hope to see you in the spring, when the cuckoos have picked up all the dirt. Every fine day makes me long for a walk on the commons. . . . I have finished my copy from Ruysdael, all but the glazing, which cannot be done till the picture is dry. It has been roasting in the sun these two or three days. To-morrow I hope to go on with my copy from Sir George Beaumont's little Claude.[3] I shall remain in town the chief of this summer. Indeed I find it necessary to fag at copying, some time yet, to acquire execution. The more facility of practice I get, the more pleasure I shall find in my art; without the power of execution I should be continually embarrassed, and it would be a burthen to me. This fine weather almost makes me melancholy; it recalls so forcibly every scene we have visited and drawn together. I even love every stile and stump, and every lane in the village, so deep-rooted are early impressions." In a letter, probably subsequent to these, he says, "My visit to the Whalleys[4] has done me a world of good. The regularity and good example in all things, which I had an opportunity of seeing *practised* (not *talked of* only), during my stay with that dear family, will, I trust, be of service to me as long as I live. I find my mind much more decided and firm; and since I have been this time in town, I have acquired, considerably, what I have so long and so ardently desired, patience in the pursuit of my profession. I

[1] Smith's shop was at 40 Frith Street, Soho. In the complete MS. of this letter, there are references to the selling of the painting by Ruysdael whose purchase is mentioned in the next letter to be quoted. It seems therefore that Leslie has printed these two letters in the wrong order.

[2] R. R. Reinagle (1775–1862), painter of Panoramas and of landscapes and portraits in water-colour and oil.

[3] The 'Hagar'. [4] Mrs. Whalley was Constable's second sister.

know very little of what is going on in the arts, but I have free admission to Mr. Bryan's[1] picture-room, where are some fine works, particularly some landscapes by Gaspar; I visit this once a week at least."[2]

"(Month illegible), 1800. Dear Dunthorne, Here I am quite alone among the oaks and solitudes of Helmingham Park.[3] I have taken quiet possession of the parsonage, finding it empty. A woman comes from the farm house, where I eat, and makes my bed, and I am left at liberty to wander where I please during the day. There are abundance of fine trees of all sorts, and the park on the whole affords good objects rather than fine scenery. But I can hardly judge yet what I may have to show you. I have made one or two drawings that may be useful."

Two of these drawings, dated July 23rd and 24th, are in my possession, and though slight and merely in black and white, they show that he at that time possessed a true sense of the beautiful in composition. In the year 1801, it appears by one of his sketch books, he visited Derbyshire.[4] The sketches he made there, like those at Helmingham, are slight and general. They are washed in one tint only, and with no attempt at the beautiful finish or force of chiaroscuro seen in his later studies.

"1801. Dear Dunthorne, . . . I have got three rooms in a very comfortable house, No. 50, Rathbone Place. My large room has three windows in front. I shall make that my shop, having light from the upper part of the middle window, and by that means I shall get my easel in a good situation. I hope to be able to keep more to myself than I did in former times, in

*[1] Michael Bryan (1757–1821) professional connoisseur and author of the *Biographical and Critical Dictionary of Painters and Engravers* (1813–16).

*[2] Leslie omits the following important sentences from his transcript of this letter: "I am determined to compleat some little performance for the exhibition. I have concluded on my subject and effect, and it will be a kitkat size, that is two feet and a half by three feet." Cf. p. 13 below.

*[3] Helmingham Park, Suffolk, belonged to the Earl of Dysart. Constable visited there on several occasions, and in 1830 exhibited a painting of a *Dell Scene, Helmingham*, at the R. A.

*[4] Some pages from the Derbyshire sketch-book are in the Victoria and Albert Museum (Nos. 247–247g–1888). See Plate 2.

London. I have been among my old acquaintances in the art, and am enough disgusted (between ourselves) with their cold trumpery stuff. The more canvas they cover, the more they discover their ignorance and total want of feeling. . . . I have seen —— twice. He has painted a 'Landscape, Dedham', from the sketch he took from Mrs. Roberts'. He calls it his best picture. It is very well pencilled, and there is plenty of light without *any light at all*."

"Rathbone Place, January 8th, 1802. Dear Dunthorne, . . . About a fortnight back, I was so fully in the hope of making an immediate visit to Bergholt that I deferred writing. I then knew nothing of the anatomical lectures[1] which I am at present attending, and which will be over in about a week or ten days. I am so much more interested in the study than I expected, and feel my mind so generally enlarged by it, that I congratulate myself on being so fortunate as to have attended these lectures. Excepting astronomy, and that I know little of, I believe no study is really so sublime, or goes more to carry the mind to the Divine Architect. Indeed the whole machine which it has pleased God to form for the accommodation of the real man, the mind, during its probation in this vale of tears, is as wonderful as the contemplation of it is affecting. I see, how-ever, many instances of the truth, and a melancholy truth it is, that a knowledge of the things created does not always lead to a veneration of the Creator. Many of the young men in this theatre are reprobates.

"I have done little in the painting art since I have been in town yet. A copy of a portrait and a background to an ox for Miss Linwood is all. I have not time to say half I could wish about my Derbyshire excursion, therefore I will say nothing."

In 1802, Constable's name appeared for the first time in the catalogue of the exhibition of the Royal Academy as an

[1] Delivered by Mr. Brookes at his Anatomical Theatre. To these lectures, and to his dissecting room, Mr. Brookes, very liberally, gave the students of the Royal Academy free admission. Many extremely accurate and beautiful coloured drawings, of a large size, made by Constable at this time, from dis-sections, bear evidence of the interest with which he pursued the study of anatomy.

exhibitor; the picture being merely called 'Landscape'. I think it likely, however, he may have sent pictures for exhibition in 1800 or 1801, or in both years, which were rejected; as in a letter, apparently written in the winter of 1799, he speaks of preparing some little thing for the exhibition.[1]

Those of my brother artists who remember the Academy twenty years ago will not have forgotten Samuel Strowger, the most symmetrical of models in the Life School, and the best of servants to the Institution. He was a Suffolk man, and had worked on a farm in Constable's neighbourhood, where he was distinguished in the country phrase as 'a beautiful ploughman', until he enlisted in the Life Guards, when his strict attention to his duties soon acquired for him the character of the best man in his regiment. The models of the Academy are generally selected from these fine troops; Sam was chosen, and the grace of his attitudes, his intelligence and steadiness, induced the Academy to procure his discharge, and to place him in the Institution as head porter and occasional model. Sam and Constable, who had known each other in Suffolk, were thus brought together again in London; and Strowger showed his readiness to patronise his old acquaintance, as far as lay in his power, by interceding, when he could venture to do so, during the arrangements of the exhibitions, in behalf of his works. As they were generally views in Suffolk, they had peculiar charms in Sam's eyes, and he could vouch for the accuracy with which they represented all the operations of farming. He was captivated by one of them, a 'Corn Field with reapers at work', and pointed out to the arranging committee its correctness, 'the *lord*', as the leading man among reapers and mowers is called in Suffolk, being in due advance of the rest. But with all his endeavours to serve his friend the picture was either rejected or not so well placed as he wished, and he consoled Constable, and at the same time apologised for the members of the committee, by saying, 'Our gentlemen are all great artists, sir, but they none of them know anything about the *lord*.'

★[1] Cf. *n.* 2 p. 11 above.

I cannot take leave of my old friend Strowger without mentioning that towards the close of his life, the students of the Academy presented him with a silver snuff-box of huge dimensions; and that a very exact portrait of him in his best days was painted by Wilkie. It is the head of the intelligent farmer in the 'Rent Day', who, seated at the table with his finger raised, appears to be recalling some circumstance to the recollection of the steward.

I have heard Constable say that under some disappointment, I think it was the rejection, at the Academy, of a view of Flatford Mill, he carried a picture to Mr. West, who said, 'Don't be disheartened, young man, we shall hear of you again; you must have loved nature very much before you could have painted this.' He then took a piece of chalk, and showed Constable how he might improve the chiaroscuro by some additional touches of light between the stems and branches of the trees, saying, 'Always remember, sir, that light and shadow *never stand still*.' Constable said it was the best lecture, because a practical one, on chiaroscuro he ever heard. Mr. West, at the same time, said to him, 'Whatever object you are painting, keep in mind its prevailing character rather than its accidental appearance (unless in the subject there is some peculiar reason for the latter), and never be content until you have transferred that to canvas. In your skies, for instance, always aim at *brightness*, although there are states of the atmosphere in which the sky itself is not bright. I do not mean that you are not to paint solemn or lowering skies, but even in the darkest effects there should be brightness. Your darks should look like the darks of silver, not of lead or of slate.' This advice was not addressed to an inattentive ear.

Constable acknowledged many obligations to the amiable President of the Academy, in whom every young artist found a friend; but the greatest was one which possibly affected the whole course of his life. In the spring of 1802, Dr. Fisher, Rector of Langham, and afterwards Bishop of Salisbury, had procured for him the situation of a drawing-master in a school; but Mr. West strongly dissuaded him from accepting it, telling

him that if he did so he must give up all hopes of distinction. Such advice, and from so high an authority, was very agreeable to Constable; the difficulty, however, remained, of declining Dr. Fisher's well-intentioned offer without giving him offence, which Mr. West undertook and easily accomplished. To this affair Constable alludes in the next letter.

"London, May 29th, 1802. My dear Dunthorne, I hope I have now done with the business that brought me to town with Dr. Fisher. It is sufficient to say that had I accepted the situation offered, it would have been a death-blow to all my prospects of perfection in the art I love. For these few weeks past, I believe I have thought more seriously of my profession than at any other time of my life; of that which is the surest way to excellence. I am just returned from a visit to Sir George Beaumont's pictures with a deep conviction of the truth of Sir Joshua Reynolds' observation, that 'there is no easy way of becoming a good painter'. For the last two years I have been running after pictures, and seeking the truth at second hand. I have not endeavoured to represent nature with the same elevation of mind with which I set out, but have rather tried to make my performances look like the work of other men. I am come to a determination to make no idle visits this summer, nor to give up my time to commonplace people. I shall return to Bergholt, where I shall endeavour to get a pure and unaffected manner of representing the scenes that may employ me. There is little or nothing in the exhibition worth looking up to. *There is room enough for a natural painter*[1]. The great vice of the present day is *bravura*, an attempt to do something beyond the truth. Fashion always had, and will have, its day; but truth in all things only will last, and can only have just claims on posterity. I have reaped considerable benefit from exhibiting; it shows me where I am, and in fact tells me what nothing else could."

In 1803, Constable exhibited at the Academy two 'Landscapes' and two 'Studies from Nature'; and in April he made a

*[1] The word written by Constable was '*painture*', in the sense of 'style in painting'.

trip from London to Deal, in the *Coutts*, East Indiaman, with Captain Torin, a friend of his father.

"London, May 23rd, 1803. Dear Dunthorne, I have for some time felt a weight on my mind from having so long neglected writing to you. Indeed there is this strange fatality about me, that I seem to neglect those whose love and friendship I most value. . . . My voyage I will mention first. I was near a month on board, and was much employed in making drawings of ships in all situations. I saw all sorts of weather. Some the most delightful, and some as melancholy. But such is the enviable state of a painter that he finds delight in every dress nature can possibly assume. When the ship was at Gravesend, I took a walk on shore to Rochester and Chatham. Their situation is beautiful and romantic, being at the bottom of finely formed and high hills, with the river continually showing its turnings to great advantage. Rochester Castle is one of the most romantic I ever saw. At Chatham I hired a boat to see the men-of-war, which are there in great numbers. I sketched the *Victory* in three views. She was the flower of the flock, a three decker of (some say) 112 guns. She looked very beautiful, fresh out of dock and newly painted. When I saw her they were bending the sails; which circumstance, added to a very fine evening, made a charming effect. On my return to Rochester, I made a drawing of the Cathedral, which is in some parts very picturesque, and is of Saxon architecture. I joined the ship again at Gravesend, and we proceeded on our voyage, which was pleasant enough till we got out to sea, when we were joined by three more large ships. We had almost reached the Downs when the weather became stormy, and we all put back under the North Foreland, and lay there three days. Here I saw some very grand effects of stormy clouds. I came on shore at Deal, walked to Dover, and the next day returned to London. The worst part of the story is that I have lost all my drawings. The ship was such a scene of confusion, when I left her, that although I had done my drawings up very carefully, I left them behind. When I found, on landing, that I had left them, and saw the ship out of reach, I

was ready to faint. I hope, however, I may see them again some time or other. Now I think I must have tired you, and I will change the subject.

"The exhibition is a very indifferent one on the whole. In the landscape way most miserable. I saw, as I thought, a great many pictures by Sir F. Bourgeois, but it proved that not half of them belonged to him, but to another painter who has imitated his manner exactly. Sir Francis was the hangman, and was so flattered by these imitations that he has given them as good places as his own. There are, however, some good portraits in the exhibition. I have seen some fine pictures lately, and have made a few little purchases; twelve prints by Waterloo, and four fine drawings by him, with some other prints. But my best purchases are two charming little landscapes by Gaspar Poussin, in his best time. . . . I feel now, more than ever, a decided conviction that I shall sometime or other make some good pictures. Pictures that shall be valuable to posterity, if I reap not the benefit of them. This hope, added to the great delight I find in the art itself, buoys me up, and makes me pursue it with ardour.

"Panorama painting seems all the rage. There are four or five now exhibiting, and Mr. R——[1] is coming out with another, a view of Rome, which I have seen. I should think he has taken his view favourably, and it is executed with the greatest care and fidelity. This style of painting suits his ideas of the art itself, and his defects are not so apparent in it; that is, great principles are neither expected nor looked for in this mode of describing nature.[2] He views nature minutely and *cunningly*, but with no greatness or breadth. The defects of the picture at present are a profusion of high lights, and too great a number of abrupt patches of shadow. But it is not to be considered as a whole. . . . I shall soon be at home again. The weather is not, however, very tempting, and while I find so

★[1] Probably Reinagle who, with T. E. Barker, produced a Panorama of Rome.

[2] Sir George Beaumont was of opinion, and, perhaps with some reason, that the effect of panorama painting has been injurious to the taste, both of the artists and the public, in landscape.

much to interest me, at this busy time of the Arts, in London, I shall stay a week or two longer."

Constable was fortunate enough to recover his marine sketches, about 130,[1] and the use he made of his drawings of the *Victory* will be seen immediately.

Between this period and 1807, no letters either to or from Constable have reached my hands. In 1804 he did not exhibit, but he painted an altar-piece for Brantham Church near Bergholt, the subject, 'Christ blessing little Children'. The figures are of the size of life, and all standing, except a child in the Saviour's arms. The arrangement of the masses is good, but it has no other merit; and indeed is no otherwise worthy of notice than as a proof that he did wisely, after one more attempt, in making no farther incursions into this walk of the art. In 1805 he exhibited a 'Landscape, Moonlight', and in 1806, a drawing of 'His Majesty's Ship *Victory* in the Battle of Trafalgar, between two French Ships of the Line'.[2] This subject was suggested to him by hearing an account of the battle from a Suffolk man, who had been on Nelson's ship.

In this year his maternal uncle, David Pike Watts, recommended to him a tour in Westmoreland and Cumberland in search of subjects for his pencil, and paid his expenses. He spent about two months among the English lakes and mountains, where he made a great number of sketches,[3] of a large size, on tinted paper, sometimes in black and white, but more often coloured. They abound in grand and solemn effects of light, shade, and colour, but from these studies he never painted any considerable picture, for his mind was formed for the enjoyment of a different class of landscape. I have heard him say the solitude of mountains oppressed his spirits. His nature was peculiarly social and could not feel satisfied with scenery, however grand in itself, that did not abound in human associations. He required villages, churches, farmhouses, and cottages; and I believe it was as much from

*[1] Nine of these are now in the Victoria and Albert Museum.
*[2] Now in the Victoria and Albert Museum (No. 169-1888).
*[3] Many of these are now in the Victoria and Albert Museum. See Plate 4.

natural temperament as from early impressions that his first love, in landscape, was also his latest love. In 1807 he exhibited some of the results of his excursion; 'A View in Westmoreland', 'Keswick Lake',[1] and 'Bow Fell, Cumberland'.

The Earl of Dysart wishing to have some family pictures copied, Constable was introduced to his lordship and the Countess as a young artist who would be glad to undertake them. The consequence was his being employed in making a number of copies, chiefly from Sir Joshua Reynolds;[2] and although it is to be regretted that much of his time should have been spent on any but original works, yet he no doubt derived improvement in his taste for colour and chiaroscuro by this intimate communion with so great a master of both.

About this time his mother, at the conclusion of a letter to him, says: "How thankful I am that you so much enjoy the invaluable blessing of health. It is, I trust, the kind gift of Providence, rendered the more permanent by your own prudence and good conduct. Long may you enjoy it on such terms!" And his uncle, Mr. Watts, thus speaks of him at the same period: 'J.C. is industrious in his profession, temperate in diet, plain in dress, frugal in expenses, and in his professional character has great merit.'

In 1808 he exhibited at the Royal Academy, three pictures, 'Borrowdale', 'A Scene in Cumberland', and 'Windermere Lake', and at the British Gallery, 'A Scene in Westmoreland', probably the one he had exhibited at the Academy the preceding year, and 'Moonlight (a Study)'. In 1809 his pictures at the Academy were three, with the title merely of 'Landscape'; and at the British Gallery he had also three,[3] 'Borrowdale', 'A Cottage', and 'Keswick Lake', the latter having been exhibited at the Academy.

*[1] Possibly the painting in the National Gallery of Victoria, Melbourne (No. 140). See Plate 5.

*[2] These are now at Ham House.

*[3] According to the catalogue, Constable exhibited a fourth painting at the B.I.: this was 'Windermere Lake' and may have been the same painting which he exhibited at the R. A. in the previous year. Constable was later to make a habit of exhibiting works twice, at the R. A. and the B. I.

In this year he painted his second and last attempt in sacred history, an altar-piece for Neyland Church, a single half figure of the Saviour blessing the bread and wine. Although, from the slightness of the execution, this picture can only be considered as a sketch of the size of life, it is in all respects much better than the Brantham altar-piece. There is no originality in the treatment, but a subject so often painted almost precludes originality. The light falls on the face from a lamp, and the colour and effect are very agreeable, broken colours partaking of purple and brownish yellow being substituted in the draperies for the ordinary blue and red. Still, such are its deficiencies, that it is evident a long course of study and practice would have been required before he could have done justice, if ever, to subjects of its class.

In 1810 he exhibited at the Academy 'A Landscape' and 'A Church-Yard'.[1]

The following passage in a letter from John Jackson, dated October 23rd, 1810, shows that Constable's friendship with that eminent artist had then commenced. They were men who could fully appreciate each other: "I spent ten days in Hants, and was delighted beyond measure with the New Forest. I think it indescribably beautiful; but perhaps you may have seen it. If not, I wish we might find some sequestered cottage to put our heads in by night, and in the day explore and sketch, for a fortnight or three weeks: but more of this when we meet."

Constable and Wilkie were also much together at that time, and their friendship never suffered any diminution. Constable sat to Wilkie for the head of the physician in his picture of the 'Sick Lady', and again, in the character of a physician, at a late period of their lives; as will be noticed in its proper place.

*[1] This is probably identical with the 'Church Porch' exhibited the following year at the B. I. If so, it is now in the National Gallery (No. 1245).

1811–1812

West's Picture of 'Christ healing the Sick'. Constable's Art. Traits of his Character. His Health affected. Sir George Beaumont's Prescription. Another Prescription. Attachment to Miss Bicknell. Their Marriage objected to by her Friends. Visit of Miss Mary Constable to her Brother. Correspondence with Miss Bicknell. Exhibition at the Royal Academy, 1812. Archdeacon Fisher. Mr. Stothard. Constable engaged on Portraits. Fire at his Lodgings.

IN 1811, an extraordinary event in the history of English Art occurred: the directors of the British Institution bought West's picture of 'Christ healing the Sick' for £3000. Constable's fond mother, who had seen this picture, after saying she preferred the principal figure and infant in her son's Brantham altar-piece, thus concludes a letter to him: "In truth, my dear John, though in all human probability my head will be laid low long ere it comes to pass, yet with my present light, I can perceive no reason why you should not, one day, with diligence and attention be the performer of a picture worth £3000."

In this year he sent to the Academy two pictures, 'Twilight' and 'Dedham Vale',[1] and to the British Gallery, 'A Church Porch',[2] which as well as the 'Dedham Vale' remained in his possession to the end of his life, and I am therefore well acquainted with them. The 'Porch' is that of Bergholt Church, and the stillness of a summer afternoon is broken only by the voice of an old man to whom a woman and girl sitting on one of the tombs are listening. As in many of the finest Dutch pictures, the fewness of the parts constitutes a charm in this little work; such is its extreme simplicity, that it has nothing to arrest attention, but when once noticed, few pictures would longer detain a mind of any sensibility. I have heard the word *sentiment* ridiculed when applied to representations of inanimate objects. But no other word can express that from which the impression of this picture results, independently of the figures.

★[1] Now in the collection of Major Proby. See Plate 11.
★[2] Now in the National Gallery. (No. 1245).

In the 'Dedham Vale' an extensive country is seen through a sunny haze, which equalises the light, without injuring the beauty of the tints. There is a tree of a slight form in the foreground, touched with a taste to which I know nothing equal in any landscape I ever saw. Such pictures were, however, too unobtrusive for the exhibition, and Constable's art had made no impression whatever on the public. But when we look back to the fate of Wilson, and recollect that Gainsborough was only saved from poverty by his admirable powers in portraiture, and that the names of Cozens and Girtin are scarcely known to their countrymen, we shall not hastily conclude that to fail in attracting general notice is any proof of want of merit in an English landscape painter. It may be that the art, so simple and natural, as it is in the best works of these extraordinary men, becomes a novelty which people do not know how to estimate; Steele, in a paper of the *Tatler*, speaks of an author 'who determined to write in a way perfectly new, and describe things exactly as they happened'.

Constable's father and mother wished him to apply himself to portrait painting, but he had not the happiness, like Gainsborough, to combine landscape and portrait in equal perfection. He painted the latter indeed, occasionally, all his life, but with very unequal success; and his best works of this kind, though always agreeable in colour and breadth, were surpassed, in more common qualities, by men far inferior to him in genius. His profession had hitherto been profitless, but it may be doubted whether under any circumstances he would have become a rich man by his own exertions; for although he was an early riser, frugal in his habits of living and not addicted to any vicious extravagance either of time or money, yet of neither was he an economist. Both were always too readily at the disposal of others; it was as difficult for him to say no to a borrower as to shut his door against a lounger, still less could he ever resist an appeal to his charity; and if a book or a print he wanted came in his way, the chances were he would buy it, though with the money that should pay for his next day's dinner. He was well aware of this want of resolu-

tion, and often formed plans of economy, but failing in a constant and steady adherence to them, they seldom proved of much real advantage to him.

It now became apparent to Constable's friends that his health was declining. It was, I believe, at this time that Sir George Beaumont undertook to be his physician, and prescribed for him that he should copy a picture entirely from memory. He was to walk every day to Sir George's house in Grosvenor Square, look at the picture as long as he pleased, then return home and paint as much of it as he had retained in his recollection, until the copy was finished. The regular exercise and change of scene, combined with an agreeable and not too arduous employment were to work the cure. The picture selected was a landscape by Wilson, and the experiment was tried, but the malady under which Constable laboured was not to be so easily removed.

The following is part of a very long letter from a friend who often bestowed advice on him less judicious than well intentioned. It is addressed to "J.C. aged thirty-five", which marks it as belonging to this period. "Dear John, I am sorry to see too visible traits in your whole person of an inward anxiety which irritates your nervous system, deranges the digestion, and undermines the health. But health alone, that invaluable possession, is not the sole thing impaired; the mental powers are liable to participate in the depression of the animal system. It is not in the power of even your nearest friend to see into the secret causes of the operations of the mind; but a tolerable opinion may be formed of what passes within the thoughts of another person by certain external traits. The conclusion to be drawn from these is, that your indisposition arises from more than one cause, though one has of late been predominant, and has become the main trouble which absorbs the minor ones, and resolves all the subordinate cares into one overwhelming solicitude, and this is a deep concern of the heart and affections." I will spare the reader any more of this letter, which comprises four pages of the usual advice as to the best means of combating a hopeless passion, which is generally

thrown away on similar occasions; one page being a quotation from 'an able divine'. Enclosed in the letter I found a printed paper entitled: 'A Cure for Love. Take half a grain of sense, half a grain of prudence,' etc., etc.

Another long letter, from the same kind mentor, appears to have been written the next day; and however well meant, was certainly not very well timed.

"Dear John, I amused myself at seven o'clock this morning in transcribing the enclosed, which I hope will amuse you more than my yesterday's extract. You see I copy from the great masters, whether in Divinity, Morals, or the Arts.[1] I sometimes wish you had copied more; and that at an early age you had put yourself under a great master. That dread of being a mannerist, and that desire of being an original, has not, in my imperfect judgment, produced to you the full advantage you promised yourself from it. As far as my unqualified and simply native taste extends (which I acknowledge to be very in-adequate to form a correct judgment), I had rather see some of the manner of those highly extolled works, which have commanded the applause of the public at large, from the perfect connoisseur down to the simple spectator. I have before taken the freedom to offer my sentiments to you; you have before paid me the compliment to ask and receive them. I have no motive in my observations but your good, or what I conceive to be so, joined to a regard to truth, and an aversion to flattery. My opinion is, that cheerfulness is wanted in your landscapes; they are tinctured with a sombre darkness. If I may say so, the trees are not green, but black; the water is not lucid, but over-shadowed; an air of melancholy is cast over the scene, instead of hilarity," etc. How must the artist have writhed under this friendly advice, ill in body and depressed in mind as he then was.

Maria Bicknell, the young lady between whom and Con-

[1] I have omitted transcribing the enclosure, nor should I have interrupted the narrative with any of the effusions of this correspondent, but that the reader may judge, from these specimens, of many similar inflictions to which Constable was, for some years, subjected from the same quarter. They smack of the wisdom as well as of the style of Polonius.

stable there now existed a mutual attachment, was the daughter of Charles Bicknell, Esq., of Spring Gardens, Solicitor to the Admiralty, and grand-daughter, by her mother's side, to the Rev. Dr. Rhudde, Rector of Bergholt, where Constable's acquaintance with her had commenced as early as the year 1800, while she was a child. Objections to their union arose on the part of Miss Bicknell's friends, Dr. Rhudde being its chief opposer. He was probably unwilling that his grand-daughter should marry a man below herself in point of fortune, and whom he might, not unreasonably, consider as without a profession, since Constable could scarcely appear in any other light to his best friends. A difference had arisen between Golding Constable and the rector, which at that time estranged them from each other; and there was a story current in Bergholt of a caricature of the doctor by Constable, which, whether true or false, was unfortunate. How far any or all of these circumstances operated on Dr. Rhudde's mind, or what other objections he may have had to receive Constable as a grandson-in-law, I know not, but it became afterwards plain that Mr. Bicknell would not long have opposed the marriage, had it not been from fear of excluding his daughter's name from the will of her grandfather, who was very rich. As it was, the lovers were doomed for five years to suffer all the wearing anxieties of hope deferred, of which their own letters form a deeply interesting history.

The first I have seen of this series is from Miss Bicknell, who was on a visit at the house of a friend in the country.

"Spring Grove, Nov. 2, 1811. My dear Sir, You have grieved me exceedingly by the melancholy account you give of your health, and I shall feel much better satisfied when I know you are in Suffolk, where I do not doubt that good air, with the nursing and attention of your friends, will go a great way towards your recovery. I dare not suffer myself to think on your last letter. I am very impatient, as you may imagine, to hear from papa, on a subject so fraught with interest to us both; but was unwilling to delay writing to you, as you would

be ignorant of the cause of such seeming inattention. I hope you will not find that your kind partiality to me made you view what passed in Spring Gardens too favourably. You know my sentiments; I shall be guided by my father in every respect. Should he acquiesce in my wishes, I shall be happier than I can express. If not, I shall have the consolation of re-flecting that I am pleasing him, a charm that will in the end give the greatest satisfaction to my mind. I cannot write any more till the wished, but fearfully dreaded, letter arrives. With the most ardent wishes for your health, believe me, my dear Sir, your obliged friend, Maria E. Bicknell."

Constable's fond mother, who, from the commencement of his attachment to Miss Bicknell, entered warmly into all his feelings on the subject, thus replied to a letter she had received from him:

"East Bergholt, Nov. 3, 1811. Your letter of the 31st ult. pleases me, because it tells me you are 'far better'. But you cannot imagine how you have surprised and filled me with conjecture by saying, 'I have been kindly received by the Bicknells this morning, and my mind is in some measure quieted. I have Mr. Bicknell's permission to write to Miss Bicknell, which I have done this afternoon.' Now, my dear son, what may be augured from this? I pray it may prove favourable. They are too good, and too honourable, to trifle with your feelings; therefore I am inclined to hope for the best, and that it will end well."

"To Mr. John Constable, Spring Grove, Nov. 4. I have received my father's letter. It is precisely such a one as I expected, reasonable and kind; his only objection would be on the score of that necessary evil, money. What can we do? I wish I had it, but wishes are vain; we must be wise, and leave off a correspondence that is not calculated to make us think less of each other. We have many painful trials required of us in this life, and we must learn to bear them with resignation. You will still be my friend, and I will be yours. Then, as such, let me advise you to go into Suffolk, you cannot fail to be better there. I have written to papa, though I do not, in

conscience, think he can retract anything he has said; if so, I
had better not write to you any more, at least till I can coin.
We should both of us be bad subjects for poverty, should we
not? Even painting would go on badly; it could hardly sur-
vive in domestic worry. I hope you have done a good deal this
summer; Salisbury, I suppose, has furnished some sketches.[1]
You are particularly fortunate in possessing the affectionate
esteem of so kind and excellent a man as Mr. Watts, whose
wishes you must consult on this most important point.
Remember, dear sir, if you wish to oblige me and all your
friends, it must be by taking care of your health. Adieu, and
think me always sincerely yours, M.E.B."

Constable, however, abated not 'a jot of heart or hope'.
"Be assured," he wrote to her, "we have only to consider our
union as an event that must happen, and we shall yet be
happy." To this she replied, "You grieve and surprise me by
continuing so sanguine in a subject altogether hopeless. I
cannot endure that you should harbour expectations that
must terminate in disappointment. I never can consent to act
in opposition to the wishes of my father; how then can I con-
tinue a correspondence wholly disapproved of by him? He
tells me that I am consulting your happiness as well as my own
by putting an end to it. Let me then entreat that you will cease
to think of me. Forget that you have ever known me, and I
will willingly resign all pretensions to your regard, or even
acquaintance, to facilitate the tranquillity and peace of mind
which is so essential to your success in a profession which will
ever be in itself a source of continued delight. You must be
certain that you cannot write without increasing feelings that
must be entirely suppressed. You will, therefore, I am sure,
see the impropriety of sending me any more letters. I con-
gratulate you on your change of residence.[2] It is, I think, a very

[1] Constable told Farington on the 7th Dec. 1811 that he had spent three
weeks in Salisbury during the previous September. A pencil drawing in the
Victoria and Albert Museum (No. 825–1888), which perhaps represents part
of Salisbury Cathedral, is dated 1811.

[2] Constable had moved from 49 Frith Street to 63 Charlotte Street, where
he was to remain until 1817.

desirable situation. Farewell, my dear sir, and ever believe me your sincere and constant well-wisher, M.E.B. Spring Grove, Dec. 1811."

From his father Constable received, on the same subject, the following letter:

"East Bergholt, Dec. 31, 1811. Dear John, Your present prospects and situation are far more critical than at any former period of your life. As a single man, I fear your expenses, on the most frugal plan, will be found quite equal to the produce of your profession. If my opinion were asked, it would be to defer all thoughts of marriage for the present. I would farther advise a close application to your profession, and to such parts as pay best. At present you must not choose your subjects, nor waste your time by accepting invitations not likely to produce future advantages. When you have hit on a subject, finish it in the best manner you are able, and do not in despair put it aside, and so fill your room with lumber. I fear your great anxiety to excel may have carried you too far above yourself, and that you make too serious a matter of the business, and thereby render yourself less capable; it has impaired your health and spirits. Think less, and finish as you go (perhaps that may do). Be of good cheer, John, as in me you will always find a parent and a sincere friend. At your request, you may expect to see your sister at No. 63, next Thursday afternoon,"

Constable's youngest sister, the lady mentioned in this letter, remained with him in London from the commencement of 1812 to the middle of May; and by the affectionate interest she took in all that agitated his mind, and the truly feminine gentleness of her manners, contributed much to his comfort.

It was scarcely to be expected that the injunctions of Miss Bicknell, to write no more to her, should be obeyed by Constable, now that matters had gone so far, and a regular interchange of letters soon took place between them.

"To Miss Bicknell. 63, Charlotte Street, April, 1812. I have dispatched my pictures to Somerset House: my friends assure me they are my best; but Leonardo da Vinci tells us to mind

what our enemies say of us. It is certainly one of the great ends of a public exhibition, that we hear the truth. I have sent four pictures, the 'View of Salisbury', 'Flatford Mill', and two small ones.[1] My good friends the Bishop of Sarum and Mrs. Fisher called to see them. I shall have great pleasure in giving you some account of the exhibition. Lawrence has sent a picture of Kemble in Cato. Mr. Farington spoke highly of it to me. . . . Let me beg of you to continue to cheer my solitude with your endearing epistles; they are next to seeing you, and hearing you speak. I am now engaged with portraits. Mr. Watts sat to me this morning, and seems pleased with what is going on. I am copying a picture for Lady Heathcote, her own portrait as Hebe. She will not sit to me, though she wants many alterations from the original; but I can have prints, drawings, miniatures, locks of hair, etc., etc., without end. You may be able to tell me, better than I can you, any public matter, as I never have an opportunity of seeing the newspaper."

"63, Charlotte Street, Fitzroy Square, April 24, 1812. . . . I believe I mentioned to you that I left a card for Dr. Rhudde in Stratton Street. I have had a polite message from him, offering to take any letter, etc., to Bergholt. I called with a letter for my mother, and saw the doctor, who was very courteous. I am glad I have seen him; for though this may not better our cause, it cannot make it worse, and I have not to reflect on myself for any omission or neglect.

"I met Mr. West[2] in the street the other day; he had been much gratified with my picture of the Mill, etc., which passed the Council of the Academy. I wished to know whether he considered that mode of study as proper for laying the foundation of real excellence. 'Sir,' said he, 'I consider that you have attained it.' . . . What happiness it is to me to impart to you any little circumstances that in any way connect themselves with our future welfare, when I know how they will be received

*[1] The two small paintings were 'Landscape: A recent shower' and 'Landscape: Evening'. It has been suggested that the latter is perhaps No. 127–1888 in the Victoria and Albert Museum.

*[2] Benjamin West, P.R.A. (1738–1820).

by you; and though I am denied the pleasure of communi-
cating them with

'Your arm fast lock'd in mine'

yet I have had that pleasure, and may yet again for many
years. Mary Constable has left Epsom, and I have detained her
here for a few days on her return. She begs her kind remem-
brance to you."

"63, Charlotte Street, May 6, 1812. My dearest Maria, I am
writing to you on my mother's birthday and wedding-day.
Perhaps you will think me very busy with my pen; but I am
glad to recollect that you may be expecting to hear from me
about this time. Your kindness will remember that I can
scarcely gain any intelligence of you but from yourself. I have
made two hasty visits to the exhibition. The portraits by
Lawrence and Owen are very excellent; and there are some
beautiful fancy pictures by Thomson, the Infant Jupiter, and
Lavinia resting her arm on her mother. Mr. West's is truly an
heroic landscape;[1] and Turner has another, a scene among the
Alps, with Hannibal and his army.[2] It is so ambiguous as to be
scarcely intelligible in some parts (and those the principal),
yet, as a whole, it is novel and affecting. Mr. Farington has
some beautiful landscapes, but they are heavy and crude. I
waited to see them by twilight, when they looked much
better. My own landscapes have excellent situations. My dear
Mary is still with me, but I must part with her in a few days."

"To Mr. John Constable. Spring Grove, May 14, 1812. I
am sorry, my dear John, that you should have felt any dis-
appointment by my silence. I will not therefore delay thanking
you for your last two letters. . . . You will, I am sure, make
allowances for me. Think how much of the charm of writing
is broken, not having my mother's approbation to add to my
joy by sharing it. But do not let me grieve you by sorrow, that
will intrude its hideous form to me. I am sure you have suffered
sufficiently on my account. What do you think of accompany-

[1] 'Saul before Samuel and the Prophets'.
*[2] Now in the Tate Gallery (No. 490).

ing Sadak in his search for the waters of oblivion? but were they now within my reach, I could not drink them."

Constable's health again suffered, and he was advised to go into the country. On the 24th of May he wrote to Miss Bicknell, "I am still looking towards Suffolk, where I hope to pass the greater part of the summer; as much for the sake of study as on any other account. You know I have always succeeded best with my native scenes. They have always charmed me, and I hope they always will. I have now a path marked out very distinctly for myself, and I am desirous of pursuing it uninterruptedly." This last sentence is worthy of attention, as it shows the steadiness of purpose which belonged to his character in all matters relating to his art, while to those who knew or observed him but slightly, there was an appearance of vacillation and indecision in his manner entirely at variance with the real stability of his mind. It will be seen, in the sequel, how impossible it was to drive him out of the path he had chosen, though few indeed were the encouragements he met with to continue in it. In the same letter he says, "I am getting on with my picture for Lady Heathcote. Lady Louisa Manners has a wretched copy by Hoppner from Sir J. Reynolds, which she wishes me to repaint, so that I fear it must be, at least, a fortnight or three weeks before I can get into Suffolk. My friend John Fisher is half angry with me because I will not pass a little time with him at Salisbury; but I am determined not to fritter away the summer, if I can help it. I will quote part of his letter (which he has followed to town), that you may see what an enthusiast he is: 'We will try and coax you here, dear Constable, by an account of the life we will lead. We will rise with the sun, breakfast, and then set out for the rest of the day. If we tire of drawing, we can read or bathe, and then home to a short dinner: We will drink tea at the Benson's, or walk the great aisle of the cathedral, or if the maggot so bites, puzzle out a passage or two in Horace. I think this life of Arcadian or Utopian felicity must tempt you.'

"I believe there are more exhibitions than usual open at this time. I have been most gratified at Wilkie's."

The Rev. John Fisher (afterwards Archdeacon Fisher) was chaplain to his uncle, the Bishop of Salisbury. He was the eldest son of Dr. Fisher, Master of the Charter House, and though sixteen years younger than Constable, they had contracted a friendship for each other which never altered excepting by its growth.

"Charlotte Street, June 6th, 1812. Yesterday I took a long walk with Mr. Stothard. I left my door about six in the morning, we breakfasted at Putney, went over Wimbledon Common, and passed three hours in Coombe Wood (Stothard is a butterfly-catcher), where we dined by a spring, then back to Richmond by the Park, enjoyed the view, and so home. All this on foot, and I do not feel tired now, though I was a little so in the morning. I only asserted I was well before, I hope now this is a proof of it."

Constable had, for some time, been the chosen companion of Stothard's long walks, the chief relaxation of that admirable artist from the drudgery of working for the publishers. These walks lengthened with the lengthening days, and I have heard him speak of the hilarity with which Stothard would enter his room on a fine afternoon in the spring' and say, 'Come, sir, put on your hat, my boys tell me the lilacs are out in Kensington Gardens.' I have seen a beautiful pencil drawing of a shady lane, which Constable made during their excursion to Coombe Wood, while his companion, who was introduced into it, was engaged with his butterfly nets. Stothard was then about fifty years of age; his deafness precluded him from the enjoyment of general society, but with a single friend, and, as in this instance, a younger man, who looked up to him with great respect and admiration, and whose mind was in many respects a kindred one, he was very communicative. In their walks together, he, no doubt, felt his infirmity as little as possible; while the hours passed with him must have contributed to soothe the spirits of Constable, disquieted as they then were.

"Charlotte Street, June 10th, 1812. You will see by the cover that the good bishop is as kind to me as ever. He and Mrs. Fisher were here yesterday for an hour or two; and I have

completed the portrait[1] quite to their satisfaction. I am to make a duplicate of it for the palace at Exeter. During their stay, Mrs. Fisher wrote to the Marchioness of Thomond, to introduce me to a sight of her fine collection of Sir Joshua Reynolds' pictures. I am going this morning to Pall Mall (I believe I told you that I had something to do there, with a portrait of Lady Louisa Manners); from thence to call on Sir George Beaumont; he wishes to see the Gainsboroughs at Lord Dysart's, and in return he is to take me to the Marquis of Stafford's Gallery. These things delay my visit to dear Bergholt, and I am sighing for the country. I am told the trees never were more beautiful; indeed, I never saw them in greater perfection than in my walk with Mr. Stothard to Richmond."

"Charlotte Street, June 15th. I am making sad ravages of my time with the wretched portraits I mentioned to you. I am ungallant enough to allude entirely to the ladies' portraits.[2] I see no end, if I stay, to my labours in Pall Mall. Lady Louisa was quite distressed when I told her I must order my colours away; but I see no alternative, and must fly like another Telemachus, though not for the same reason. I am sure you will pardon me, when I tell you that duty and affection to my mother made it impossible for me to withhold some of your letters from her. The perusal of them made her more than ever lament our unhappy situation. My father is uncommonly well; on horseback at six o'clock in the morning, pursuing his plans with all the ardour of youth: surely this is a delightful proof of the blessings of a well spent and temperate life. . . . In one of your letters you ask me what I have read lately. I have all Cowper's works on my table. I mostly read his letters. He is an author I prefer to almost any other, and when with him I always feel the better for it."

"East Bergholt, June 22nd. From the window where I am now writing, I see all those sweet fields where we have passed

[1] Of the Bishop.
[2] These were copies by Hoppner, with alterations according to the fancies of the ladies.

so many happy hours together. I called at the Rectory on Saturday with my mother. The doctor was unusually courteous, and shook hands with me on taking leave. Am I to argue from this that I am not *entirely* out of the pale of salvation? How delighted I am that you are fond of Cowper. But how could it be otherwise? for he is the poet of religion and nature. I think the world much indebted to Mr. Hayley. I never saw, till now, the supplement to the letters; perhaps some of his best are to be found there, and it contains an interesting account of the death of poor Rose, a young friend of the poet's. Nothing can exceed the beautiful appearance of the country; its freshness, its amenity." "July 22nd. I have been living a hermit-like life, though always with my pencil in my hand. Perhaps this has not been much the case with hermits, if we except Swaneveldt (the pupil of Claude); who was called the 'Hermit of Italy', from the romantic solitudes he lived in, and which his pictures so admirably describe. How much real delight have I had with the study of landscape this summer! either I am myself improved in the art of seeing nature, which Sir Joshua calls painting, or nature has unveiled her beauties to me less fastidiously. Perhaps there is something of both, so we will divide the compliment. But I am writing this nonsense with a sad heart, when I think what would be my happiness could I have this enjoyment with you. Then indeed would my mind be calm to contemplate the endless beauties of this happy country."

In a letter dated in August, he says, "Many of my friends have urged my leaving a profession so unpropitious; but that, you know, is impossible."

"East Bergholt, September 6th, 1812. I am happy to hear of your safe arrival at Bognor . . . on the same day I found myself quietly drinking tea with my father and mother. . . . I was looking anxiously for your letter, and am grieved to find your spirits so much affected. You have hitherto borne your share of our sorrows (and you have had by far the greatest share) with a fortitude that has made me ashamed of myself. I can only imagine our feelings to have been very similar; but let

me believe that much of our present suffering may be the effect of parting; and that, with this fine weather, added to the delightful scenes you are in, you have recovered your usual serenity. . . . I have not resumed my landscape studies since my return. I have not found myself equal to the vivid pencil that landscape requires. I am going to-morrow to stay a few days at General Rebow's, near Colchester, to paint his little girl, an only child, seven years old; I believe I am to paint the general and his lady at some future time: this is in consequence of my portrait of young Godfrey, which has been much admired." . . .

"To Mr. John Constable. Bognor, September 10th. . . . Continue to write to me, my dear John, without the least reserve; the more I am acquainted with you, the happier I shall be. We are both very unfortunately situated (but really you must think me very silly to tell you what is so evident). We can, however, make writing alleviate many of our troubles, and be to us one of our highest pleasures. I used to dislike it excessively; but now there is no employment I like so well. . . . Have the goodness to remember me kindly to your mother, and tell her how much I am obliged to her for her frequent recollections of me. And you, my dearest John, accept every affectionate wish from M.E.B."

"To Mr. John Constable. Bognor, November 6th. It was particularly kind of your mother to call in Spring Gardens. You do not mention anything that passed, so I suppose it was merely the common chit-chat of the day. You will believe how earnestly I hope my father's visit to Suffolk will produce some change for the better. But I dare not be too sanguine; for then bitter would be my disappointment. Grateful for the present share of happiness we enjoy, we must not be too anxious for the future. Your letters afford me a continual source of pleasure. . . . Farewell, my dearest John; may health and spirits long attend you, and then I shall always subscribe myself, your happy and affectionate Maria."

"To Miss Bicknell. 33, Portland Place, November 10th, 1812. . . . Should the circumstance of a fire in Charlotte Street

appear in any of the papers, it is possible you may meet with it; and I write this hasty line or two, that you may not be uneasy on my account. The fire did in fact happen on the premises I inhabit; but I have lost nothing. We shall suffer a temporary inconvenience; but Mr. Watts has kindly ordered me a bed in his house, and a neighbour, Mr. Henderson, in Charlotte Street, has allowed me a room to paint in while the house is under repair. We were put to some alarm and bustle, but no one was hurt; and I hope Mr. Weight's insurance will cover his loss. The fire began in a workshop at the back of the house, about four o'clock in the morning, and spread so very fast, that at one time we thought of saving ourselves only. I, however, secured my most valuable letters; and we went to work removing whatever we could into the street. We were not long without help; but it was an hour before any engine came. It appeared as if nothing could save the house, and it was very difficult to pass up and down stairs, owing to the great heat of the windows; but we persevered as long as we could, and while we were getting Lady Heathcote's large picture down, I had a shower of glass about me from the window on the staircase. I ran with it over the way to Mr. Farington's, and on my return for something else, I found the poor woman-servant, who had lately nursed Mrs. Weight, in great distress, as all her fortune was in the garret, and in her pockets which were under her pillow; there was no time to be lost, I ran up-stairs, and she was overjoyed to see me return with them, through the smoke, quite safe. It was now that the engines arrived, and fortunately succeeded in putting a stop to the flames. Mr. Weight's loss is greater than he at first expected; all the premises are burnt at the back of the house, the back drawing-room and its contents are destroyed, and all the back windows. I cannot bear to leave these poor people in their distress, and we think of taking a temporary place till the house is repaired."

"To Mr. John Constable. Bognor, Nov. 16. My dearest John, Had it been merely a letter of form I had to write, you should have received it sooner; but, as it is, you perfectly know

how sincerely and fervently thankful I am that you have sustained no personal harm. You acted considerately and like yourself. I should have been sadly alarmed at any account of the fire previous to yours; but I had not seen it in the papers, though I dare say it has been inserted, as they are always glad of news, and I believe the more melancholy the better."

Constable had presented to his friend Fisher a small landscape, of which that gentleman writes in a letter, dated "Nov. 13, 1812. Your painting has been much criticised; disliked by *bad* judges, gaped at by *no* judges, and admired by good ones. Among these, Coxe[1] the historian, who has seen much, was particularly pleased with it. It put him in mind, he said, 'of the good old Dutch forest painting school.' He looks at it whenever he comes into my room, which is most days. What it wants, he says, is, that 'what is *depth* near, should not be *gloom* at a distance.' By the words far and near, I mean as the spectator recedes from or approaches the picture. This is, I think, a just observation. I am now looking at it. It is most pleasing when you are directed to look at it; but you must be *taken* to it. It does not *solicit attention*; and this I think true of all your pictures, and the real cause of your want of popularity. I have heard it remarked of Rubens, that one of his pictures *illuminates* a room. It gives a cheerfulness to everything about it. It pleases before you examine it, or even know the subject. How he obtained this, or how it is to be obtained—*hic labor, hoc opus est*. Don't laugh at my feeble criticisms, Constable; I mean your service, and all men are allowed to talk *good-natured* nonsense. You shall have something to put you in mind of the great 'Escurial'[2] at Lord Radnor's. I have to thank you for the ability to view that work as it ought to be viewed. You gave me another sense. . . . I passed three most delicious days in this country with Dr. Callcott and his brother the artist. . . . How is your mind? at rest? Set it so, if you can, for your success, as

*[1] William Coxe (1747–1828), historian and ecclesiastic. Constable told Farington (17th Dec. 1811) that he had met him when he visited Stourhead with Bishop Fisher in Sept. 1811.

[2] A Landscape by Rubens. *Fisher had referred, in an unpublished letter of 8th May, 1812, to Constable's desire to copy Lord Radnor's Rubens.

you know, depends upon it. I shall see you soon in town, till when

'Adieu—adieu—remember me!'

though I am no ghost. Believe me, my dear fellow, Yours most faithfully, John Fisher."

In a letter, without date, but written about this time, Constable says, "My good friends in Seymour Street continue their great kindness to me, I have just completed another portrait for them, for the Palace at Exeter. I told Mrs. Fisher yesterday how much I thought his lordship had of the character of the Archbishop of Cambray. She was pleased to hear me say so, and said that, although it had not been observed to her before, she had always called him her Fenelon. Mr. Watts and I are the best friends in the world. Should I not be happy when I consider all these blessings, and that you love me?"

The portraits Constable had painted, of the Bishop of Salisbury[1] and Mr. Watts, had given great satisfaction, and on the 30th of November his mother thus wrote to him; "Fortune seems now to place the ball at your foot, and I trust you will not kick it from you. You now so greatly excel in portraits that I hope you will pursue a path the most likely to bring you fame and wealth, by which you can alone expect to obtain the object of your fondest wishes."

Portraiture, we are told, originated in love; and Constable's friends now hoped that love would make a portrait painter of him. Its immediate effects, however, seemed more likely to retard his advance, both in portrait and in landscape; and Miss Bicknell, who saw this with great grief, thus admonished him. "By a sedulous attention to your profession, you will very much help to bestow calm on my mind, which I shall look for in vain while I see with sorrow how unsettled you appear, and consequently unfitted to attend to a study that requires the incessant application of the heart and head. You will allow others, without half your abilities, to outstrip you in the race of fame, and then look back with sorrow on time neglected

★[1] The original has not been traced: the replica, to which Constable refers in his letter of 10th June, 1812 (above), is in the Palace at Exeter.

and opportunities lost and perhaps blame me as the cause of all this woe. Exert yourself while it is yet in your power; the path of duty is alone the path of happiness. Let us wait with quiet resignation till a merciful Providence shall dispose of us in the way that will be best. Believe me, I shall feel a more lasting pleasure in knowing that you are improving your time, and exerting your talents for the ensuing exhibition, than I should do while you were on a stolen march with me round the Park. Still I am not heroine enough to say, wish, or mean, that we should never meet. I know that to be impossible. But, then, let us resolve it shall be but seldom, not as inclination, but as prudence shall dictate. Farewell, dearest John; may every blessing attend you, and in the interest I feel in your welfare, forgive the advice I have given you, who, I am sure, are better qualified to admonish me. Resolution is, I think, what we now stand most in need of, to refrain for a time, for our mutual good, from the society of each other."

1813–1814

Constable's Pictures in .the Exhibitions of 1813. Exhibition at the British Gallery of the Works of Reynolds. Turner. J. Dunthorne, Jun. 'Willy Lott's House'. Sale of two of Constable's Pictures. His Pictures at the Academy, 1814. Excursion in Essex. Picture of 'Boat-building'. Constable's Disposition to shun Society.

"To Miss Bicknell. 63, Charlotte Street, May 3rd, 1813. Mr. West informs me, it is the opinion of the council, as well as his own, that I have made an advance upon myself this year. Since I had last the happiness of seeing you, I have had so great a share of ill health that I have not been able to paint; but I hope the summer and a look at the country will revive me. I told you I was about to commence a portrait of Lady Lennard. I began it three weeks ago, and it promised to be like; but I was obliged to decline it, and this circumstance has given me real concern, as I am anxious to maintain the friendship of this worthy family. . . . Shall I mention my profession again? I am really considered to have been more successful in it this last year; and is it unreasonable to suppose that if, under such untoward circumstances, I have exerted some energy, I might do much more if this load of despondency could be removed from me?"

The pictures mentioned in the foregoing letter were called in the catalogue of the Academy, 'Landscape, Boys Fishing',[1] and 'Landscape, Morning'. In January he had exhibited at the British Gallery, one picture, with no title but 'Landscape'.[2]

In the summer of this year, the directors of the British Institution exhibited at their rooms the most splendid collection of pictures that were ever seen together as the productions of one man; and the reputation of Reynolds, high as it was, was raised by this assemblage of his works. Through the kindness of Mr. Watts, Constable received a card for the dinner,

[1] Formerly in the collection of the Hartree family.
[2] According to the B. I. Catalogue, it was called 'Landscape: A scene in Suffolk'.

given by the directors, on this memorable occasion; and the following is the account he gave of the day to Miss Bicknell: "The company assembled at an early hour in the Gallery, from which there was a covered way to Willis' rooms. On the arrival of the Prince Regent, the Marquis of Stafford and the governors of the Institution hastened to conduct him upstairs. His manner was agreeable, and I saw him shake hands with many of the company. Dinner was announced at seven, the Marquis of Stafford (the president) in the chair, behind which, on a considerable elevation, was placed a statue of Sir Joshua Reynolds, by Flaxman. The Earl of Aberdeen made an excellent speech; he said that 'although the style of Sir Joshua Reynolds might differ in appearance from the style of those specimens of art which are considered the nearest to perfection in the ancient Greek sculpture, and the productions of the great schools of Italy; yet his works were to be ranked with them, their aim being essentially the same—*the attainment of nature with simplicity and truth.*' The Regent left the table about ten, and returned to the Gallery, which was now filled with ladies. Among them I saw Mrs. Siddons, whose picture is there as the 'Tragic Muse'. Lord Byron was pointed out to me; his poetry is of the most melancholy kind, but he has great ability. Now, let me beg of you to see these charming works frequently; and form, in your own mind, the idea of what painting should be from them. It is certainly the finest feeling of art that ever existed."

"Spring Garden Terrace, June 9th. My dear John. Having only a few minutes to converse on Friday, you know we did not say much. I will, therefore, try what I can do in a letter. Writing I dislike excessively, but still I have no other means of telling you what passes here, and I take it for granted you like to know. I think you seemed much better than when I saw you at the Academy. I was quite hurt then at your appearing so very far from well. The portrait you gave me looks pale, as you did then. That is the only fault I find with it. I was enchanted with Sir Joshua Reynolds' pictures. I think it must have been a beautiful sight to have seen them by candle light,

and the rooms filled with company elegantly dressed. . . . I imagine next month you will like to quit London for Suffolk, as the study of nature will be more agreeable than the picture galleries. I will not forget to drink your health in a bumper on the 11th. Adieu, dear friend, why are we thus attached when everything conspires against us!"

"Palace, Sarum, June 14th, 1813. Dear Constable, I have heard your great picture spoken of here, by no inferior judge, as one of the best in the exhibition. It is a great thing for one man to say this. It is by units that popularity is gained. I only like one better, and that is a picture of pictures, the 'Frost'[1] by Turner. But then you need not repine at this decision of mine; you are a great man, and like Buonaparte, are only to be beaten by a frost. I despair of ever seeing you down here. What a reflection is it in this life that, whenever we have a pleasant scene, there is little hope of repeating the view. How many delightful hours of pleasantry have I passed in a society that will never meet together again, except under the sod. It is one argument for living while you can live. 'Dum vivimus vivamus.' The same argument will, by the bye, hold good of reading. Read a book while it lies before you: ten to one if you read it another time. I only know, the little knowledge I have has been picked up by odds and ends. In a bookseller's shop, late at night, at breakfast, or while waiting for a friend who was late at dinner. Pray, as you regard your interest, call on the Bishop and his lady, as he may attribute your not calling to neglect, and not to humility. Everybody does not know, as well as myself, that there is an exhibitioner and a painter for fame, who is possessed of modesty and merit, and is too honest and high-minded to push himself by other means than his pencil and palette. Believe me, dear Constable, Yours very faithfully, John Fisher."

"63, Charlotte Street, June 30th. When I last had the happiness of seeing you, my dearest Maria, I had fixed a day for going into Suffolk. I was, however, prevented by a call upon me for portraits; for I assure you, my reputation in that

*[1] Turner's 'Frosty Morning', now in the National Gallery (No. 492).

way is much on the increase. One of them, a portrait of the Rev. George Bridgman, a brother of Lord Bradford, far excels any of my former attempts in that way, and is doing me a great deal of service. My price for a head is fifteen guineas; and I am tolerably expeditious when I can have fair play at my sitter. I have been much engaged for Lady Heathcote, who seems bent on serving me. My pictures of herself and her mother occupy either end of the large drawing-room in Grosvenor Square; they have magnificent frames, and make a great dash. She is to bring me a handsome boy at the Christmas holidays. She has a little dance on Friday, when my pictures will be seen for the first time publicly. I am now leaving London for the only time in my life with my pockets full of money. I am entirely free from debt (not that my debts ever exceeded my usual annual income), and I have required no assistance from my father. I have arranged matters with Sir Thomas Lennard, and am to pass a month with him very late in the season; which I am delighted to find gives me possession of the three ensuing months to myself, and I hope to do a good deal in that time. I do assure you, my dearest Maria, I am not trying to give you the favourable side, only, of myself; but am merely mentioning facts as they have occurred to me within the last two or three months, during which time we have unfortunately had so little communication with each other. But I trust the time is at hand when the ground will be rendered more smooth for us. You may probably know that there has been some correspondence between Mr. Bicknell and myself. When I thought I was leaving town, I wrote to him, to request he would consent to an interview, or some sort of communication between us; he would agree to neither; yet I do not repent of what I have done, as I was happy at least to have an opportunity of approaching him in a respectful manner. . . . I thank God daily for a thousand blessings which I enjoy; and I can lay my hand on my heart and say, 'I have a conscience void of offence.' I look forward to many happy years with you, but we might have been spared a world of pain. . . . I am quite delighted to find myself so well, although

I paint so many hours; but my mind is happy when so engaged.
. . I dined with the Royal Academy last Monday in the
council room. It was entirely a meeting of artists (none but
the members and exhibitors could be admitted), and the day
passed off very well. I sat next to Turner, and opposite Mr.
West and Lawrence. I was a good deal entertained with
Turner. I always expected to find him what I did. He has a
wonderful range of mind. . . . I leave town with a much more
comfortable feeling on your account than I had last year. You·
looked so well, and seemed so happy; and to see you com-
fortable ought to make me happy under any circumstances."

"Richmond, August 25th, 1813. Knowing, my dearest
John, that you are expecting a letter from me, I cannot delay
any longer thanking you for your last letter, which I received
the day before I left town; I wish I could divest myself of
feeling so like a culprit when I write to you. It would be so
much pleasanter for you and for me; but I know I am breaking
through rules prescribed to me by those I love, and making you
uncomfortable by my sombre reflections. I think of you equally
if I write or do not write; so recollect in future, not to expect to
hear from me, unless I have something very particular to say."

"Spring Garden Terrace, February 18th, 1814. Your wish,
my dear John, is totally impracticable—of corresponding
weekly; but I will write as often as I can. Indeed, I was just
going to tell you that your last letter had given me much
pleasure; for it seemed written in better spirits than usual. . . .
You have both surprised, deceived, and pleased me. How
could you say there was no picture of yours at the British
Gallery? I think the cats[1] excessively pretty, comical creatures.
I am sure you must have been entertained in painting them.
The whole has a richness of colour that pleases me. You must
forgive my criticising your pictures. . . ."

In a letter to Miss Bicknell, dated February 1814,[2] the first

[1] Two martin cats, of which he exhibited a small picture at the British
Gallery.

*[2] Shirley, in his edition of Leslie's *Life* (London, 1937), states that the MS. of
this letter is dated 19th Feb. 1813.

mention of young Dunthorne,[1] the son of Constable's early friend, occurs. Of this young man, to whom he was much attached, and who became an extremely useful assistant to him, he says: "I have written to Dunthorne to send me Johnny. He is not at all vulgar, and naturally very clever; but were he not, I should love him for his father's sake." To Dunthorne, Constable wrote: "I am rather disappointed at not seeing Johnny here yet; but as the weather is now fine though cold, I wish you would let him come. I am desirous of having him now, for I think he will be useful to stimulate me to work, by setting my palette, etc., which you know is a great help, and keeps me cheerful. I am anxious about the large picture, 'Willy Lott's House',[2] which looks uncommonly well in the masses and tone. I am determined to detail, but not retail it out. Tell Abram, Mr. Coxe[3] intends having my 'Windmill'[4] engraved, and has put it into the hands of Mr. Landseer for that purpose. It is a pretty subject, one of the Stoke Mills. I am determined to finish a small picture on the spot, for every large one I intend to paint. This I have always talked about, but have never yet done."

The little farmhouse, which in the last letter is called 'Willy Lott's House', is situated on the edge of the river, close to Flatford Mill. It is a principal object in many of Constable's pictures; but the most exact view of it occurs in the one engraved for the 'English Landscape', with the title of 'A Mill Stream',[5] and is taken from the front of the mill, the wheel of which occasions the ripple seen on the surface of the water. Willy Lott, its possessor, was born in it; and it is said, has passed more than eighty years without having spent four whole days away from it.

[1] John Dunthorne, jun. (1798–1832). See above, p. 3.

[2] This may be the painting (size 28 × 36 in.) acquired by the Ipswich Museum in 1941: the Ipswich painting is related to 'The River Stour, near Flatford Mill, afternoon', in the Tate Gallery (No. 1816).

[3] Peter Coxe, the brother of Archdeacon Coxe, and author of a poem called the 'Social Day', for which the engraving was made.

[4] A water-colour now in the Victoria and Albert Museum (No. 342–1888) engraved by J. Landseer.

[5] The painting is in the Tate Gallery (No. 1816).

So little was Constable's art as yet appreciated that the sale of two of his pictures, this year, must be mentioned as an extraordinary event; a small one[1] exhibited at the British Gallery to Mr. Allnutt, and a larger one of a 'Lock'[2] to Mr. James Carpenter. The last is mentioned in the following note to Mr. Watts:—"63, Charlotte Street, April 12th, 1814. My dear Uncle, I received your kind note this morning. Accept my best thanks for the excellent advice it contained, and which, I am well aware, I stand much in need of. I am willing to allow that I possess more than a usual share of the failings incident to the species; as an artist, I know I have many great deficiencies, and that I have not yet, in a single instance, realised my ideas of art. Your kind solicitude respecting my picture of the 'Lock' is highly gratifying to me; but it may now cease, as the picture has become the property of Mr. Carpenter, who purchased it this morning. He is a stranger to me, and bought it because he liked it. You say, truly, that my mind is not at ease. Perhaps there may be something constitutional; but it is certainly much increased, since I have had the misfortune to involve the happiness of the most amiable being on the face of the earth in my own fate. The excellent lady to whom I allude continues faithful to me in my adversity; and that too amidst a scene of persecution and unkindness, which has continued many years; therefore I may yet be happy; and believe me, my dear Uncle, the great kindness which you have always shown me at your table, and elsewhere, as a friend and relation, has not a little contributed to support my mind through much trouble, which I believe has been increased by an extraordinary susceptibility of feeling."

The picture purchased by Mr. Allnutt led to an acquaintance between Constable and that gentleman, who has recently favoured me with the following account of its commencement.

*[1] The painting sold to Allnutt was probably that exhibited at the R. A. (No. 28) and not the smaller of the B. I. exhibits. Cf. Sir Charles Holmes, *The Burlington Magazine*, vol. viii, p. 287, and Shirley's edition of Leslie, p. 72.

*[2] 'Landscape: A Lock on the Stour'.

"Dear Sir, Many years ago, I purchased at the British Institution a painting by Mr. Constable. But as I did not quite like the effect of the sky, I was foolish enough to have that obliterated, and a new one put in by another artist which, though extremely beautiful, did not harmonise with the other parts of the picture. Some years after, I got a friend of Mr. Constable to ask him if he would be kind enough to restore the picture to its original state, to which he readily assented. Having a very beautiful painting by Mr. (now Sir Augustus) Callcott, which was nearly of the same size, but not quite so high, I sent it to Mr. Constable together with his own, and expressed a wish that, if he could do it without injury to the picture, he would reduce the size of it in height, by lowering the sky, so as to make it nearer the size of Mr. Callcott's, to which I wished it to hang as a companion. When I understood from him that it was ready for me, I called at his house to see it; and this was the first interview I ever had with him. He asked me how I liked it; to which I replied, I was perfectly satisfied; and wished to know what I was indebted to him for what he had done to it, in order that I might settle the account. He then said, he had no charge to make, as he felt himself under an obligation to me, which he wished to acknowledge, and was happy he had now an opportunity of doing so. I told him I was not aware of any obligation; and therefore, wished he would name a price. To which he replied that I had been the means of making a painter of him, by buying the first picture he ever sold to a stranger; which gave him so much encouragement that he determined to pursue a profession in which his friends had great doubts of his success. He likewise added that, wishing to make the picture as acceptable to me as possible, he had, instead of reducing the height of the old picture, painted an entirely new one of the same subject, exactly of the size of the one by Callcott; and that if I was satisfied with the exchange (which of course I was), it gave him much pleasure. I remain, dear Sir, yours very faithfully, John Allnutt. Clapham Common, February 2nd, 1843."

The pictures Constable sent to the Academy this season were, 'A Ploughing Scene in Suffolk', and a 'Ferry'.

From Miss Bicknell. "Spring Garden Terrace. I deferred writing, my dear John, in hopes of being able to tell you where our summer quarters would be fixed; but it still remains undecided. Only think of your not making one among the 200,000 persons who I hear are come to town to see our illustrious visitors;[1] I suppose you intend consoling yourself with a view of their pictures. . . . Indeed, my dear John, people cannot live now upon £400 a year—it is a bad subject, therefore, adieu to it. I imagine it will not be very long before you are in town. I wonder if I shall see you. Alas! that it should be a matter of doubt."

"To Miss Bicknell. East Bergholt, July 3rd, 1814. I have been absent from this place more than a fortnight, on a visit to the Rev. Mr. Driffield, at Feering,[2] near Kelvedon. He is a very old friend of my father's, and once lived in this parish. He has remembered me for a long time; as he says he christened me one night, in great haste, about eleven o'clock. Some time ago, I promised him a drawing of his house and church at Feering; and, during my visit, he had occasion to go to his living at South Church, and I was happy to embrace his proposal that I should accompany him; by which I saw more of the county of Essex than I had ever seen before, and the most beautiful part of it; as I was at Malden, Rochford, South End, Hadleigh, Danbury, etc., etc. At Hadleigh there is a ruin of a castle, which from its situation is vastly fine. It commands a view of the Kent hills, the Nore, and the North Foreland, looking many miles to sea. I have filled, as usual, a little book of hasty memoranda of the places which I saw. My companion, though more than seventy, is a most active, restless creature, and I never could get him to stop long at a place. He could outwalk and outrun me on any occasion; but he was very kind

[1] The Emperor Alexander, the King of Prussia, etc.
*[2] A pencil-drawing of the Porch of Feering Church, dated 28th June 1814, is in the Victoria and Albert Museum (No. D. 230–1888). Other drawings which relate to this tour are in the Victoria and Albert Museum.

and good-tempered. Indeed, my dear Maria, this little excursion was so amusing to me that, although I was never a moment without you in my thoughts, there were times when I was so delighted with the scenery, as to forget that my mind had been so long a stranger to happiness. You tell me that you have an offer of going into Wales. Let me, my beloved child, entreat you to embrace it if you are able to leave your excellent mother, to whom I know you are always ready to devote yourself. I am confident that such a tour would be a real blessing to you; the change of air, and then the sublime scenery. I did hope that we might have visited these delightful places together for the first time; but it will be happiness enough for me to know that you are happy. . . ."

"To Miss Bicknell. East Bergholt, Sept. 18th, 1814. This charming season, as you will guess, occupies me entirely in the fields; and I believe I have made some landscapes that are better than usual, at least that is the opinion of all here. I do hope that nothing will happen to interrupt my present pursuits, but that I shall pass the rest of the autumn as I have done the summer; and I also hope on my return to London to have the great happiness of seeing you much oftener than I have hitherto done. I believe we can do nothing worse than indulge in useless sensibility, but I can hardly tell you what I feel at the sight, from the window at which I am writing, of the fields in which we have so often walked. A calm autumnal setting sun is glowing on the gardens of the rectory and on those fields where some of the happiest hours of my life have been passed."

Among the landscapes mentioned in this letter was one which I have heard him say he painted entirely in the open air. It was exhibited the following year at the Academy, with the title of 'Boat-building'.[1] In the midst of a meadow at Flatford, a barge is seen on the stocks, while just beyond it the river Stour glitters in the still sunshine of a hot summer's day. This picture is a proof that, in landscape, what painters call warm colours are not necessary to produce a warm effect. It has

*[1] Now in the Victoria and Albert Museum (No. F.A. 37). See Plate 17.

indeed no positive colour, and there is much of grey and green in it; but such is its atmospheric truth that the tremulous vibration of the heated air near the ground seems visible. This perfect work remained in his possession to the end of his life.

"To Miss Bicknell. East Bergholt, Oct. 2nd, 1814. We have had a most delightful season. It is many years since I have pursued my studies so uninterruptedly and so calmly, or worked with so much steadiness or confidence. I hope you will see me an artist some time or other."

Constable's close application to his art while at Bergholt had prevented his paying as much attention to some of his friends there as it would appear he was expected to do, and after his return to town, his mother wrote to him. "I believe it is thought you avoid notice too much: this will damp the ardour of the best friendships. 'Tis true you have been delightfully busy this summer, and so far so good."

"To Miss Bicknell. Oct. 25th, 1814. . . . I am happy to hear of some improvement in your mother's health; I hope it may continue to advance. Though any notice or good wishes from me I know will be useless, yet I mention it for your sake. . . . I have had a distressing letter from my friend John Fisher on the death of his uncle, General Fisher. Poor Fisher was acting the part of a comforter when no comfort could be imparted. The distress of the general's daughter, Mrs. Conroy, and of his son-in-law, was beyond all belief. A fine manly soldier weeping like an infant; and Fisher was obliged to tear her from the coffin when they were taking it away. He wishes me to undertake (as it might prove a means of consolation) a portrait of the general from a drawing. He was extremely like the good bishop, mild, sensible, and placid. I could give him little hope of making much of a picture, but shall willingly try. . . . The studies I have made this summer are better liked than any I have done; but I would rather have your opinion of them than that of all others put together. But fate is still savage. I lament every moment the want of your society, and feel the loss of it in my mind and heart. *You* deserved a better fate."

"To Miss Bicknell. 63, Charlotte Street, Nov. 12th, 1814.

You say you shall leave Brighton in a fortnight. Let me hope, then, you have received benefit from its good air and general appearance of cheerfulness. I never was at a bathing town, but I am told they are amusing. You will judge of my great ignorance of what is going on in the gay world, when I tell you that, till I read your letter yesterday, I did not know that any of the royal family had visited Brighton this season. . . . I never fail to find unceasing delight in the art; but who are seeking for its honours I know not: it is sufficient for me to know that I am not, though I will allow that four or five years ago, when I was more youthful, I was a little on tiptoe for fame. I have hardly yet got reconciled to brick walls and dirty streets, after leaving the endeared scenes of Suffolk. At the same moment that I received your letter I had one from my mother so amusing that I long to show it to you. It is quite a journal of the time I was with them, though she regrets, at the end, that my natural propensity to escape from notice should have so much increased upon me."

"Brighton, Nov. 15th, 1814. You will be surprised, my dear John, to hear from me again so soon. Indeed I fear I shall ruin you in postage. But really you have written me such a strange letter that I cannot forbear sending you my sentiments upon it, and I am delighted to find that I am supported in them by Mrs. Constable. It appears strange to me that a professional man should shun society. Surely it cannot be the way to promote his interest. Why you should no longer be anxious for fame is what I cannot comprehend. It is paying me a very ill compliment. If you wish to remain single, it may do very well. We shall return to town next Tuesday. I trust the following day, if it should be tolerably fine, to have the pleasure of seeing the *recluse* in St. James' Park about twelve o'clock; if not, the following day at the same hour. You can then if you please make your defence, and promise to behave better for the future. I must have no more of this propensity to escape from notice: I must have you known, and then to be admired will be the natural consequence. I do not know how you will like my strictures on your conduct, but I cannot help that. It is

better you should know my mind now than afterwards. It is not too late to quarrel. It is your turn next to accuse me, and I am sure I stand convicted of numberless errors."

"Dec. 12. When I took leave of you, my dearest John, last Saturday, I fully thought I should see you again before you left town; but alas! it is your fate as well as my own to be often disappointed. It is, I am well convinced, for our mutual benefit that we should not often see each other. It is this alone makes me support the privation with tolerable good-humour. But *your* time, so infinitely valuable to me, I cannot have it lost. The genius of painting will surely, one day or other, rise up against me for too often keeping one of her favourite sons from a study that demands his exclusive attention. . . . Mamma, I am happy to say, is much better."

Constable permitted to visit Miss Bicknell. Death of his Mother. Death of Miss Bicknell's Mother. G. Dawe. Exhibition, 1815. Delicacy of Miss Bicknell's Health. Lady Spencer. Constable's Studies at Bergholt. Illness of his Father. Dr. Rhudde. Exhibition, 1816. Death of Constable's Father. General and Mrs. Rebow. Pictures painted at Wivenhoe Park. The Rev. J. Fisher. Constable's Marriage. Visit to Osmington. Dr. Rhudde's Legacy to Mrs. Constable.

"EAST BERGHOLT, January 6th, 1815. My dear son John. I send you a mother's Christmas gift, in the form of six new shirts. Four of them are hemp, and you said you should like to try them for working shirts. The other two are Sunday ones, with the collars cut to the pattern of your cousin ———'s. How you will like them I cannot tell. But I hope it will be the only imitation of him you will try; with the exception of the kind intentions of his heart, and his dutiful affection to his mother and sisters, which will spring up and show themselves through all the confusion in his affairs. The magnitude of his debts really terrifies me. O, my dear John, pray keep out of debt, that earthly Tartarus! I return you the pocket-book. It is very pretty, and much increased in value for the donor's sake, who, I hope, will one time or other, be rewarded better than by a *poor* artist. You must try hard for fame and gain. We have lived to see the beginning of a new year. Who may be permitted to see the close of it, God only knows. To those who do, may it prove a happy one, and to you amongst that number. Ann Constable."

"Spring Garden Terrace, February 23rd. My dearest John, I have received, from papa, the sweet permission to see you again under this roof (to use his own words) 'as an occasional visitor'. From being perfectly wretched, I am now comparatively happy. . . . M. E. Bicknell."

Mrs. Constable, in a letter to her son, dated "East Bergholt, March 7th", thus speaks of this unexpected gleam of sunshine on the propsect of the lovers. "It gives me pleasure to know you are a visitor in a friendly way, in Spring Gardens. You must make every allowance for Mr. Bicknell, who is, most

assuredly, not a free agent in this matter. He is under rigid restrictions; from which, for the sake of his family, he must not swerve. As circumstances stand, I esteem it a great point gained; and it is a comfort to my mind, which has long been a silent sufferer from the treatment you have met with, so derogatory to your respectability and honourable intentions."

Mrs. Constable was not, however, destined to see her son, and the object of his affections, more happy than they now were. She had lately suffered much anxiety on account of her husband's health, which was declining. And this, perhaps, hastened a paralytic attack, with which she was seized on the 9th of April, while gardening, a recurrence of which terminated her well-spent life of the 8th of May. In her last letter to her son, she earnestly exhorted him to use his influence with a friend at Bergholt, whose conduct had placed him at variance with his wife. "How can he bear," she said, "to worry her, as it were, into her grave. And as to the children, all their budding days of happiness, their youthful prime, are blighted by their father's imprudence. Do, my dear John, try to persuade him to the ways that make for peace: 'Blessed are the peace-makers; for theirs is the kingdom of God.' May this be your portion in the world to come, and health and happiness in this. So prays your affectionate mother."

The death of this excellent woman was felt by her son as a very heavy blow. She had cheered and encouraged him in his profession, and obtained for him introductions calculated to advance his prospects, at a time when his other friends considered them hopeless. She, more than any one else, shared in all the anxieties arising out of his engagement with Miss Bicknell, which she hoped to see happily fulfilled; and she neglected no means, however trifling, to propitiate Dr. Rhudde, as a single instance will show. Constable had sent her a present of a large drawing in water colours of Bergholt Church,[1] which, in the letter she wrote to acknowledge its

*[1] This drawing is now in the Lady Lever Art Gallery, Port Sunlight. It is dated 1811, and according to an inscription on the back, it was sent to Dr. Rhudde in February of that year. See Plate 12.

receipt, she described as 'the most beautiful drawing she had ever beheld'. But it immediately occurred to her to present it to the rector, which she did in the name of her son. It was useless. Dr. Rhudde acknowledged the present in a polite letter; but, unwilling to remain the obliged person, he enclosed a bank note, requesting Constable to purchase with it something to remember him by, 'when he should be no more'. The death of Miss Bicknell's mother, who had long been ill, occurred not many days after that of Mrs. Constable.

"To Miss Bicknell. East Bergholt, May 21st, 1815. My dearest love, When I left town it was not my intention to have remained so long absent. I received your kind note, and regretted you were so situated that you could not see me. I called, however, the day before I came here; and, although your note had somewhat prepared me for the afflicting intelligence which I received at your door, I could not but be shocked, as I was not aware that your dear mother was so near her removal. It is singular that we should, both of us, have lost our nearest friends, the nearest we can have in this world, within so short a time; and now, more than ever, do I feel the want of your society."

"To Miss Bicknell. 63, Charlotte Street, June 16th. I have seen Spilsbury again; he still urges me to make him a visit at his cottage, near Tintern Abbey. I ought to see another country, and this is a charming one. I am half inclined to go, but I need not decide for a week or ten days. I pine after dear Suffolk; but is not this indolence? My heart, as you know too well, is not there. At least, not all of it. But you say, you would not give a farthing for a divided heart; however, make yourself easy, you have by far the greatest part; but what vanity is this!"

"June 17th. I have given up all thoughts of Wales, and I now only wonder that I indulged in them. I have sold myself for the work I am engaged in, which is a large landscape in the background of a picture at Mr. Dawe's.[1] It occupies me at least twelve, and sometimes fourteen hours a day. This I do

[1] The portrait of Miss O'Neil, in the character of Juliet, now in the possession of the Garrick Club.

by choice, as well as by agreement, that I may the sooner get back to dear Bergholt, and find a day to see you before I go."

"June 28th. I find there is no end to my labours for Dawe. Therefore, with even a loss to myself, should it be so, I am determined to relinquish them. He is very anxious to engage me in other works; and he would even take a promise from me for a twelvemonth to come. We are full of anxiety about our relations who were in the late dreadful battle;[1] we can get no account of them whatever." "June 30th. I have done at Mr. Dawe's, and have given *him* great satisfaction; but I have persisted in making him no more promises; he is an over-match for me."

Constable, this year, exhibited at the Academy eight works and among them, the exquisite one I have mentioned, called 'Boat-building'; the others were, 'A View of Dedham',[2] 'A Village in Suffolk', 'A Landscape', 'A Sketch', and three drawings. At the British Gallery, he exhibited one picture, called 'Landscape'.

"To Miss Bicknell. East Bergholt, July 13th. . . . I think I never saw dear old Bergholt look half so beautiful as now, the weather has been so delightful. There is no village news, except that they are all very gay, and the youngest man among them is Dr. Rhudde. . . ."

"To Mr. John Constable. . . . I was much pleased with your letter. You appear calm, resigned, affectionate, and happy. It communicated the same feelings to me. . . . I am very glad you have had a conversation with papa. In the winter it will be well to renew it. Of the doctor, I can say nothing but that I believe it will be wisest to leave him to himself. How delightful this sweet rain will make those dear fields look, that I envy you the view of. I should like to transport myself there once a week: am I not very moderate? How much you must enjoy painting in the open air, after Mr. Dawe's room."

[1] Of Waterloo; at which were present two of Constable's cousins, Captain Gubbins, who was killed; and Lieutenant Allen. The mothers of these officers and Mrs. Constable were sisters.

★[2] Formerly in the Gould collection.

"East Bergholt, August 27th. . . . I have, my dearest love, little to tell you of what is passing here. I live almost wholly in the fields, and see nobody but the harvest men. The weather has been uncommonly fine; though we have had some very high winds that have discomposed the foliage a great deal. We are all well; my father takes his rides as usual, and is pretty well, but we think he gradually grows weaker. This, however, we cannot but expect; but his present appearance is a striking proof of the blessings attending the old age of a virtuous life.[1] . . . I received a newspaper containing an account of Mr. Stothard's pictures from Lord Byron's works, etc.—am I not obliged to you for it? It must have been directed by your hand."

"Putney Heath, August 29th. . . . It *was* I who sent the newspaper; just to show you that I *sometimes* think of you, and in expectation of hearing from you, so it answered my plan exactly."

"Putney Heath, September 9th. I cannot resist, my dear John, taking up my pen again, fearing you should have deemed my last letter unworthy of notice; and I may, perhaps, be absent a week after the 16th; and then, I hope, you would have thought my silence long. How charmed you must be with this long continuance of fine weather. I should suppose for many seasons you have not painted so much in the open air. Nature and you must be greater friends than ever. I am suffering a little, to-day, from being out late yesterday. Is it not a sad thing to be so delicate? I must not be out after sunset. It is easy enough to avoid it, so that trouble is soon got over. The moon shall tempt me no more. . . . I regret you have not seen Mrs. ——, she is much interested in our future welfare. Fortune, I am sure, delights to torment us. But hold, my pen! I do not think I am ever long dejected. Tell me what you have been reading. But I suppose you have not found much time for it. I am studying French, quite hard, and I find it very amusing. . . . My dear John, good-bye, you will allow this to be, for me, quite a long letter! Will the end of October oblige

[1] Golding Constable was then in his 77th year.

you to return to London? Though I long to see you, I am always sorry when you leave Suffolk. It must be so pleasant for you to be there. I should never like to leave the country while a single leaf remained on the trees."

"East Bergholt, September 14th. . . . I am concerned to find by your letter that you are still so delicate, and that you are so liable to be hurt by any little unusual exertion. Pray take care of yourself. I am happy to hear that your father is so friendly and kind to you. I shall always venerate him for his goodness to you, who are all the world to me. I am sure you will believe me, my dear Maria, when I say that I allow no bad disposition nor any wrong feeling to remain in my heart, towards any one, for both our sakes. For should it be, as I trust it is, God's good pleasure that we should pass our lives together; it will be but sensible conduct, as well as a religious duty, to have as little to disturb our peace as possible; for, as life advances, our trials will increase, and at the end all our ill conduct must be accounted for. I have, as you guess, been much out of doors."

"To Miss Bicknell, October 1st. I cannot help regretting the departure of our delightful summer; but I continue to work as much as possible in the fields, as my mind is never so calm and comfortable as at those times. . . . This morning we had the sacrament at our church, and I am happy to say my father was able to join us. . . . You do not mention when you leave Putney Heath. Should I be likely to stop here a few weeks longer, I shall come to town for a day or two, for I am anxious to see you. . . ."

Constable remained at Bergholt until the beginning of November. In a letter to Miss Bicknell, dated the 1st of that month, he says, "My Aunt Allen's second son is lately made a post-captain; and our cousin, Colonel Gubbins,[1] is preferred (Mr. Watts writes me word) above fifty other field officers to command the light companies of the army in Paris; and when, added to these good things, your papa introduces me to the

[1] The brother of Captain Gubbins who was killed at Waterloo. Colonel Gubbins had just returned from America, where he had been present at the attack on New Orleans.

Prince Regent,[1]—who cannot do otherwise than give me a bit of red or blue riband for my very excellent landscapes, you may justly be proud of the family you are to be connected with."

"Putney Heath, October 2nd. I must praise you, my dear John, for writing on the day I named. I should have been very sorry had you not. Is it not delightful that we can depend upon each other? I must tell you what a pleasant ride I had yesterday through Wimbledon Park, to see Lady Spencer (very grand, is it not?) who had politely desired papa to bring his daughter. She appeared to be a very pleasant woman, but had she not, a title is too apt to make us think so. Does it not seem strange?— a charming house and park, and she says, she 'would not give two-pence for it.' Such is the world! what we have we do not value, and what we have not we want. . . . These are charming days for walking, but surely too cold and damp for painting."

"East Bergholt, October 19th. . . . I have been every day intending to write to you, but I have been so much out, endeavouring to catch the last of this beautiful year, that I have neglected almost every other duty. I have put rather a larger landscape on hand than I ever did before. And this it is my wish to secure in a great measure before I leave this place; as I here find many aids, and I am sure that if I go to London to stay, first, I shall meet with many trifling jobs to interrupt me, which I shall do with pleasure when I have my own pictures under command. You shall hear from me again in a day or two."

After a short visit to London, Constable again wrote from Bergholt on the 15th of November. "I have received your kind and affectionate note, and your lovely present, which I cannot enough prize. It is the first thing of the kind I ever possessed. It is my intention to continue here till I feel that I have secured such a picture as I intend for the exhibition. Here everything is calm, comfortable, and good; and I am at a distance from you, which effectually removes the anxious desire I always feel, when you are in London, to meet you,

[1] Mr. Bicknell was solicitor to the prince.

perhaps too often for each other's comfort, till we can meet for once, and I trust, for good. . . . My kindest regards to all about you, and, believe me, ever dear Maria, unalterably yours."

"Spring Garden Terrace, December 28th. I dare say, my dear John, you are expecting to hear from me, and I am expecting to hear from you; as your last letter led me to suppose you would write again in a day or two. But it is painting that takes up all your time and attention. How I do dislike pictures; I cannot bear the sight of them; but I am very cross, am I not? You may spare yourself telling me I am very unreasonable, for I know it already. But I cannot be reconciled to your spending month after month in the country. You say you have no expectation of remaining in London for some time. At all events it is pleasant intelligence. But I feel how very often the visits here are distressing. I believe you are right to remain where you are; in a comfortable home, and rendering the declining years of your father happy. Whatever attention you can show him, must make your hours pass the more agreeably. Whenever I wish you away, I know I do wrong. I wish we could always like what is right. Henceforth I will endeavour. . . . Accept, my dearest John, the good wishes of the season; not only you, but all your family, and believe me, affectionately yours, M.E.B.—P.S. I am in very good humour now, so that I shall be happy to hear your pictures please you. Is Bergholt gay this Christmas? Do you not think if I were to write seldom, and fill the paper, it would be better? I certainly will in future."

"East Bergholt, December 31st. Believe me, my dearest Maria, I have been for some time past most anxious to write to you. I have even written more than one letter, without being able to prevail on myself to send them. This house has been the scene of great anxiety and alarm, owing to the very dangerous state of my dear father's health. But, thank God, for the last two or three days he has revived; and, although in a very weak and low state, he seems to be free from immediate danger. As you may suppose, I have not been painting

much, nor am I likely to return to London for the present, at least, not to remain. Dr. Rhudde has been very kind in his inquiries after my father, and has sent him word that he will call upon him at the shortest notice."

"East Bergholt, January 7th, 1816. It is impossible to contemplate, without satisfaction, the frame of mind my father has been in, all through his illness. His pious resignation in what appeared the hour of death; his calmness, and his thankfulness for all the blessings he has enjoyed, will, I hope be always before me, and prove a guide to my future life. His pillow is light to him, and he is so kind as to consider the having all his children about him as not among the least of his blessings. I have got to work again with alertness, and am, I hope, advancing. I have no intention of coming to London to stay; but I hope, if my father continues as well as he now is, to be there, for a few days, soon. I have a letter of thanks from Mr. Watts, for a most beautiful brace of pheasants, which I wish it had been in my power to have given to you. But from these little courtesies, dear to a heart that is not bad, I am cut off."

"To Mr. John Constable. Though I have not written to you, my dearest John, I have thought continually of you. When you last wrote, the idea of danger seemed past, and I rejoice that it pleases God still to bless you with a father. May the impression it has made on you never wear off; it shall be a lesson to me. Of this I am confident, that those who really love and fear God are the only wise people. Remember me kindly to your sisters. M.E. Bicknell."

"East Bergholt, January 14th. . . . My dear father continues charmingly, all things considered, and this imparts cheerfulness to the whole house. . . . He will drink your health in a bumper with me to-morrow.[1] . . ."

Miss Bicknell's next letter alludes to a visit paid by her father to Dr. Rhudde. "January 18th. . . . I do not think I have been quite so comfortable lately as I ought to be. I had most foolishly, most romantically, I own, flattered myself that the

[1] Her birthday.

late visit to the Rectory would have produced some good for us; but the state of our affairs seems as bad as ever; with, to me, the addition of your spending the winter in the country. Though, remember, in your father's present state of health, I would not for the world, you should be anywhere else. In the summer it is a thing of course, and we have been used to it, and know it must be; but in the winter and spring months we have always been together. . . . We certainly have not too many enjoyments. . . . I am afraid you will be said to be very unsociable by the Bergholt belles and beaux, if you refuse being at any of their card parties."

Soon after receiving this letter, Constable spent a few days in town, and returned to Bergholt, from whence he wrote to Miss Bicknell on the "25th January . . . On my arrival here, I found my dear father sadly. There is certainly a great alteration in him since I left home. I fear his time is now short indeed. I am glad I went to London; and do let me entreat you to be calm, and let nothing that can be said vex you. . . . I love you entirely, and nothing, save death, can prevent our being happy together. We can never be rich; but we can have what riches cannot purchase, and what enemies cannot deprive us of. Dr. Rhudde and Mrs. —— are entirely inveterate against me. But don't let that vex you. The one never saw me, and the other has had no opportunity of knowing me. But time will set all to rights."

The permission Mr. Bicknell had given Constable, to pay occasional visits at his house, had been kept a secret from Dr. Rhudde. But an accident now discovered it to him; and Miss Bicknell wrote to Constable. "February 7th. . . . The doctor has just sent such a letter that I tremble with having heard only a part of it read. Poor dear papa, to have such a letter written to him! he has a great share of feeling and it has sadly hurt him. . . . I know not how it will end. Perhaps the storm may blow over; God only knows. We must be patient. I am sure your heart is too good not to feel for my father. He would wish to make us all happy if he could. Pray do not come to town just yet. I hope by the end of the month peace will be

restored." Constable replied: "I am truly sorry anything should have happened to cause us any concern from that quarter. But my sisters trust the calm will not be long disturbed; though I have always feared it was a deceitful one, and that we have been making ourselves happy over a barrel of gunpowder. But, my love, let me hear from you, and tell me whether I may see you when I return to London. All this nonsense has been kept from my father, or it must have vexed him."

"February 13th. I would rather, my dear John, write too soon, than that you should wonder why you do not hear from me; but you have already so much to distress you that I hardly know if I should tell you what, I fear, will only do so more. The kind doctor says he 'considers me no longer as his grand-daughter', and from the knowledge I have of his character, I infer he means what he says. I have not seen his letters. Papa says, if we were to marry, and live at Bergholt, he thinks the doctor would leave the place."

"To Miss Bicknell, February 18th. I trust, my dearest love, you have allowed yourself to be made as little unhappy as possible, by what has been lately passing in your house. You have always been so kind as to believe that my affection for you was never alloyed by worldly motives. I, now, more than ever repeat it: and I assure you that nothing can be done, by any part of your family, that shall ever make any alteration in me towards you. I shall not concern myself with the justice or injustice of others; that must rest with themselves; it is sufficient for us to know that we have done nothing to deserve the ill opinion of any one. Our business is now more than ever with ourselves. I am entirely free from debt, and, I trust, could I be made happy, to receive a good deal more than I do now by my profession. After this, my dearest Maria, I have nothing more to say, than the sooner we are married the better; and from this time, I shall cease to listen to any arguments the other way, from any quarter. I wish your father to know what I have written if you think with me."

"February 25th. I was expecting to hear from you, my dearest Maria, all last week. I wrote you a long letter last Sunday; and I am very anxious to hear from you again, as I fear you are unwell. Do give me a line by return of post, otherwise it is probable I may come to London on Wednesday. My dear father is no better, but the contrary. His dropsy certainly increases, and Mr. Travis says it is out of his power to help him. Mrs. Whalley is here, who cheers our fireside a good deal. Her mildness and serenity always make her a most welcome guest everywhere. Do pray write to me. I am restless to see you; yet my poor father is in such a sad state that every week we look for the change. But tell me that you are well, and I shall be easy."

"Spring Garden Terrace, February 26th. My dearest John, I received your letter at Greenwich. . . . Greenwich, I am told, is a damp, unhealthy place, and I am sorry I went, for it has delayed, a few days, my writing to you. I walked out, fool-ishly, on a very damp day, and have got a cold. I have had a blister, and shall now be well in a few days; I have only to keep quiet. I will write to you again in a day or two. There is not, my dearest John, the least cause for you to be uneasy. I fully intended writing to-day, and only mention this cold to make my excuse for seeming neglect. We are all perfectly quiet here, and it would be a great pity for you to leave your poor father. Perhaps you might regret it. It must be a pleasure to him to have you with him. Your affection is a source of the greatest happiness to me; but may I entreat that you will not wish to hear very frequently from me. It only makes you uncom-fortable if I do not write on the day you imagine I will. Papa says, if we remain as we are, he has no expectation that the doctor will alter his will. Let us then wait any time, rather than you should experience the misery of being much in debt, added to having a very delicate wife. . . . I am glad you have the addition of Mrs. Whalley to your society."

Towards the end of March, Constable arrived in town with two pictures for the Academy, one of which is called in the

III. A GIRL IN A RED CLOAK.
Collection Colonel J. H. Constable

IV. JOHN HARDEN: CONSTABLE PAINTING MRS. HARDEN.
Pencil, 1806. Collection A. S. Clay

catalogue, 'A Wheat Field',[1] and the other, 'A Wood, Autumn'. The latter was purchased by Mr. Watts.

He was recalled to Bergholt by the death of his father, which in a letter to Miss Bicknell he thus describes: "My dear father died while sitting in his chair as usual, without a sigh or pang, and without the smallest alteration of his position or features, except a gentle inclination of his head forwards; and my sister Ann, who was near him, had to put her face close to his to assure herself that he breathed no more. Thus it has pleased God to take this good man to Himself, the rectitude of whose life had disarmed the grave of its terrors, and it pleased God also to spare him the pangs of death. May 19th, 1816."

"East Bergholt, July 17th. My dearest love, You would certainly have heard from me before, had I left London on the day I mentioned, but I could not get away before Tuesday. I found all my friends here quite well, and we make a large family party; nine with Mrs. Whalley's two children, and your portrait (which gives great pleasure here, as an additional proof of your kindness to me). . . . We are all very happy among ourselves; but so used have I been, on entering these doors, to be received with the affectionate shake of the hand of my father, and the endearing salute of my mother, that I often find myself overcome by a sadness I cannot restrain. . . . I am sitting before your portrait; which when I look off the paper, is so extremely like that I can hardly help going up to it. I never before knew the real pleasure a portrait can afford."

"Putney Heath, August 15th. . . . How well you knew what I should like, when you sent me the delightful letters of Gessner. My only regret is that I have finished them so soon. I shall

*[1] It has been thought that this is the painting now in the Tate Gallery (No. 1065), where it is called 'A Cornfield, with Figures: a Sketch'. In the following year Constable exhibited at the B. I. a 'Harvest Field: Reapers, Gleaners', whose measurements (including frame) were 2 ft. 9 in. × 3 ft. 6 in. It seems likely that the same painting was exhibited at the R. A. and the B. I. If this was so, it is unlikely that it was the Tate Gallery painting, whose dimensions (excluding the frame) are only $9\frac{1}{2} \times 15\frac{1}{2}$ in. The Tate Gallery painting, however, is of approximately this date, and it may be a sketch for the exhibited painting.

send to the library for the rest of his works. My dear John, you know the moments were too short and too precious for me to write a note when you took the box; but I expected you would make a very pretty speech for me when you gave it to your sister. I am very glad she was pleased with it. I had great pleasure in doing it for her. Thank you, my dear John, for sending me your sweet picture. Come early this evening."

When Constable, on one of his visits to Spring Garden Terrace, placed himself beside Miss Bicknell, and took the hand which was soon to be given to him for life, her father said 'Sir, if you were the most approved of lovers, you could not take a greater liberty with my daughter.'—'And don't you know, sir', he replied, 'that I am the most approved of lovers?' —She had been treated, for five years, as if she were a boarding-school girl in danger of falling a prey to a fortune-hunter. But she had now arrived at the age of twenty-nine; a time of life at which, patient as she was, she felt entitled to determine for herself a matter which so entirely affected her own happiness. A journey into Wales, under the care of an uncle, was pro-posed to her; and in allusion to this, she says, in a letter to Constable, dated July 30th, "I am not to go unless I get stronger than I am at present, and then it will do me much good, the change of air and scene. My uncle intends to take plenty of time for the journey, that it may not be fatiguing. I think, therefore, you may safely trust to my discretion, and then my dear John shall find me ready, if it is his decided wish, for another and far pleasanter journey."

"Putney Heath, August 20th. . . . I do not like, dear John, that you should have to borrow money; and I think you said it would be some time before you came into possession of your own. I only suggest this for our consideration, but, alas! I know too well that you have thought of it with sorrow. Let me know what you think, for it makes me perfectly uncom-fortable. I am glad to be going from home for a short time."

"East Bergholt, August 21st. My dearest love, I returned from my very pleasant visit at General Rebow's on Monday. . . . The general and Mrs Rebow are determined to be of some

service to me. I am going there again, and shall stay a week, in all probability. Do be so kind as to let me hear from you before you go to Mr. Lambert's. I am to paint two small landscapes for the general; one in the park, of the house, and a beautiful wood and piece of water;[1] and another a wood, with a little fishing house, where the young lady (who is the heroine of all these scenes) goes occasionally to angle. They wish me to take my own time about them; but the general will pay me for them when I please, as he tells me he understands, from Mr. Driffield, that *we* may soon want a little ready money. They are both well acquainted with our history, and hope to see us there together. I am next year to paint another picture of the little girl with her donkey, for their house in town. This, my love, is just such a commission as will be of real service to me. I am getting on as well as I can wish with my own pictures; but these little things will rather interrupt them, and, I am afraid, will detain me here a week or two longer than I could have wished."

"Putney Heath. August 23rd. I thank you, dear John, for yours, this moment received. How very happy the account of your visit makes me; you seem so truly comfortable there. I am delighted that you return on Monday, and that the views you are to paint are so pretty. . . . My uncle set off last night by the mail. The weather has so much improved that I have been silly enough to regret (only for a moment) that I did not go. But then, poor dear papa! I ought *sometimes* to comply with his wishes with pleasure."

"Wivenhoe Park, August 30th. My dearest love, I have been here since Monday, and am as happy as I can be away from you. Nothing can exceed the kindness of the general and his lady. They often talk of you, because they know it will please me, and I am sure they will show you the same attentions they show me. I feel comfortable with them, because I know them to be sincere people; and though of

★[1] At the R. A. 1817, Constable exhibited a painting of 'Wivenhoe Park, Essex, the seat of Major-General Rebow'. It is now in the National Gallery of Art, Washington (Widener Collection). See Plate 14.

family, and in the highest degree refined, they are not at all people of the world, in the common acceptation of the word. I am going on very well with my pictures for them. The park is the most forward. The great difficulty has been to get so much in it as they wanted. On my left is a grotto with some elms, at the head of a piece of water; in the centre is the house over a beautiful wood; and very far to the right is a deer house, which it was necessary to add; so that my view comprehended too large a space. But to-day I have got over the difficulty, and begin to like it myself. I think I shall make a large picture from what I am now about. When do you return? If I should be delayed longer in the country than I at first expected, I shall run up for a day, to see you. I shall write to John Fisher soon."

"Wivenhoe Park, September 7th. My dearest love, I hasten to send you the enclosed letter from our friend Fisher. I can only say that I am ready to adopt any plan that may meet your feelings on this occasion, and I repeat Fisher's words, that, 'I shall be happy and ready to marry you', at the time he mentions. I am advised by my good friends here, to try one more effort with the doctor; but I shall do entirely in this as you direct."

The following is the letter enclosed: "Osmington, near Dorchester, August 27th, 1816. My dear Constable, I am not a great letter writer, and when I take pen in hand, I generally come to the point at once. I therefore write to tell you that I intend to be in London on Tuesday evening, the 24th, and on Wednesday shall hold myself ready and happy to marry you. There, you see, I have used no roundabout phrases; but said the thing at once, in good plain English. So, do you follow my example, and get you to your lady, and instead of blundering out long sentences about 'the Hymeneal altar', etc., say that on Wednesday, September 25th, you are ready to marry her. If she replies, like a sensible woman, as I suspect she is 'Well, John, here is my hand, I am ready'—all well and good. If she says, 'Yes, but another day will be more convenient', let her name it, and I am at her service. And, now my dear fellow, I have another point to settle. And that I may gain it, I shall

put it in the shape of a request. It is that, if you find, upon your marriage, your purse is strong enough to make a bit of a détour, I shall reckon it a great pleasure, if you and your bride will come and stay some time with my wife and me. That lady joins with me in my request. The country here is wonderfully wild and sublime, and well worth a painter's visit. My house commands a singularly beautiful view, and you may study from your very window. You shall have a plate set by the side of your easel, without your sitting down to dinner. We never see company, and I have brushes, paints, and canvas in abundance. Of an evening, we will sit over our autumnal fireside, read a sensible book, perhaps a sermon, and after prayers, get us to bed, at peace with ourselves and all the world. Since I have been quiet down here, out of the way of the turmoil and bustle of ——'s great dinners, I have taken much to my easel, and have improved much. Your visit will be of wonderful advantage to me. Tell your lady that I long to be better acquainted with her, as does Mrs. Fisher; and I beg her to use her influence with you to bring you to see,— yours, with sincerity, John Fisher."

On the 15th September, Constable wrote to Miss Bicknell: "What can I do about writing to your father? Will it be time enough if I call on him when I come to town? You must be my adviser." She replied: "Papa is averse to everything I propose. If you please, you may write to him; it will do neither good nor harm. I hope we are not going to do a very foolish thing. . . . Once more, and for the last time! it is not too late to follow papa's advice and *wait*. . . . Notwithstanding all I have been writing, whatever you deem best, I do. This enchanting weather gives one spirits."

They were married on the 2nd of October, 1816, at St. Martin's Church, by Mr. Fisher, whose invitation to Osmington[1] they accepted. Mr. Fisher had himself been married but three months.

*[1] Drawings made by Constable when on his honeymoon at Osmington are in the Victoria and Albert Museum; e.g. 'Osmington Bay', dated 7th Nov. 1816 (No. 311–1888), 'Portland Island', dated 20th Nov. 1816 (No. 628–1888), and others.

Mr. Bicknell did not long withhold his forgiveness from his daughter, and now that he allowed himself opportunities of knowing Constable, he became extremely fond of him. In one of Miss Bicknell's letters which has not been quoted, she said, "It grieves me that papa and you cannot be better acquainted, but the loss is mutual." Dr. Rhudde was not so soon reconciled to the marriage, but at his death, which occurred in 1819, he left his grand-daughter a legacy she probably little expected of £4000.

1817–1821

Housekeeping. Birth of a Son. Exhibitions 1817, 18, and 19. Birth of a Daughter. Constable elected an Associate of the Royal Academy. Sale of his large pictures 'The White Horse' and 'Stratford Mill' to Archdeacon Fisher. Exhibition 1820. Matthews' *Diary of an Invalid.* Stothard's 'Canterbury Pilgrims'. White's *Selborne.* Exhibition 1821. Excursion in Berkshire and to Oxford. Studies at Hampstead. Criticisms on the 'Stratford Mill'. Constable's remarks on Skies.

ALTHOUGH my acquaintance with Constable began about this time, I have little to tell of the next two years of his life but that which the catalogues of the Exhibition furnish. I remember him in 1817 living in a small house, No. 1, Keppel Street, Russell Square; and that his first child, a fine boy, to whom his own name had been given, might be seen almost as often in his arms as in those of his nurse, or even his mother. His fondness for children exceeded, indeed, that of any man I ever knew.

In this year he exhibited at the British Gallery, 'A Harvest-field with Reapers and Gleaners',[1] and at the Academy, 'Wivenhoe Park', 'A Cottage',[2] a portrait of Mr. Fisher,[3] and 'A Scene on a navigable River',[4] and in the autumn he paid a visit to Bergholt, as the dates of some of his sketches[5] show.

In 1818, he sent to the Academy, 'Landscape, breaking up of a Shower', three other landscapes, 'A Gothic Porch', and 'A Group of Elms',[6] the two last being drawings in lead pencil; and to the British Gallery he sent, 'A Cottage in a Corn-field',[7]

*[1] Cf. *n.* p. 65.

*[2] Has been thought to be the painting called 'Cottage in a Cornfield' in the Victoria and Albert Museum (No. 1631–1888). But cf. *n.* 7.

*[3] In the possession of the Fisher family. See Plate vii.

*[4] Now in the National Gallery (No. 1273), where it is called 'Flatford Mill on the River Stour'. See Plate 18.

*[5] Some of these dated sketches are in the Victoria and Albert Museum.

*[6] Probably the drawing at the Victoria and Albert Museum (No. E. 3237–1911). See Plate 21.

*[7] Although Leslie's description of this painting closely corresponds with the 'Cottage in a Cornfield' in the Victoria and Albert Museum, the measurements given in the B. I. catalogue do not: see Plate 20. Constable also exhibited at the B. I. this year a 'Scene on the Banks of a River'.

probably exhibited at the Academy the year before. The cottage in this little picture is closely surrounded by the corn, which on the side most shaded from the sun, remains green, while over the rest of the field it has ripened; one of many circumstances that may be discovered in Constable's landscapes, which mark them as the productions of an incessant observer of nature. But these and other latent beauties passed wholly unnoticed in the Exhibitions; indeed, the pictures that contained them were for the most part unheeded, while more showy works, by artists whose very names are now nearly forgotten, were the favourites of the day.

Constable's art was never more perfect, perhaps never so perfect, as at this period of his life. I remember being greatly struck by a small picture, a view from Hampstead Heath,[1] which I first saw at *Ruysdael House*, as Mr. Fisher called his residence in Keppel Street. I have before noticed that what are commonly called warm colours are not necessary to produce the impression of warmth in landscape; and this picture affords, to me, the strongest possible proof of the truth of this.[2] The sky is of the blue of an English summer day, with large, but not threatening, clouds of a silvery whiteness. The distance is of a deep blue, and the near trees and grass of the freshest green; for Constable could never consent to parch up the verdure of nature to obtain warmth. These tints are balanced by a very little warm colour on a road and gravel pit in the foreground, a single house in the middle distance, and the scarlet jacket of a labourer. Yet I know no picture in which the mid-day heat of Midsummer is so admirably expressed; and were not the eye refreshed by the shade thrown over a great part of the foreground by some young trees, that border the road, and the cool blue of water near it, one would wish, in

*[1] From Leslie's description and from Miss Constable's statement, this can be identified as the painting in the National Gallery (No. 1236) called 'Hampstead Heath: the house called "The Salt Box" in the distance'.

[2] It is, perhaps, unnecessary to remark that we associate the idea of warmth with red, orange, and yellow, because they are the colours of fire; and that, in a summer landscape, they can only have place in very small proportions excepting at the rising and the setting of the sun, the coolest hours of the day.

looking at it, for a parasol, as Fuseli wished for an umbrella when standing before one of Constable's showers. I am writing of this picture, which appears to have been wholly painted in the open air, after an acquaintance with it of five-and-twenty years; and, on referring to it again and again, I feel my first impressions, whether right or wrong, entirely confirmed. At later periods of his life, Constable aimed, and successfully, at grander and more evanescent effects of nature; but in copying her simplest aspects, he never surpassed such pictures as this; and which, I cannot but think, will obtain for him, when his merits are fully acknowledged, the praise of having been the most genuine painter of English landscape that has yet lived.

The following beautiful passage is from a letter written to Mrs. Constable in May 1819, while he was on a short visit to Bergholt: "Everything seems full of blossom of some kind and at every step I take, and on whatever object I turn my eyes, that sublime expression of the Scriptures, 'I am the resurrection and the life', seems as if uttered near me."

In 1819, he sent two pictures to the British Gallery, not before exhibited, 'Osmington Shore, near Weymouth',[1] and 'A Mill', and to the Academy he sent the largest and most important work he had yet produced, 'A Scene on the river Stour', afterwards called, from a white horse in a barge near the foreground, 'Constable's White Horse'.[2] This fine land-scape, which was too large to remain unnoticed, attracted more attention than anything he had before exhibited. It is the one mentioned by him in the following letter to Arch-deacon Fisher,[3] dated July 17th. "I should like of all things to make you a visit in the autumn, though I cannot allow myself to be sanguine; yet it is cheering to think about it; such a visit would have many charms for me. Your society, the cathedral, the walks, and those mines of art, Longford and Wilton, to which you could procure me admission to make some studies.

*[1] Perhaps related to 'Weymouth Bay' in the National Gallery (No. 2652). See Plate 15.

*[2] Now in the Frick Collection, New York. See Plate 19.

[3] Mr. Fisher had been installed Archdeacon of Berkshire, in the latter part of 1817.

"The price I have put on my large landscape is one hundred guineas, exclusive of the frame; it has served a good apprenticeship in the Academy, and I shall work a good deal upon it before it goes to the British Gallery. I should hardly like to part with my copy of Ruysdael; its being an old school exercise (of which I have too few), gives it a value to me beyond what I could in conscience ask for it. We will talk about the Claude when we meet. I have procured the drawing by Cozens for you, and could pictures choose their possessors, you would have had many like it long ago. I do not wonder at what you tell me of poor ——'s pictures. Such collections and judges always make me melancholy. I neither visit them nor talk about them if I can help it. But such things are driven down the throats of ignorance, by ignorance still more overbearing, backed, by the bye, with good dinners. . . . I have made a sketch of the scene on the Thames, which is very promising."[1]

"August 13th. My dear Fisher. I was happy to receive your friendly letter yesterday. Nothing would give me greater pleasure than to make you a visit, and I hope to be able to accomplish it, ere long. I am under an engagement to paint the portraits of General and Mrs. Rebow, at Wivenhoe Park, about this time. I have written to know if it is still his wish, and when I have his answer you shall hear from me again. My wife thanks you for your kind enquiries after her and her infant. They are both well, and a more lovely little girl, at a month old, was never seen. We are so proud of her, and at the same time so ambitious, as to be induced to ask a great favour: it is our wish to be allowed to name you for her Godfather. We shall take her to church in a few days, and shall be happy to hear from you."[2]

In October, 1819, Constable was called to Bergholt by the division of his father's property, of which his part amounted to £4000; and in November he was elected an Associate of the

[1] 'The Opening of Waterloo Bridge'. ★This may be the oil-sketch at Burlington House.

★[2] Fisher communicated his acceptance in a letter dated the following day.

Royal Academy, on which occasion he received the following note from Mr. Fisher: "Close, Salisbury, November 1819. My dear Constable, The Bishop and Mrs. Fisher bid me, with my own, to present their congratulations on your honourable election. Honourable it is, for the Royal Academy is, in the first place, an establishment of this great country, and as such, to be held in great respect; and in the second place, you owe your election to no favour, but solely to your own un-supported, unpatronised merits. I reckon it no small feather in my cap that I have had the sagacity to find them out."

Mr. Fisher did not content himself with praising his friend, but by the purchase of 'The White Horse', while he manifested his sincerity, he rendered Constable a service which was, per-haps, of more importance to him at that crisis of his life than it would have been at any later period; and his desire to follow this up, by farther acts of friendship, will be seen in a letter dated "April 19, 1820. My dear Constable, I am under obliga-tions to an architect here, who has retired from business. I want to make him a present of something near £20. I would rather give him one of your pictures, if I thought he would appreciate it. See what you can do for me. . . . Do not part with your London and Westminster view without apprising me; as I rather think I shall like to have it, in case I am strong enough in purse. At any rate, *I* can do you no harm by saying *no*, if I cannot purchase. I am infinitely obliged by your pur-chase of the Claude. You can send it me down with the picture. You did right in sending the sea-coast windmill to the exhibi-tion. Pray come as soon as you can, and stay as long as you can."

"Salisbury, April 27th. 'The White Horse' has arrived safe; it is hung on a level with the eye, the frame resting on the ogee moulding in a western side light, right for the light in the picture. It looks magnificently. My wife says she carries her eye from the picture to the garden and back again, and ob-serves the same sort of look in both. I have shown it to no one, and intend to say nothing about it, but leave it to people to find it out, and make their own remarks. I am quite impatient

to see you here, and wish your young family would permit your wife to join the party. J. Fisher."

The 'White Horse', on many accounts the most important picture to Constable he ever painted, and certainly one of the finest, is now in the possession of L. Archer Burton, Esq., of the Woodlands, Hants. In a letter written to Miss Gubbins (a lady related to that gentleman and to Constable), at a late period of his life, he calls it, "one of my happiest efforts on a large scale, being a placid representation of a serene grey morning, summer".

"Keppel Street, September 1st, 1820. My dear Fisher, . . . I have settled my wife and children comfortably at Hampstead. I am glad to get them out of London for every reason. Things do not look well, though I fear nothing.[1] I hear the Duke of Wellington was in the most imminent danger yesterday, and had nearly lost his life by the hands of an old woman! We had a pleasant journey to London. In truth, we were all made more fit for such an excursion by the unbounded kindness of yourself and Mrs. Fisher, and our kind friends at the Palace. Indeed, my dear Fisher, my wife and I feel quite at a loss how to speak to you of these things. My Salisbury sketches[2] are much liked; that in the Palace grounds, the bridges and your house from the meadows, etc. . . .[3] I have just been giving some relief to the poor old organist you saw at my door; he is almost in a state of starvation, with a wife and children. He is taken for an Italian, and is, in consequence, in danger in the streets. I shall venture to give him five shillings for you, and add it to your running account."

I do not know whether the present, mentioned in Mr. Fisher's letter of the 19th of April, was made; but Mr. Tinney of Salisbury, as the Archdeacon's solicitor, having ren-

[1] The excitement occasioned by the trial of Queen Caroline was then at its height.

★[2] Some of these are in the Victoria and Albert Museum.

★[3] Shirley, in his edition of Leslie, states that Leslie has omitted the following sentences at this point: "I am putting my river Thames on a large canvas. I think it promises well . . ." The reference is to 'The Opening of Waterloo Bridge', which was not completed in its final form until 1832.

dered him some services for which he felt under great obliga-
tions, he purchased a large picture of Constable, which he pre-
sented to that gentleman; but as Mr. Fisher considered the price,
one hundred guineas, to be far below its value, he, with much
delicacy, in a letter to Constable, spoke of the transaction as
"our joint present". This noble picture, which I well remember
in the exhibition of 1820, and which has since been admirably
engraved by Mr. Lucas, is about as large as 'The White Horse',
and has more subject. On the extreme left of the spectator, the
wheel and part of a water-mill are seen. In the foreground are
some children fishing, admirable for the expression of their
attitudes, their faces not being seen. Sir George Beaumont
said of the largest boy, that 'he was undergoing the agony of a
bite'. To the right, and in the middle distance, a barge lies with
extreme elegance of perspective on the smooth river; light
clouds throw their shadows over a rising distance of great
beauty, and a group of tall trees forms the centre of the com-
position. It is a view, and when it was painted, was an exact
one of Stratford Mill on the Stour, not far from Bergholt.[1]
Constable sent with it a small picture to the Academy, 'A
View of Harwich Lighthouse'.[2]

"Weymouth, February 14th, 1821.[3] My dear Constable, I
am here paying the last duties to my wife's mother. She died
silently and suddenly, on Monday morning at three o'clock.
Rather a singular accident happened to me in consequence of
her death. I was in the church, at Osmington, with the old
clerk alone, pointing out the site of her grave, when the old
man suddenly exclaimed, 'I cannot stand, sir', and dropping
into my arms, died.

[1] Mr. Lucas's engraving of this picture was published, after the death of
Constable, with the title of 'The Young Waltonians'. A title he certainly
would not have given it. *The painting, now called 'Stratford Mill', is in the
National Gallery of British Sports and Pastimes, Hutchinson House.

*[2] Perhaps the painting now in the Tate Gallery (No. 1276).

*[3] Shirley, in his edition of Leslie, states (p. 122 n.) that 'Leslie misread the
date of this as 1821': Shirley ascribes the letter to 1820. The present editor has
examined the MS. of the letter, through the courtesy of Edward Fisher, Esq.,
the present owner: it is dated clearly 'Feb. 14 1821'. The point is of some im-
portance as this letter contains a reference to 'The Hay Wain' (cf. p. 78 n. 3).

"When you next see Stothard tell him the following anec-
dote. I went to call upon a poor curate, living in one of our
mud villages on a lonely part of this coast, and was shown into
a dark low underground parlour. Casting my eye round the
comfortless walls, I was refreshed by spying in a corner a
most charming bit of light and shadow; and walking up to see
what else it contained, I found Stothard's 'Canterbury Pil-
grims',[1] with the morning light breaking over the Dulwich
Hills. The poor man little less than worships this print.—Pray
get, at your circulating library, the *Diary of an Invalid.*[2] You
will be much amused with it; for it is written in a lively easy
manner. When you come to his critiques on painting and
statuary, you will find another corroboration of our often
repeated opinion that persons of the highest education in the
sciences are often mere children in their knowledge of the art.
... [3] As soon as the spring arrives I will make a correct sketch
of our ferry house at Portland, and send it to you. I saw it, the
other day, standing in sea-bleached desolation. J. Fisher."

Constable, in his reply to this letter, after condoling with
Mr. and Mrs. Fisher on the melancholy news with which it
commenced, says, of another large work he was engaged on,
"My picture is getting on, and the frame will be here in three
weeks or a fortnight. Believe me, my dear Fisher, I should
almost faint by the way when I am standing before my large
canvases, were I not cheered and encouraged by your friend-
ship and approbation. I now fear (for my family's sake) I shall
never make a popular artist, *a gentlemen and ladies' painter.* But
I am spared making a fool of myself, and your hand stretched
forth teaches me to value what I possess (if I may say so); and
this is of more consequence than gentlemen and ladies can
well imagine. The Bishop and Mrs Fisher attacked me about

[1] Constable told me he was in Stothard's room when he was finishing the
picture of the 'Pilgrims', and that he was then painting the two dogs gambolling
at the head of the cavalcade. They were the last objects introduced into the
composition.

★[2] Henry Matthews, *The Diary of an Invalid.* London, 1820.

★[3] Leslie has omitted the following passage here: "When will Tinney receive
his picture (i.e. 'Stratford Mill')? And how thrives the Haywain?"

————'s[1] pantomime again yesterday; but I spoke my mind, as the shortest way: I could not sacrifice myself to such gross ignorance."

The '*pantomime*' here alluded to was an extravagant and melo-dramatic conception of historical art, at that time popular. The Bishop of Salisbury, though a man of great refinement of mind, was no judge of painting, and was, therefore, led away, on that subject, by the fashions of the time. His unceasing kindness to Constable, whose art he did not appreciate, was the result of friendship alone.

"Close, Salisbury, March 6th. My dear Constable, . . . I am reading, for the third time, White's *Natural History of Selborne*. It is a book that would delight you, and be highly instructive to you in your art, if you were not already acquainted with it. White was the clergyman of the place, and occupied himself with narrowly observing and noting down all the natural occurrences that came within his view: and this for a number of years. It is most elegantly written I fear the book is scarce. But if you can procure it, buy it for me and keep it by you. It is in your own way of close observation, and has in it that quality that, to me, constitutes the great pleasure of your society. . . . J. Fisher."

In 1821, Constable exhibited four pictures at Somerset House, 'Hampstead Heath',[2] 'A Shower', 'Harrow', and 'Landscape, Noon';[3] the last was the third he had painted on a six-foot canvas, encouraged to proceed with works on so large a scale by Mr. Fisher's two purchases. This picture is mentioned in the next letter, and will be again spoken of as 'The Hay Wain'.

"To Archdeacon Fisher. No. 1, Keppel Street, April 1st, 1821. . . . My picture goes to the Academy on the 10th; it is not so grand as Tinney's. Owing, perhaps, to the masses not being so impressive, the power of the chiaroscuro is lessened,

[1] Martin's, i.e. John Martin (1789–1854), who exhibited his 'Belshazzar's Feast' at the B. I. in Feb. 1821.

[2] Perhaps the painting of Hampstead Heath now in the National Gallery (No. 1236), described by Leslie above, p. 72.

[3] 'The Hay Wain', in the National Gallery (No. 1207). See Plate 29.

but it has a more novel look than I expected. I have yet much
to do to it, and calculate on three or four days there. I hear of
so many clever pictures, particularly by non-members, that it
must be a capital show. They are chiefly historical and fancy
pictures, and why? the Londoners, with all their ingenuity as
artists, know nothing of the feelings of a country life, the
essence of landscape. . . . How much I am obliged to you for
the mention of the books. The *Diary* is delightful, it has given
me new information on subjects that I have heard of all my
life. No doubt the 'Invalid' is a clever fellow; but these tourists
in Italy think they must talk about pictures, and relate anec-
dotes of painting. I would recommend them to remember the
story of Alexander's visit to the painting room of Apelles. He
mentions the landscapes of Gaspar Poussin (whose works
contain the highest feeling of landscape painting), and
imagines defects, that he may afford an opportunity to 'our
own Glover'[1] to remedy them. This is too bad; and he here
shows himself to be truly an invalid.[2] The mind that produced
the 'Selborne' is such a one as I have always envied. The single
page of the life of Mr. White leaves a more lasting impression
on my mind than all that has been written of Charles V or
any other renowned hero. It shows what a real love of nature
will do. Surely the serene and blameless life of Mr. White, so
exempt from the folly and quackery of the world, must have
fitted him for the clear and intimate view he took of nature.
It proves the truth of Sir Joshua Reynolds' remark that 'the
virtuous man alone has true taste'. This book is an addition to
my estate. Stothard was amused with your mention of his
'Pilgrims', but said he believed 'many of his prints were to be

[1] John Glover (1767–1849), water-colourist and painter in oils.

[2] The following is the passage from Matthews' *Diary of an Invalid*, which
excited his indignation. "Doria Palace. Large collection of pictures; Gaspar
Poussin's green landscapes have no charms for me. The fact seems to be that
the delightful green of nature cannot be represented in a picture. Our own
Glover has perhaps made the greatest possible exertions to surmount the diffi-
culty, and give with fidelity the real colours of nature; but I believe the beauty
of his pictures is in an inverse ratio to their fidelity; and that nature must be
stripped of her green livery, and dressed in the browns of the painters, or con-
fined to her own autumnal tints in order to be transferred to canvas."

found amongst the Hottentots'. I dined, last week, at Sir George Beaumont's. Met Wilkie, Jackson, and Collins. It was amusing to hear them talk of ——'s[1] picture. Sir George said some clever things about it, but he added, 'even allowing the composition, its only merit, to be something, still if the finest composition of Handel's were played entirely out of tune, what would it be?' "

In June, Constable accompanied his friend Fisher during his visitation in Berkshire, and made some beautiful pencil and washed drawings of the scenery in the neighbourhood of Reading, Newbury, and Abingdon. He also visited Oxford, with Fisher, and made an exquisite drawing of Blenheim, from the Park.[2]

"Salisbury, July 19th, 1821. My dear Constable, Your picture is hung up in a temporary way at Tinney's, till his new room is finished, and excites great interest and attention. How does 'The Hay Wain' look now it has got into your own room again? I want to see it there, for how can one participate in a scene of fresh water and deep noon-day in the crowded copal atmosphere of the Exhibition? which is always to me like a great pot of boiling varnish. . . . Yours very sincerely, John Fisher."

"No. 2, Lower Terrace, Hampstead, August 4th, 1821. My dear Fisher, . . . I am as much here as possible with my family. My placid and contented companion and her three infants are well. I have got a room at a glazier's, where is my large picture, and at this little place I have many small works going on, for which purpose I have cleared a shed in the garden, which held sand, coals, mops, and brooms, and have made it a workshop. I have done a good deal here. I have fitted up my drawing-rooms in Keppel Street, and intend keeping them in order, hanging up only decent works. 'The

*[1] Martin's.

*[2] From dated drawings in the Victoria and Albert and the British Museum, several days of the itinerary can be reconstructed: 4th–5th June, Newbury—5th–6th June, Reading—7th June, Abingdon. A pencil drawing of Blenheim Palace in the Victoria and Albert Museum is dated June 8th, 1821. A drawing of the High Street, Oxford, dated 9th June 1821, is in the British Museum.

Hay Wain' looks well in them, but I shall do more to it. . . . I am now going to pay my court to the world. I have had experience enough to know that, if a man decries himself, he will find people ready enough to take him at his word. Sir George Beaumont is going to Italy; he has presented me with a beautiful little landscape, a mill, the same mill in Tinney's picture, it is quite a Rembrandt, full of tone and chiaroscuro. There is some hope of the Academy's getting a Claude from Mr. Angerstein's,[1] the large and magnificent marine picture, one of the most perfect in the world; should that be the case, though I can ill afford it, I will make a copy of the same size. A study would be only of value to myself, the other will be property to my children, and a great delight to me. The very doing it will almost bring me into communion with Claude himself. Lawrence told me that, should I really wish it, it would stimulate him to farther exertions to get it from Mr. Angerstein. In the room where I am writing, there are hanging up two beautiful small drawings by Cozens;[2] one, a wood, close, and very solemn; the other, a view from Vesuvius, looking over Portici, very lovely. I borrowed them from my neighbour, Mr. Woodburn. Cozens was all poetry, and your drawing is a lovely specimen."

"Salisbury, August 6th, 1821. My dear Constable, Very few can copy Claude, I exhort you to it by all means. It will secure two or three hundred pounds to your family, and will furnish *us* with an inexhaustible store of pleasure. I get impatient to know whether your wife will allow you to run down this autumn. Any time from September 1st to January will be convenient to me, and you need not be at any expense at all. One night in the mail and you are here. The assizes are holding, and C——[3] is here. Your letters lay on the table. He said that there were *some parts* of your last picture good. I told him if he had said, *all* the parts were good, it would be no compliment, unless he said the *whole* was good. Is it not strange how utterly

[1] Pictures are lent to the Academy by most of the possessors of collections for the use of the painting-school.

*[2] John Robert Cozens (*c.* 1752–1797). *[3] Coleridge.

ignorant the world is of the very first principles of painting?
Here is a man of the greatest abilities, who knows almost
every thing, and yet he is as little a judge of a picture as if he
had been without eyes. There's Matthews again with 'his own
Glover'."[1]

"Hampstead, September 20th, 1821. My dear Fisher, How
much I should like to come to you! and I cannot say I will not,
but I fear I must go into Suffolk soon, on account of a job.[2]
I have made some studies, carried farther than any I have done
before; particularly a highly elegant group of trees[3] (ashes,
elms, and oaks), which will be of as much service to me as if I
had bought the field and hedgerow which contain them; I
have likewise made many skies and effects;[4] we have had
noble clouds and effects of light and dark and colour, as is
always the case in such seasons as the present. The great
Claude does not come to the Academy this year (a young
lady is copying it), but they expect it next year, and it would
have been madness for me to have meddled with it this season,
as I am now behindhand with the bridge.[5] The beautiful
Ruysdael, 'The Windmill' which we admired, is at the
Gallery. I trust I shall be able to procure a memorandum of it;

[1] Lord Dudley, in a letter to the Bishop of Llandaff, admirable for its good
sense and candour, speaking of the excellencies of the old masters, says, "I
believe that merit to be of a sort which requires study, habit, and, perhaps,
some practical knowledge of the principles of the fine arts, to perceive and
relish. You remember that Sir Joshua Reynolds tells us he was at first incapable
of tasting all the excellence of Raphael and Michael Angelo. And if he, already
no mean artist, was still uninitiated in some of the higher mysteries of art, and
obliged at first to take upon trust much of that which was afterwards made
clear to him by further study and labour, what shall we say about the sincerity
of those who, knowing so much less, pretend to feel so much more? For my
own part, I think of them very much as I should think of anybody who, being
just able to pick out the meaning of a Latin sentence, should affect to admire
the language and versification of the *Georgics*."

[2] A portrait.

★[3] This is perhaps the 'Trees near Hampstead' in the Victoria and Albert
Museum (No. 1630–1888).

★[4] A number of studies of skies with dates about this time are in the Victoria
and Albert Museum and at Burlington House. See Plate viii.

[5] His fourth large picture. ★This was the 'View on the Stour', to be exhibited
at the R. A. in 1822.

and there is a noble N. Poussin at the Academy, a solemn, deep, still summer's noon, with large umbrageous trees, and a man washing his feet at a fountain near them. Through the breaks in the trees are mountains, and the clouds collecting about them with the most enchanting effects possible. It cannot be too much to say that this landscape is full of religious and moral feeling.[1] It is not large, about three and a half feet, and I should like to, and will, if possible, possess a facsimile of it. I must make time. If I cannot come to you, I will send you the results of this summer's study. My wife and children are well, we have not had an hour's illness all the summer."

On the 26th of September, Fisher wrote to tell Constable of objections that were made to the sky in Mr. Tinney's picture, by a "grand critical party" who had sat in judgment on it. "After talking in vain for some time," he continues, "I brought them out of my portfolio two prints from Wouvermans and a Vander Neer, where the whole stress was laid on the sky, and that silenced them. While in every other profession the initiated only are judges, in painting, all men, except the blind, think themselves qualified to give an opinion. The comfort is, that the truth comes out when these self-made connoisseurs begin to buy and collect for themselves. At Lord Shaftesbury's, about twelve miles from this place, there is a daylight Vander Neer. When you come we will go and see it. I had nearly forgotten to tell you that I was the other day fishing in the New Forest in a fine deep broad river, with mills, roaring back-waters, withy beds, etc. I thought often of you during the day. I caught two pike, was up to the middle in watery meadows, ate my dinner under a willow, and was as happy as when I was 'a careless boy'. What have you done with your 'Midsummer Noon', and what do you intend to do with it?"

"Hampstead, October 23rd, 1821. My dear Fisher, . . . I am most anxious to get into my London painting-room, for I do

[1] This picture is in the National Gallery. ★It is catalogued as 'Landscape: A man washing his feet at a fountain', and is now considered to be after Nicolas Poussin.

not consider myself at work unless I am before a six-foot canvas. I have done a good deal of skying, for I am determined to conquer all difficulties, and that among the rest. And now talking of skies, it is amusing to us to see how admirably you fight my battles; you certainly take the best possible ground for getting your friend out of a scrape (the example of the old masters). That landscape painter who does not make his skies a very material part of his composition, neglects to avail himself of one of his greatest aids. Sir Joshua Reynolds, speaking of the landscapes of Titian, of Salvator, and of Claude, says: 'Even their *skies* seem to sympathise with their subjects.' I have often been advised to consider my sky as '*a white sheet thrown behind the objects*'. Certainly, if the sky is obtrusive, as mine are, it is bad; but if it is evaded, as mine are not, it is worse; it must and always shall with me make an effectual part of the composition. It will be difficult to name a class of landscape in which the sky is not the key note, the standard of scale, and the chief organ of sentiment. You may conceive, then, what a 'white sheet' would do for me, impressed as I am with these notions, and they cannot be erroneous. The sky is the source of light in nature, and governs everything; even our common observations on the weather of every day are altogether suggested by it. The difficulty of skies in painting is very great, both as to composition and execution; because, with all their brilliancy, they ought not to come forward, or, indeed, be hardly thought of any more than extreme distances are; but this does not apply to phenomena or accidental effects of sky, because they always attract particularly. I may say all this to you, though *you* do not want to be told that I know very well what I am about, and that my skies have not been neglected, though they have often failed in execution, no doubt, from an over-anxiety about them, which will alone destroy that easy appearance which nature always has in all her movements.

"How much I wish I had been with you on your fishing excursion in the New Forest! What river can it be? But the sound of water escaping from mill-dams, etc., willows, old rotten planks, slimy posts, and brickwork, I love such things.

Shakespeare could make everything poetical; he tells us of poor Tom's haunts among 'sheep cotes and mills'. As long as I do paint, I shall never cease to paint such places.[1] They have always been my delight, and I should indeed have been delighted in seeing what you describe, and in your company, 'in the company of a man to whom nature does not spread her volume in vain'. Still I should paint my own places best; painting is with me but another word for feeling, and I associate 'my careless boyhood' with all that lies on the banks of the Stour; those scenes made me a painter, and I am grateful; that is, I had often thought of pictures of them before I ever touched a pencil, and your picture is the strongest instance of it I can recollect; but I will say no more, for I am a great egotist in whatever relates to painting. Does not the Cathedral look beautiful among the golden foliage? its solitary grey must sparkle in it."

"Close, Salisbury, October 24th. My dear Constable, I had a most agreeable breakfast this morning, your letter serving me in lieu of the newspaper, which is now too dull to read. I was glad to see your handwriting so clear and smooth. A certain proof of a tranquil mind. I shall be alone and disengaged on Saturday the 3rd of November, and continue so until the 26th of the same month. I think the earlier you come the better. I project, if the weather be fine, to go and see Winchester Cathedral. The roof has been near falling in, owing to the constant cutting away of the great supporting pillars to let in monuments (of folly and bad taste). . . . Our Cathedral looks well this weather, but it is not so much relieved by the warm tints as you would imagine. Owing to the moisture of the season, and the great and rapid decomposition of the vegetation, there is a constant humid halo, which makes the shadows at all hours very blue, and gives the landscape a cold tone. I am sorry your children have been unwell. Mine

[1] The last picture he painted, and on which he was engaged on the last day of his life, was a mill, with such accompaniments as are described in this letter.
* This was the 'Arundel Mill and Castle', exhibited at the R. A. 1837. See Plate 54.

are in high health and good humour. How many dinners a week does your wife get you to eat at a regular hour, and like a Christian?"

In November, Constable visited Salisbury, where, notwithstanding the lateness of the season, he made some beautiful sketches.[1]

*[1] A drawing of Salisbury Cathedral with trees, dated 2 Nov. 1821, is in the Victoria and Albert Museum (No. 797–1888).

1822

Mr. Samuel Lane. Farington. Coxe's *Life of Correggio*. Gold grounds. Constable's fourth large Picture. Stothard's 'Wellington Shield'. Farington's House. The Bishop of Salisbury. Studies of Skies. Illness. System of Copying at the British Gallery. Picture of 'Salisbury Cathedral from the Bishop's Grounds'. David's Picture of 'The Coronation of Josephine'. Constable's dread of a National Gallery.

S OON after his first arrival in London, Constable had become acquainted with Mr. Samuel Lane,[1] of Greek Street, Soho; and this acquaintance ripened into a friendship which continued to the end of his life. The following passage is from one of his letters which Mr. Lane has permitted me to make use of: "February, 1822. My dear Lane, I have been with my wife to look over Mr. Farington's house, which has left a deep impression on us both. I could scarcely believe that I was not to meet the elegant and dignified figure of our departed friend, where I have been so long used to see him, or hear again the wisdom that always attended his advice, which I do indeed miss greatly."

"Salisbury, March 25th, 1822. My dear Constable, Coxe is on the eve of publishing *Correggio*;[2] but he has some sad stuff in it about the manner in which he is supposed to have mixed his colours, and talks about his painting on gold leaf to produce a warm effect. He will send you, by my advice, the proof sheets of that part of his work which treats of Correggio's art, for your correction. . . . The above was written yesterday. I left off, trying to recollect some anecdote I had to tell you. I have just recalled it to my memory. It is, as you know, part of the Apocalypse, that the just should reign a thousand years, and then the consummation of all things. During the tenth century, in consequence of this prediction, there was a universal expectation that the world was about to end. The agitation of men's minds is described by contemporary writers as

★[1] Samuel Lane (1780–1859), portrait-painter.

★[2] Published 1823 under the title *Sketches of the Lives of Correggio and Parmegiano*.

extreme. Among other effects which this expectation pro-
duced, was the neglect to repair their houses and churches.
So that when the dreaded period was past, their buildings were
found to be in a most dilapidated condition. The eleventh
century, therefore, was much occupied in building, repairing
and beautifying. Hence we know that few, very few of our
buildings can be older than that period. And that the eleventh
century and the beginning of the twelfth are probable periods
to which to refer back many of our most beautiful structures.
It was the same cause that enriched the church and made it so
powerful. Men, expecting the day of judgment, were glad to
compound for their sins by granting away their estates (which
would not much longer be of use to them or their heirs) to
religious purposes. J. Fisher."

"Keppel Street, April 13th 1822. My dear Fisher, I have
not seen any of the sheets of Mr. Coxe's *Life of Correggio*; but
I hear of a letter from him to Jackson, expressing a desire that
they may be seen by his friend Constable. There is no doubt
but it will be interesting, but as to painting on gold grounds,
it is all over with the *alchymy* of the art, I hope never to be
revived again. Yet dark ages may return, and there are always
dark minds in enlightened ones. In the early German and
Italian pictures, gold was used for glories, etc., and made to
appear as a thing unconnected with the painting, and so far
supernatural; and this has been done as late as Carlo Dolci, and
it sometimes appears very beautiful when blended into trans-
parent colour behind the heads of saints, etc. But still it looks
like trick, and Correggio was above all trick, nor do I believe
he ever resorted to any such nonsense to aid his brightness. I
have sent my large picture to the Academy. I never worked so
hard before. I do not know that it is better than my others,
but perhaps few vulgar objections can be made to it." (The
writing is here interrupted by a beautiful pen sketch, which
has the force of a mezzotinto engraving.) "The composition
is almost totally changed from what you saw. I have taken the
sail, and added another barge in the middle of the picture, with
a principal figure, altered the group of trees, and made the

bridge entire. The picture has now a rich centre, and the right hand side becomes only an accessory. I have endeavoured to paint with more delicacy but hardly anybody has seen it. I hear of some excellent pictures. I am going into Suffolk about an altar-piece, a gift from a gentleman. —— is annoyed by your designating his old masters trash. He goes by the *rule of name*.

"I have some nibbles at my large picture of the 'Hay Wain', in the British Gallery. I have an offer of £70 without the frame to form part of an exhibition in Paris. I hardly know what to do. It might promote my fame and procure me commissions, but it is property to my family; though I want money dreadfully; and, on this subject, I must beg a great favour of you, indeed I can do it of no other person. The loan of £20 or £30 would be of the greatest use to me at this time, as painting these large pictures has much impoverished me. If you can, I know you will oblige me. If not, say so. This summer I shall devote to money getting, as I have several commissions, both landscape and otherwise. But a large picture, and if possible, a good one, was necessary this year. The next must take its chance. I hope, indeed I really believe, I have never yet done anything so good as the one now sent.

"Stothard has published his beautiful etching of 'The Shield of Wellington', three and a half feet circle. Oblige me and my dear old friend by purchasing one. My conscience acquits me of any neglect of my last picture. I have dismissed it with great calmness and ease of mind."

Of this picture,[1] another view on the Stour, and very near Flatford Mill, an admirable line engraving, by Mr. W. R. Smith is published in Messrs. Finden's *Gallery of British Art*; and a first sketch of the subject is engraved in the *English Landscape*.

"Keppel Street, April 17th. My dear Fisher, Accept my thanks for your very kind letter. The contents will be highly useful, for, as I told you, I had been so long upon unprofitable

*[1] Now in the Henry E. Huntingdon Library and Art Gallery, California. See Plate 27.

canvas that I was getting hard run. But I am now busy on some minor works which will bring things soon about again. My writing requires much apology; but I seldom sit down till I am already fatigued in my painting-room, and near the post hour, and I must say of my letters as Northcote says of his pictures, 'I leave them for the ingenious to find out.' I made two or three fruitless attempts to read the last I sent you, and the postman ringing his bell at the moment, I dismissed it. I must work hard this summer, but I should like much to take the Windsor coach to hear your sermon, though I can ill spare a day, and now that I have an opportunity of earning a little money, I must make it a religious duty to do it. I shall not let the Frenchman have my picture. It would be too bad to allow myself to be knocked down by a Frenchman. In short, it may fetch my family something one time or other, and it would be disgracing my diploma to take so small a sum, less by near one half than the price I asked.

"Several cheering things have lately happened to me, pro-fessionally. I am certain my reputation rises as a landscape painter, and that my style of art, as Farington always said it would, is fast becoming a distinct feature. I am anxious about this picture. My neighbour ——,[1] who expects to be an Academician before me, called to see it. He has always praised me; now he said not a word; till, on leaving the room, he looked back and said, he hoped his picture would not hang near it.

"I trust you will come to London on your visitation; I shall be much disappointed if you do not. I am about Farington's house; I think this step necessary; I shall get more by it than my family, in conveniences, though I am loth to leave a place where I have had so much happiness, and where I painted my four landscapes; but there is no end to giving way to fancies; occupation is my sheet anchor. My mind would soon devour me without it. I felt as if I had lost my arms after my picture was gone to the Exhibition. I dare not read this letter over, take it as one of my sketches."

★[1] Clint, i.e. George Clint (1770–1854), A.R.A. 1821, never R.A.

"April. My dear Fisher, I have been to Farington's this morning; they are sharp about the house, and wished me to take the fixtures, and such of the furniture as I may like, at a valuation. I have refused the latter, so stands the matter at present; they will sell the Wilsons;[1] they are well worth sixty, or eighty, or even a hundred guineas the pair.

"Tinney is confined to town by indisposition; I have seen him often, and he views me favourably for your sake, and is determined to love painting as an intellectual pursuit of the most delightful kind, in preference to dirt, and old canvas, varnish, etc. He has desired me to paint him, as a companion to his landscape, another picture at my leisure for a hundred guineas.[2] If, however, I am offered more for it, even five hundred guineas, I may take it, and begin another for him. This is very noble (when all the nobility let my picture come back to me from the Gallery), and will enable me to do another large picture, to keep up and add to my reputation. . . . How much I should like to be now at Osmington; but work I must and will. If I recollect, the ashes have very beautiful mosses, and their stems are particularly rich at Osmington. I have never thanked you for your account of the middle ages and the expectation of the last day. I was not aware that its influence was so enormous."

In 1822, Constable exhibited at the Academy five pictures, 'Hampstead Heath', 'A View on the Stour, near Dedham',[3] 'Malvern Hall, Warwickshire',[4] 'A View of the Terrace, Hampstead', and 'A Study of Trees from Nature'.

The next letter is from the Bishop of Salisbury. "Malmsbury, August 3rd, 1822. Dear Sir, My daughter Elizabeth is about to change her situation, and try whether she cannot perform

[1] Two beautiful little views in Italy, now in the possession of Miss Rogers.

[2] This commission from Mr. Tinney was never executed; why, I know not; but I believe Constable afterwards painted for him one or two small pictures.
*Some details of Constable's motives in not carrying out Tinney's commission are given in Shirley's edition of Leslie pp. 129–30.

*[3] Cf. p. 90 n. 1.

*[4] Paintings by Constable of this subject exist in several versions: it has not been satisfactorily established which of these was exhibited at the R. A. See Plate 6.

the duties of a wife as well as she has done those of a daughter. She wishes to have in her house in London a recollection of Salisbury; I mean, therefore, to give her a picture, and I must beg of you either to finish the first sketch of my picture, or to make a copy of the small size. I wish to have a more serene sky. I am now on my visitation, and shall not be at Salisbury till the 20th, but my letters follow me."

"Osmington, October 1st. My dear Constable. . . . Captain Forster, a gentleman of property, near Windsor, is an admirer of your art. He is to meet you at Salisbury, he was first caught by a sketch-book of yours which I had. Your pencil sketches always take people, both learned and unlearned. Surely it would answer to publish a few of them. Get one done on stone, as an experiment, unless it is derogatory from the station you hold in the art. . . . J. Fisher."

"To Archdeacon Fisher. Hampstead, October 7th, 1822. My dear Fisher, several adverse circumstances had yielded to my wishes, and I had determined on meeting you at Salisbury on the day appointed; but things have changed again, and I know not how to come so far as Weymouth. The loss of four days on the road in serious, and I am now in the midst of a great struggle, and time is my estate. I have got several of my commissions into tolerable forwardness, especially two kit-cat landscapes for Mr. Ripley, and I am determined to overcome all my difficulties while a great deal of health and some little youth remains to me. I have got things into a train, by following which they are made comparatively easy. Such a journey would turn me inside out, and a visit to your coast would wash my brains entirely. I must wait, and still hope to meet you when quite convenient to yourself, and when you return to the Close. I shall send you some picture to look at. 'Green Highgate' has now changed its frame, and become a very pretty picture, and deserves a better, or at least, a new name. I have made about fifty careful studies of skies, tolerably large to be careful. I do not regret not seeing Fonthill; I never had a desire to see sights, and a gentleman's park is my aversion.

"It is singular that I happened to speak of Milman;[1] no doubt he is learned, but it is not fair to encumber literature. The world is full enough of what has been already done, and as in the art there is plenty of fine painting but very few good pictures, so in poetry there is plenty of fine writing, and I am told his is such, and as you say, 'gorgeous', but it can be compared; Shakespeare cannot; nor Burns, nor Claude, nor Ruysdael, and it has taken me twenty years to find this out. This is, I hope, my last week here, at least this summer; it is a ruinous place to me; I lose time here sadly. One of my motives for taking Charlotte Street was to remain longer in London. In Keppel Street we wanted room, and were 'Like bottled wasps upon a southern wall'; but the five happiest years of my life were passed there."

Twenty of Constable's studies of skies made during this season are in my possession, and there is but one among them in which a vestige of landscape is introduced. They are painted in oil, on large sheets of thick paper, and all dated, with the time of day, the direction of the wind, and other memoranda on their backs. On one, for instance, is written, "5th of September, 1822.[2] 10 o'clock, morning, looking south-east, brisk wind at west. Very bright and fresh grey clouds running fast over a yellow bed, about half way in the sky. Very appropriate to the 'coast at Osmington'."

"35 Charlotte Street, Fitzroy Square, October 31st, 1822. My dear Fisher, We left Hampstead a fortnight ago last Friday, and I have not yet had my pencil in my hand. I got laid up attending bricklayers and carpenters at six and seven in the morning, leaving a warm bed for cold damp rooms and washhouses, for I have had immense trouble to get the house habitable; but, though I am now quite well, I am aware that the time is past in which it was convenient for you to receive me. It has proved a very great disappointment to me, and I

*[1] Henry Hart Milman (1791–1868), poet and historian.
*[2] There is a sky-study in the Victoria and Albert Museum (No. 590–1888) inscribed with the same date. It is not, however, the same as that mentioned by Leslie.

fear that my not coming has vexed you, especially as I have not heard from you. I have got the large painting-room into excellent order; it is light, airy, sweet, and warm; I, at one time, despaired of attaining either of these qualities. I have now two six-footers in hand,—one of which I shall send to the Gallery at £200.

"*The art will go out*; there will be no genuine painting in England in thirty years. This will be owing to pictures driven into the empty heads of the junior artists by their owners, the directors of the British Institution, etc. In the early ages of the fine arts, the productions were more affecting and sublime, for the artists, being without human exemplars, were forced to have recourse to nature; in the latter ages, of Raphael and Claude, the productions were more perfect, less uncouth, because the artists could then avail themselves of the experience of those who were before them, but they did not take them at their word, or as the chief objects of imitation. Could you but see the folly and ruin exhibited at the British Gallery, you would go mad. Vander Velde, and Gaspar Poussin, and Titian, are made to spawn multitudes of abortions: and for what are the great masters brought into this digrace? only to serve the purpose of sale. Hofland has sold a shadow of Gaspar Poussin for eighty guineas, and it is no more like Gaspar than the shadow of a man on a muddy road is like himself."[1]

A letter from the Bishop of Salisbury to Constable, dated November 12th, contained a draft with these words: "Lawyers frequently receive retaining fees, why should not painters do the same?" The picture he was engaged on for the bishop, was finished and exhibited in the following spring. It is an extremely beautiful work, and one with which he took great

[1] The directors of the British Institution are assuredly not accountable for the abuse of the privilege they grant annually to artists of making copies from the old masters at their Gallery; a privilege of which some of our best painters have availed themselves with advantage to their own practice, and of which Constable had himself intended to make use. He did not sufficiently consider that those who are content to spend much of their time in copying pictures, are not of that class who would advance or even support the art under any circumstances.

pains, a view of the 'Cathedral from the Bishop's Grounds'.[1]
In the foreground he introduced a circumstance familiar to all
who are in the habit of noticing cattle. With cows there is
generally, if not always, one which is called, not very accu-
rately, *the master cow,* and there is scarcely any thing the rest
of the herd will venture to do until the *master* has taken the
lead. On the left of the picture this individual is drinking, and
turns with surprise and jealousy to another cow approaching
the canal lower down for the same purpose; they are of the
Suffolk breed, without horns; and it is a curious mark of
Constable's fondness for everything connected with his
native county, that scarcely an instance can be found of a cow
in any of his pictures, be the scene where it may, with horns.

"Charlotte Street, December 6th. My dear Fisher, There is
nothing so cheering to me as the sight of your handwriting,
yet I am dilatory in answering you. I will gladly do all I can
for R——[2] and his picture, but you know I can only send it,
I possess no favour in that place, I have no patron but yourself,
and you are not a grandee; you are only a gentleman and a
scholar, and a real lover of the art. I will mention R——'s
picture to Young, and this is all that is in my power. Is it not
possible to dissuade him from coming to London, where he
will be sure to get rid of what little local reputation he may
have? But perhaps he prefers starving in a crowd, and if he is
determined to adventure, let him by all means preserve his
flowing locks, they will do him more service than even the
talents of Claude Lorraine, if he possessed them.

"——[3] shall have his picture when I can find an opportunity
of sending it. Had I not better grime it down with slime and
soot, as he is a connoisseur, and perhaps prefers filth and dirt
to freshness and beauty?

"I have been to see David's picture of 'The Coronation of
the Empress Josephine'. It does not possess the common

*[1] Now in the Victoria and Albert Museum (No. FA 33). See Plate 26.

[2] A young artist of Salisbury who had sent a picture to town for exhibition
at the British Gallery. *His name was Read.

*[3] Dodsworth, a friend of John Fisher's.

v two views of golding constable's house at
east bergholt. Pencil, 1814. Victoria & Albert Museum

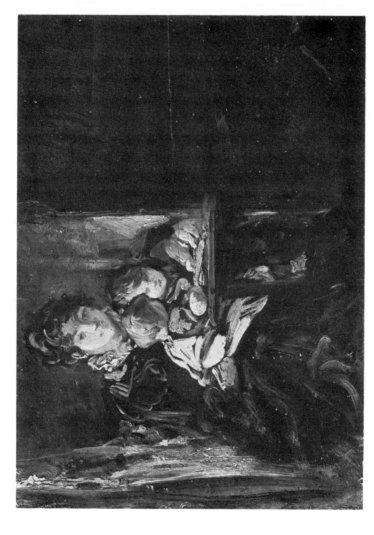

VI. MRS. CONSTABLE WITH TWO OF HER CHILDREN.
Collection Colonel J. H. Constable

language of the art, much less anything of the oratory of Rubens or Paul Veronese, and in point of execution it is below notice; still I prefer it to the productions of those among our historical painters who are only holding on to the tail of the shirt of Carlo Maratti, simply because it does not remind me of the *schools*. I could not help feeling as I did when I last wrote to you of what I saw at the British Institution. Should there be a National Gallery (which is talked of) there will be an end of the art in poor old England, and she will become, in all that relates to painting, as much a nonentity as every other country that has one. The reason is plain; the manufacturers of pictures are then made the criterions of perfection, instead of nature."

Here, as well as in his remarks on the system of copying pursued at the British Gallery, Constable's inference seems hasty. Neither connoisseurs nor legislators can promote the rise or hasten the decline of the arts in any material degree. A multitude of concurring circumstances, varying in every age and nation, contribute to these; meantime, it is something that a collection of fine pictures should be accessible to the public; and if the National Gallery should help, only in a small degree, to keep our young artists from the dissipation of their time, and the injury their unformed minds receive while running all over Europe in quest of the art, which can only be acquired by years of patient and settled industry, it may effect some good.[1] Constable, at this moment, forgot what at other times he fully admitted, that good pictures are the necessary interpreters of nature to the student in art. If the

[1] Those who are old enough to compare the present state of painting, among us, with what it was before the Continent was thrown open to our artists, cannot but have misgivings as to the advantage of foreign travel to British students. If, as it may be feared, we are more and more losing sight of nature, it may be less owing to the influence of the National Gallery, than to the example from abroad of, I will not call it imitation but *mimicry* of early art. This is so easy a thing to succeed in, and is so well calculated to impose on ourselves and others a belief that we possess the spirit of the primitive ages of art, that we cannot too carefully guard against its seduction. The purity of heart belonging to childhood is, no doubt, as desirable to the painter as to the Christian, but we do not acquire this by merely imitating the *lisp* of infancy.

reader will turn to the end of the book, he will find in the remarks on Claude,[1] in the lecture he delivered on the 2nd of June 1836, at the Royal Institution, and on Rembrandt[2] at the close of the next lecture, his settled opinions on this subject. But that his dread of picture worship should lead him to express himself as he did, in the letter last quoted, I can well understand, knowing as I do the notions prevailing among the artists and amateurs with whom he lived. Among the last may be particularly mentioned the amiable and accomplished Sir George Beaumont, at that time the leader of taste• in the fashionable world. Few men better discriminated, than did Sir George, the various excellencies of the old masters; but he never considered how many beauties might remain in nature untouched by their pencils, and consequently he was averse to any deviation from their manner. It is curious that throughout the whole of his intercourse with.Constable, Sir George assumed the character of a teacher.

*[1] Cf. pp. 307–9 below.
*[2] Cf. p. 319 below.

1823

Illness. Picture of 'Salisbury Cathedral'. Sir John Leicester's Pictures. Wilson. Constable's Pictures at the Exhibition. Sir Godfrey Kneller's House. *Life of Correggio.* The Rev. T. J. Judkin. Sir William Curtis. Visit to Archdeacon Fisher. Fonthill. The Diorama. Visit to Cole-Orton Hall. Adventure on the Road. Sir George and Lady Beaumont. Pictures at Cole-Orton. Manner of passing the day there. Scenery of its neighbourhood. Southey. Difference of opinion between Sir George and Constable on Art. Studies at Cole-Orton. Return to London. Illness. Pictures for the Exhibition. Southey and the Church.

CONSTABLE was prevented by illness from finishing either of the large pictures he had on hand in time for the exhibitions of 1823, and even from writing again to Fisher until the 1st of February in that year, when he thus resumed their correspondence: "My very dear Fisher, Ever since Christmas my house has been a sad scene of serious illness; all my children,[1] and two of my servants laid up at once. Things are now, thanks to God, looking better, but poor John is still in a fearful state. I am unfortunately taken ill again myself, but to-day I am better, and determined to write to you. What with anxiety, watching, nursing, and my own indisposition, I have not seen the face of my easel since Christmas, and it is not the least of my troubles that the good bishop's picture is not fit to be seen; pray, my dear Fisher, prepare his lordship for this; it has been no fault of my own. Your excellent mother and family, hearing of our distress, most kindly called here. The sight of Mrs. P. Fisher always does one good; her looks say we should patiently submit to all things, and this is confirmed in her own conduct, for she can."

"Charlotte Street, February 21st. My dear Fisher, I was cheered by your letter and kind inquiries. I am now at work again, and some of my children are better, but my poor darling boy John is in a sad state indeed; God only knows how it will end. Baillie and Gooch see him continually, and are not without hope; but I am worn with anxiety. . . . I am weak and much emaciated. They took a great deal of blood from me

[1] He had now two sons and two daughters.

which I could ill spare. I have fretted for the loss of time, and being away from my easel, but most of all for my poor dear boy; but I will leave my house, and go into my painting-room. I have put a large upright landscape in hand, and I hope I shall hold up to get it ready for the Academy, with the Bishop's picture.

"I am sorry to see you again haunted by that *phantom*, 'The Church in danger'; it does not speak a just state of mind or thinking. That the vultures will attack it, and everything else that is valuable, is likely enough; but you say, 'they have failed on the State'; that, therefore, still stands between the Church and them, for they can only fall together. The nobility know the value of intellect, and endeavour to arm themselves from the same sources as you do, the Universities; and consider the ages they have stood, and the storms they have weathered. ... I look forward to coming to you at Gillingham to do something at the mill."

"May 9th. I had many interruptions in my works for the Exhibition, as you know, so that I have no large canvas there. My Cathedral[1] looks uncommonly well; it is much approved of by the Academy, and moreover in Seymour Street.[2] I think you will say when you see it, that I have fought a better battle with the Church than old H——e, B——m, and all their coadjutors put together. It was the most difficult subject in landscape I ever had on my easel. I have not flinched at the windows, buttresses, etc.; but I have still kept to my grand organ colour, and have, as usual, made my escape in the evanescence of the chiaroscuro. I think you will like it, but you could have done me much good. I am vexed to see the good bishop is looking ill; it may be a temporary cold, but he breaks, no doubt. This has been a fearful winter for old and young. Callcott admires my Cathedral; he says I have managed it well. Wilkie's pictures are the finest in the world. Perhaps the outdoor scene is too black.[3] Fuseli came up to him and

*[1] The picture of Salisbury Cathedral mentioned above (p. 96).

*[2] Bishop Fisher's town house was in Seymour Street.

[3] The 'Parish Beadle'. The other was the small whole-length portrait of the Duke of York, painted for Sir Willoughby Gordon.

said, 'Vell, vat dis? is dis de new vay, de Guercino style?'
Speaking of me, he says, 'I like de landscapes of Constable;
he is always picturesque, of a fine colour, and de lights always
in de right places; but he makes me call for my greatcoat and
umbrella.' This may amuse you, when contemplating this
busy but distant scene; however, though I am here in the midst
of the world, I am out of it, and am happy, and endeavour to
keep myself unspotted. I have a kingdom of my own, both
fertile and populous,—my landscape and my children. I have
work to do, and my finances must be repaired if possible. I
have a face now on my easel, and may have more."

Speaking in this letter of Italy, Constable continues, " 'Oh
dear, oh dear, I shall never let my longing eyes see that famous
country!' These are the words of old Richardson, and like
him I am doomed never to see the living scenes that inspired
the landscape of Wilson and Claude. No, but I was born to
paint a happier land, my own dear old England; and when I
cease to love her, may I, as Wordsworth says,

'never more hear
Her green leaves rustle, or her torrents roar!'[1]

I went to the gallery of Sir John Leicester, to see the English
artists. I recollect nothing so much as a large, solemn, bright,
warm, fresh landscape by Wilson, which still swims in my
brain like a delicious dream. Poor Wilson! think of his fate,
think of his magnificence. But the mind loses its dignity less
in adversity than in prosperity. He is now walking arm in arm
with Milton and Linnaeus. He was one of those appointed to
show the world the hidden stores and beauties of nature."

With the picture of "Salisbury Cathedral from the Bishop's
Garden', Constable exhibited, at the Academy, "A Study of
Trees, a Sketch', and 'A Cottage'; and to the British Gallery
he sent a picture of Yarmouth Jetty.[2]

[1] 'O England! dearer far than life is dear,
If I forget thy prowess, never more
Be thy ungrateful son allowed to hear
Thy green leaves rustle, or thy torrents roar!
Thanksgiving Ode on the General Peace.

*[2] Now in Lord Glenconner's collection.

"Gillingham, Shaftesbury, May 9th. My dear Constable, . . . I dined, yesterday, at the house built by Sir Godfrey Kneller, that man of wigs and drapery. On the staircase hung a beautiful portrait of Pope, by him. How unlike his usual efforts! I long to hear how you have succeeded in the Exhibition. The *Courier* mentions you with honour. 'Constable has some admirable studies of landscape scenery.' . . . J. Fisher."

"Gillingham, May 18th. My dear Constable, . . . Coxe showed me the proof sheets of his *Life of Correggio*. It is really very nicely done. He has got over the critical part better than I expected. But he has, evidently, not quite a clear idea of chiaroscuro. He has no notion that harmony and brilliancy of effect are connected with light and shade; or that Correggio's great originality lay in that department. But still, his book is well done. He proves, I think, very satisfactorily, that Correggio did not die in poverty or of the load of copper. He shows that he had bought houses and property in the city of Correggio. And what is more, gold was the currency of the country, and they never paid in copper. It would not have been a legal tender. . . . J. Fisher."

In a letter to Mr. Fisher, dated July 3rd, after speaking of some purchases which he had made for that gentleman, one of which was a Flemish picture of fruit, etc., Constable says, "I have been for a day or two at Southgate, at Judkin's. We dined with Sir William Curtis; he is a fine old fellow, and is now sitting for his portrait to Lawrence for the king, who desired it in these words, 'D——n you, my old boy, I'll have you in all your canonicals, and then I can look at you every day.' He is a great favourite,—birds of a feather. Let me know your wishes about the picture."

"My dear Constable, Where real business is to be done you are the most energetic and punctual of men. In smaller matters, such as putting on your breeches, you are apt to lose time in deciding which leg shall go in first. I thank you heartily for the speed with which you have executed both my commissions. I have never had this picture out of my eye since I saw it. Still-life is always dull, as there are no associations with it; but this is

so deliciously fresh that I could not resist it. If you have one of your coast windmills hanging on your wall framed, I wish you would put it up with the fruit-piece. And now with regard to our meeting, I am unwilling to put off your visit to the old age of summer, when all the associations are those of decay; I will therefore work hard at the infirmary sermon, which I am to preach at the cathedral in September, and get it finished by the 20th of August, about which time I shall expect you, and I care not how long you stay. I have discovered *three mills*, old, small, and picturesque, on this river. I have a great desire to possess your 'Wain'; but I cannot now reach what it is worth, and what you must have; but I have this favour to ask, that you will not part with it without letting me know. It will be of the most value to your children by continuing to hang where it does, till you join the society of Ruysdael, Wilson, and Claude. As praise and money will then be of no value to you, the world will liberally bestow both. Tinney says his picture is inferior to mine. He cannot find out that mine hangs alone, and that his is hurt, as is always the case, by villainous company. J. Fisher."

"July 10th. My dear Fisher, I am always pleased with myself when I have pleased you. You have made an excellent purchase of a most delightful work: it is a pearly picture, but its tone is so deep and mellow that it plays the very devil with my land-scapes; but I shall make my account of it, as I am now working for tone. The painter is C. de Vris, an artist contemporary with Rubens. De Heem painted his excellent fruit and flower pieces at the same time, but this painter's works are more scarce, and Mr. Bigg thinks, more excellent; I have stripped it of its trumpery border which was cemented on the surface of the picture, and hid two inches all round, to the great injury of the composition. It has cost me some trouble to make good the background, but it was well worth recovering, as the want of an efficient field crowded the composition. I count much on our meeting; it will be my only holiday. The time you speak of will do exactly for me. My wife is amused with your temptation; you think '*three mills*' irresistible, but it is

you I want. I have a proposal to make to Tinney; he must let me have his picture and fifty or sixty guineas, and I will paint him another, more for the ladies and old hums. Sir William Curtis has a hankering after my 'Wain', but I am not sanguine, and you I should much prefer; we can talk about it when we meet; it was born a companion to your picture; it must be yours. It is no small compliment to the picture, that it haunted the mind of the alderman from the time he saw it at the institution; but though a man of the world, he is all heart, and really loves nature.[1] It does me a great deal of good where it now is, therefore let it remain for the present. Should Tinney and I agree, it will enable me to paint another large picture for the Exhibition; I am hurt this year for the want of one. —— showed me a pretty picture he is painting, but it is insipid, and far too pretty to be natural. Sir George Beaumont has just left me; he is pleased with a large wood I have toned."[2]

"Charlotte Street, August 18th. My dear Fisher, Astley Cooper often arrives an hour sooner than the time fixed for performing an operation, by which the patient is spared the anticipation of the approaching moments; I had fixed Wednesday, the 20th, to come to you, and I now make it Tuesday, the 19th. Your beautiful fruit-piece has left my house, but it will not arrive soon enough at Salisbury to meet us; you will not grudge what it has cost you; it is lovely, and always puts me not only in good humour, but in the humour for painting. I have not the sea-piece; I gave it to Gooch for his kind attention to my children for which he would receive no fee. Half an hour ago I received a letter from Woodburne to purchase it, or one of my sea-pieces; they are much liked, and you have my sketch of Osmington. I have a great deal to say which must be deferred till to-morrow. I leave my family with great pleasure because they are all so well. My wife laughed much at your saying, 'But I don't expect you to come.' I was at the

[1] Constable told me of Sir William Curtis, that during an illness he had a fine picture by Gainsborough hung in his chamber that he might see it through the opening of his bed curtains.

[2] A large sketch of the dell in Helmingham Park. *Probably the painting in the collection of T. W. Bacon.

Countess of Dysart's *fête champêtre* at Ham House. I have pleased her by painting two portraits lately, and she has sent me half a buck."

"To Mrs. Constable. Gillingham, Dorsetshire, 29th August. My dearest love. I was at Fonthill yesterday. It was very good-natured of Fisher to take me to see that extraordinary place. The ticket to admit two persons is a guinea, besides impositions afterwards. Fisher says, there have been great changes in the articles since last year; so that it is quite an auctioneer's job. Many superb things are now not there, and many others added; especially pictures. One of the latter (or I am greatly mistaken), a battle by Wouvermans, I saw at R——'s just before I left town. Yesterday, being a fine day, a great many people were there. I counted more than thirty carriages, and the same number of gigs, and two stage coaches; so that in spite of the guinea tickets there was a great mixture of company, and indeed very few genteel people. There was a large room fitted up with boxes like a coffee-house, for dinners, etc., etc. Mr. ——'s name (the auctioneer's) seemed here as great as Buonaparte's. Cards of various kinds, and boards were put up, 'Mr. —— desires this,—Mr. —— takes the liberty of recommending the following inns for beds', etc., etc. But I observed many long faces coming away from the said inns.

"I wandered up to the top of the tower. Salisbury, at fifteen miles off, darted up into the sky like a needle, and the woods and lakes were magnificent; and then the wild region of the downs to the north. But the distant Dorsetshire hills made me long much to be at dear old Osmington, the remembrance of which must always be precious to you and me. The entrance to Fonthill and the interior are beautiful. Imagine Salisbury Cathedral, or indeed, any beautiful Gothic building, magnificently fitted up with crimson and gold, ancient pictures, and statues in almost every niche; large gold boxes for relics, etc., and looking-glasses, some of which spoiled the effect. But on the whole it is a strange, ideal, romantic place; quite fairy-land. The spot is chosen in the midst of mountains and wilds. We

have had such sad weather that I have been able to do but little, but I have made one or two attacks on the old mill."

"September 30th. My dear Fisher. I should have thanked you before now for my delightful visit; but I found on my return so much occupation that my writing has been too long delayed. But I trust forms will weigh as little with you as with me, in a friendship which is at once the pride, the honour, and the grand stimulus of my life. My Gillingham studies give great satisfaction; Mr. Bigg likes them better than anything I have yet done. I found my wife and children all well; better than I ever had them. I am now pretty full handed, but my difficulty lies in what I am to do for the world next year; I must have a large canvas. I must write to Tinney about his picture, which I wish to have up; I shall be glad of it, frame and all. —— asked me to see his picture; it is such art as I cannot talk about; heartless, vapid, without interest. I was at the private view of the 'Diorama;[1] it is in part a transparency; the spectator is in a dark chamber, and it is very pleasing, and has great illusion. It is without the pale of the art, because its object is deception. The art pleases by *reminding,* not by *deceiving.* The place was filled with foreigners, and I seemed to be in a cage of magpies."

"Salisbury, October 2nd. My dear Constable, Tinney consents to let his picture come to London, but he does it, he confesses, because he can deny you nothing. He dreads you touching it. L——, the engraver, says it 'has a look of nature which seems diffused over the canvas as if by magic, and this Constable may in an unlucky moment destroy, and he will never paint another picture like it, for he has taken to repeat himself.' I know not whether this remark was his own, or merely the echo of what he had heard said by other artists; in either case it is right you should be told of it. I must repeat to you an opinion I have long held, that no man had ever more than one conception. Milton emptied his mind in his first book of *Paradise Lost,* all the rest is transcript of self. The *Odyssey* is a repetition of the *Iliad.* When you have seen one Claude you

* [1] A moving Panorama.

have seen all. I can think of no exception but Shakespeare; he is always varied, never mannered."

"October 19th. My dear Fisher, Thank you for your kind, amusing, and instructive letter. I shall always be glad to hear anything that is said of me and my pictures. My object is the improvement of both. L——, like most men living on the outskirts of the art, and like followers and attendants on armies, etc., is a great talker of what *should be*, and this is not always without malignity. Such persons stroll about the foot of Parnassus, only to pull down by the legs those who are laboriously climbing its sides. He may be sincere in what he tells Tinney; he wonders at what is done, and concludes the picture cannot be made better because he knows no better. I shall write to Tinney and request the picture, but with a promise not to meddle with it, even if I see anything material that would improve it, without first informing him of my intention.

"By the time you receive this, I shall be at breakfast with Sir George and Lady Beaumont, at Cole-Orton Hall, Leicester-shire, near Ashby de la Zouch. I look to this visit with pleasure and the hope of improvement. All Sir George's beautiful pictures are there, and if I can find time to copy the little Claude, evidently a study from nature,[1] it will much help me. Sir George will not possess these things longer than until a room can be got ready at the British Museum, to receive them. After my delightful visit to you, I should have been content. But Sir George so much desired to see me, and is such a friend to art, that I thought it a duty to myself to go. . . . I want to get back to my easel in town, and not to witness the rotting, melancholy dissolution of the trees which two months ago were so beautiful. I must talk to you about Coxe's *Life of Correggio*; he has made such confusion and nonsense about art, with the letter of A. Caracci, and the letter itself is so beautiful."

"To Mrs. Constable. Cole-Orton Hall, October 24th. My very dear love. I hasten to fulfil my promise of writing to you

[1] Now in the National Gallery. This picture he mentions again as 'The Little Grove'. *Now called 'Landscape with a goatherd and goats' (N. G. No. 58).

on my arrival here, though Sir George and Lady Beaumont wish me to defer it to another day, as he wants me in his painting-room. . . . O dear! this is a lovely place indeed, and I only want you with me to make my happiness complete. Such grounds, such trees, such distances, and all seems arranged to be seen from the various windows of the house. All looks like fairyland.

"I wish you to write to Mrs. Whalley, she will take it sisterly and kind. Tell her what an adventure I had at Leicester, as I was determined not to go by without seeing Alicia.[1] I did not choose to dine at Northampton, but counted much on tea at Leicester. Just as it was made, and almost poured out, I ran to Miss Linwood's, and found that she and all her young ladies were at the theatre (about half-past eight). Thither I hastened, saw Alicia,—shook hands, kissed her,—she looked delightfully,—her hair curled and beautifully parted on her fair round forehead,—her cheeks rosy, owing to being so surprised, —her chin dimpled, and her teeth beautifully white. Saw three strange figures on the stage, who had just ended a strange song,—the audience were all clapping their hands, and all this took place in half a minute. Hastened back to the inn to finish my tea,—party broken up,—coach driving off,— and myself nearly left behind. Will not this amuse her? Copy it, and your letter will be almost formed.

"Only think, I am now writing in a room full of Claudes (not Glovers, but real Claudes), Wilsons, and Poussins. But I think of you and am sad in the midst of all. And my ducks,— my darling Isabel, my Charley boy, my Minna, and my dear, dear John. J. C."

"Cole-Orton Hall, November 2nd. My very dear Fisher. Your letter is delightful, and its coming here serves to help me in the estimation of Sir George and Lady Beaumont. Nothing can be more kind, and in every possible way more obliging than they both are to me. I am left entirely to do as I like, with full range over the whole house, in which I may *saturate* myself with art; only on condition of letting them do as they like. I

[1] Mrs. Whalley's daughter, who was at school at Leicester.

have copied one of the small Claudes; a breezy sunrise, a most pathetic picture.[1] Perhaps a sketch would have served my present purpose, but I wished for a more lasting remembrance of it; and a sketch of a picture is only like seeing it in one view; it will not serve to drink at again and again. I have likewise begun the little grove by Claude; a noon-day scene 'which warms and cheers, but which does not inflame or irritate.' Through the depths of the trees are seen a waterfall, and a ruined temple, and a solitary shepherd is piping to some goats and sheep.

'In closing shades and where the current strays,
 Pipes the lone shepherd to his feeding flocks.'

I draw in the evening, and Lady or Sir George Beaumont reads aloud. Sir George has known intimately many persons of talent of the last half century, and is full of anecdote. This is a magnificent country, abounding in the picturesque. The bell is now going for church. Sir George and Lady Beaumont never miss, morning and evening every Sunday, and have family prayers. . . . In the breakfast room hang four Claudes, a Cozens, and a Swaneveldt; the sun glows on them as it sets. In the dark recesses of the gardens, and at the end of one of the walks, is a cenotaph erected to the memory of Sir Joshua Reynolds, and on it some beautiful lines by Wordsworth. There is a magnificent view from the terrace over a mountainous region, and there is a winter garden, the thought taken by Sir George from *The Spectator*."[2]

[1] The 'Cephalus and Procris', another of Sir George Beaumont's valuable gifts to the National Gallery. *Now called 'Landscape: Death of Procris' (N. G. No. 55). Ascribed to Claude.

[2] Wilkie, who, in company with Mr. Haydon, visited Cole-Orton Hall in August, 1809, thus describes the house and its situation. 'Dance, who designed it, has acquitted himself well. We found it most spacious and magnificent. We entered first through a large portico into the lobby which leads into a splendid hall lighted from the ceiling. Round the hall is a suite of rooms fitted up in the most elegant manner. The rooms above are chiefly bedrooms, while at the top of all is the painting room of Sir George himself. . . . The country around is picturesque and rather richly wooded; and as we have the advantage of seeing it from an eminence, the distance softens it to the eye, and helps to render it less rugged than any other part of the country we came through

"To Mrs. Constable, November 2nd. The weather has been bad, but I do not at all regret being confined to this house. The mail did not arrive yesterday till many hours after the time, owing to some trees being blown down, and the waters out.... I am now going to breakfast before the 'Narcissus'[1] of Claude. How enchanting and lovely it is; far, very far surpassing any other landscape I ever beheld. Write to me. Kiss and love my darlings. I hope my stay will not exceed this week."

In one of his letters from Cole-Orton to his wife, Constable says, "Sir George rises at seven, walks in the garden before breakfast, and rides out about two, fair or foul. We have had breakfast at half-past eight, but to-day we began at the winter hour, nine. We do not quit the breakfast-table directly, but chat a little about the pictures in the room. We then go to the painting-room, and Sir George most manfully sets to work, and I by his side. At two the horses are brought to the door. I have had an opportunity of seeing the ruins of Ashby, the mountain stream and rocks (such Everdingens) at Grace Dieu, and an old convent there, Lord Ferrars', a grand, but melancholy spot. At dinner we do not sit long; Lady Beaumont reads the newspaper (*The Herald*) to us, and then to the drawing-room to tea, and after that comes a great treat; I am furnished with some portfolios full of beautiful drawings or prints, and Sir George reads a play in a manner the most delightful. On Saturday evening it was 'As You Like It', and I never heard the 'seven ages' so admirably read before. Last evening, Sunday, he read a sermon, and a good deal of Wordsworth's 'Excursion'. Some of the landscape descriptions in it are very beautiful. About nine, the servant comes in with a little fruit, and a decanter of water, and at eleven we go to bed. I always find a fire in my room, and make out about an hour

between this and London.' Wilkie also speaks of a ruined abbey in the neighbourhood, rendered interesting by being the birthplace of Beaumont who wrote in conjunction with Fletcher, and whose brother was an ancestor of Sir George.

*[1] Now in the National Gallery (No. 19), where it is called 'Landscape: Narcissus'.

longer, as I have everything here, writing desk, etc., and I grudge a moment's unnecessary sleep in this place. You would laugh to see my bedroom; I have dragged so many things into it, books, portfolios, prints, canvases, pictures, etc."

"November 9th. How glad I was, my dear love, to receive your last kind letter, giving a good account of yourself and our dear babies. . . . Nothing shall, I hope, prevent my seeing you this week; indeed I am quite nervous about my absence, and shall soon begin to feel alarmed about the exhibition. . . . I do not wonder at your being jealous of Claude. If anything could come between our love, it is him. I am fast advancing a beautiful little copy of his study from nature of a little grove scene. If you, my dearest love, will be so good as to make yourself happy without me for this week, it will, I hope, be long before we part again. But, believe me, I shall be the better for this visit as long as I live. Sir George is never angry, or pettish, or peevish, and though he loves painting so much, it does not harass him. You will like me a great deal better than you did. To-morrow Southey is coming, with his wife and daughter. I know you would be sorry if I were not to stay and meet him, he is such a friend of Gooch's;[1] but the Claudes, the Claudes, are all, all, I can think of here. . . . The weather is so bad that I can hardly see out of the window, but Friday was lovely. I shall hardly be able to make you a sketch of the house, but I shall bring much, though in little compass, to show you. . . . Thursday was Sir George's birthday. Sixty-nine, and married almost half a century. The servants had a ball, and I was lulled to sleep by a fiddle."

"November 18th. My dearest love, . . . I was very glad to hear a very nice account of you and my dear babies. . . . I shall finish my little Claude on Thursday; and then I shall have something to do to some of Sir George's pictures, that will take a day or two more, and then home. . . . I sent you a hasty shabby line by Southey, but all that morning I had been engaged on a little sketch in Miss Southey's album, of this house, which pleased all parties here, very much. Sir George

<hr>

*[1] Dr. Robert Gooch (1784–1830), who attended Constable's family.

is loath to part with me. He would have me pass Christmas with him, and has named a small commission which he wished me to execute here, but I have declined it, as I am so desirous to return. Sir George is very kind, and I have no doubt, meant this little picture to pay my expenses. I have worked so hard in the house that I never went out of the door last week, so that I am getting quite nervous. But I am sure my visit here will be ultimately of the greatest advantage to me; and I could not be better employed to the advantage of all of us by its making me so much more of an artist. . . . The breakfast bell rings. I now hasten to finish, as the boy waits. I really think seeing the habits of this house will be of service to me as long as I live. Everything so punctual. Sir George never looks into his painting-room on a Sunday, nor trusts himself with a portfolio. Never is impatient. Always rides or walks for an hour or two, at two o'clock; so will I with you, if it is only into the square. I amuse myself, every evening, making sketches from Sir George's drawings about Dedham, etc. I could not *carry* all his sketch books. . . . I wish I had not cut myself out so much to do here,—but I was greedy with the Claudes."

In his next letter to his wife, Constable deplores the facility with which he allowed his time to be consumed by loungers in his painting-room, an evil his good nature to the last entailed on him. Mrs. Constable in one of her letters had said, "Mr. —— was here nearly an hour on Saturday, reading the paper, and talking to himself. I hope you will not admit him so often. Mr. ——, another lounger, has been here once or twice."

"Cole-Orton Hall, November 21st. My dearest love, I am as heart-sick as ever you can be at my long absence from you, and all our dear darlings, but which is now fast drawing to a close. In fact, my greediness for pictures made me cut out for myself much more work than I ought to have undertaken at this time. One of the Claudes would have been all that I wanted, but I could not get at that first, and I had been here a fortnight before I began it. To-day it will be done, with per-

haps a little touch on Saturday morning. I have then an old picture to fill up some holes in. But I fear I shall not be able to get away on Saturday, though I hope nothing shall prevent me on Monday. I can hardly believe I have not seen you or my Isabel, or my Charley, for five weeks. Yesterday there was another very high wind, and such a splendid evening as I never before beheld, at this time of the year. Was it so with you? But in London nothing is to be seen, worth seeing, in the *natural* way.

"I certainly will not allow of such serious interruptions as I used to do, from people who devour my time, brains, and everything else. Sir George says it is quite serious and alarming. Let me have a letter on Sunday, my last day here, as I want to be made comfortable on my journey, which will be long and tiresome, and I shall be very nervous as I get near home; therefore, pray let me have a good account of you all. I believe some great folks are coming here in December, which Sir George dreads, as they so much interfere with his painting habits; for no artist can be fonder of the art."

"November 25th. My very dearest love, I hope nothing will prevent my leaving this place to-morrow afternoon, and that I shall have you in my arms on Thursday morning, and my babies; O dear! how glad I shall be. I feel that I have been *at school,* and can only hope that my long absence from you may ultimately be to my great and lasting improvement as an artist, and indeed, in everything. If you have any friends staying with you, I beg you will dismiss them before my arrival."

Though Sir George Beaumont and Constable agreed, generally, in their opinions of the old masters, yet their tastes differed materially on some points of art, and their discourse never languished for want of 'an animated no'. A constant communion with pictures the tints of which are subdued by time no doubt tends to unfit the eye for the enjoyment of freshness; and Sir George thought Constable too daring in the modes he adopted to obtain this quality; while Constable saw that Sir George often allowed himself to be deceived by the effects of time, of accident, and by the tricks that are, far

oftener than is generally supposed, played by dealers, to give mellowness to pictures; and, in these matters, each was disposed to set the other right. Sir George had placed a small landscape by Gaspar Poussin on his easel, close to a picture he was painting, and said, 'Now, if I can match these tints I am sure to be right.' 'But suppose, Sir George,' replied Constable, 'Gaspar could rise from his grave, do you think he would know his own picture in its present state? or if he did, should we not find it difficult to persuade him that somebody had not smeared tar or cart grease over its surface, and then wiped it imperfectly off?' At another time, Sir George recommended the colour of an old Cremona fiddle for the prevailing tone of everything, and this Constable answered by laying an old fiddle on the green lawn before the house. Again, Sir George, who seemed to consider the autumnal tints necessary, at least to some part of a landscape, said, 'Do you not find it very difficult to determine where to place your *brown tree*?' And the reply was, 'Not in the least, for I never put such a thing into a picture." But however opposite in these respects their opinions were, and although Constable well knew that Sir George did not appreciate his works—the intelligence, the wit, and the fascinating and amiable manner of the Baronet had gained his heart, and a sincere and lasting friendship subsisted between them.

During his visit to Cole-Orton, besides his admirable copies of the Claudes, he made a sketch from a landscape by Rubens, a large sketch of the front of the house, and a drawing of the cenotaph erected to Sir Joshua Reynolds.[1]

Constable had never been, nor was he ever again, so long separated from his wife and children as on this occasion; and his anxiety to return, and at the same time, his wish to complete the copies he undertook at Cole-Orton, confined him so much to his easel that the visit proved an injury instead of a benefit to his health.

*[1] Constable's drawing of the Cenotaph, dated 28th Nov. 1823, is now in the Victoria and Albert Museum (No. 835-1888). See Plate 52. Other drawings made by Constable when on this visit to Coleorton are in the same Museum.

"Salisbury, December 12th. My dear Constable, . . . I know not how to advise you for the exhibition. 'The Waterloo' depends entirely on the polish and finish given to it. If I were the painter of it, I would always have it on my easel, and work at it for five years, a touch a day.

"The great storm played destruction at Gillingham. It blew down two of my great elms, bent another to an angle of forty-five degrees with the ground, and stripped a third of all its branches, leaving only one standing entire. This I have taken down, and your wood exists only in your sketches. The great elm in the middle of the turf is spared.

"Southey is a friend of the establishment: but in one point I think him (with diffidence) wrong. He would adopt the Methodist preacher into the church as an inferior servant. This was the very cause of the corruptions and downfall of the Roman Catholic establishment. For the sake of peace and unity they adopted enthusiasts, received their errors into the creeds of the church, and then had to *defend* them. You cannot make use of the *men* without receiving their opinions.

"Varley is here teaching drawing to the young ladies. '*Principles,*' he says, 'are the thing. *The warm grey, the cold grey, and the round touch.*' John Fisher."

"December 18th. My dear Fisher. Your kind and welcome letter, as usual, breathes nothing but good humour, friendship, and understanding. I wanted just such a one; as almost, from the time of my return, I have been laid up and am quite disabled by pains in the bones of my head and face, probably originating in the teeth. It began at Gillingham. However, they have condemned one this morning who, though not the principal, was still an accessory before the fact. Perhaps I may look for some ease, but I have lived on suction for the last fortnight. . . . I shall now turn to your letter to see what requires noticing.

"First. I am settled for the exhibition. My 'Waterloo' must be done, and one other; perhaps one of Tinney's, 'Dedham', but more probably my 'Lock'. I must visit Gillingham again for a subject for the other next summer.

"Second. How much I regret the grove at the bottom of your garden. This has really vexed me. I had promised myself passing the summer hours in its shade.

"Third. I am glad the great elm is safe.

"Fourth. What you say of Southey is wise, just, moderate, and undeniable. Though he can say much, he cannot gainsay that short sentence of yours. It marks you master of your own profession; and every hour's experience proves to me that no man, not educated, from his early youth, to a profession, can fully and justly enter into it."

1824

Letter from Sir George Beaumont. Picture of 'The Opening of Waterloo Bridge'. Lady Paintress. Sale of two large Pictures to a Frenchman. Picture of a 'Lock on the Stour'. Description of Brighton. Mr. Phillips. J. Dunthorne, Jun. Venetian Secret discovered by a Lady. Mr. Ottley. Washington Irving. Note from Mr. Brockedon. Archibald Constable. French Criticisms on Constable's Pictures.

"To John Constable, Esq. Dear Sir, I am very sorry to hear you have been so unwell since your visit to Cole-Orton, and am afraid it arose from too intense application. You must do me the justice to tell Mrs. Constable that I never failed daily proposing riding or walking. I am quite sure artists save time in the end, by allowing the necessary interruptions for air and exercise. However, now it is over, I hope it will be a warning, and in the meantime, I must say your time was not passed unprofitably, and your industry has acquainted you with many of the arcana of Claude's mysterious and magical practice. I thank you for the trouble you have taken in sending my colours, etc., and finally, wish you success in the application of the result of your studies. I hope you feel no remains of your illness, and will go on merrily with your preparations for Somerset House; but remember, air and exercise, or you may be interrupted. At all events, it must injure you in the long run, for I am convinced that many artists bring on various complaints, and shorten their lives from inattention to this point. It does not surprise me to hear that Sir Thomas Lawrence has delivered an excellent discourse, and it adds to my pleasure to hear that it is to be printed, and also that with his usual liberality of feeling and good taste, he has spoken in high terms of Mr. West.[1] I beg my compliments to Mrs. Constable, and request her to inform you from me, with her influence superadded, that unless you take more air and exercise, you will never reach my age. I remain, my dear sir,

*[1] Sir Thomas Lawrence delivered an *Address to the Students of the R. A.* . . . on 10th Dec. 1823. It was published in 1824. Lawrence succeeded Benjamin West as P.R.A. in 1820.

with every good wish, truly yours, G. Beaumont. Cole-Orton Hall, January 6th, 1824. How are your copies approved?"

Whatever good effects Sir George's advice may have produced, were not lasting, for Constable never adhered to any plan of regular exercise. In town, he was often obliged to quit his easel; but even when called out, so constantly was his attention drawn to passing objects that he loitered rather than walked, and his pace could scarcely be quickened into exercise, unless he was late for some appointment.

A letter to Constable from the Bishop of Salisbury, dated January 6th, enclosing a draft, concludes thus, "Our new year opens under many pleasing circumstances; fine weather, returning plenty, public quiet, and the appearance of general peace. May you and yours have many happy returns of such a year."

"January 17th. My dear Fisher, The Frenchman[1] who was after my large picture of 'The Hay Cart' last year, is here again. He would, I believe, have both that and 'The Bridge', if he could get them at his own price. I showed him your letter, and told him of my promise to you. His object is to make a show of them at Paris, perhaps to my advantage. I should like to advise with you about the large 'Waterloo'; it is a work that should not be hurried. I am engaged on my upright 'Lock', and I hope, one of Tinney's new ones. I only want to work harder to be comfortable. My success in life seems pretty certain, but no man can get much by study, and the labour of his own hands."[2]

"January 18th. My dear Constable. Thurtell said,[3]—but perhaps, you are as sick of his name as you were of the queen's,

[1] i.e. Arrowsmith, the Anglo-French dealer. He and another dealer named Schroth were responsible for the import into France of a considerable number of paintings by Constable.

[2] A part of this letter which Leslie has omitted refers to "the picture of the Cathedral belonging to Mr. Mirehouse". This was a version of 'Salisbury Cathedral from the Bishop's Grounds' which Constable painted for Mirehouse, the Bishop's son-in-law. Such a painting is still in the possession of the descendants of the Mirehouse family. See note on Plate 26.

[3] This is a humorous hit at the importance attached to everything said or done by a convicted murderer.

so we will change the subject. . . . Let your 'Hay Cart' go to Paris by all means. I am too much pulled down by the agricultural distress to hope to possess it. I would, I think, let it go at less than its price for the sake of the *éclat* it may give you. The stupid English public, which has no judgment of its own, will begin to think there is something in you if the French make your works national property. You have long lain under a mistake; men do not purchase pictures because they admire them, but because others covet them. . . .

"Did you know the fact in natural history that rooks prefer to build in elm trees before all others, and that they seldom or never frequent chestnuts? When we were felling our elms at Gillingham, some rooks flew over and were clamorous. Whether deprecating our work of destruction or not, I cannot tell.

"In the new novel attributed to Sir Walter Scott (*St. Ronan's Well*), is the following passage. 'There are very well bred artists, said Lady Penelope, it is the profession of a gentleman.' —'Certainly', answered Lady Binks; 'but the poorer class have often to struggle with poverty and dependence. In general society, they are like commercial people in presence of their customers; and that is a difficult part to sustain. And so you see them of all sorts—shy and reserved, when they are conscious of merit—petulant and whimsical, by way of showing their independence—intrusive in order to appear easy—and sometimes obsequious and fawning, when they chance to be of a mean spirit.' Are either you or —— acquainted with Sir Walter Scott?

"I am shut up in lodgings here,—the walls covered with *old masters*. I suffer like the martyrs of old, who had their eyes put out with hot brazen basins, held before their faces. But I am relieved by one picture which I guess to be a genuine Vanderhayden. Is not that the name of the man who painted brick buildings so minutely? It is very true and delicate, and with pretty light and shadow, but the sky looks as if it had been touched up. J. Fisher."

"January 22nd. My dear Fisher, . . . I have done the little

'Waterloo',[1] a small balloon to let off as a forerunner of the large one. . . ."

Mr. Fisher in a letter dated "Weymouth, February 12th" says, "I beg to congratulate you on the appearance of your name in the newspapers. Do not despise them too much. They cannot give fame, but they attend on her. *Smoke* gives notice that the house is on fire. I shall be in town Wednesday or Thursday next."

"April 15th. My dear Fisher, I have been for some time desirous of writing to you, but I was never more fully bent on any picture than that on which you left me engaged. It is gone to its audit, and my friends tell me it is my best; it is a good subject, and an admirable instance of the picturesque. I hear there are some fine pictures this year at the Academy, from some of the old as well as some of the new Academicians. On Saturday I shall go for a few days into Suffolk; I wish to see what they are about, and Lady Dysart wants me to look at the woods which she has given into the care of my brother, that I may bring a report to her, as he cannot leave them. I have had the Frenchman again with me; we have agreed as to price, two hundred and fifty pounds the pair, and I give him a small picture of 'Yarmouth' into the bargain."

"I dined the other day with ——, to be introduced to a lady paintress, 'with whom I should be much pleased'. I found a laughing, ignorant, fat, uncouth old woman; but very good-natured; and she gave me no trouble, as she wanted no instruction from me. When she told me of an oil proper for painting, I told her it would not do, but she assured me it would, and that she could give me no greater proof of it than that one of her pictures was painted entirely with it."

Constable exhibited but one picture this year. 'A Boat passing a Lock'.[2]—The scene of this subject is close to Flatford Mill, and was often painted by him from different points of view. An early picture of it, in which the lock is on the right of the foreground, forms one of the most complete subjects

★[1] Perhaps the oil-sketch in the Victoria and Albert Museum (No. 322–1888).
★[2] Now in the collection of S. Morrison, Esq.

of the *English Landscape*.[1] The little wooden bridge, a principal feature in the engraving entitled the 'River Stour, Suffolk', is here introduced at a greater distance, with the whole of the picturesque cottage near it.

"May 8th. Dear Fisher, I have just deposited my picture in its place, and opposite, and as a companion to one by Mrs. ——.[2] To what honours are some men born! My Frenchman has sent his agent with the money for the pictures; they are now ready, and look uncommonly well, and I think they cannot fail to melt the stony hearts of the French painters. Think of the lovely valleys and peaceful farm-houses of Suffolk forming part of an exhibition to amuse the gay Parisians. My 'Lock' is liked at the Academy, and indeed it forms a decided feature, and its light cannot be put out, because it is the light of nature, the mother of all that is valuable in poetry, painting, or anything else where an appeal to the soul is required. The language of the heart is the only one that is universal; and Sterne says, he disregards all rules, but makes his way to the heart as he can. But my execution annoys most of them, and all the scholastic ones. Perhaps the sacrifices I make for lightness and brightness are too great, but these things are the essence of landscape, and my extreme is better than white-lead and oil, and *dado painting*. I sold this picture on the day of the opening for one hundred and fifty guineas, including the frame, to Mr. Morrison. I do hope my exertions may tend towards popularity; but it is you who have so long held my head above water. Although a good deal of the devil is in me, I do think I should have been broken-hearted before this time but for you. Indeed, it is worth while to have gone through all I have for the hours and thoughts we have had together. I am in high favour with all the Seymour Street family, and I look continually back to the great kindness shown to me in my early days, when it was truly of value to me; for long I tottered on the threshold, and floundered

*[1] This is presumably the engraving called 'A Lock on the Stour', after 'Landscape: Boys Fishing,' exhibited R. A. 1813.

[2] The lady described in the last letter.

in the path, and there never was any young man nearer being lost; but here I am, and I must now take heed where I stand."

"Gillingham, May 10th. My dear Constable. I admire your lion-like generosity in passing over my long silence without vituperation. I am glad you did not ask me for a reason, for I can assign none, except that I was always thinking of you, daily intending to write, and daily neglecting to put my intention into execution. Your last letter is evidently written in a tone of great exultation, and with reason. Your fame and fortune are both advanced; and for both you are indebted but to Providence and your own exertions. I am not surprised that 'The Navigator' sold on a first inspection; for it was one of your best pictures. The purchase of your two great landscapes for Paris is surely a stride up three or four steps of the ladder of popularity. English boobies, who dare not trust their own eyes, will discover your merits when they find you admired at Paris. We now *must* go there for a week. . . . I generally leave you wiser than I came to you, and some of your pithy apophthegms stick to my memory like a thorn, and give me a prick when I fall a-dozing. 'A man is always growing', you said, 'either upwards or downwards'. I have been trying to grow 'upwards' since we parted. When I consulted you about the Lancastrian Sunday School in my parish, you advised me to 'be quiet and do all the good I could'. I took your advice, and the quakers have, unsolicited, dropped the offensive rules. J. Fisher."

"Gillingham, May 11th. My dear Constable. . . . They have had one or two smart brushes at the Church in Parliament, but have been triumphantly defeated. One member said, 'If half the industry had been used to bring to light the good done by the clergy, which has been used to malign them, the Church would need no defender.' However, I am indifferent to such attacks. I am at my post, and intend to be found at it, happen what will. The people of this place are given to my charge, and I will discharge the duty, with or without the tithes. What has become of 'Waterloo'? I am ready to receive you at

Salisbury at any moment. Will you go with me on my visitation? J. Fisher."

"My dear Fisher, I have counted on the pleasure of seeing Berkshire again with you, but that is not possible this year; I have just now engaged to get seven pictures[1] of a small size ready for Paris by August. The large ones are to be exhibited at the Louvre, and my purchasers say they are much looked for at Paris. The director of the Academy at Antwerp, Mr. Vanbree, has been here; he says they will make an impression on the Continent. . . . The world is rid of Lord Byron, but the deadly slime of his touch still remains."

"Brighton, May 29th.[2] The dignitary of the Church seems to have forgotten the dignitary of the easel. . . . I am busy here, but I dislike the place, and miss any letter from you. I am, however, getting on with my French affairs; one of the largest is quite complete, and is my best in sparkle with repose, which is my struggle just now. Brighton is the receptacle of the fashion and off-scouring of London. The magnificence of the sea, and its, to use your own beautiful expression, 'everlasting voice', is drowned in the din and tumult of stage coaches, gigs, flys, etc., and the beach is only Piccadilly or worse by the seaside. Ladies dressed and undressed; gentlemen in morning-gowns and slippers, or without them or anything else, about knee deep in the breakers; footmen, children, nursery-maids, dogs, boys, fishermen, and Preventive Service men with hangers and pistols; rotten fish, and those hideous amphibious animals, the old bathing-women, whose language, both in oaths and voice, resembles men, all mixed together in endless and indecent confusion. The genteeler part, or Marine Parade, is still more unnatural, with its trimmed and neat appearance, and the dandy jetty or Chain Pier, with its long and elegant strides into the sea a full quarter of a mile." (Here the writing is interrupted by a sketch.) "In short, there is nothing here for a painter but the breakers and the sky, which

[1] In the original letter, Constable gives the measurements of these as follows: two of them 20 × 30 in., two 12 × 20 in. and three 10 × 12 in.

[2] The date on the MS of this letter is only partly legible, but, for various reasons, it must be August, not May, 29th.

have been lovely indeed, and always varying.[1] The fishing-boats here are not so picturesque as the Hastings boats; the difference is this." (Here a sketch.) "But these subjects are so hacknied in the Exhibition, and are indeed so little capable of the beautiful sentiment that belongs to landscape, that they have done a great deal of harm. They form a class of art much easier than landscape, and have, in consequence, almost sup-planted it. While in the fields, for I am at the west of this city, and quite out of it, I met with a most intelligent and elegant-minded man, Mr. Phillips.[2] We became intimate, and he con-tributes much to our pleasure here. He is a botanist, and all his works on Natural History are instructive and entertaining, calculated for children of all ages; his *History of Trees* is delightful. We are at No. 9, Mrs. Sober's Gardens, so called from Mrs. Sober, the lady of the manor; she has built a chapel; and a man who was taken before the magistrates quite drunk, when asked what he was, said he was 'one of Mrs. Sober's congregation'. Last Tuesday, the finest day that ever was, we went to the Dyke, which is, in fact, the remains of a Roman encampment, overlooking one of the grandest natural land-scapes in the world, and consequently a scene the most unfit for a picture. It is the business of a painter not to contend with nature, and put such a scene, a valley filled with imagery fifty miles long, on a canvas of a few inches; but to make something out of nothing, in attempting which, he must almost of neces-sity become poetical; but you understand all this better than I. My wife and children are delightfully well."

In June, Constable returned to London with young Dun-thorne, leaving his family at Brighton. While in town, he kept a diary, which he sent at intervals to Mrs. Constable, and from which the following are a few extracts: "Wednesday, June 16th. . . . A French gentleman[3] and his wife called; they

[1] On the back of one of Constable's oil sketches made in the summer of this year at the west end of Brighton, is written, 'The neighbourhood of Brighton consists of London cow-fields, and hideous masses of unfledged earth called the country.'

*[2] Henry Phillips (1775–1838), banker and horticultural writer.

*[3] The Vicomte de Theeluson.

were much pleased, could talk a little English, and we got on very well. He ordered a little picture, and wished to know if I would receive any commissions from Paris, where he said I was much known and esteemed, and if I would go there, the artists would receive me with great *éclat*. He was delighted with Tinney's picture, which now looks very beautiful on the easel; it is of service to me to have so good a work to show. Jackson told me that Lord Fitzwilliam would certainly have bought my picture, if it had not been sold to Mr. Morrison. Fisher called and dined. Leslie called to ask me to pass the evening with him. He staid to tea. Fisher and Leslie had a good deal of talk about Washington Irving. A new book of his just out. Fisher is quite pleased with Irving."

"June 21st. . . . Collins called; he says I am a great man at Paris, and that it is curious they speak there of only three English artists, namely Wilkie, Lawrence, and Constable. This sounds very grand. He was quite struck with the look of Tinney's picture. He hopes it will go to the Gallery."

"June 22nd. . . . Had a letter from Paris. Mr. Arrowsmith informed me of the safe arrival of my pictures, and how much they were admired; he talks of coming again the end of next month; I shall be ready for him; his letter is flattering, but I have no wish to go to Paris."

"June 24th. —— called. He did not want to see me, but had something to say to a man he had with him, and if I would give him leave, would take him into the parlour.—He easily makes himself at home."

"June 25th. After breakfast called on the bishop by his wish. He had to tell me that he thought of my improving the picture of the Cathedral, and mentioned many things.—'He hoped I would not take his observations amiss.' I said, 'Quite the contrary, as his lordship had been my kind monitor for twenty-five years.' I am to have it home to-morrow. He says I must visit the colonel,[1] at Charleton, this or next month, for a day or two. I do not wish it, as I begin to be tired of going to school. The good bishop had been at Dedham, and found the

[1] A relation of the bishop, an amateur landscape painter.

wretched ——'s all at daggers drawn. He reconciled them, and insisted on their shaking hands, which they did. Mr. Neave called this evening about five. He is always the most agreeable person in the world. He was quite astonished at the picture on the easel (Tinney's) and hoped I would always keep to the picturesque, and those scenes in which I am 'so entirely original'. Mrs. Hand tells me that Owen[1] always speaks so very highly of me, in every way, that it is quite delightful."

"June 28th. F. Collins[2] called to ask me to a party; but Sir George Beaumont had sent me tickets for the British Institution this evening, and I thought it would be a treat to Johnny Dunthorne to see so many fine ladies."

"June 30th. Sir George Beaumont called to know if I would undertake a singular commission. There is a lady who has devoted herself to the discovery of what is called the Venetian secret of colouring. She has been at it these twenty years, and has at length written to the Secretary of State to desire proper trials may be made of it by some eminent artists. Sir George asked me to try it, saying I should be paid for my time, etc., and thinking that, as the lady is now at Brighton, it might not be inconvenient to me. I shall see him again to-morrow; the lady's name I forget."

"July 1st. I am glad to find the lady who has discovered the Venetian secret declines submitting it to any one artist. She wants the governors of the British Institution to send many artists, and to offer very high premiums for their success, so Sir George hopes there will be an end of it. Mrs. —— saw the Exhibition, and was delighted with my picture, which, she says, 'flatters the spot, but does not belie nature'."

"July 2nd. Received a letter from the Institution offering prizes for the best sketches and pictures of the Battles of the Nile and Trafalgar; it does not concern me."

"July 3rd. Mr. Ottley[3] called this morning. I was introduced

*[1] Presumably the portrait-painter, William Owen R.A. (1769–1825).

*[2] The brother of William Collins R.A.

*[3] William Young Ottley (1771–1836), writer on art and collector of paintings and drawings.

to him by Sir George Beaumont. He was much pleased, and stayed a long time, and looked at a good many things. He is more of a connoisseur than an artist, and therefore full of objections. A good undoer, but little of a doer, and with no originality of mind. He invited me to drink tea with him.— Mr. Appleton, the tub-maker, of Tottenham Court Road, called to know if I had a damaged picture which I could let him have cheap, as he is fitting up a room up one pair of stairs. ... Went to tea with Mr. Ottley. Saw some beautiful prints. Such a collection of Waterloo's etchings, I never saw. There was also an abundance of his own things, which gave me a great deal of pain; so laborious, so tasteless, and so useless, but very plausible. They were all of the single leaf,[1] and chiefly laurels, weeds, hops, grapes, and bell vines; and ten thousand of them. He is a very clever writer and a good man. He says he has lost a great deal by his publications on art."

"July 7th. Took tea with Rochard.[2] The Chalons[3] and Newton[4] there. A pleasant evening. Saw in a newspaper on the table, a paragraph mentioning the arrival of my pictures in Paris. They have caused a stir, and the French critics by profession are very angry with the artists for admiring them. All this is amusing enough, but they cannot get at me on this side of the water, and I shall not go there."

"July 10th. Dressed to go to Leslie's to dinner. It is a very fit house for an artist, but sadly out of the way. But it is quite in the country. Willes and Newton there. After dinner took a walk in the fields and to the new church, St. John's Wood, where my poor uncle, David Pike Watts, is buried. Saw the tomb. A lovely evening."

In another part of this journal, Constable describes the familiarity of some of his neighbour's pigeons. They came

[1] He means that every single leaf was drawn without attention to the masses.
*[2] Either S. J. Rochard (1788–1872) or his younger brother, F. T. Rochard (1798–1858): they were both miniaturists and had come to London from France some years previously.
*[3] A. E. Chalon R.A. (1780–1860), miniaturist and water-colourist, and his brother J. J. Chalon R.A. (1778–1854) water-colourist.
*[4] Gilbert Stuart Newton R.A. (1794–1835), portrait-painter.

into a room where John Dunthorne was working, and perched on the easel; and he continues: "Mary Constable told me a funny story of one of her swans and a duck that had young ones. He poked his long neck towards some of her brood, and she attacked him with fury, and after a great to-do, and splashing, and noise, and hissing, and flapping of wings, she drove him off, and rode away in triumph on his back."

"Brighton, July 18th. My dear Fisher, I have often attempted to write to you, but in London I have so many occupations and interruptions, that I was glad to put it off 'till I arrived here, whither I am come to seek some quiet with my family. . . . I have formed a plan of receiving no commission under twenty guineas, however small, as the picture must be complete, and the subject as good as one on a six-foot canvas. We have received a letter from the wise men of the Institution; they offer a good thing; it is to receive some pictures from living artists which are in private hands, to form an Exhibition[1] next year instead of the old masters. I have to beg that Tinney's picture may be one, and as it is already in my possession, it is convenient. . . . The French critics have begun with me, and that in the usual way, by comparison with *what has been done*. They are angry with the artists for admiring these pictures, which they 'shall now proceed to examine', etc. They acknowledge the effect to be 'rich and powerful, and that the whole has the look of nature, and the colour, their chief excellence, to be true and harmonious; but shall we admire works so unusual for these excellencies alone? what then is to become of the great Poussin?' They then caution the younger artists to 'beware of the seduction of these English works'. All this comes of being regular critics. The execution of my pictures, I know, is singular, but I like that rule of Sterne's, 'Never mind the dogmas of the schools, but get at the heart as you can'; and it is evident something like this has been attained, by the impression these pictures have made on most people who have seen them here and abroad. I have the paper, and will

*[1] The B.I. Special Exhibition of 1825 included 'The White Horse' and 'Stratford Mill' by Constable. Cf. pp. 137, 143 below.

send it to you. I am planning some large landscape, but I have
no inclination to pursue my 'Waterloo'; I am impressed with
a notion that it will ruin me. I want to see you at Salisbury,
but how or when, I know not. I am looking for a month's
quiet here, and have brought with me several works to com-
plete. What a blessing it is thus to be able to carry my pro-
fession with me. My wife is much better and stronger for the
change."

Constable's youngest brother, Mr. Abram Constable, with
whom he kept up a constant correspondence, in a letter dated
August 2nd, says: "I fully coincide in your opinion of John
Dunthorne. He is certainly the most extraordinary young
man within my knowledge. So clever, so active, so innocent,
—'tis marvellous. I assure you I had not overlooked his con-
duct. . . . Johnny has made every enquiry about the elm called
'Buck's elm', and no intention is entertained of its coming
down at present; but a look-out shall be kept to prevent it, if
possible. 'Tis of no value when down, and I hope that circum-
stance will prevent it. . . . John Dunthorne is too good to pass
his life among dissolute workmen."

Immediately on alighting from the coach after one of his
journeys either to or from Brighton, Constable made the
beautiful sketch[1] from which the engraving in the *English
Landscape*, called 'Summer, Afternoon after a Shower', was
taken; it was the recollection of an effect he had noticed near
Red Hill.

"Gillingham, Shaftesbury, September 8th. My dear Con-
stable. . . . You recollect, probably, a conversation we had
with Leslie respecting Washington Irving. I said that Irving
had not done justice to the present character of the clergy.
That they were a class of men who much admired his works,
and had literary reputation much at their disposal. In his new
work, the *Tales of a Traveller,* he has made us ample amends.
I copy the following from page 316, vol. i. 'He was a good
man: a worthy specimen of that valuable body of our country
clergy, who silently and unostentatiously do a vast deal of

*[1] This is probably the oil-sketch now in the National Gallery (No. 1815).

good; who are, as it were, woven into the whole system of rural life, and operate upon it with the steady yet unobtrusive influence of temperate piety and learned good sense.' The rest of the volume is on the same subject, and gives a pretty picture of the serene tranquillity and decorum of a Cathedral city, and a most amiable hint at the character of a *Prebendary*. Is this accident?—Take an opportunity to let Leslie know that the compliment has not been lost on the body. . . . I have a great mind to dress up your description of Brighton and send it to *John Bull*. It *is* an odious place. J. Fisher."

"November 2nd. My very dear Fisher, I am determined to write to you, though scarcely equal to it. . . . All my indispositions have their source in my mind. It is when I am restless and unhappy that I become susceptible of cold, damp, heats, and such nonsense. I have not been well for some weeks, but I hope soon to get to work again. . . ."

"November 2nd. My dear Constable, Association of ideas is sometimes very singular. What is there in common between you and Alderman Wood? and yet seeing his name at the head of a paragraph in a newspaper, made me think of you. I found that his son had been elected to some living in the city, and that J —— had been a rival candidate. The name of J —— called that of Constable to my mind by an intimate association, and so I stole a few moments to write to you on the spur of the recollection.—November 4th. I had written thus far, when, yesterday, I received your distressing letter. I was very sorry to perceive both from the matter and the handwriting that you were very much out of order. But I trust the cold weather, and your temperate habits, will soon restore nature to her healthy action. . . . Everybody has been ill. Abernethy says that there is not a healthy man in London; such is the state of the atmosphere and mode of life. . . . I copy you a passage from D'Israeli's *Anecdotes*, in the absence of news. 'In all art, perfection lapses into that weakened state too often dignified as classical imitation. It sinks into mannerism, wantons into affectation, or shoots out into fantastic novelties. When all languishes in a state of mediocrity, or is deformed by

false taste, then some fortunate genius has the glory of restoring another golden age of invention.' History of the Caracci. J. Fisher."

"November 13th. My dear Constable. This moist muggy weather seems to have deranged everybody; and among others, your humble servant. I have been, as the old women say, 'quite poorly', this last week, and not equal to the energy of a letter. . . . I hope you will diversify your subject this year as to *time* of day. Thomson, you know, wrote not four Summers, but four Seasons. People get tired of mutton at top, mutton at bottom, and mutton at the side, though of the best flavour and smallest size. When you write again, give us a little history of your wife and children. J. Fisher."

"Charlotte Street, November 17th. My dear Fisher, Thank you for your letter of yesterday. . . . John Dunthorne is here; he cheers and helps me so much that I could wish to have him always with me; he forwards me a good deal in subordinate parts, such as tracing, squaring, etc. This morning a gentleman called on me who has nine telescopes; you may judge how thick they soon got;[1] it is John's forte, he is to see them to-morrow. I am planning a large picture, and I regard all you say; but I do not enter into that notion of varying one's plans to keep the public in good humour. Change of weather and effect will always afford variety. What if Vander Velde had quitted his sea pieces, or Ruysdael his waterfalls, or Hobbema his native woods. The world would have lost so many features in art. I know that you wish for no material alteration; but I have to combat from high quarters, even from Lawrence, the plausible argument that *subject* makes the picture. Perhaps you think an evening effect might do; perhaps it might start me some new admirers, but I should lose many old ones. I imagine myself driving a nail; I have driven it some way, and by per-severing I may drive it home; by quitting it to attack others, though I may amuse myself, I do not advance beyond the first, while that particular nail stands still. No man who can do any

[1] Young Dunthorne, who was very ingenious, was fond of astronomy. His father showed me, in 1840, the remains of a large telescope made by him.

one thing well, will be able to do any other different thing equally well; and this is true even of Shakespeare, the greatest master of variety. Send me the picture of the shady lane when you like. Do you wish to have any other? The sketch-book I am busy with for a few days; it is full of boats and coast scenes. Subjects of this sort seem to me more fit for execution than for sentiment. I hold the genuine pastoral feeling of landscape to be very rare, and difficult of attainment. It is by far the most lovely department of painting as well as of poetry. I looked into Angerstein's the other day; how paramount is Claude! . . . Can anything exceed the villainy of the newspapers? after having said everything bad of ——, most of which is true, they are now endeavouring to turn justice from its course. I met Sir —— several times at Brighton. He is a strong, sensible, stupid, clever, foolish, vulgar dog; very amusing, no doubt a great liar, has long been carried about on the shoulders of the world, and his mind is filled with all the dirt of life. I fear you will be annoyed by this ill-written rigmarole letter. But forgive it, as it has afforded much amusement to my mind to write it. My wife wants some account of Mrs. Fisher and your children."

"My dear Constable, You will find in the enclosed some remarks upon your pictures at Paris. I returned last night and brought this with me. The French have been forcibly struck by them, and they have created a division in the school of the landscape painters of France. You are accused of carelessness by those who acknowledge the truth of your effect; and the freshness of your pictures has taught them that though your means may not be essential, your end must be to produce an imitation of nature, and the next exhibition in Paris will teem with your imitators, or the school of nature *versus* the school of Birmingham. I saw one man draw another to your pictures with this expression, 'Look at these landscapes by an Englishman,—the ground appears to be covered with dew.' Yours very sincerely, William Brockedon,[1] 11, Caroline Street, Bedford Square, December 13th."

★[1] William Brockedon (1787–1854), painter, author, and inventor.

Constable told me of a singular practice of a namesake of his, who was not, however, a relation. Archibald Constable, the Edinburgh publisher, called on him, I think in this year, and introduced himself, saying that, wherever he was, he made it a point to call on every person he could find, bearing his own name, whom he had not previously known.[1]

"Charlotte Street, December 17th. My dear Fisher, . . . How much I should like to pass a day or two with you at Bath; but after such an interrupted summer, and so much indisposition in the autumn, I find it quite impossible to leave London, my work is so much behindhand. We hear of sad illnesses all round us, caused, no doubt, by the excessive wet. I have just received a letter from Sir George Beaumont; he has been seriously ill, and quite unable until lately to touch a pencil. Everything which belongs to me belongs to you, and I should not have hesitated a moment about sending you the Brighton sketch-book, but when you wrote, my Frenchman was in London, we were settling about work, and he has engaged me to make twelve drawings, to be engraved here, and published in Paris,[2] all from this book. I work at these in the evening. This book is larger than my others, and does not contain odds and ends, but all regular compositions of boats or beach scenes; there may be about thirty of them. If you wish to see them for a few days, tell me how I am to send them to you. My Paris affairs go on very well. Though the director, the Count Forbin, gave my pictures very respectable situations in the Louvre in the first instance, yet on being exhibited a few weeks, they advanced in reputation, and were removed from their

[1] I did not meet with the following account of the origin of the name, in time to place it, where it should have appeared, in the first chapter. 'The surname of Constable first took its rise from an office of great trust so called in former times, as the constable of Chester, the constable of Richmond; and at this time there is a constable of the Tower of London, which office was introduced into England by the Normans. Some of this sort of offices were in Bretagne, in France, whence many of William the Conqueror's army came into England with him, among whom we find one Constable, the first of that name, as appears by the list or table of Battle Abbey, in the Tower of London, printed in How's *Chronicle*, p. 138.'—Poulson's *History of Holderness*, vol. ii.

★[2] There is no record that these engravings were published.

original situations to a post of honour, two prime places in the principal room. I am much indebted to the artists for their alarum in my favour; but I must do justice to the count, who is no artist I believe, and thought that as the colours are rough, they should be seen at a distance. They found the mistake, and now acknowledge the richness of texture, and attention to the surface of things. They are struck with their vivacity and freshness, things unknown to their own pictures. The truth is, they study (and they are very laborious students) pictures only; and as Northcote says, 'They know as little of nature as a hackney-coach horse does of a pasture.' In fact, it is worse, they make painful studies of individual articles, leaves, rocks, stones, etc., singly; so that they look cut out, without belonging to the whole, and they neglect the look of nature altogether, under its various changes. I learnt yesterday that the proprietor asks twelve thousand francs for them. They would have bought one, 'The Waggon', for the nation, but he would not part them. He tells me the artists much desire to purchase and deposit them in a place where they can have access to them. Reynolds is going over in June to engrave them, and has sent two assistants to Paris to prepare the plates. He is now about 'The Lock', and he is to engrave the twelve drawings. In all this I am at no expense, and it cannot fail to advance my reputation. My wife is translating for me some of the criticisms. They are amusing and acute, but shallow. After saying, 'It is but justice to admire the truth, the colour, and the general vivacity and richness of surface, yet they are like preludes in music, and the full harmonious warblings of the Æolian lyre, which *mean nothing*'; and they call them 'orations and harangues, and high flowery conversations affecting a careless ease', etc. However, it is certain they have made a stir, and set the students in landscape to thinking. Now you must believe me, there is no other person living but yourself to whom I could write in this manner, and all about myself; but take away a painter's vanity, and he will never touch a pencil again."

The following is part of Mr. Fisher's reply to this letter. "I am pleased to find they are engraving your pictures, be-

cause it will tend to spread your fame: but I am almost timid about the result. There is, in your pictures, too much evanescent effect, and general tone, to be expressed by black and white. Your charm is colour, and the cool tint of English daylight. The burr of mezzotint will never touch that."

1825

Brighton Sketches. Family Picture at Woodmanstone. Picture of 'The Jumping Horse'. Gold Medal awarded to Constable by the King of France. Duc de Choiseul. Paley. Sharon Turner. Picture of 'The Lock'. Opinion expressed of it by S. W. Reynolds. Constable's Pictures in the Exhibition at the Academy. Sale of two Pictures to Mr. Darby. Exhibition, at the British Gallery, of a Selection of the Works of Living Artists. Illness of Constable's eldest son. Picture of 'The White Horse' sent to Lisle. Dinner at Lady Dysart's. Northcote. Cat and Chickens. Mr. Bannister. J. Dunthorne's Description of 'The Devil and Dr. Faustus'.

IN a letter dated January 5th, 1825, Constable speaks of sending some of his Brighton oil sketches[1] to Fisher, and says, "Perhaps the sight of the sea may cheer Mrs. Fisher" (who was then very ill); he adds, "I am writing this hasty scrawl in the dark before a six-foot canvas, which I have launched with all my usual anxieties. It is a canal scene, my next shall contain a scratch with a pen."

"January 22nd. My dear Fisher, I am uneasy that I have not heard from you. I hope your invalids have neither relapsed nor increased in number. I write from Woodmanstone, a village six miles south-east of Croydon. I am painting a group of three children with a donkey, the grandchildren of Mr. Lambert, whose ancestors lived here in 1300. It is to go to the parents in the East Indies. The children are here for their education, and spoke the language imperfectly on their arrival. The butcher was driving home a calf in his cart, when one of the boys exclaimed, 'Aunt, what for one *gentleman* take away *cow* in *gig*.' You may suppose I left home to execute this commission very unwillingly.—The large subject[2] on my easel is promising; it is a canal, and full of the bustle incident to such a scene when four or five boats are passing in company; with dogs, horses, boys, men. women and children, and best of all, old timber, props, water plants, willows, stumps,

★[1] A number of oil-sketches of subjects in and around Brighton, dated 1824, are in the Victoria and Albert Museum. See Plate 32.
★[2] 'The Leaping Horse'.

sedges, old nets, etc.—I shall not object, if you do not, to your picture going to the gallery,[1] but I shall try for Tinney's when the time comes, as I think it has more qualities for exhibition among other pictures.—I had this morning a letter from Paris, informing me that on the king's visit to the Louvre, he was pleased to award me a gold medal for the merit of my landscapes. At the same time he made Sir Thomas Lawrence a Knight of the Legion of Honour. I have a pride and satisfaction in mentioning this to you; but I can truly say that your early notice of me, and your friendship for me in my obscurity, was worth more, and is looked back to by me with more heartfelt satisfaction than this, and all the other notice I have met with, put together.—I left home on Thursday, and shall be back by the end of the week. My little group is on the canvas, and makes a pretty picture.[2] In the background is Woodmanstone Church" (here follows a pen sketch of the picture). "Mr. Lambert is the old country squire. His study contains pictures of racers and hunters, guns, gaiters, gloves, turn-screws, tow, gun-flints, etc. You cannot think how much I regret being here to the neglect of my large landscape; but I must not quarrel with kind friends, and kick down the ladder."

"Bath, January 27th. My dear Constable, You have but too well guessed the cause of my silence. Two of my children have been ill with fever and inflammation of the windpipe.... My wife, thank God, is entirely recovered; and for my own part, I have not been so well for years.—Your package arrived safe. Your Brighton sketches carried us down to Osmington in imagination. I showed them to an artist living here: he wished to know what colours you used. The Choiseul Gallery[3] has been of the greatest comfort to me. I have copied, in lead pencil, Ostade's butcher selling the ox, the boy looking out of

★[1] Constable refers to the B.I. Special Exhibition of 1825. Cf. pp. 128, 143.

★[2] This painting was on loan to the Brighton Art Gallery in 1950. It is reproduced and described in the *Burlington Magazine*, Aug. 1950.

★[3] A volume of engravings by P. F. Basan after paintings in the collection of the Duc de Choiseul was published in Paris in 1771. The paintings in the Choiseul collection were mostly by Dutch 17th-century artists.

the window into the sunshine, and a Vanderheyden. Thanks
to you for giving me the *sixth* sense, the power of receiving
pleasure from the chiaroscuro. It has whiled away many an
anxious hour.—I was impatient to hear how you fared at the
visit of the King of France to the Louvre. Your medal could
not have given you greater exultation than it did me. Indeed
I always consider your fame as mine, and, as you rise in slow
and permanent estimation, pride myself that I have formed as
permanent a friendship with a man of such talent. But these
things are better felt than said.—I shall be running up to
London soon, when I shall get a sight of your new six-foot
canvas. My wife observed that your enumeration of objects
'carried her down to the river side'. I should like to see my
picture at the Gallery.—I do think that an impression of your
'Cathedral' would sell at Salisbury; but it entirely depends upon
the brilliancy of the engraving. . . . I began this letter two days
ago; since then I have carried my two sick boys to a house on
the top of Lansdown, and they begin to recover.

"I have been reading much, lately, on the subject of the
French revolution. The Duc de Choiseul was principally, but
ignorantly, perhaps, instrumental in bringing it about, pro-
tecting and abetting Voltaire and Co. He little thought that,
in patronising their licentious pens, he was laying the founda-
tion of the bloody insurrection which was to disperse his
gallery of pictures, and send them to be sold to the 'Nation of
shopkeepers'. He it was who banished the Jesuits, the first and
necessary step to success in bringing about the change. He died
the year before the volcano burst. . . . John Fisher."

"Bath, April 8th. My dear Constable, I rode yesterday out
of the white atmosphere of Bath, into the green village of
Bath-Easton, and found myself by instinct at the *mill,* sur-
rounded by wiers, back-waters, nets and willows; with a
smell of weeds, flowing water, and flour in my nostrils. I need
not say that the scene brought you to my mind and produced
this letter."

Mr. Fisher, after speaking of the serious illness of Mrs.
Fisher, continues, "I will send you, in a week or two, your

sketches back. In the same box I shall enclose two volumes of Paley's posthumous sermons, which you may read to your family of a Sunday evening. They are fit companions for your sketches; being exactly like them, full of vigour, fresh, original, warm from observation of nature, hasty, unpolished, untouched afterwards. There is prefixed to a new edition of his works, a life of Paley, by his son, in which the inner man is laid open. If you can get it, there are parts that will delight you. He appears to have been a strong-minded, guileless, simple-hearted man, who told the truth, and declared his honest opinion to every man he met with, friend or foe. Hence he was sometimes in scrapes. I hope to be able to get a peep at the metropolis and your picture about the 20th of June. . . . In a letter I had from the Charter House, it was mentioned that you were out of spirits, seemingly, and had lost your usual glee in conversation. What cog of the wheel wanted grease? J. Fisher."

Constable's answer to this letter is missing,[1] but its tenor may, in part, be seen by Mr. Fisher's reply. "Bath, April 10th. My dear Constable, . . . We are going on for the present very prosperously. . . . My mind and spirits have been much shaken; and I received your voluntary offer, to come down to Osming-ton, with an exhilaration that I have been long unused to. We will wander home from the shore about dusk to the remnants of dinner, as heretofore, and spend the evening in filling up sketches. There is always room for you. Will you accompany me on my visitation, the 14th, 15th, 16th June, and return with me to Osmington? . . . Why was not your picture on your easel a few weeks longer? I have looked over your letter but find no other observation to make on it, so I will conclude

*[1] It is now in Lord Plymouth's collection, and is quoted in part in Shirley's edition of Leslie. It contains the following reference to 'The Leaping Horse': 'I have worked very hard, and my large picture went last week to the Academy. But I must say that no one picture ever departed from my easel with more anxiety on my part with it. It is a lovely subject, of the Canal kind, lively and soothing, calm and exhilarating, fresh and blowing. But it should have been on my easel a few weeks longer . . .' The letter also refers to "many orders in small for Paris".

with a quotation that will please you. By the bye, you never answer my letters. You write as if you had not received them. My extract is from Sharon Turner's *History of England*,[1] vol. i. page 424, 4to. He is speaking of our classical education, that it stunts originality, contracts the mind, and makes men knowing only in *words*. It is a complete illustration of your saying that 'a good thing is never done twice'.—

" 'It has been remarked that great excellence has been usually followed by a decline. No second Augustan age is found to occur. A Virgil emerges, and if he cast on his countrymen an everlasting spell, no future Virgil appears,—no second Homer or Euripides,—no succeeding Pindar, Horace, Demosthenes, Thucydides, Tacitus, or Cicero. The fact is remarkable. But it is accounted for, not in a want of talent, but from the destruction of talent by injudicious education. It is in literature, as in painting: if we study departed excellence too intensely, we only imitate; we extinguish genius, and sink below our models. If we make ourselves copyists, we become inferior to those we copy. The exclusive or continual contemplation of preceding merit contracts our faculties within, *greatly within*, its peculiar circle, and makes even that degree of excellence unattainable which we admire and feed upon.'

"There is more on the subject, equally good if you turn to the book. It is a highly amusing work. Quite original itself. J. Fisher."

"Charlotte Street, April 13th, 1825. My dear Fisher, Thank you for your second letter. You say you 'are going on prosperously', and this has relieved me from a sad feeling which has haunted me ever since I read the second paragraph in your first. . . . It is true I do not answer your letters, but I read them over and over, and they generally form answers to mine. All your quotations are good, and make for my grand theory. It is the rod and staff of my practice, and can never fail or deceive its possessor.

"They are overwhelmed with large pictures at the Academy; what will become of mine I know not, but I am told it looks

★[1] Sharon Turner's *History of England*, published 1814–29.

bright. . . . My 'Lock' is now on my easel;[1] it is silvery, windy, and delicious; all health, and the absence of everything stagnant, and is wonderfully got together; the print will be fine. . . . I am so harassed and interrupted that I must now conclude almost as abruptly as I did my last. . . . The visit to Osmington I much look to. Nothing shall readily occur to prevent it. I will give up Paris first. . . . I have rather a cheering account of my picture at Somerset House. Its original feeling will support me through all inaccuracies. But they should not be there, to make it more *academical,* and to prevent the *learned vulgar,* in our art, from blowing their noses upon it. . . . I am summoned to tea with my wife and new baby."[2]

Constable's description of his picture of 'The Lock', and some passages from other letters in a similar strain of exultation, have been retained contrary to the advice of a gentleman with whose opinion on many points I am so fortunate as to coincide. It appeared to me that in making selections from letters not intended for publication, if all that might seem egotistical were omitted, the interest would be greatly and unnecessarily lessened, and by this impression I have been guided throughout my undertaking. The utterance of a man's real feelings is more interesting, though it may have less of dignity than belongs to a uniform silence on the subject of self, while the vanity is often no greater in the one case than in the other. In the present instance, the artist's exultation to his most intimate friend at the accomplishment of his aim in one of his most important works is so natural, and the qualities he had kept steadily in view while engaged on it are so well described by him, that I cannot think I am doing so much injustice to his memory by preserving the passage as I should do by its omission. I am enabled to add, to what he has himself said of 'The Lock', the opinion of another person, Reynolds, the admirable engraver, who was a good judge

*[1] The 'Boat Passing a Lock' (R.A. 1824) which S. W. Reynolds was engraving. Cf. p. 134.

[2] His third daughter.

of pictures, and whose praises of it in the following letter were sincere, for he had undertaken to engrave it at his own risk.

"To Mr. J. Constable. My dear Sir, I have, since the arrival of your picture, been before it for the last hour, the light of a cheerful day through the clean windows falling full upon it. It is, no doubt, the best of your works, true to nature, seen and arranged with a professor's taste and judgment. The execution shows in every part a hand of experience; masterly without rudeness, and complete without littleness; the colouring is sweet, fresh, and healthy; bright not gaudy, but deep and clear. Take it for all in all, since the days of Gainsborough and Wilson no landscape has been painted with so much truth and originality, so much art, so little artifice. Yours very truly, S. W. Reynolds."

Reynolds was interrupted in the execution of his plate by illness, and did not live to complete it; but the same subject, from a second picture[1], has since been most admirably engraved, on a larger scale, by Mr. Lucas, and forms the companion to his print of 'The Corn Field'.

Constable exhibited three pictures this year at the Academy, of which the one mentioned by him as the canal scene was the largest.[2] The chief object in its foreground is a horse mounted by a boy, leaping one of the barriers which cross the towing paths along the Stour (for it is that river, and not a canal), to prevent the cattle from quitting their bounds. As these bars are without gates, the horses, which are of a much finer race and kept in better condition than the wretched animals that tow the barges near London are all taught to leap; their harness ornamented over the collar with crimson fringe adds to their picturesque appearance, and Constable, by availing himself of these advantages, and relieving the horse, which is of a dark colour, upon a bright sky, made him a very imposing object. His other works at the Academy were both land-

*[1] A replica of the 'Boat Passing a Lock' was No. 76 in the Constable sale (15th May 1838).

*[2] 'The Leaping Horse', now in the possession of the R.A. See Plate 37.

scapes[1] one of which was described in a newspaper as 'A scene without any prominent features of the grand or beautiful, but with a rich broken foreground sweetly pencilled, and a very pleasing and natural tone of colour throughout the wild green distance.'

These two last pictures were purchased by Mr. Francis Darby, of Colebrook Dale. Constable was highly delighted that they had attracted the notice of an entire stranger to him.

In the summer of this year, the directors of the British Institution, instead of their annual display of works of the old masters, collected, as they had proposed, some of the best pictures of living artists, and Constable was enabled by the kindness of Mr. Fisher and Mr. Tinney to send to this exhibition 'The White Horse' and 'Stratford Mill'.[2]

Among Mr. Fisher's letters, I found a sheet of paper dated "Osmington, Weymouth, August 12th", and containing only a pen sketch of an hour-glass with wings. That Constable was at this time in a state of extreme anxiety on account of his eldest son, who was very ill, will be seen by Mr. Fisher's next letter, dated, "Osmington, August 24th", in which he says, "It struck me after I had despatched my blank memorandum, that the illness of yourself, or some of your family, was the cause of your non-appearance here. Your letter with its uncomfortable details has just reached me. If you can get the consent of the mother, bring your poor boy down here directly; or send him to my house at Salisbury and we will meet him there. He shall have the best advice the country affords, with sea air, sea bathing, and good food. You must exonerate me from any responsibility if anything happens: and if he does well we will see what can be done for him in the

*[1] These two landscapes were in the Beecham Sale, at Christies, 3rd, 4th May, 1917, lots 8 and 9. It seems that Constable executed replicas of them for Schroth, the Paris dealer. They both represented Hampstead Heath. Cf. Shirley's edition of Leslie, pp. 191–194, for letters referring to the sale of the R.A. paintings, and the National Gallery *Catalogue of the British School* by Martin Davies, pp. 37–39, for notes on the Schroth paintings.

*[2] The two paintings were Nos. 113 and 117 in the Catalogue. Cf. pp. 128 and 137.

way of education. This will relieve the mind and spirits of your wife, who is not strong, and will give you more leisure for your easel. . . . Bring your boy down yourself by easy stages, or if you prefer it, bring one of your healthy boys and leave him here to take his chance. As for money matters do not make yourself uneasy. Write for anything you want, and send me any picture, in pledge, you think proper. Your family or yourself shall have the *difference* whenever it is called for. Whatever you do, Constable, get rid of anxiety. It hurts the stomach more than arsenic. It generates only fresh cause for anxiety by producing inaction and loss of time. I have heard it said of generals who have failed, that they would have been good officers if they had not harassed themselves by looking too narrowly into *details*. Does the cap fit? It does *me*. . . . I would have come to Hampstead had I been able. I could sooner do it now and at this distance, and *will* come if it will do you any good.

"Pity me. I am sitting in the shade with my children by me, writing to you, with a quiet stomach and cool head; and I am obliged to leave all this to go ten miles to eat venison and drink claret with a brother officer, whose head is filled with the same sort of materials that his venison pasty is made of. Let me hear from you again soon, and believe me always faithfully yours, John Fisher. . . . You want a *staff* just at present. Lean upon me, *hard*."

"Charlotte Street, September 10th. My very dear Fisher, I was overcome by your kind and most friendly letter, which some changes here have prevented my answering sooner. Your offer to receive my dear boy, indeed, all your friendly suggestions are fully appreciated by my wife and me, and we cannot sufficiently express our sense of them; but the distance at which you are from us is so great, and you have such a charge of your own, that we know not what to do. We determined to give our poor boy the chance of the sea, and about a week ago I took them all to Brighton. I am now quietly at my easel again; I find it a cure for all ills. My commissions press in on me, and I have sent for Johnny Dun-

thorne, who wishes to be here again. . . . But I crave your
forgiveness on a serious matter; your large picture, 'The
White Horse', is now exhibiting at the city of Lisle. Wilkie,
Sir Thomas Lawrence, and myself were each applied to for
pictures by the mayor of that city, who, under Royal
Authority, is the head of its establishments. It will be safely
returned about Christmas. Lawrence has sent some, but Wilkie
is abroad."

From the diary which Constable kept with great regularity
and minuteness, and sent at intervals to Mrs. Constable, the
following are a few quotations: "September 4th. Set off for
Lady Dysart's, and had a pleasant ride in the Richmond coach.
Received in the most agreeable manner, and found there Miss
Vernon, once maid of honour to Queen Charlotte, Mrs.
Charles Tollemache and her daughter, and Lady Laura. We
all walked in the garden before dinner, at which I was placed
at the bottom of the table, opposite Lady Dysart. All sorts of
conversation, but not much that I remember. They talked of
dress and of the new large sleeves; Lady D. did not like them,
nor the long waists that the ladies now wear. They said I was
very amusing, and Lady D. gave me a sovereign for old
Fontaine,[1] and Mrs. Tollemache half-a-crown. After tea,
Lady D. said, 'We shall shock Mr. Constable, we are going to
have a game of cards.'[2] They played a four game, I know not
what; I walked about the grounds, and plucked as much fruit
as I wanted.

"September 7th. Got up early. Set to work on my large
picture,[3] took out the old willow stump by the horse, which
has improved the picture much; made one or two other
alterations. Leslie called and wanted to see old Fontaine,
thinking from my description he would make a good Don
Quixote. Indeed he has the look of an old gentleman. . . .
Called at Hamlet's for my medal, met there Richard Gubbins;[4]

[1] The Swiss organist, who had become a regular pensioner of Constable.
[2] Constable never played. He said he 'considered the time spent at a card
table as a vacuum in life.'
[3] 'The Leaping Horse', which had met with no purchaser.
*[4] Constable's first cousin.

he was looking at some beautiful bracelets, no doubt for his lady. My poor girl had none of these pretty things, but they go but a little way towards happiness, nor do they always insure a good husband; but Richard will make a good husband, he is so good a son. . . .

"September 13th. . . . In the evening went to Mr. Northcote's, and had a delightful conversation about painting, etc. It is wonderful to see him with all the energy of youth. His eye sparkling so bright and so sharp. . . .

"September 16th. This morning, a grand epoch, was ushered in by a prodigious bustle with the fowls in the garden; the black hen making a great to do, the cock strutting about, and Billy[1] looking at them in great astonishment from the back kitchen window. When all was a little quiet, I looked into the brewhouse, and saw her on the nest I had made, and at breakfast Elizabeth brought me a beautiful egg, probably the first ever laid in these premises. How much we have changed this house from what it was in Mr. Farington's time; his attics turned into nurseries, a beautiful baby born in his bedroom, his washhouse turned into a brewhouse, his back parlour, which contained all his prints, into a bedroom, and his painting rooms made habitable; well done! Billy is a most laughable cat; he plays with the kit, pulls it out of its basket, tosses it up, and holds it with his fore feet in a most ridiculous manner; the old Lady Hampstead[2] looking on all the while, rather smiling than otherwise. Sir George Beaumont called; he liked what I was about, but wanted me to imitate pictures. . . . Took poor Mrs. H—— her money. I was told she was ill and in bed. How sadly this poor artist's widow closes her days. Fortune seems indeed blind to give Miss Mellon so much, and this poor widow, who is really a gentlewoman, so little. I went to the back drawing-room to see how Johnny was getting on, and a dear little Robin was washing himself in the pigeon's dish at the window. Dipping himself all over, and making such a dashing, and shaking, and bobbing, and bustle, that it was quite ridiculous. One comes to Mr. Bigg's garden,

[1] A cat. [2] The mother of the kitten.

and sings every night and morning quite loud and beautiful; does not this portend a hard winter? We do a great deal of painting, not going out, and I am getting my small commissions off my hands as fast as I can. I will do as you advise, 'not undertake little things, but keep to my large pictures.' But I must make my mind easy as to those I have on hand, namely, 'Salisbury Cathedral',[1] Mr. Carpenter's picture, Mr. Ripley's, Mr. Arrowsmith's, and Mr. Mirehouse's[2] picture to be altered. All these are paid for, and one more fortnight will clear them all off; how comfortable I shall then be. I am making my last picture saleable, getting the outline on the 'Waterloo', etc.

"Sunday, October 2nd. Our dear blessed wedding day, owing to which we have five babies. . . .

"October 4th. . . . In the evening Mr. Stothard called; we walked to Islington together, he came back to tea with me, and I consulted him, fortunately, about the 'Waterloo Bridge', in which he suggested a very capital alteration. It will increase its consequence, and do so much for it that I am quite in spirits. Your father wanted me to go to St. Martin's Court to see three pictures by Morland, one at nine shillings, the others at twelve each. If I considered them to be original, I was to purchase them for him, as he thought them very pretty paintings. I went and found three coloured and varnished engravings from Morland, Mr. Bigg, and Wheatley. The boxing ring is much on the decline: let us hope it will become extinct. I am at work on my large 'Waterloo' on the *real canvas*; in the evening we are busy setting my portfolios in order, etc. 'Waterloo' promises delightfully."

In one of Mrs. Constable's letters to her husband, she says, "I have no treat like your journal and letters. . . . I hardly allow myself to wish for you, knowing how well and profitably you are employed; but I endeavour to make myself happy, as the separation is for our mutual good. But when you do come, I

*1 Perhaps the version of 'Salisbury Cathedral from the Bishop's Grounds' dated 1826, now in the Frick Collection, New York.

*2 Cf. p. 118 *n*. 2.

trust we shall enjoy our rides and walks.—I long to go with you to the Dyke, and to watch with you the flying shadows on the downs. The Darbys are quite delighted with our cottage. They say we have Hampstead with the addition of the sea."

"Osmington, September. My dear Constable. . . . I despair of ever seeing you out of London, but I repeat that I have bed and board at your service. The news is, that Mat. Parham's (alias Perne's) mill[1] is burnt to the ground, and exists only on your canvas. A huge misshapen, new, bright, brick, modern, improved, patent monster is starting up in its stead.—Do you recollect the situation of Talbot's barn behind the old Manor House, near the church at Osmington? It took fire on the 28th September, when it was surrounded by fourteen large ricks at the distance of no more than twenty yards. No water,—no engines,—straw on every side,—the barn full of wheat,—and thatched cottages, and cornstacks in every direction. Talbot lost his presence of mind, and everybody was at fault. The occasion called me out of my usual indolence. I took the command, gave plenty of beer and good words, worked hard myself, and in twenty minutes we smothered the fire with no other loss than that of the barn. It was distressing to hear the poor rats squalling at one end of the barn as the fire approached them. They could not escape."

"Charlotte Street, November 12th. My dear Fisher, . . . What you say of Mrs. Fisher and yourself and family makes me very happy. I am just returned from Brighton, and am glad that I can give you a good account of my wife and children; my poor boy has gained strength and composure. I have been only occasionally with them, being very busy here, where I have done a great deal. I am hard at my 'Waterloo', which shall be finished for the next Exhibition, saving only the fatalities of life. I have nearly completed a second 'Cathedral', and I think you will perhaps prefer it to the first, but I will send it to Salisbury for your inspection. I have much more to say about pictures, but you say I never answer your letters. Your last delighted me. The account of the fire and the

★[1] The subject of several paintings by Constable

rats interested John Dunthorne and me alike. How fortunate that you were there. I am vexed at the fate of the poor old mill. There will soon be an end of the picturesque in the kingdom. I desire to come to Salisbury, if only for two days, to renew our friendship in those walks where it first took so deep a root. I *will* come. How did the fire originate? Write for me when you wish for me. You set my mind at rest by the way in which you speak of your picture being at Lisle; they have sent to know the price; I have set them right on that head. I am uncommonly well; never in better health or spirits."

"Charlotte Street, November 19th. My dear Fisher. . . . My expectation of the happiness of seeing you at Salisbury will be but a vision. I am so hard run in every way that I know not which canvas to go to first. My 'Waterloo', like a blister, began to stick closer and closer and to disturb my rest at nights. But I am in a field that knows no favour or affection: 'Go on' is the only order heard. . . . My name will not appear at the opening of the noble institution in Edinburgh.[1] I should like to have struck a blow in that quarter; but I must submit to circumstances. . . . John Dunthorne and I are delighted at the full occupation we have here. He is calm, gentle, clever, industrious, full of prudence, and free from vice."

"November 26th. My dear Fisher, My new picture of Salisbury is very beautiful, and I have repainted entirely that belonging to Mr. Mirehouse: but when I thus speak of my pictures, remember it is to *you*, and only in comparison with myself. These pictures of the 'Cathedral' have caused me of late to be almost abiding with you. My finances are sadly deranged, and this, I fear, will cause me to give up my large work. I have just had a visit from Mr. Bannister[2] to request a landscape; he has long desired one of me, from which, as he says, 'he can feel the wind blowing on his face'. Two chimney sweepers were at my door, 'What?' he said, 'brother brush'."

In the journal written for his wife Constable says, "November 25th. Painted all day on Mr. Mirehouse's little picture of

*[1] The Royal Scottish Academy.
[2] The inimitable 'Jack Bannister', a well-known actor.

the 'Cathedral', making in all three 'Cathedrums', as pretty Minna[1] calls them. Miss Bigg was here to know what we paid for asses' milk, as they charge six shillings a quart at the *Wellington Ass Shop* in the New Road. Mr. Strutt called to say they had orders for the play, Drury Lane, and asked me to join them to see 'Dr. Faustus and the Devil'. I declined, so he was kind enough to take Johnny Dunthorne, and he was much pleased, though 'it was very terrible'. The Devil was of a flaming red, and had a diabolical countenance, and it was shocking to see how he led on his victim to perpetrate every crime, till he was involved in Hell at last."

"November 28th. Master Billy kicked up a terrible rumpus in the yard to-day; he wanted to have a game of play with the fowls, but they took it in earnest, and made a great noise, especially the cock. John and I went to their assistance. Mr. Balmanno called, and was so delighted with my 'Waterloo' (though he only saw the sketch and outline) that he says it will be my triumph, and that I shall 'certainly set the Thames on fire, if anybody can'. I am now finishing a copy of my 'Lock',[2] which rejoices me a good deal; it is a very lovely subject. Mr. Bannister called, and saw all my goings on. He is fond of my landscapes, and says he must have one. I think he likes the 'Lock' so much that I shall reduce it to the size of Fisher's old mill; how I shall please him, or when, I do not know. He says 'he breathes the open air in my pictures, they are more than fresh, they are exhilarating.'

"Miss Arnott called to ask me, with her mother's compliments, to dine there on Christmas Day. I told her I had a wife, and must needs go and see her."[3]

[1] His eldest daughter.

*[2] This may be the version of the subject which Constable presented to the R.A. as his Diploma Picture. If so, he is using the word 'copy' in a loose sense, for the Diploma Picture (signed, and dated 1826) differs in some essentials from the 'Boat Passing a Lock' (R.A. 1824). See Plate 35.

*[3] Leslie has made several minor confusions of date in his transcripts from Constable's journal of 1825.

CHAPTER X

1826–1827

Return of the 'White Horse' from Lisle. Gold Medal voted to Constable. Letters of N. Poussin. Constable's Picture of 'The Cornfield'. Letter from Mr. Phillips. Mr. Fisher's Description of the Valley of Sutton and Preston. Anecdote of one of Mr. Fisher's Children. Exhibition at the Royal Academy, 1826. Description of a ruined Man. Paul Pry. Ludicrous Occurrence to the Ghost in 'Hamlet'. *The Brighton Gazette*. 'The Glebe Farm'. Mr. Fisher and Bishop Burgess. Northcote. Picture by Ruysdael. Exhibition at the Academy, 1827. Constable removes his family to a House in Well Walk, Hampstead.

"CHARLOTTE STREET, January 14th, 1826. My dear Fisher, I begin this hasty note by wishing you a happy new year, hoping Mrs. Fisher and all your children are well, and bearing up against this, to me, dreadful weather. All my family are at Brighton, and I left them well on Thursday. I stayed a fortnight with them, and painted there one of my best pictures, the subject, the 'Mill (Perne's) at Gillingham';[1] it is about two feet, and is so very rich and pleasing that, if you are at Salisbury, and would like to see it, I will beg the proprietor, Mr. Hand, to let me send it to you; Mere Church is in the distance. 'The White Horse' did me great credit at Lisle. I am honourably mentioned in the final discourse of the prefect, and a gold medal was voted to me, which I received yesterday. The discourse is curious; he speaks of the 'raciness and originality of the style, which being founded entirely in nature, is capable of much beauty, but dangerous to all imitators.' So far the Exhibition has extended my reputation, and I trust you will forgive what I did. There are generally among the works of an artist, one, two, or three pictures on which hang more than usual interest; this is one of mine. All things considered, the medal should be yours. Much pleasure had I at Brighton, mixed with a sentiment of melancholy, by a book in French which my wife read to me while I was painting the 'Mill', *The Letters of Nicolo Poussin*, now first published,[2] having hitherto lain undiscovered. They are written to his employers

★1 Now in the collection of Mr. W. L. Lewis, New York. See Plate 50.
★2 *Collection de Lettres de Nicolas Poussin.* Paris 1824.

151

in Paris, and are to me replete with interest. My wife has dis-
covered that painters now and painters then are little different.
The letters contain apologies to friends for not finishing their
pictures sooner, anxieties of all kinds, insults from ignorance,
etc.; one of them speaks of 'strange news from England, the
beheading of King Charles', etc. My large picture is at a
stand owing to the ruined state of my finances. You richly
deserve all I think of you for your kindness about your
picture. . . . I am executing all my commissions, amounting
in all to four hundred pounds; two months will complete
them. J. Dunthorne is painting portraits in the country."

"Charlotte Street, February 1st. . . . My dear Fisher, Your
picture is now standing in my room, and without a speck of
injury; do not hurry its departure. All this morning I have
been engaged with a sitter; a dissenter, but without knowing
why, only that his wife will not let him go to Church."

"Osmington, February 5th. My dear Constable. I plead
guilty to neglect, and feel much humbled by the forgiving
tone of your last letter. The truth is, my mind has been
unusually occupied for the last six months. I do not affect the
plea that I could not find *time*, but I could not find the *dis-
engaged mind*. When I write to you, I do it with all my heart,
and when its impulses are obstructed with care or business, I
have no appetite for our agreeable correspondence. . . .
Bishop Burgess has, in a most flattering manner, reinstated me
in my old situation as chaplain, and I am just where I was in
my uncle's time.[1] This is a very tall feather in my cap, and I
am not a little elevated by it. I sit at the bottom of the old table,
but, I confess, I painfully miss old faces. . . . I shall be at
Salisbury for some days at the end of this month, and I should
like much to have Perne's mill there to look at. J. Fisher."

Having laid aside the 'Waterloo', Constable was engaged
on a subject more congenial to his taste, 'The Cornfield', now
in the National Gallery. It had been seen by Mr. Phillips of
Brighton, who suggested some materials for its foreground in
a letter of which the following is a part: "March 1st. My dear

*[1] Bishop Fisher died in 1825.

Sir, I think it is July in your green lane. At this season all the tall grasses are in flower, bogrush, bullrush, teasel. The white bindweed now hangs its flowers over the branches of the hedge; the wild carrot and hemlock flower in banks of hedges, cow parsley, water plantain, etc.: the heath hills are purple at this season; the rose-coloured persicaria in wet ditches is now very pretty; the catchfly graces the hedge-row, as also the ragged robin; bramble is now in flower, poppy, mallow, thistle, hop, etc."

"April 8th. My dear Fisher. I should not have remained so long silent after your last kind and friendly letter, had I been wholly without news of you and yours. I am glad to find from my friends in Seymour Street that you are all well, and that I may expect to see you for some continuance of time in London, 'after the lilacs have blossomed at Osmington.'

"I will endeavour to answer your letters in future, but when I write to you, I am always full of myself, which is indeed abominable; but you must thank yourself for taking a greater interest in all that concerns me than any other human being. . . . I have despatched a large landscape[1] to the Academy, upright, of the size of the 'Lock', but a subject of a very different nature: inland corn fields, a close lane forming the foreground; it is not neglected in any part; the trees are more than usually studied, the extremities well defined, as well as the stems; they are shaken by a pleasant and healthful breeze at noon:

'while now a fresher gale
Sweeping with shadowy gusts the fields of corn', etc.

I am not, however, without my anxieties, though I have not neglected my work, or been sparing of my pains. . . . I, at this moment, hear a rook fly over my painting-room, in which I am writing; its call transports me to Osmington, and makes me think I am speaking and not writing to you; it reminds me of our happy walks in the fields, so powerful is the voice of nature. My picture occupied me wholly: I could think of and speak to no one. I felt like a relation of mine in the battle of

*[1] 'The Cornfield'.

Waterloo. He said he 'dared not turn his head right or left, but always kept it straight forward, thinking of himself alone.' I hear of some fine pictures that are gone; Callcott has three; Ward, a battle; Collins', I hear, are very fine, but I have not seen them; Lawrence has but one whole length, Shee only one, Jackson but one, and Phillips none, so there will be a dearth of large canvases. I am not writing in the best of spirits. To-day my boy has gone to Brighton to school; John Dunthorne is gone with him. I saw him as far as Charing Cross, and then left him to his fate. I hope for the best, and that the air will do him good. I am much worn, having worked hard, and have now the consolation of knowing I must work a great deal harder, or go to the workhouse; I have some commissions, however, and I do hope to sell this present picture. ——[1] threatens me with having to paint his portrait:

'Angels and ministers of grace defend me!'

He is hospitable, but there is a coarseness about him that is intolerable."

"To Mr. Samuel Lane. I am just returned from Suffolk. I left London by the mail of Wednesday night in great anxiety and alarm for the state of my brother, who was suddenly attacked by fever. I returned on Sunday morning. He was better, and I hope free from danger. 15th April."

"Osmington, April 22nd. My dear Constable. With this I send you your sketch books, so long detained. But they have propagated your name in heavy soils, where your pictures would never have taken root. My wife, to save the books from rubbing, sends some little memoranda of kindness to our god-children. . . . I had rather see you here than in London; this is a country that the more you live in it, the more you discover its beauties. Did you ever look down the little wooded valley of Sutton and Preston from the spring heads in the little amphi-theatre formed by the hills? It has a peep of the blue bay, with Portland in the distance, and two old forlorn ash trees in the foreground; the place is very sequestered, and is frequented by

★[1] Mirehouse.

kingfishers and woodcocks; but fellows from Weymouth with padded chests and vacant faces come there and let off guns, and disturb the quiet genius of the place; this in return for your rook. When your pet, Belim,[1] repeats his Catechism, we cannot make him say otherwise than, 'And walk in the *same fields* all the days of my life'; he might have a worse idea of happiness."

"Charlotte Street, April 26th. My dear Fisher, I received your letter and the books; and the kind recollections of Mrs. Fisher and yourself towards your god-children have afforded me great pleasure. I shall proceed to *answer* your letter. First, to say that you may have the comfortable room next ours, with either a feather-bed or mattress, as you please, and for as long as you please. Secondly, the spot you speak of, I well recollect, is lovely; the expanse around, contrasted with the deep recesses and solitudes below; but in general these subjects deceive on canvas. The anecdote of dear Belim is very pretty; depend on it, the love of nature is strongly implanted in man. I have lately been into Suffolk, and have had some delightful walks 'in the *same fields*'. Bless the dear boy! our ideas of happiness are the same, and I join with you in praying that he may never seek it in less hallowed places.

"When my mind is disturbed it stirs up the mud. How could circumstances ever place me in such a situation as to write so much stuff to an *Archdeacon*![2]

"I am now busy at the Academy, and am writing early, as after breakfast I must be there. My wife is very good, and is at the breakfast-table by eight; she is now there, and as I have much to do, I will put this letter into my pocket, and finish it at Somerset House. It is quite out of my power to describe the scene of dismay and desolation the rooms present. I could quote Dante and Milton:

'Dire was the tossing,' etc.

but it is a delightful show. Turner never gave me so much

[1] William.

[2] Constable here alludes to parts of his correpondence with Mr. Fisher relating to a third person, and which for that reason are not published.

pleasure or so much pain before. Callcott has a fine picture of a picturesque boat driven before the wind on a stormy sea; it is simple, grand, and affecting. He has another large work, not so good, rather too quakerish, as Turner is too yellow; but every man who distinguishes himself stands on a precipice. Sir Thomas Lawrence's portraits of Peel and Canning are very fine. He has a lady playing on a guitar hanging by Turner, and you seem to hear its imperfect sounds over his 'wide watered shore'. 'Canning' is over the fireplace, an 'Entombment' by Westall at the bottom of the room, and Etty's 'Judgment of Paris' on the west side centre; the details of this show we shall soon analyse together. Chantrey loves painting, and is always upstairs. He works now and then on my pictures, and yesterday he joined our group, and after exhausting his jokes on my landscape, he took up a dirty palette, threw it at me, and was off. Presently he came back and asked me if I had seen a beastly landscape by ———. It is so indeed. The voice in my favour is universal, it is my 'best picture'.

"——— has some of his heartless atrocious landscapes in Seymour Street, and has sent to consult me on them. How shall I get out of such an infernal scrape? Truth is out of the question. What part can I then play?"

Constable exhibited, with 'The Cornfield',[1] a smaller landscape, but I do not remember the subject.

"Charlotte Street, July 7th. My dear Fisher. You will receive Dunthorne's Wilsons[2] to-morrow; Mrs. Fisher cannot fail to be pleased with them.—I have added a little to your batch of Waterloos, making, I think, a nice bargain for ten guineas. Have you done anything to your walls? they were of a colour formed to destroy every valuable tint in a picture. ... A poor wretched man called to see me this morning; he had a petition to the Royal Academy for charitable assistance: it was ———. His appearance was distress itself, and it was

*[1] Now in the National Gallery (No. 130). Constable's second exhibit was 'A Mill at Gillingham in Dorsetshire'; this is believed to be Mr. Lewis's picture mentioned on p. 151.

*[2] Copies by Dunthorne after paintings by Richard Wilson.

awful to behold to what ill-conduct may bring us; yet calamity
has impressed even on this man an air of dignity; he looked
like Leslie's Don Quixote. When I knew him at the bishop's
he wore powder, had a soft subdued voice, and always a smile,
which caused him to show some decayed teeth, and he carried
a gold-headed cane with tassels. Now, how changed! his neck
long, with a large head, thin face, nose long, mouth wide, eyes
dark and sunken, eyebrows lifted, hair abundant, straight,
erect, and very greasy; his body much emaciated and shrunk
away from his dismal black clothes, and his left arm in a sling
from a fall, by which he broke the left clavicle; I shall try the
Artist's Fund for him. I cannot efface the image of this ghostly
man from my mind. . . . Poor Mr. Bicknell is in a sad state;
he had an attack of apoplexy about ten days ago; it was coming
on when you saw him. . . . I have made several visits to the
terrace at Lord Pembroke's; it was the spot of all others to
which I wanted to have access.[1] I have added two feet to my
canvas. My wife and all here are well. I trust we shall not need
a country excursion, in which we leave this convenient house.
and pay four guineas a week for the privilege of sleeping in a
hen-coop, for the sake of country air."

"September. My dear Leslie, On returning to town this
morning, and once more perusing your note, I find myself
quite mistaken. I had missed the date, and consequently missed
'Paul Pry',[2] a serious loss to me; but the word 'to-morrow',
instead of naming the precise day, often leads to such mistakes
on the side of the reader, the writer being fully aware of what
he means; but it is my loss, and I assure you I had not a little
reckoned on seeing such a master of humour, in company with
yourself. I write in the forlorn hope that possibly you and Mrs.
Leslie did not go."

Few persons more thoroughly relished good acting than
did Constable, when he could be prevailed on to witness it.
Yet so seldom did he visit the theatres that he never saw either

[1] Part of Lord Pembroke's house and terrace form the nearest objects in the
picture of 'The Opening of Waterloo Bridge'.

*[2] A comedy by John Poole, which had first been produced in 1825.

Kean or Liston, though I had several times proposed to accompany him when those great masters of their art were to perform.

I have heard him give a ludicrous account of an accident that happened during one of the few visits he ever paid to a theatre. The play was 'Hamlet', and the ghost, from some derangement of the machinery, stopped in his descent, and remained for a considerable time presenting a half-length figure, shaken occasionally by the efforts of the carpenters to complete his exit, which was at length accomplished more rapidly than was desirable, amidst roars of applause. Constable happened to mention the circumstance some years afterwards to his neighbour, Mr. Pope,[1] adding, 'I shall never forget it,' when the latter said, 'Neither shall I, for I was that unlucky ghost.'

"Charlotte Street, September 9th. My dear Fisher, It is a very long time since I have heard from you, and I have now no means of hearing of you elsewhere. Let me have a line soon to dispel the thought that anything may be amiss, or any part of your family out of health. You once said 'life is short', let us make the most of friendship while we can. I have little to say of what belongs to myself, but that little is good. My children are well, and my wife, for her, very tolerable; they are in a small house on Downshire Hill, to which it is an easy walk from home. I have just come back from a day or two at Brighton, where I had been to return my boy to Mr. Phillips. John Dunthorne is still in Suffolk very busy; his last job is a large sign of the Duke of Marlborough. I have written to hasten him; he is wanted here by myself and others. My last landscape is a cottage scene with the Church of Langham, the poor bishop's first living; it is one of my best in colour, fresh and bright, and I have pacified it into tone and solemnity. My friend Mr. Phillips is commencing a literary journal at Brighton: he wants me to contribute some paper on Art, landscape, of course. What do you say? . . .Rochefoucault says, 'Lovers are never tired of each other's company, because they always talk of themselves.' "

★1 Alexander Pope (1763–1835), tragic actor and miniature-painter.

The cottage with Langham Church was a pet subject with Constable; he repeated it frequently, and left one or two unfinished pictures and sketches of it with considerable variations. His best picture of this pretty subject, and one of his most perfect works, is that from which the engraving in the *English Landscape*, with the title of 'The Glebe Farm' is taken.[1] The rising ground and trees on the right hand are imaginary, as the ground, in reality, descends rather steeply on that side of the church.

"Close, Salisbury July 1st. My dear Constable. The two pictures arrived safe on Friday, and within an hour were up in their places; 'The White Horse' looking very placid, and not as if just returned from the Continent. It is wonderfully improved by Dunthorne's coat of varnish. The 'Cathedral' looks splendidly over the chimney-piece. The picture requires a room full of light. Its internal splendour comes out in all its power, and the spire sails away with the thunder-clouds."

"Maidenhead, September 27th. My dear Constable. Do not accuse me of neglect. You were never more occupied in the month of April preparing for the Exhibition, than I have been since the month of August. Last week there was an ordination, and I preached the sermon which you will soon see in print. . . . I write this sitting in commission upon a dispute between a clergyman and his parishioners, and compose while the parties argue. There is a brother parson arguing his own case, with powder, white forehead, and a very red face, like a copper vessel newly tinned. He is mixing up, in a tremulous tone, with an eager blood-shot eye, accusations,—apologies,—statements,—reservations,—and appeals, till his voice sounds on my ear, as I write, like a distant waterfall. . . .

"I am doubtful about your *Brighton Gazette*. You are in possession of some very valuable and original matter on the subject of painting, particularly on the poetry of the art. I should be sorry to see this seed sown on an unvisited field,

*[1] Now in the Tate Gallery (No. 1274). Oil-sketches of the subject are in the Tate Gallery (No. 1823) and the Victoria and Albert Museum (No. 161–1888).

where it would blossom in forgetfulness, while some thriving author, like a sparrow, would fly off with a sample, and take the credit from you. Throw your thoughts together as they arise in a book, that they be not lost; when I come to see you, we will look them over, put them into shape, and do something with them. Pray do not forget to put together the history of your life and opinions, with as many remarks on men and manners as may occur to you. *Set about it immediately; life slips.* It will perhaps bring your children in a hundred pounds in a day of short commons, if it does nothing else; besides, I have been all along desirous of writing your life and rise in the art. . . .

"I live with the new bishop as son with father, or brother with brother. Our habits of life similar, our pursuits similar, our modes of thought similar, or only sufficiently different to increase the pleasure of communication. . . . I have been unconsciously acquiring, at Osmington, in long winter evenings, a greater share of knowledge than I was myself aware of; and find that I have no reason to be discontented with the use I have made of my time. The bishop improves me and drives me on in my classical acquirements; while in general divinity and comprehensive views of history I find myself 'in easy circumstances'. He is urging me to overcome my indolence and show myself in print, and before I die I shall be out. I have got my nerves steadier, and my understanding more under my control. My ambition is strongly awakened, and I see glimpses of light through the wood."

"Charlotte Street, November 28th. My dear Fisher, The rumour may have reached you that I have another boy; the number of my children is now six, being three of each.

"I gloried in your letter. Its friendship for me was, if possible, forgot in the delight of seeing you at length properly appreciating yourself. You need never fear indulging too much in the exulting tone it breathes. Take care that you launch your boat at the appointed time, and fearlessly appear before the world in a tangible shape. It is the only way to be cured of idle vapours and useless fastidiousness.

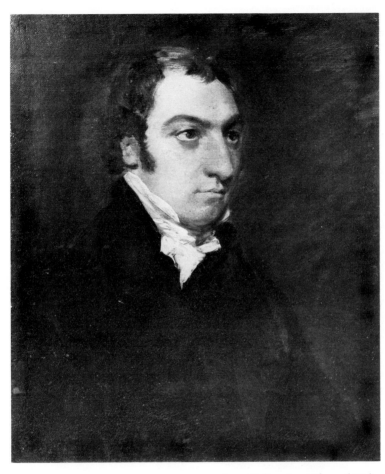

VII. ARCHDEACON JOHN FISHER. 1817. Collection Edward Fisher

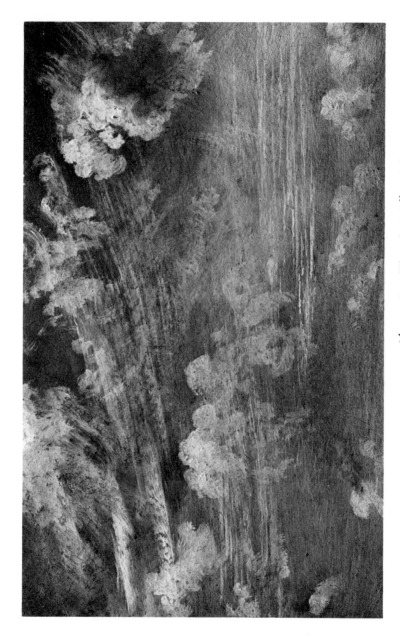

VIII. STUDY OF CLOUDS. About 1821. Victoria & Albert Museum

"My wife is at Hampstead, and both she and the infant are doing well. I am endeavouring to secure a permanent small house there, and have put the upper part of this house into an upholsterer's hands to let, made my painting room warm and comfortable, and have become an inhabitant of my parlours. I am three miles from door to door, and can have a message in an hour. I shall be more out of the way of idle callers, and above all, see nature, and unite a town and country life, and to all these things I hope to add a plan of economy. . . .

"I passed last evening with Northcote; he enjoys a green old age, and is as full of vivacity as ever; he is always instructive and amusing. Talking of excellence, he said, 'It should be the aim of an artist to bring something to light out of nature for the first time. Something like that for which in mechanics a patent would be granted; an original invention or a decided improvement; patents are not given for making a time-piece or a telescope, as long as it differs not from others.' He says, 'The failures, and difficulties of success, in the arts and literature are for the most part caused by our early habits and education. Virgil is driven into boys as the height of excellence, whereas he is but a farthing candle compared with Shakespeare.' The first book he (Northcote) ever read was 'Jack the Giant-killer', and he still believes it unequalled.

"I have taken your advice, and not written anything for the *Brighton Courier.*—I have seen an affecting picture this morning by Ruysdael; it haunts my mind, and clings to my heart, and stands between you and me while I am talking to you; it is a water-mill; a man and boy are cutting rushes in the running stream (the tail-water); the whole so true, clear, and fresh, and as brisk as champagne; a shower has not long passed.—I am delighted to see how you live with the bishop; that you avail yourself of his great worth and understanding, and that he does not use his rank nor the wisdom of age, to trip up and overbear the valuable qualities, the vigour and energy, to be found in youth and middle age."

In 1827 Constable sent to the Academy a large picture of

'The Marine Parade and Chain Pier at Brighton',[1] and two smaller ones, 'A Water Mill at Gillingham, Dorsetshire', [2] and 'Hampstead Heath'. To the British Institution he sent his 'Cornfield', and 'The Glebe Farm'.[3]

"Sunday Evening, August 26th. My dear Fisher, We sadly neglect much happiness that lies within our reach. Weeks and months have passed since we met, and no communication. I know not where you are, and you know not what I have been so long about. Your cares lay far and wide apart, and I am not wholly without mine. Still we do amiss to remain inactive towards each other for both our sakes. No worse account can be given of life than to have neglected the social duties. . . . We are at length fixed in our comfortable little house in Well Walk, Hampstead, and are once more enjoying our own furniture, and sleeping in our own beds. My plans in search of health for my family have been ruinous; but I hope now that our movable camp no longer exists, and that I am settled for life. So hateful is moving about to me, that I could gladly exclaim, 'Here let me take my everlasting rest!' The rent of this house is fifty-two pounds per annum, taxes twenty-five, and what I have spent on it, ten or fifteen. I have let Charlotte Street at eighty-two pounds, retaining my two parlours, large front attic, painting-room, gallery, etc. This house is to my wife's heart's content; it is situated on an eminence at the back of the spot in which you saw us, and our little drawing-room commands a view unsurpassed in Europe, from Westminster Abbey to Gravesend. The dome of St. Paul's in the air seems to realise Michael Angelo's words on seeing the Pantheon: 'I will build such a thing in the sky.' We see the woods and lofty grounds of the East Saxons to the north-east. I read Turner's *History* continually, for two

*[1] Now in the Tate Gallery (No. 5957). See Plate 42.

*[2] Thought to be the painting now in the Victoria and Albert Museum (No. 1632–1888).

*[3] To the B.I. Constable also sent 'A Mill at Gillingham'. The measurements given in the B.I. catalogue for 'The Glebe Farm', if correct, make it impossible that this was the finished version now in the Tate Gallery (No. 1274). Perhaps Constable exhibited the sketch (Tate Gallery No. 1823) whose dimensions correspond.

reasons: first, I think thereby of you, and secondly, its information is endless, and of the best kind. I have Burnet's book on colour[1] for you from Carpenter's; where shall I send it, or shall I meet you at Sarum during your durance, and make a few autumnal sketches on spots endeared to us both? My 'Brighton' was admired on the walls, and I had a few nibbles out of doors. I had one letter from a man of rank, inquiring what would be 'its *selling* price'; is not this too bad? but this comes of the bartering at the Gallery. My Dr.[2] —— has paid, but nothing more; no one will buy a schoolmaster, for who would hang up a picture of the keeper of a treadmill, or a turnkey of Newgate, who had been in either place? Mr. Bannister is my neighbour here; a very fine creature he is; very sensible, natural, and a gentleman.

"Lord De Tabley's English pictures have lately sold for eight thousand pounds;[3] two thousand more than he gave for them: a landscape by Wilson, five hundred pounds; query, had he fifty for this truly magnificent and affecting picture? 'May this expiate!' John Dunthorne has completed a very pretty view of your lawn and prebendal house, with the great alder and the cathedral.[4] He is now in Suffolk, painting a portrait of ——, whose ugliness is portentous; how John will get on with him I know not. We long to hear news of you and Mrs. Fisher and your children. We are well here. My pretty infant soon after you saw him was seized with whooping-cough. I find medical men know nothing of this terrible disorder, and can afford it no relief, consequently it is in the hands of quacks. I have been advised to put him *three times over and three times under a donkey*, as a certain cure. . . . I have painted one of my best pictures here."

*[1] John Burnet, *Practical Hints on Colour in Painting*, London 1827.

[2] An engraving from one of his portraits

*[3] Lord de Tabley's collection was dispersed on 7th July, 1827: it included contemporary English paintings, several by Turner but none by Constable.

*[4] Mr. Edward Fisher possesses a painting by Dunthorne which answers this description. It is closely based on Constable's sketch of 'Salisbury Cathedral from the river', now in the National Gallery (No. 2651) and reproduced here on Plate 44.

"Close, Salisbury, September 3rd. My dear Constable, . . . I am elected a member of the Royal Literary Society, and must appear in London, in December, to be installed. I shall then have an opportunity of seeing you at the bottom of Well Walk. The arrangement is good in one particular. You will be less disturbed by morning flies than in Charlotte Street. . . . I am worn to death with the incessant visiting of the same persons, and the same prate of this busy-idle place. The whole of the diocese is on my hands, I educate my own boys, and there you have sufficient reasons why I write so seldom. J. Fisher."

Constable passed the remainder of this year happily with his family at Hampstead, where he painted several small landscapes.

CHAPTER XI

1828–1829

Illness of Mr. Abram Constable, and of Mrs. Constable. Birth of Constable's
youngest Child. Pictures of 'Dedham Vale', and of 'Hampstead Heath'. Death
of Mr. Bicknell. His Bequest to Mr. and Mrs. Constable. Exhibition at the
Royal Academy, 1828. Death of Archdeacon Coxe. Illness of Mrs. Constable.
Her Death. Constable ill. Receives a commission to paint a Sign. Elected an
Academician, 1829. Congratulations from some of his Friends. Sir Thomas
Lawrence and Constable. Picture of Hadleigh Castle. Constable engaged in
preparing the *English Landscape* for publication. Mr. David Lucas.

IN the spring of 1828, Constable was called to Flatford by an
illness of his brother Abram, Mrs. Constable being at the
same time extremely unwell.

The following note to Mr. Samuel Lane must have been
written at this time. "My dear Lane, I am glad to hear of your
return. I hope we shall meet soon. My poor wife is still very
ill at Putney, and when I can get her home I know not. We
talk of Brighton, but we only talk of it. She can't make such a
journey. I am glad to remain quiet at my work, as I want to rid
my mind of some troublesome jobs. I am just returned from
Suffolk, where I was again called to see my brother, but I left
him so much better that I am cheered. I advised him to send
away all his doctors. They have left him in possession of his
purse only,—now empty,—and of himself, only his skeleton."

"Charlotte Street, June 11th. My dear Fisher, Is it possible
that I should have had little or no tidings of you since we
parted in November? We do sad injustice to our friendship.
This silence is a bad thing, and I am determined not to let this
(my birthday) pass without emancipating myself from what
appears almost a spell, for I never felt a greater desire to write
nor ever had in reality more to say to you, at least of myself,
than now. This has been to me a most eventful year, for half of
it has not yet passed, and three things of moment to myself
have occurred: first, the birth of a baby boy, whom we have
named Lionel Bicknell, 2nd of January: secondly, I have
painted a large upright landscape, perhaps my best; it is in the

165

Exhibition, and noticed as 'a redeemer' by *John Bull*, and another, less in size but equal in quality, purchased by Chantrey: thirdly, and lastly, though *not least,* Mr. Bicknell has left us a fortune that may be £20,000!—This I will settle on my wife and children, that I may do justice to his good opinion of me. It will make me happy, and I shall stand before a six-foot canvas with a mind at ease, thank God!

"The Exhibition is poor; but though the talent is small, its produce in money has been very great; £150 per diem, perhaps, on an average. I have little time to speak of it. Lawrence has many pictures, and never has his elegant affettuosa style been more happy. Jackson is the most of a painter, but he does not rank with Lawrence in general talent. Turner has some golden visions, glorious and beautiful; they are only visions, but still they are art, and one could live and die with such pictures. Some portraits that would petrify you. Newton has 'The Vicar of Wakefield', most affecting. . . .

"My wife is sadly ill at Brighton; her letter to-day is however cheerful. Hampstead, sweet Hampstead, is deserted. I am at work here, and shall take my boy and pretty Minna to Brighton on the 20th."

The upright picture mentioned in this letter was a view of 'Dedham Vale',[1] and the small one, the 'Hampstead Heath'.

"Salisbury, June 19th. My dear Constable. . . . Your legacy gave me as much pleasure as it could have communicated to yourself. You will now be relieved from the carking cares of leaving a young family to privation and the world. You will feel that your fame and not your bread is dependent upon your pencil. . . . Mr. Bicknell has paid you a high moral compliment. . . . My plan of provision is to leave a home, and bread to eat, round which the weak and unsuccessful of my family may rally. Perhaps this should be your plan.

"Poor Coxe, as you probably know from Peter, is no more. He died of old age.—A more irreproachable, friendly man did not exist. He was always benevolently employed, and at his funeral, the congregation disturbed the service with sobs.

* [1] Now in the National Gallery of Scotland (No. 2016). See Plate 41.

After a great dinner, he used to steal into his kitchen and give his cook a guinea. His domestics never left him. A silent but strong compliment. His regard to truth was remarkable. He is the author of twenty-four quarto volumes, and has hardly been convicted of a mistake. He was quoted as an authority in his lifetime, an event of rare occurrence. . . . J. Fisher."

Constable returned with his wife to Hampstead, from whence he wrote on the 22nd of August to John Dunthorne, Jun., who was at Bergholt, "I do hope things are not going on worse here. On the contrary, I believe Mrs. Constable to be gaining ground. Her cough is pretty well gone and she has some appetite, and the nightly perspirations are, in a great measure, ceased. All this must be good, and I am a great deal cheered. Still I am anxious,—she is so sadly thin and weak. I am determined to try and get her out. . . . The Neyland business can soon be decided upon.[1] *I hope you will do it,* but only in conjunction with your father. I think it requires not a moment's hesitation. Take care of cold. Work with the door and windows of the church open, even if that should make it colder. It will drive out damp and smell of graves, etc. Nothing so bad as the air of a large apartment, as it never changes itself, and it always flies to the heart, liver, and lights. I was nearly killed, copying Sir Joshua, at Lady Dysart's, Hyde Park Corner. . . . Remember Claude painted sham architecture in churches, and it did not prevent his becoming a painter. But he fell off a scaffold."

In a letter to Mr. Dominic Colnaghi,[2] dated September 15th, Constable writes: "I am greatly unhappy at my dear wife's illness; her progress towards amendment is sadly slow, but still they tell me she does mend; pray God this may be the case! I am much worn with anxiety." And in a note to Mr. S Lane, dated October 2nd, he says: ". . . My dear wife continues much the same; I do hope she is not worse, and home may yet do wonders."

[1] This seems to have been that John Dunthorne should paint some ornamental work in the interior of Neyland Church.

*[2] Dominic Paul Colnaghi (1790–1879), print-dealer and connoisseur.

The letter, to which the following is a reply, is missing. It no doubt, contained a desponding account of the state of Mrs. Constable's health. "Close, Salisbury, October 4th. My dear Constable, Your sad letter has just reached me, and I grieve to say, at a time when I fear I cannot move. I am expecting to be called into residence at this place, when I must be a fixture until January. But if this be not the case, and I can get my liberty, I will come and see you soon. I fear your friendship makes you overvalue the use I can be of to you; but what I can give, you shall have. . . . I began this letter at Salisbury and I finish it at Osmington, and to-morrow I start for Salisbury again. Support yourself with your usual manliness, and believe me always your most faithful and attached, John Fisher."

Mrs. Constable's sufferings, which she endured with that entire resignation to the will of Providence that she had shown under every circumstance of her life, were occasioned by pulmonary consumption. I was at Hampstead a few days before she breathed her last. She was then on a sofa in their cheerful parlour, and although Constable appeared in his usual spirits in her presence, yet before I left the house, he took me into another room, wrung my hand, and burst into tears, without speaking. She died on the 23rd of November.

"Osmington, Weymouth, November 29th. My dear Constable, I write with the hope and intention of giving you comfort, but really I know not how; yet if there be any consolation to the heart of man to know that another feels with him, you have that consolation. I do sympathise with you, my old and dear friend, most truly, and I pray God to give you fortitude. I am additionally grieved that I cannot come and say this in person, but I am so entangled with my family and numerous affairs, that I cannot reach London until December. Our new but estimable friend, Evans,[1] paid me a most flattering visit. He travelled one hundred miles out of his way to come and see me in my Arcadia for twelve hours only. He arrived over night, and left me next day at noon; we had time,

[1] Mr. Evans of Hampstead was the medical friend who had attended Mrs. Constable.

however, to exchange a great deal of mind. Our conversation turned, of course, much upon you; we agreed that for your comfort, during the trial upon you for the exercise of your patience, you should apply yourself rigidly to your profession. Some of the finest works of art, and most vigorous exertions of intellect, have been the result of periods of distress. Poor Wilson painted all his finest landscapes under the pressure of sorrow.

"Let us talk of other things. I met in Schlegel a happy criticism on what is called Gothic architecture. We do not estimate it aright unless we judge of it by the spirit of the age which produced it, and compare it with contemporary productions. The Gothic Minster was the work which gave birth to that phenomenon, the Crusades, and realised that poetical beautiful monster, the mailed knight, who went forth in purity and honour to preach the Gospel with his mouth, while he broke its laws with his sword. The Minster was raised to hold such worshippers while alive, and to contain their gorgeous tombs when dead; and we never look at the Cathedral aright, unless we imagine mitred abbots and knights in chained armour, walking in procession down its solemn aisles. I have put Schlegel into our own language, and have enlarged a little on his notion, since he only hints the thing. What a propriety it gives to the tombs of the cross-legged knights! The monkish priests exacted the tribute of putting off the knightly spur when the Cathedral was entered. Our choristers fine anybody at this day coming in with spurs.—I do not know what to go on writing to you about. I live here apart from the world, and run into contemplative habits. Socrates considered life only as a *malady* under which the nobler spirit was condemned for a time to linger, and called living, 'the learning how to die'; he meant that the vexations of life render death desirable. The word *malady* explains the cock sacrificed to Æsculapius; death was curing him of his *malady,* and he sacrificed the fowl, in playful allusion to this, to the god of physic. It is singular, but this notion has much helped me under some very vexatious circumstances. Christianity puts the argument

higher, and makes the *malady* preparative to better and lasting health. . . . J. Fisher."

"Osmington, December 7th. My dear Constable, As soon as my mother is fixed at Hampstead, I will come and pay you a visit, and help you to bear your privation. . . . Evans's letter was so far satisfactory that he reported you to be in a state of complete self-possession. I entreat you to retain it, for you have need only to look within yourself, and find satisfaction. I wish, if 'Brighton' is not out of your possession, you would put it on your easel by your side, and mellow its ferocious beauties. Calm your mind and your sea at the same time, and let in sunshine and serenity. I feel much for your situation, but cannot put these feelings into words. You have a treasure in your new friend Evans, who is always at hand. . . . J. Fisher."

"January 8th, 1829. My dear Constable, . . . The tone of your letter to me was very satisfactory. You appear to be smitten, but not cast down. I will lend you any assistance in my power in the education of your children. There is a little book published by the Society for Promoting Christian Knowledge, which is all you want for religious instruction, Crossman's *Introduction*, to which you may add Nelson's *Practice of True Devotion*. It is a most sensible book. . . . J. Fisher."

Constable returned with his children to London, but retained the house at Hampstead as an occasional residence.

"Charlotte Street, January 21st. My dear Leslie, Do not believe me to be either ungrateful or negligent in that I have not called on you, or taken any notice of your kind attentions to me on my coming hither. You know that I have my seven children here. This is a charge I pray God you may never feel as I do. Six of the seven are in lovely health, but I grieve to say my darling boy John is in a sad state. . . . In this sweet youth I see very much that reminds me of his mother; but I must not trust myself on this subject; my grievous wound only slumbers. I hope dear Mrs. Leslie and your children are well. My thoughts are often on your infant, for I well remember, on its being brought into my drawing-room at Hampstead, the

gleam of joy that overspread that countenance which is never absent from my sight. . . . I should like to see you, and am anxious to pass an evening with you. I send this note by a messenger, that you may appoint any afternoon that I can come to you. I have been ill, but I have endeavoured to get to work again, and could I get afloat on a canvas of six feet, I might have a chance of being carried away from myself. I have just received a commission to paint a *mermaid* for a *sign* to an inn in Warwickshire. This is encouraging, and affords no small solace after my previous labours in landscape for twenty years. However, I shall not quarrel with the lady now, she may help to educate my children." He then changes the subject, and after some pleasantry, goes on to say, "I would not write this nonsense at all, were it not to prove to you, my dear Leslie, that I am in some degree, at least, myself again."

Constable made a very pretty and finished sketch of the mermaid,[1] but I do not think the matter ever went farther. He gave the sketch to Mr. Evans.

On the 10th of February, he was elected an Academician. That this distinction should not have been conferred on him at a much earlier period of his life is a proof that the progress of an original style of art, in the estimation even of artists, is very slow. Much as he was pleased at the attainment of this honour, he could not help saying, 'it has been delayed until I am solitary, and cannot impart it.' He did not add with Johnson, 'until I am known, and do not want it'; for no painter of equal genius was ever less known in his own country. Wilkie, who had been for some time abroad, told me that, when he saw Constable's pictures in the Louvre, he could not understand why the painter of such magnificent works had not long been a full member of the Academy.

"Lodge, Charter House, February 11th. My dear Constable, Although I fully expected the event, your note telling me that you are an Academician gave me the greatest pleasure. Your rewards are at last beginning to flow in upon you, although

· *[1] A pen and ink sketch of this subject is in the collection of Colonel J. H. Constable.

(as everything is ordained in a state of trial) the painful is mixed with the sweet. My mother sends her congratulations, which are worth the having. To-morrow I go with you to call upon your friends. The event is in every way important to me, since my judgment was embarked in the same boat with your success. Most faithfully yours, John Fisher."

"My dear John Chalon. Accept my thanks for your kind message to me by your brother. I greatly rejoice in the event of my election, as it is attended with so many gratifying circumstances; but I assure you, in none more so than the certainty that it cannot fail to promote and continue our esteem for each other. I beg my kindest regards to your family. Believe me, dear Chalon, your brother's kind and constant support of me has made an impression on my mind never to be done away by time or circumstances. After he left me last night, there came 'though last, not least', Turner and Jones.[1] We parted at one o'clock this morning, mutually pleased with one another. I shall take an early opportunity of calling at your house. . . . Ever, dear Chalon, believe me to be most sincerely yours, John Constable. Charlotte Street, February 11th.

"34, Gerrard Street, Soho, February 11th. My dear Constable, Our friend Peter Coxe has just called in the highest glee to tell me of your good fortune, or rather of your having attained an honour which ought to have been conferred on you long ago. It is now somewhere about twenty-seven years since you and I first entered the Academy together as students. From that period, in much intercourse, it is to me a gratifying reflection that never on any single occasion did any cloud interpose to interrupt the sunshine of our friendship, nor even the shadow of a cloud, yet you have produced many, but always painted them so well that they have only increased my admiration of your very original genius. Our uniform coincidence of opinions on men and things is equally remarkable.— Having gained this election, you have nothing higher to look up to in this world. I would, therefore, my dear friend, take

*[1] George Jones R.A. (1786–1869), painter of battles, portraits and landscapes: one of Turner's executors.

this opportunity, and the privilege of a friend, to direct your attention more and more to another election which we are all too apt to lose sight of, our election to a glory far above and beyond all the kingdoms of this world and to secure which is the great purpose for which we are sent into it. I should have had the pleasure of calling to congratulate you, but I am still confined by illness. Believe me to remain on all occasions, my dear Constable, ever affectionately yours, Andrew Robertson."[1]

Constable called, according to custom, after the honour that had just been conferred on him, to pay his respects to Sir Thomas Lawrence, who did not conceal from his visitor that he considered him peculiarly fortunate in being chosen an Academician at a time when there were historical painters of great merit on the list of candidates. So kind-hearted a man as Lawrence could have no intention to give pain; but their tastes ran in directions so widely different, and the president, who attached great importance to subject, and considered high art to be inseparable from historical art, had never been led to pay sufficient attention to Constable's pictures to become impressed with their real merit, and there can be no doubt but that he thought the painter of, what he considered, the humblest class of landscape was as much surprised at the honour just conferred on him, as he was himself. Constable was well aware that the opinions of Sir Thomas were the fashionable ones; he felt the pain thus unconsciously inflicted, and his reply intimated that he looked upon his election as an act of justice rather than favour. What occurred at this visit, as well as some ill-natured paragraphs in the newspapers, will explain a passage marked by italics in a note to me, dated "Hampstead, April 5th. Since I saw you I have been shut up here. I have forwarded my picture of 'Hadleigh Castle', which I shall send to Charlotte Street to-morrow morning. Can you oblige me with a call to tell me whether I ought to send it to the Exhibition? I am grievously nervous about it, as *I am still smarting under my*

*[1] Andrew Robertson (1777–1845), miniaturist: he came to London in 1801, when he first met Constable.

election. I have little enough either of prudence or self-knowledge, as you know, and I am willing to submit to what you and others whom I value may decide. I shall dine with the Dowager Lady Beaumont to-day, and I hope I shall meet you. I could hardly refuse; yet at this time (for I am in the height of agony about my crazy old walls of the Castle), I could rather wish myself at home. I beg an answer by bearer to tell me how you all are. My children are lovely, and all the better for being here. Last Monday we had a little party, it being the birthday of two of mine, and I sat down to table with fourteen, the eldest of whom was only eleven."

"Charlotte Street, April 23rd. My dear Fisher, I am glad that you can make this house serviceable to your family on any occasion. My housekeeper will provide all that is necessary, so that the sole attention of your servant can be devoted to your little boy.[1] They could not have come more conveniently; my own family having left this house to-day, where they have been passing Easter, the beds and rooms are well aired. Mrs. Savage,[2] who is anything but what her name implies, proposes that the front bedroom, being large and having two beds, be theirs; one bed is so large that your boy can either sleep with or from your servant; a fire can be kept constantly there or in the drawing-room for them for the day. I live down here (in the parlour), and shall not be put at all out of my way.

"I have just got a letter from the Academy. The Pandemonium opens on Saturday, in which we are allowed every excess for six days (Sunday excepted).[3]

"Your sudden departure put me out a good deal and made me angry, and it was a disappointment to my friends in the Academy. Propitiate them on your return, and then you may leave me to myself.—I was sadly ill after you left me. I never had so bad a cold before. However, Hampstead and a picture set me tolerably well up. I have sent the great 'Castle', such as

[1] Who was sent to town to undergo a slight operation, the removal of a spot from his lip.

[2] His housekeeper.

[3] The varnishing days allowed to the members of the Academy.

it is, to the Exhibition, and a rich 'Cottage'. Nothing shall prevent my coming to you at Salisbury in the summer; Evans would be delighted, but he has suffering humanity on his hands. I passed a day or two with my children at Ham House, the Countess of Dysart's; she was very kind to them, and pleased with them.

"Wilkie has eight pictures, Lawrence eight, Jackson, Phillips and Pickersgill eight each. Callcott, though not eight, has one eight feet long,—a classical landscape. Turner has four. They have an immense crash[1] in the hall; and it is evident the Devil must vomit pictures over London. . . . Poor old Northcote was at the edge of death, but revived. I saw him yesterday."

"Osmington, April 27th. My dear Constable, I shall be at Eton with my boy Osmond on the 1st May, and must stay there a fortnight.—I thank you, most gratefully, for your kindness in receiving my little boy Frederick and his nurse. . . . I beg your pardon for using you so ill when in London. But the cold, bitter, north-east winds kept me in such a state of irritation, the whole of my stay, that I should have been a most unpleasant inmate to you, and have disturbed your serenity. I felt this, and staid purposely away. I gave you all of my company that I *dare*; and at last suddenly left London, and its windy streets, in a precipitate fit of desperation. I have not yet recovered it. There is a deep cellar in the infernal regions reserved for the most desperate. London, in March, is a type of it. See Milton's *Cold* Hell. Why did you turn out into an unwholesome room on my account? I cannot hold myself responsible for such instances of unwise hospitality. Your life is valuable.

"Will you run down to Windsor for a few days, between May 1st and 14th? You will find me there in lodgings. Pray do; and let us walk over those delicious scenes again of natural and artificial magnificence; where parsons eat, and stuff, and dream of preferment; where pedagogues flog little boys, talk burly, and think themselves great men in three-cornered hats;

[1] He alludes to the quantity of pictures rejected.

where statesmen . . .; and where everybody ems indifferent to the splendid scenes that surround them. Ever yours, somewhat cynically, J. Fisher."

"Osmington, April 30th. My dear friend, I discovered in an old pocket-book, this day, an extract from Milton's prose works. *When* I made it, and from *which* of his works, I forget. But this I remember that I meant to send it to you, saying what I now say; that it is the principle upon which my friendship for you is founded. You know that I do not use words in mere flattery.—'As to other points, what God may have determined for me I know not. But this I know, that if he ever instilled an intense love of moral beauty into the breast of any man, he has instilled it into mine. Ceres, in the fable, pursued not her daughter with a greater keenness of inquiry, than I have, day and night, the idea of Perfection. Hence, whenever I find a man despising the false estimates of the vulgar, and daring to aspire, in sentiment, language, and conduct, to what the highest wisdom, through every age, has taught us as most excellent, to him I unite myself by a sort of necessary attachment. And if I am so influenced, by nature or by destiny, that by no exertion or labour of my own I may exalt myself to the summit of worth and honour, yet no powers of heaven or earth will hinder me from looking with reverence and affection upon those who have thoroughly attained to that glory.' . . . My dear Constable, ever yours faithfully, John Fisher."

The 'Hadleigh Castle',[1] Constable's principal picture in the Exhibition of 1829, received rather rougher usage than usual from the newspaper critics; but it finely embodied to the eye the following lines from Thomson's 'Summer', with which its title was accompanied in the catalogue of the Exhibition:

> 'The desert joys
> Wildly, through all his melancholy bounds,
> Rude ruins glitter; and the briny deep,
> Seen from some pointed promontory's top,

*[1] The painting of Hadleigh Castle in the National Gallery (No. 4810) seems to be a full-size sketch for the R.A. exhibit. See Plate 51.

Far to the blue horizon's utmost verge,
Restless, reflects a floating gleam.'

I witnessed an amusing scene before this picture at the Academy on one of the varnishing days. Chantrey told Constable its foreground was too cold, and taking his palette from him, he passed a strong glazing[1] of asphaltum all over that part of the picture, and while this was going on, Constable, who stood behind him in some degree of alarm, said to me 'there goes all my dew'. He held in great respect Chantrey's judgment in most matters, but this did not prevent his carefully taking from the picture all that the great sculptor had done for it.

"Charlotte Street, July 4th. My dear Fisher. I was most happy to receive Mrs. Fisher's very kind letter, in which you are so kind as to wish to see me with my children. I have taken places in the coach for Wednesday next, the 7th, and we *three* shall be with you to *tea*;—I am told, before six o'clock, so that we shall be able to walk over the bridge before dark.—The weather may be more settled by the time I come to you, but the fine effects of such a season make ample amends for its inconvenience. My children are all well, and I think I never felt in better health, thanks to Evans.

"I took a farewell look with him at the Academy on Thursday. He is impressed with my 'Castle'. . . . He will be delighted to join us at Salisbury.—His intellect and cultivation are, as you discovered, of the first class, and his integrity invaluable. I have just done a small portrait of his mother.—If you have not your book of Claude's etchings at Salisbury, will you procure it?—as it contains his epitaph and some memoranda, and I am engaged to give a sketch of his character to prefix to a book of engravings, now making from the National Gallery.

"I passed the afternoon of yesterday with Jackson at his villa alone. He used a definition which was useful and comprehensive.—He said, 'The whole object and difficulty of the art (indeed, of all the fine arts) is to *unite imagination with nature*.'

[1] Glazing is the process of using transparent colour alone.

We were talking of ——[1] and ——[2] etc., etc.—The art is now filled with *Phantasmagoria*.—More when we meet.—"

"Salisbury, September 3rd. My dear Constable. Many thanks for your continual remembrance of me, which is worth more than all; but nevertheless many thanks for your outward signs of remembrance, your venison, and your re-vivification of the Claude.—I shall be at Windsor on Saturday night, September 5th, with my boy. Now either let me see you there, or hear from you.—I yearn to see you tranquilly and collectedly at work on your next great picture, undisturbed by gossips good and ill-natured; at a season of the year when the glands of the body are unobstructed by cold, and the nerves in a state of quiescence. You choose February and March for composition, when the strongest men get irritable and uncomfortable, during the prevalence of the N.E. winds, the great destruction of the frame in England.

"Minny[3] is the nicest child in the house possible. Nobody would know of her existence if she were not seen. She improves in French and music (her ear is perfect), and she dances quadrilles with the chairs, like a parched pea on a drum head.

"—— and —— have been together on the visitation for three weeks. They have neither broken bread nor spoken together, nor, I believe, seen one another.—What a mistake our Oxford and Cambridge Apostolic missionaries fall into when they make Christianity a stern, haughty thing. Think of St. Paul with a full blown wig—deep shovel hat—apron—round belly—double chin—deep cough—stern eye—rough voice—and imperious manner,—drinking port wine, and laying down the law as to the best way of escaping the operation of the Curates' Residence Act. I need not, I believe, sign my name. My hand is pretty well known to you."

Constable was now engaged in preparing the *English Landscape*[4] for publication, having secured the valuable assistance of

*[1] Danby, i.e. Francis Danby A.R.A. (1793–1861).
*[2] Martin, i.e. John Martin (1789–1854). [3] Maria Constable.
*[4] 'English Landscape' was published in five separate parts of four prints each between 1830 and 1832. For further details see Shirley's edition of Leslie, pp. 254–7, and Shirley *The Published Mezzotints of Lucas after Constable*, Oxford 1930.

Mr. David Lucas; and it led to the magnificent engravings that gentleman afterwards executed of 'The Cornfield', 'The Lock', which Reynolds had contemplated, and the 'Salisbury Cathedral from the Meadows', on a large scale, and the 'Stratford Mill' and 'Hadleigh Castle' of a lesser size. A prospectus of the *English Landscape* was printed, saying, 'It is the desire of the Author in this publication to increase the interest for and promote the study of the rural scenery of England, with all its endearing associations, and even in its most simple localities; of England with her climate of more than vernal freshness, in whose summer skies and rich autumnal clouds, 'in thousand liveries dight', the observer of nature may daily watch her endless varieties of effect.' He was by this time fully aware of the obstacles that existed to a just estimation of his art, and he drew up a preface to his work, in which the following passage seems to me to be a true statement of the case between the public and himself. 'In art, there are two modes by which men aim at distinction. In the one, by a careful application to what others have accomplished, the artist imitates their works, or selects and combines their various beauties; in the other, he seeks excellence at its primitive source, nature. In the first, he forms a style upon the study of pictures, and produces either imitative or eclectic art; in the second, by a close observation of nature, he discovers qualities existing in her which have never been portrayed before, and thus forms a style which is original. The results of the one mode, as they repeat that with which the eye is already familiar, are soon recognised and estimated, while the advances of the artist in a new path must necessarily be slow, for few are able to judge of that which deviates from the usual course, or are qualified to appreciate original studies.'

In the year 1814, when a collection of pictures by Wilson, Hogarth, and Gainsborough, was exhibited at the British Gallery, in the preface to the catalogue it was said, 'The merit of Wilson's works is now justly appreciated; and we may hope that since the period of his decease, the love and knowledge of art have been so much diffused through the country, that the

exertion of such talents may never again remain unrewarded during the lifetime of him who may possess them.'—Who would not say Amen to this?—And yet, long after it was penned, Constable was as much neglected as Wilson had been, and so will it again happen with genius equally original and natural, in landscape, until that branch of the art shall be better understood, with reference to nature, than it is yet by our dispensers of fame.

In one of Constable's sketch-books, there is a draught of a letter to Mr. Fisher, in which he says, "I know not if the landscapes I now offer to your notice will add to the esteem in which you have always been so kind as to hold me as a painter; I shall dedicate them to you, relying on that affection which you have invariably extended to me under every circumstance."—In another part of this memorandum he mentions Mr. Lucas, of whom he says, "His great urbanity and integrity are only equalled by his skill as an engraver; and the scenes now transmitted by his hand are such as I have ever preferred. For the most part, they are those with which I have the strongest associations—those of my earliest years, when 'in the cheerful morn of life, I looked to nature with unceasing joy'."

Mr. Fisher died before the work was published, and it appeared without a dedication.

The first plate engraved was of 'Dedham Mill', from a very slight sketch; but Constable did not again place anything so unfinished in the hands of Mr. Lucas. A few of the many notes he wrote to that gentleman while the work was in progress, will show how much he was disquieted by the undertaking, though in itself of no great magnitude, owing to his fastidiousness in the choice and execution of the subjects (five plates that were finished being rejected by him), and to his discovering as he proceeded, that all chances of remuneration for the time and money he was spending upon it were hopeless. Indeed the *English Landscape* proved in the end to be, as Coleridge said of a work of his own, 'a secret confided to the public, and very faithfully kept'.

"September 15th. Dear Lucas, A total change has again taken place; Leslie dined with me yesterday; we have agreed on a long landscape, evening, with a flight of rooks, as a companion to the 'Spring', and the 'Whitehall Stairs', in place of the 'Castle'. Prithee come and see me at six this evening, and take the things away, lest I change again. However, I like all the last affairs if you do. I will tell you the reasons for so changing. Pray come at six. Bring something in your hand, I don't care what."

The 'Autumnal Sunset', the subject mentioned in this note was sketched in his favourite fields near Bergholt. In the distance towards the right is the tower of Stoke Church, and on the left are Langham Hill and Church.

1830–1831

Picture of 'Bergholt Churchyard'. Death of Sir Thomas Lawrence. Mr. Shee
elected President of the Royal Academy. Notes to Mr. Lucas. Constable on the
Committee of Arrangement at the Academy. Picture of 'A Dell in Helming-
ham Park' exhibited in 1830. Illness of George IV. Jackson. Bannister. Constable
Visitor in the Life Academy. Etty. Wilkie. Illness. Large Picture of 'Salisbury
Cathedral from the Meadows' exhibited, 1831. Death of Jackson. Death of
Northcote. Watteau. Greuze. John Varley. Coronation of King William IV
and Queen Adelaide. Lord B——m. Lord Lyttelton and the Ghost. Old Sarum.
Illness. Reform Bill. E. Landseer.

I HAD asked Constable to allow my sister to copy the small
picture of 'The Porch of Bergholt Church',[1] which has been
described in the first chapter, and it came to us with the follow-
ing note: "January 1830. My dear Leslie, I send the 'Church-
yard', which my friends in Portman Place are welcome to use
for any purpose but to go into it. . . . The motto on the dial is,
'Ut umbra, sic vita'."—This note was singularly followed by
his next: "January 8th. My dear Leslie, I have just received the
distressing intelligence of the death of poor Sir Thomas
Lawrence. This sad event took place last night in consequence
of internal inflammation. I could not help sending to you; the
council is called in consequence."

Constable, though always on friendly terms, had never been
very intimate with Sir Thomas Lawrence, but he felt in com-
mon with every artist in the kingdom the magnitude of the
loss of so eminent a painter, cut off with such apparent sudden-
ness; at a time, too, when he was pursuing his art with all the
energy of youth, though in his sixty-first year; and when,
indeed, so far from betraying any diminution of power, he
seemed to be improving on himself. This, I think, was
acknowledged by all who had an opportunity of seeing the
scarcely finished but very fine portrait of the Earl of Aberdeen
in the exhibition at the Academy that followed the death of
its president.

When the painting materials of Sir Thomas were sold,

[1] Cf. p. 21.

Constable purchased a palette which had belonged to Sir Joshua Reynolds, and had been given by him to Sir George Beaumont, who gave it to Lawrence. He presented this interesting relic to the Academy, with its history inscribed on a silver plate inlaid upon it.

"January 26th. My dear Lane. Mr. Shee[1] was elected last night by a large majority of the Academy; we expect much from his self-devotion and chivalrous sense of honour. . . . Yours, ever truly, J.C." Constable lived long enough to witness the ample fulfilment of the highest expectations formed on this occasion.

"January 31st. My dear Leslie. I hope your toothache is better. It is an entire illness with me whenever I am so visited. It was a grievous disappointment to all of us, not seeing you and Mrs. Leslie. My little girls were all in 'apple-pie order', to be seen. My dear Maria had been practising her steps and music all day that she might appear to advantage. All my boys were in their best, and had allowed a total clearance of the drawing-room of their numerous ships, castles, books, bricks, drawings, etc., etc., etc. I missed you by going to the Gallery where I had invited Newton and Landseer[2] to meet you, neither of whom came; though, as I class them with the nobility, they having adopted their habits, I sat up till twelve to receive them. Not having *a tongue* of my own, I had ordered one, with two lovely fowls for you, and our best silver candlesticks for your sister. My pretty Minna had ready a little present for my god-daughter, and to prove to you and Mrs. Leslie that, though our disappointment was severe, we are not angry, she begs to send it this afternoon."

"Charlotte Street, February 26th. Dear Lucas. I am anxious to see you, to have farther talk about the plates. First, I want to know how forward the 'Evening' is,[3] and the retouched 'Stoke'.[4] I have not the wish to become the possessor of the

*[1] Sir Martin Archer Shee, P.R.A. (1769–1850).

*[2] Sir Edwin Henry Landseer (1802–1873): at this time he was A.R.A., becoming R.A. in 1831. He was knighted in 1850.

*[3] 'Summer Evening' (Shirley No. 6).

*[4] 'Stoke-by-Neyland' (Shirley No. 9).

large plate of the 'Castle',[1] but I am anxious that it should be fine, and will take all pains with it. It cannot fail to be so, if I may judge from what I have seen. I have taken much pains with the last proof of 'The Summerland',[2] but I fear I shall be obliged to reject it. It has never recovered its first trip up, and the sky with the new ground is and ever will be rotten. I like your first plates far, very far, the best; but I allow much for your distractions since, with those devils, the printers, and other matters not in unison with that patient toil which ought always to govern the habits of us both. Do not neglect the 'Wood',[3] as I am almost in want of the picture. Bring me another large 'Castle', or two, or three, for it is mighty fine, though it looks as if all the chimney sweepers in Christendom had been at work on it, and thrown their soot bags up in the air. Yet everybody likes it; but I should recollect that none but friends see my things; I have no doubt the world despises them. Come early to-morrow evening, and bring what you can, and an account of the next; I am nervous and anxious about them. I have made the upright windmill quite perfect. I should like the book to consist of eight; pray tell the writer not to complete his sketch of the title; I have made another."

The engraving of the 'Evening', one of the finest of his small pictures, is the least successful of all Mr. Lucas's plates. The scene is near Bergholt, with Stoke and Langham in the distance. This plate, the 'Summerland', and the 'Autumnal Sunset',[4] all represent the same fields, and from points of view not far distant from each other.

"March 2nd. Dear Lucas, . . . Shall I see you on Thursday? Alfred Chalon says, 'The 'Castle' is a fine looking thing.' I am anxious to see a first proof of the 'Evening'; but take your time; I will be very good and patient in future. I long to see the Church, now that it is removed to a better spot—two fields off. Take care to avoid rottenness, it is the worst quality of all.

[1] 'Hadleigh Castle' (Shirley No. 11).
*[2] 'A Summerland' (Shirley No. 10).
[3] 'Helmingham Park' (Shirley No. 12).
*[4] 'Autumnal Sunset' (Shirley No. 14).

Leslie has not the 'Stoke'; take him one when you next prove it, with the last alteration."

"Dear Lucas, I send the 'Jaques' in a flat, yet feel assured you will not make a *flat* of him. I am much pleased with what we are about so far, only I fear if we do not mind, we shall not have enough of the pastoral. Leslie has just been here, and likes much the sketch in a lane, which I send for you to look at. It is a lovely subject, rich and novel, and what is better than all, *natural*; it would be a glorious full subject." The 'Jaques' mentioned by Constable in this note was a water-coloured drawing[1] of the often painted scene, the wounded stag. Of this subject he made many sketches, and contemplated a large picture, the only imaginary landscape he ever thought of painting.

As a newly-elected Academician, he was now on the committee of arrangement of the Exhibition, and in a note to Mr. Lane he says, "I am sadly harassed, and not being able to call on you is most vexatious. I cannot go out, lest my picture and my fire should *go out* too. How get you on? . . . I shall be overwhelmed with pictures, especially portraits, the painters of them all believing they can easily fill the shoes of Lawrence."

In a note to me written soon after, he says, "I regret the entire confinement I have been in since I saw you. My picture has been, and is, plaguing me exceedingly, for it is always impossible to know what a picture really wants till it comes to the last. However, it shall go. It would amuse you to see how I am beset; I have poets—earls—dukes—and even royalty at my feet; all painted canvas, of course." His own pictures this year were, the 'Dell in Helmingham Park',[2] a small landscape, and 'A view of Hampstead Heath'.[3] While assisting in the arrangement, he found much trouble from the excessive size of some of the frames; and on remonstrating with an exhibiter on this point, who defended himself by

★[1] Now in the British Museum.
★[2] Several paintings of this subject and of about this date are known: e.g. in the Tate Gallery, the T. W. Bacon collection, and the Louvre.
★[3] Now in the Victoria and Albert Museum (No. F. A. 35).

saying that his frames were made exactly on the pattern of those of Sir Thomas Lawrence, he could not help replying, 'It is very easy to imitate Lawrence in his *frames*.'

I have often observed with surprise, how readily Constable would make alterations in his pictures by the advice of persons of very little judgment. While finishing the picture of the 'Dell', he was one day beset with a great many suggestions from a very shallow source, and after adopting some of them, he felt inclined to make a stand, which he did by saying to his adviser, 'Very true; but don't you see that I might go on, and make this picture so good that it would be good for nothing.'

"May. My dear Leslie, Can you take a chop with me at five, or a dish of tea at six, on your way to the Academy to the general meeting, where I hope you will be. The debate must be learned, as we are to decide whether *plaster casts* come under the head of *marbles*, which they were not able to do at Edinburgh; I shall get there by seven to look round the Exhibition. I feel like the old woman who kept a stall at a fair, who 'hoped the king would not die during the show'."[1]

"August. My dear Leslie, Will this fine weather tempt you to walk over the fields to my pretty dwelling in Well Walk? If it should, and you can make it the afternoon to dinner, you will find Mr. Bannister and Newton. Prithee come; life is short (and so is my notice); we meet too little."

Mr. Bannister was unable on this occasion to dine with Constable, who received from him the following characteristic note: "August 17th. My dear Sir, To prevent my place being unsupplied, pray allow me to send you a *lame* excuse. Certain gouty symptoms convince me that I shall not be able to join your party. My apprehension, however, of mortification, my surgeon says, 'is a mere farce', and adds, 'Can't you be contented with the gout?' My only *mortification* will be in declining your kind invitation. Believe me, my dear friend, yours most truly, J. Bannister."

A young friend of mine, a student of the Academy, whom I had introduced to Constable, had called to ask his advice on

[1] This was written during the last illness of George IV.

the subject of engaging himself as an assistant to an eminent portrait painter; and to this matter the following note chiefly alludes: "Charlotte Street, December 29th. My dear Leslie. K. F——[1] calling on me this morning on his way to you, I send you my second number of the *Landscape*, the first yet sent out. I have carefully looked out a fine one, and beg you will receive all these trifles as marks of my affection, and if so, they are no longer trifles in my estimation. Poor F—— has much to say to you about himself and ——.[2] I know not how to advise. —— is an honourable man, and his art is sound and good, but what F—— will be able to earn with him, will, I fear, but ill requite the loss of time. These kind of engagements are seldom attended with satisfaction to either party, because they both want to make all they can of each other. I was much delighted with my day at your house on Sunday, and to complete it, I passed the evening with Turner at Tomkison's."

Though Constable strenuously objected to any style in art, however excellent, being looked at as an object to be attained, rather than as a means towards the attainment of what is always better than the best style, *nature*, yet he well understood how important it is that the student should be directed to nature by the assistance of previous art. In the month of January, 1831, he was visitor in the Life Academy. It is the duty of the visitors to determine the attitude of the model, and to give advice to the students; and he placed every figure, during his attendance, from some well-known one by a great master, beginning with an Eve from Raphael, and allowed no evening to pass without a short lecture addressed to the students.

"Dear Leslie, I set my first figure yesterday, and it is much liked; Etty congratulates me upon it; do, dear Leslie, come and see it. I have dressed up a bower of laurel, and I told the students they probably expected a landscape background from me. I am quite popular in the Life; at all events I spare neither pains nor expense to become a good Academician. My garden of

*[1] J. K. Fisher, a Hampstead painter, who exhibited at the R.A. 1830–32.
*[2] Pickersgill; i.e. H. W. Pickersgill R.A. (1782–1875), portrait-painter.

Eden cost me ten shillings, and my men were twice stopped coming from Hampstead with the green boughs by the police, who thought (as was the case) they had robbed some gentleman's grounds. . . . The fun is, my garden at the Academy was taken for a Christmas decoration, holly and mistletoe. Wilkie called yesterday; I was unfortunately at the Academy; but he good-naturedly came in, and asked to see my children, and was delighted with my dear girl, who was teaching the lesser ones; he 'hoped they were all good children'. Jackson also called. I leave home at half-past five every evening, at the latest. Come and walk down with me. It is no small undertaking to make a Paradise of the Life Academy." In another note, Constable says, "I shall look for you this evening at five, or you will look in on me in my *den*; but I must say my *lions* are exceedingly well behaved. Sass[1] and Etty are never absent; they set an excellent example. . . . I have been reading an amusing lecture to my children over the print of your 'Sir Roger De Coverley going to Church'.

"I was delighted to find how much I was agreeably reminded of poor dear old Bigg."[2]

Constable set two male figures at the Academy from 'The Last Judgment'[3] of M. Angelo;—he afterwards set a female figure which he called an Amazon.—"January 27th, My dear Leslie, I hope you will find an evening to come down to the Academy and see my Amazon. My labours finish there on Saturday. This figure is liked best of all. Etty is so delighted that he has asked me to breakfast, to meet some friends, among them Mr. Stothard."

Mr. Lucas was interrupted in the work he was engaged on, by the illness of Mrs. Lucas and one of his children, and in a note to him, dated January 4th, Constable says, "I am so very anxious to hear how things are going on in your house, that I

[1] Henry Sass (1788–1844).

[2] Mr. Bigg, R.A., sat to me for the face of Sir Roger. I thought him an admirable specimen both in look and manner of an old-fashioned English gentleman. A more amiable man never existed.

[3] Studies by Constable from these figures are in the collection of Colonel J. H. Constable.

send my man, who I trust will bring me some better account, though for the poor little fellow I cannot feel sanguine. I feel for your distress, and I trust you have seen Dr. Davis; for if human means can avail they are his. Don't think of me or my concerns for a moment; your business is with yourself. I mention this only to relieve your mind from all other anxiety, as I well know your great integrity, and that you are always too ready to devote yourself to others, or at least to me."

The early part of the spring of every year was a time of anxiety to Constable, as it is to most of our artists, who are just then finishing their works for the Exhibition. He too often found himself behindhand, and the redoubled application that his pictures demanded, as the time of sending them to the Academy drew near, fatigued his mind, and this, with the effects of the easterly winds of the season, and the increased irregularity of his meals, generally disordered his health. His usual time for dining was in the middle of the day, but when very busy it varied, and I have known him eat a few oranges while at work, and sit down to dinner ill with exhaustion, when it was too dark to paint. In addition to all this, his uneasiness about his book had now a share in producing the illness of which the next note speaks. "March 12th. Dear Lucas, My indisposition sadly worries me, and makes me think (perhaps too darkly) on almost every subject. Nevertheless, my seven infants, my time of life and state of health, and other serious matters, make me desirous of lightening my mind as much as possible of unnecessary oppression, as I fear it is already too overweighted. I have thought much on my book; and all my reflections on the subject go to oppress me; its duration, its expense, its hopelessness of remuneration; added to which, I now discover that the printsellers are watching it as their lawful prey, and they alone can help me. I can only dispose of it by giving it away. My plan is to confine the number of plates to those now on hand; I see we have about twenty. The three present numbers contain twelve; others begun are about eight or ten more, some of which may not be resumed, and we must begin the frontispiece. It harasses my

days, and disturbs my rest at nights. The expense is too enormous for a work that has nothing but your beautiful feeling and execution to recommend it. The painter himself is totally unpopular, and ever will be on this side the grave; the subjects *nothing but the art*, and the buyers wholly ignorant of that. I am harassed by the lengthened prospect of its duration; therefore I go back to my first plan of twenty, including frontispiece and vignette, and we can now see our way out of the wood. I can bear the irritation of delay (from which I have suffered so much that I attribute my present illness in part to it) no longer; consider, not a real fortnight's work has been done towards the whole for the last four months. Years must roll on to produce the twenty-six prints, and all this time I shall not sell a copy. Remember, dear Lucas, I mean not, nor think one reflection on you. Everything, with the plan, is my own, and I want to relieve my mind of that which harasses it like a disease. Do not for a moment think I blame you, or that I do not sympathise with you in those lamentable causes of hindrance which have afflicted your home. Pray let me see you soon. I am not wholly unable to work, thank God! I hope poor Mrs. Lucas is better. Dr. Davis has been to see me and my poor boy John, who is very ill. Mr. Drew gives me pills, so that both their medicines (which I take together) may get me well in double quick time."

"March 23rd. Dear Lucas, Let me know when I shall see you. I am very anxious that you should call, as I am sadly lonely, and do not get well; but I am very much better. I have formed the wish to add a windmill to the set, leaving the title and vignette distinct, and to be given in, which will look handsome. I have made a drawing of the title for you to see, and I wish you to choose the windmill. I have made a great impression on my large canvas. . . . Beechey was here yesterday, and said, 'Why, d——n it, Constable, what a d——d fine picture you are making; but you look d——d ill, and you have got a d——d bad cold!' so that you have evidence *on oath* of my being about a fine picture, and that I am looking ill. I hope Mrs. Lucas is better, and yourself well."

With the large picture of 'Salisbury Cathedral from the Meadows',[1] the one spoken of in the last note, and which will often again be mentioned, Constable exhibited at the Academy this season a smaller one of 'Yarmouth Pier', and when the anxiety of preparing for the Exhibition was over, his health improved.

British art, which had so recently sustained great losses by the deaths of Owen and Lawrence, now again suffered heavily by the death of Jackson, who had stood with them, and occasionally perhaps before either of them, in the first rank of portraiture.[2] He had lingered for some time in a decline, and as his residence was near mine, Constable heard of his death from me.

"June 2nd. Dear Leslie, Your note this morning first informed me of the departure of poor dear Jackson. One is so apt to believe that all things which give us pleasure are always to continue, that when these sad events do come, and come they must, we are the more appalled and afflicted. It seems impossible that we are to see that dear fellow no more. He is a great loss to the Academy and to the public. By his friends he will be for ever missed, and he had no enemy. He did a great deal of good, much more, I believe, than is generally known, and he never did harm to any creature living. My sincere belief is, that he is at this moment in Heaven.

"The papers still abuse the Exhibition and the painters. A book, *The Library of the Fine Arts*, has been just left here, in which they speak very properly of your pictures, and perhaps fairly of my 'Chaos', as they term the Salisbury; they say, after much abuse, 'It is still a picture from which it is impossible to turn without admiration.' I shall hope to see you very soon, but Hampstead breaks me up; I will, if I can, walk round to-morrow: I want to see Lord Grosvenor's gallery by you. I must say I like to see my friends in difficulties; no good

*[1] Now in the collection of Lord Ashton of Hyde. See Plate 43.

[2] His portrait of Canova, painted for Chantrey, and the one of Northcote, painted for the Earl of Carlisle, will, I think, bear me out in saying this. As a colourist, Lawrence certainly never approached him.

comes without them; but I can hardly understand what yours can be; I cannot believe your patron and you have chosen a canvas sufficiently large to do you justice, but I will not pre-judge. I hear a good account of Fisher; he is preaching at Salisbury."

"July 5th. My dear Leslie, I returned from Suffolk yesterday to attend the Council. I left my little girls with my family there, very happy and 'comfordil'. Nothing can exceed the beauty of the country; it makes pictures appear sad trumpery, even those that have most of nature; what must those be that have it not?"

The following letter is addressed, not to the eminent Academician but to another gentleman of the name of Ward,[1] who was at that time practising portrait painting in London: "Charlotte Street, July 22nd. Dear Ward, Our mutual loss in poor Northcote makes one cling to what is left, and I now more than ever value the stores you possess of his delightful conversation. Do you (as I trust you do) ever mean to give them to the world? they contain a mass of information, especially on the art. I do think in that respect they are above all things calculated to be useful in guiding students in the right way of thinking and regulating their lives and habits. Let me have the pleasure of seeing you soon. I am, dear Ward, always sincerely yours, John Constable."

I had asked Constable to look at a copy of a Watteau, 'The Ball',[2] from the Dulwich Gallery, on which I was then engaged at the Academy; and to this his next note alludes.

"Dear Leslie, I missed you on the day we should have met at the school of painting by about half an hour. Your Watteau looked colder than the original, which seems as if painted in honey; so mellow, so tender, so soft, and so delicious; so I trust yours will be; but be satisfied if you touch but the hem of his garment, for this inscrutable and exquisite thing would

*[1] James Ward died in 1850, leaving MSS. and note-books referring to Northcote. These were edited and first published in 1901 by Ernest Fletcher as *Conversations of James Northcote R.A. with James Ward on Art and Artists*.

*[2] 'Le Bal Champêtre' by Watteau (Dulwich Gallery No. 156).

IX. HEAD OF A GIRL. About 1830. Victoria & Albert Museum

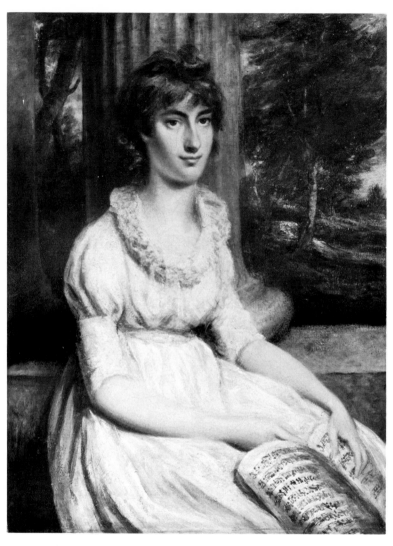

X. AN UNKNOWN WOMAN. About 1810. Tate Gallery

vulgarise even Rubens and Paul Veronese. . . . My dear little girls are beautifully bronzed; they have had a happy visit. We are all here. Come to us to-morrow evening."

"August. My dear Leslie, . . . Lady Dysart has sent me half a buck; and I hope to see the President and Howard and Mr. Bannister to partake of it about the middle of next week; will you come? One thing I much want your help in; a request is made to me by a lady (a relation) to make a copy of Mr. Wells'[1] picture of 'The Girl and Pigeon' by Greuze. This friend of mine had a dear little daughter taken from her; she pines for her child. The picture is the exact image of the soft lovely girl, of whom she is bereft without any memorial. Give me your advice how to act. I called on Landseer, who is now, I find, on a visit to Mr. Wells, and might possibly aid me. Could the picture be left with me after the close of the Gallery, I would copy it, and ensure its safety. . . . I looked into the National Gallery yesterday. Carr's Rembrandts[2] are fine, and the large Gaspar[3] magnificent; indeed, nowhere does landscape stand higher than under that roof. . . ."

"August 22nd. My dear Leslie, On Thursday next at six o'clock they tell me Lady Dysart's haunch will be in perfection; at all events it will be on my table at that hour.—It is indeed very kind of you to name my gallery to ——.[4] But should your endeavours draw him into it, can you give him understanding? 'One man may lead a horse to the pond', etc. I should be delighted, however, to have him in my room, as it would be nuts, to me, to see him so puzzled. Lord N——[5] is a better creature, but he esteems 'our own Glover' too much to like our *disowned* Constable. One picture he had of Glover, the foreground of which consisted of one hundred flower pots all in a row as thus" (here a sketch), "the sun was shining bright, but they cast no shadow.

★[1] William Wells of Redleaf, a collector.
★[2] 'A Woman Bathing' (No. 54) and 'Landscape with Tobias and the Angel' (No. 72): the second of these is now catalogued as 'School of Rembrandt'.
★[3] 'Landscape: Dido and Aeneas' (No. 95) by Gaspar Poussin.
★[4] Lord Essex.
★[5] Lord Northwick.

"Varley,[1] the astrologer, has just called on me, and I have bought a little drawing of him. He told me how to '*do* landscape', and was so kind as to point out all my defects. The price of the drawing was 'a guinea and a half *to a gentleman*, and a guinea only to an *artist*', but I insisted on his taking the larger sum, as he had clearly proved to me that I was no artist."

"September 9th. My dear Leslie, My servant told you of my being at the Coronation. I was in the Abbey eleven hours, and saw with my own eyes the crown of England put on the head of that good man, William IV; and that too in the chair of a saint! I saw also the gentle Adelaide crowned, and I trust, what may now be called the *better half* of England's crown has sought its own wearer in this instance. I saw also B——m[2] with his crown on, a sight than which nothing could be more ridiculous, for as his coronet was perched on the top of an enormous wig, he bore the external shape of a Jack in the Green, as he stood with his back towards me a full hour." (Here the writing is interrupted by a sketch). "I sat so that I commanded a view of all the peers placed in raised ranks in the south transept. The moment the King's crown was on, they all crowned themselves. At the same instant the shouts of 'God save the King', the trumpets, the band, the drums of the soldiers in the nave, and last, though not least, the artillery, which could be distinguished amid all this din, and the jar even felt, made it eminently imposing. The white ermine of the peers looked lovely in the sun; I shall sketch some of the effects;[3] the tone of the walls was sublime, heightened, no doubt, by the trappings, like an old picture in a newly gilt frame."

"September 12th. My dear Leslie. Accept my third number with my best regards. I hope Mrs. Leslie was not the worse for her visitors yesterday. Her dear infant has never been a

*[1] John Varley (1778–1843), water-colourist and teacher.
*[2] Lord Brougham and Vaux, Lord Chancellor.
*[3] A water-colour by Constable of the Coronation Procession passing Charing Cross is known: it was Lot 103 at Messrs. Sotheby's, 20th July 1949 (Gregory Sale).

moment from my sight since I left you; they were happy days with me when I had infants. Will you come any day when we can look at the old masters in Pall Mall together? I sleep in town to-night. I am glad I saw the show in the Abbey; it was very delightful, and I can now say I have seen a Coronation. Everybody seemed amused with B——m; the annoyance to him must have been great."

"September 26th. My dear Leslie. I have been passing a day or two with Digby Neave[1] at Epsom. I slept on Friday night in the room in which Lord Lyttelton saw the ghost.[2] But I neither saw nor heard anything of the lady or the bird. It is a beautiful and romantic old house; deeply fixed in trees and dells and filled with marble statues, dolphins, cupids, etc. . . . This morning I have seen ——'s studies in Italy and Greece; temples, trees, statues, waterfalls, figures, etc., etc.; excellent of their kind, and done wholly for the *understanding*; bald, and

[1] Sir Digby Neave, 3rd Bart. (1793–1868).

[2] 'Thomas, the second Lord Lyttelton, had great parts and ambition. He had all his father's foibles, but without his sound principles of religion and morality; for want of which he fell into great enormities and vices. His pleasures were restrained by no ties of relationship, friendship, or decency. He was a great lover of gaming; in his younger years he was unsuccessful, but he afterwards became more artful, and at his death he was supposed to have acquired thirty thousand pounds by play. His constitution was feeble, and by his vices so enervated that he died an old man at the age of thirty-five. He was like his father a believer of ghosts, and many stories are told, with considerable confidence, which have relation to his death. About three days before he died, a female figure with a bird in her hand appeared to him, as he imagined, and told him he should die in three days. The day of this supposed appearance he went to the House of Lords, and spoke with great earnestness on some business then in agitation. The next day he went to a villa he had at Epsom, apparently as well as he had been for some time before. The succeeding day he continued there, and was in as good health and spirits as usual, though the apparition still hung upon his mind. He spent the evening in company with the Miss Amphletts, Admiral Wolesely, Earl Fortescue, and some other persons; he seemed perfectly well, and pulling out his watch said jocularly it was ten o'clock, and if he lived two hours he should *jockey* the ghost. In about an hour he retired to his chamber, and ordered his valet to bring his powder of rhubarb which he frequently took at night. His servant brought it, and forgetting to bring a spoon was going to stir it with a key; upon which his lordship called him a dirty fellow and bid him fetch a spoon. Accordingly he went, and returning in a few minutes, found his lord in the agonies of death.'—*Supplement to Nash's* 'History of Worcestershire'.

naked,—nature divested of her chiaroscuro, which she never is under any circumstances, for we never see her but through a medium. Yet these things have a wonderful merit, and so has *watchmaking*."

One of Constable's sketch books contains a beautiful drawing[1] in water colours of the house, formerly Lord Lyttelton's, now belonging to Digby Neave, Esq. The view is taken from the lawn, which is decorated with statues, urns, etc.

Among the engravings made for the *English Landscape* which Constable afterwards rejected, when he came to arrange them with the others, was a very powerful one, a view on the Orwell,[2] with two vessels hauled up on the beach, and of this plate the next note speaks. "September 27th. Dear Lucas, I fear that we must now engrave the 'Waterloo'. The ships are too commonplace and vulgar, and will never unite with the general character of the book. Though I want variety, I don't want a hotch-potch. We must not have one uncongenial subject; if we have, it cannot fail to tinge the whole book." In another note he says, "Dear Lucas, You will be surprised and pleased with the touch proofs; they quite tempt one to proceed, so clever and artful is the devil!"

Constable was now beginning to feel symptoms of what soon proved a very serious illness; and in a note to Mr. Lucas, dated October 27th, he writes, "I think myself better, but don't much care; it gives me an excuse to be idle. Keep the new 'Old Sarum'[3] clear, bright, and sharp, but don't lose solemnity."

A city turned into a landscape, independently of the historical associations with Old Sarum, could not but be interesting to Constable; and not satisfied with Mr. Lucas's first engraving of it, in which its mounds and terraces were not marked with sufficient precision, he incurred the expense of a second plate. Sir Thomas Lawrence, who had seen the first,

★1 This drawing is now in the Victoria and Albert Museum (No. 236–1888).
★2 'View on the Orwell' (Shirley No. 24).
★3 'Old Sarum' (Shirley No. 32): the previous engraving of this subject, published Jan. 1831, is No. 8 in Shirley's catalogue.

greatly admired the treatment of this subject, and told Constable he ought to dedicate it to the House of Commons.

The plate of 'Old Sarum' was accompanied with letter-press, of which the following are passages: "This subject, which seems to embody the words of the poet, 'Paint me a desolation', is one with which the grander phenomena of nature best accord. Sudden and abrupt appearances of light—thunder clouds—wild autumnal evenings—solemn and shadowy twilights 'flinging half an image on the straining sight'—with variously tinted clouds, dark, cold and grey—or ruddy and bright—even conflicts of the elements heighten, if possible, the sentiment which belongs to it.

"The present appearance of Old Sarum, wild, desolate, and dreary, contrasts strongly with its former splendour. This celebrated city, which once gave laws to the whole kingdom and where the earliest parliaments on record were convened can only now be traced by vast embankments and ditches, tracked only by sheep-walks. 'The plough has passed over it.' In this city the wily Conqueror in 1086 confirmed that great political event, the establishment of the feudal system, and enjoined the allegiance of the nobles. Several succeeding monarchs held their courts here; and it too often screened them after their depredations on the people. In the days of chivalry, it poured forth its Longspees and other valiant knights over Palestine. It was the seat of the ecclesiastical government, when the pious Osmond and the succeeding bishops diffused the blessings of religion over the western kingdom; thus it became the chief resort of ecclesiastics and warriors, till their feuds and mutual animosities, caused by the insults of the soldiery, at length occasioned the separation of the clergy, and the removal of the Cathedral from within its walls, which took place in 1227. Many of the most pious and peaceable of the inhabitants followed it, and in less than half a century after the completion of the new church, the building of the bridge over the river at Harnham diverted the great western road, and turned it through the new city. This last step was the cause of the desertion and gradual decay of Old

Sarum. The site now only remains of this once proud and populous city, whose almost impregnable castle, with its lofty and embattled towers, whose churches, with every vestige of human habitation, have long since passed away. The beautiful imagination of the poet Thomson, when he makes a spot like this the haunt of a shepherd with his flock, happily contrasts the playfulness of peaceful innocence with the horrors of war and bloodshed, of which it was so often the scene:

> 'Lead me to the mountain's brow,
> Where sits the shepherd on the grassy turf
> Inhaling healthful the descending sun.
> Around him feeds his many-bleating flock,
> Of various cadence; and his sportive lambs,
> This way and that convolved, in friskful glee,
> Their frolics play. And now the sprightly race
> Invites them forth; when swift the signal giv'n
> They start away, and sweep the massy mound
> That runs around the hill, the rampart once
> Of iron war.' "

In a note to Mr. Benjamin Dawson of Hampstead, Constable, speaking of Old Sarum says: "Who can visit such a solemn spot, once the most powerful city of the West, and not feel the truth and awfulness of the words of St. Paul: 'Here we have no continuing city!' "

Towards the end of October Constable became very unwell, and was greatly depressed in spirits. I had called on him, and found him in a state of mind which magnified every anticipation of evil. The Reform fever was then at its crisis, and he talked much of all that was to be feared from the measure. I endeavoured to quiet his mind, but fearing that I had done him more harm than good by prolonging the conversation I wrote to him a day or two afterwards: "My dear Constable, I have heard of you twice since I saw you; once from Lucas, and once from Vaughan, and I now want to hear that you were not the worse for attending the Council. I came away from you with the uncomfortable feeling that I had excited you to talk too much, and on an irritating subject. I have not

a doubt but that at the present time, as it always has been when parties have run high, the evils on both sides are tremendously exaggerated, and I trust you will soon find your fears about the security of the funds to be groundless. . . . It is grievous to me to think that a mind like yours may be harassing itself with useless apprehensions of the future, to no other end than that of impairing your health, which is of the greatest consequence to yourself, your children, and your friends. There is no evil more certain than the dread of uncertain ones. Don't trouble yourself by writing to me unless, as I sincerely hope, you are a great deal better; but send me word that you did not suffer by going to the Academy."

"Dear Leslie, Greatly do I lament going to the Academy. I am much worse than when you and Mrs. Leslie were here. The truth is, I have long been getting ill, and it will surprise you to hear that I have always had the *worst tongue* possible. The mischief that has been so long hatching has at length come to a head. Evans tells me I must take great care of my health for my children's sake; I much doubt if my life is of any use to them, but I love them, and they love me, so the parting, at least, will be sad. . . . What makes me dread this tremendous attack on the constitution of the country is, that the wisest and best of the Lords are seriously and firmly objecting to it; and it goes to give the government into the hands of the rabble and dregs of the people, and the devil's agents on earth, the agitators. Do you think that the Duke of Wellington, the Archbishop of Canterbury, and Copley, and Eldon, and Abbot, and all the wisest and best men we have, would oppose it if it was to do good to the country? I do not. No Whig Government ever can do good to this peculiar country."

"Charlotte Street, November 4th. My dear Leslie, I know not how enough to thank you and dear Mrs. Leslie for the kind interest you both take in me. I am now, perhaps, quite well, and I can give you no greater proof of it than by telling you that the Reform Bill now gives me not the least concern. I care nothing about it, and have no curiosity to know whether it be dead or alive, or if dead, whether it will revive from its

ashes. I hope to pass a quiet and domestic winter. My illness was much increased by fretting and pining for my children, of whom I saw little or nothing. I shall now call Hampstead *my home*, Charlotte Street *my office*. Only think, I had the children here only three or four months all last year, and then took them to Hampstead looking like parboiled rabbits. I have begun the copy of Mr. Wells' picture."[1]

"November 26th. My dear Leslie, I am sending to poor Lucas, fearing he must be ill, as I have not heard of him so long. . . . I shall bring my children to Charlotte Street at Christmas. where I shall have a pleasant party, and I hope often to see you and Mrs. Leslie. I was delighted to have Edwin Landseer on Sunday at my retreat; besides, he fell in love with my eldest daughter, and I could not say nay; it was to paint her."[2]

"Well Walk, December 17th. My dear Leslie, I cannot let Lucas depart, without a wretched line or two to you. I have not been in London since we parted last at the Academy. My sad illness has a good deal returned, and the worst is, it is accompanied by an attack of acute rheumatism which has quite disabled me. Thank God, this right hand is left me entire, reminding me, if I could ever forget it, of your dear child's surprise at 'the poor gentleman who was all shot away but his hand';[3] but my left side and arm prevented my work-ing by pain and helplessness. Fourteen leeches, however, on that shoulder, dislodged part of the enemy, but only that he should make a lodgement in my knee, and now I can't stand; but I am so much better in general health that I bear it with tolerable grace, *for me*."

"Charlotte Street, Tuesday, December 28th. My dear Leslie. . . . I have parted with my dear little Maria for a week on a visit to Putney, a great sacrifice on my part; I miss her exceedingly; she is so orderly in all her plans, and so full of

[1] Presumably this is the copy of Mr. Wells' Greuze: cf. p. 193.

[2] Leslie has greatly abbreviated this letter. Constable gave a long description of a Council Meeting at the R.A. and discussed with feeling the reasons for the non-election of J. M. Gandy (1771–1843) to the status of R.A.

[3] On seeing an engraving of an antique fragment.

method,—so lady-like by nature, and so firm, and yet so gentle, that you cannot believe the influence this heavenly little monitor has on this whole house, but most of all on me, who watch all her dear ways with mingled smiles and tears. This calls to my recollection two lines of an epitaph in a country churchyard, written by a gentleman on his wife:

'The voice of all who knew her this confest,
But chief the voice of him who knew her best.'

Should I live, and this dear image of her mother be spared to me, what a blessing and comfort to my old age; I have, indeed, much to be thankful for. . . . I must put Mrs. Leslie's name to this paper, or how can I convey to you and her my sincere good wishes of the season? I hope you and she may be happy for many many Christmases. For myself, I am always happy if my children are well, which, thank God, is the case now."

"December 29th. I shall try all I can to get well, and come to you on Monday with my two little girls, who, I am sure, will be much delighted. But I am still a poor devil; however, to-day I have been painting, and to-morrow I hope to get the Greuze finished. My pretty Minna dressed up my mantel-piece with Christmas boughs, and set out a little table in the dining-room, that I might look pretty in her absence, which I scrupulously forbid to be disturbed."

CHAPTER XIII

1832

Illness. Turner. Claude. Hobbema. Gainsborough. Stanfield. Picture of 'Waterloo Bridge'. Mr. Lawley. Callcott. Constable's Mode of Proceeding with his Pictures. The Palette Knife. Exhibition at the Academy, 1832. Constable's eldest Daughter dangerously Ill. Illness of John Dunthorne, Jun. New Apartments for the Academy. Death of Archdeacon Fisher. Copy of de Hooge. Death of J. Dunthorne, Jun. Constable attends his Funeral at Bergholt. Vale of Dedham. E. Landseer. Mr. George Constable. Picture of 'Englefield House'.

"HAMPSTEAD, January 1832. My dear Leslie, We intend reaching Charlotte Street, pack and package, with my seven children, about Thursday. I am not certain, however, of myself, for Evans says I may not be fit for removal by that time. He is a skilful and honest doctor, a very sensible man with great acquirements, and a most sincere friend, so that I have many blessings yet. I am not sorry to have missed the visitorship in the Life this year, and next year I shall be ineligible; my youth being gone, I can hardly stand the fags I lay on myself. I hope all is well with you."

The painful illness from which Constable had lately suffered so severely, had not yet left him. I had written from Petworth describing some of the pictures there, and received the following letter, dictated by him, for he was disabled by rheumatism in his hand from holding a pen: "From my bed, Charlotte Street, January 14th. My dear Leslie, Accept my thanks for your kind letter. I rejoice to hear that you and Mrs. Leslie and the dear children got through your journey so comfortably. For myself, I have had rather a severe relapse, but I passed last night almost wholly free from pain, the first, I believe, for these three weeks. I had great pleasure in seeing my brother, by whom I was much excited on family matters, he entering with great cordiality into all my wishes regarding my children. The exertion was, no doubt, too great for me, but Evans assured me, last night, he had not seen me so well. I am much interested with your account of the pictures at Petworth. I remember most of Turner's early works; amongst them was

one of singular intricacy and beauty; it was a canal with numerous boats making thousands of beautiful shapes, and I think the most complete work of genius I ever saw. The Claude I well know; grand and solemn, but cold, dull and heavy; a picture of his old age. Claude's exhilaration and light departed from him when he was between fifty and sixty, and he then became a professor of the 'higher walks of art', and fell in a great degree into the manner of the painters around him; so difficult it is to be natural, so easy to be superior in our own opinion. When we have the pleasure of being together at the National Gallery, I think I shall not find it difficult to illustrate these remarks, as Carr has sent a large picture[1] of the latter description. Hobbema, if he misses colour, is very disagreeable, as he has neither shapes nor composition. Your mention of a solemn twilight by Gainsborough has awakened all my sympathy; do pray make me a sketch of it of some kind or other, if it is only a slight splash.

"As to meeting you in these grand scenes, dear Leslie, remember the Great were not made for me, nor I for the Great; things are better as they are. My limited and abstracted art is to be found under every hedge and in every lane, and therefore nobody thinks it worth picking up; but I have my admirers, each of whom I consider an host. My kindest regards to Mrs. Leslie."

"My dear Leslie, After three weeks inability to hold my pen, I resume it for the first time to write to you. . . . So far had I written when your letter arrived. I am now recovering, I may say fast, and am beyond the fear of relapses; but certainly, as you say, 'excitement under illness is a much worse thing than is generally imagined.' I sat up yesterday, dressed, by the fire, and ate a small fish for my dinner, to the great delight of Alfred, who would dine with me, as he it was, he said (and truly), 'who nursed me so well'. How heavenly it is to wake, as I now do, after a good night, and see all these

[1] The subject of this picture, which is called 'Sinon before Priam', is evidently David at the cave of Adullam. *It is now catalogued as 'Landscape: David at the Cave of Adullam' (N. G. No. 6).

dear infants about my bed, all up early to know how papa passed the night. Even little Lionel puts out his little face to be kissed, and smacking his lip, says, 'Are you well, better to-day?' I am often inquired after by kind friends, and the sympathy of my real, own, and dear friends is great indeed. I have got my 'Church'[1] from Hampstead, to hang at the foot of my bed to amuse me.

"How kind of you to think of the Gainsborough;[2] the 'Lord Rodney'[3] I remember at Mr. Bigg's, who did it up very well, and of whom Lord Egremont bought it. Bigg had it to sell for a gentleman; he showed it to Lord Egremont, who seemed hardly to notice it, but on going away, he suddenly turned round at the door, and said, 'You may send me the Admiral.' I knew the grandson of Lord Rodney, who was enough like the picture to have sat for it.

"I had a terrific visit from K. F—— on Sunday morning. He was brushed up and 'bearded like the pard', and going to hear Irving,[4] who, he said, was the only man to preach the Bible, explain the prophecies, etc. I cautioned him against enthusiasm in religion, which, as it has no foundation, is apt to slip from under a man, and leave infidelity or madness; but I talked to a tree. However, touching his picture of 'Circe' told better, and he went away with a ghastly smile, nearly crushing my hand in that grasp of his. This visit really did excite me, and I fell into a passion, which did me good. . . . P——[5] has just been here, accompanied by Newton's dog, who has presented me with two fleas, lest I should now sleep. God bless you all. Alfred close at my elbow. . . . Jones likes my preface. . . . I have seen Stanfield,[6] and am much struck with him altogether as a sound fellow; he has great power."

[1] Probably the 'Church Porch', exhibited at the B.I. 1811. Cf. pp. 21, 182.

[2] Of which I was making a sketch for him.

[3] By Sir Joshua Reynolds, one of his finest pictures. *It is still in the collection at Petworth House.

[4] Edward Irving (1792–1834), non-conformist preacher.

[5] Powell; i.e. Peter Powell, actor and amateur painter.

[6] Clarkson Stanfield R.A. (1793–1867), first a painter of stage-scenery then a popular and successful painter of landscape.

"March 3rd. My dear Leslie, Many thanks for your visit yesterday. I have got my large 'Waterloo' beautifully strained on a new frame, keeping every inch of canvas. It gives me much pleasure in the present occupation, but how long that will last I know not. Archdeacon Fisher used to compare himself in some situations to a lobster in the boiler; very comfortable at first, but as the water became hotter and hotter, grievously perplexed at the bottom. P—— called yesterday.[1] I joked with him at first on the folly of fighting with windmills, but he is quite confirmed in the boundless notions he entertains *on the wrong side of everything*. My best regards; I shall soon come and see you; I am quite tired and out of patience at being so long ill and disabled."

"March 4th. My dear Leslie, I have not the power to come so far as your house, but I want much to see you, and to thank Mrs. Leslie for her very kind note of yesterday, of which Alfred has taken possession for his 'real own', as he says it was intended for him, for he is mentioned in it. Mrs. Leslie was so good as to speak of me in the usual kind way in which you are both pleased to consider me, to Mr. Lawley,[2] who called yesterday afternoon, and nothing could be more agreeable than we both were to one another; he admiring my pictures, and I admiring him for doing so; but he has not admired only, he has taken a great fancy to my 'Heath', and to my book, which is now assuming a tangible shape. . . . He desired the India copies of my book to be put up for him, and he will send one of his 'lazy fellows' for them on Monday morning; all this is very delightful to me. He was much pleased with my *Harlequin's jacket*, and said he should often call and see it, for it was ' a most amusing picture, the houses—the bridge—St. Paul's—the numberless boats'—etc. I wish I could get to your house, but my knee is so bad I could not walk to the top of my own street."

[1] A friend of Constable and of mine, whose good heart and strong understanding should have kept him aloof from that class of politicians who would overturn the established institutions of the country.

[2] Now Sir Francis Lawley.

In a note to Mrs. Leslie, dated March 28th, Constable, speaking of Alfred Chalon's very fine water-colour drawing, the whole-length portrait of Mrs. la Touche,[1] says, "Has Leslie seen Chalon's old lady in black? it is the grandest 'Il Penseroso' ever done in the world."

"April 9th. My dear Leslie, I hope you get on with your picture to your liking; I am in a dreadful state about mine, for I am determined to send it. I should like much to see yours, but that has not been possible, as you will do me the justice to believe. I met Callcott at dinner the other day; he said he regretted much that you had determined not to send the 'Sterne'; I regret it also; he said it 'was quite fit, and very fit for the Exhibition'; I think so too. At all events, I thought you might like to hear his opinion, and I assure you it was the only one in which we did agree during the evening. He thinks I do not believe what I say, and only want to attract attention by singularity; but my pictures being my acts, show to my cost that I am sincere, for

'He who hangs, or beats his brains,
The devil's in him if he feigns.'

But he is on the safe side. . . . My boys are all here. I saw my little girls on Sunday, all well—so the world is light as a feather to me."

"Charlotte Street, April 24th. My dear Leslie, All my little girls are here. Can Mrs. Leslie and your sister and yourself come and pass an hour with us on Thursday at seven or so. On Wednesday, the levee, which they are to view from a window in St. James' Street. If they see only the soldiers, they are worth the seeing, and 'little things are great to little minds I have never been more restless about a picture than with the premature dismissal of this, and it has not even my redeeming quality, the rural."[2]

*[1] Exhibited at the R.A. 1832.

*[2] Constable's 'restlessness' was increased by the fact that this year the customary five-days' 'varnishing'-period was not allowed to Academicians: cf. Peter Leslie's *Letters of John Constable to C. R. Leslie,* London 1931: Letter XLV (dated 27 April 1832).

Two opposite modes of proceeding are adopted by painters in the execution of their works. With some it is the practice to finish part by part as the picture proceeds, so that, while it is in progress, portions entirely or very nearly completed are seen on a canvas the remainder of which is blank. Other artists carry on the whole together; beginning with a faint dead colour, in which the masses only are laid in, and proceeding with the details gradually, and without suffering one part to advance much beyond the rest, until the whole is finished. The first mode is the most favourable to precision of touch, the last to richness of surface and truth of tone. I need not say this was the mode adopted by Constable. Indeed, in landscape it seems impossible that those almost imperceptible gradations of colour and light and shadow, which form so much of its charm, should be obtained by any other process. It has, however, the disadvantage of tempting the artist at times to sacrifice parts too much to the general effect. With Constable chiaroscuro was the one thing to be obtained at whatever cost. 'I was always determined,' he said, 'that my pictures should have chiaroscuro, if they had nothing else.' In the pursuit of this indispensable quality, and of that brightness in nature which baffles all the ordinary processes of painting, and which it is hardly possible to unite with smoothness of surface, he was led by degrees into a peculiar mode of execution, which too much offended those who were unable to see the look of nature it gave at the proper distance. In the 'Waterloo Bridge' he had indulged in the vagaries of the palette knife (which he used with great dexterity) to an excess. The subject challenged a comparison with Canaletti, the precision of whose execution is wonderful, and the comparison was made to Constable's great disadvantage; even his friend, Mr. Stothard, shook his head and said, "Very unfinished, sir", and the picture was generally pronounced a failure. It was a glorious failure, however; I have seen it often since it was exhibited, and I will venture to say that the noonday splendour of its colour would make almost any work of Canaletti, if placed beside it, look like moonlight. But such pictures ought not to be compared,

each has its own excellence, and nothing can be more true than Constable's remark that *"fine pictures neither want nor will bear comparison."*[1] It might be at this time that he wrote what I found on a scrap of paper among his memoranda: "My art flatters nobody by *imitation*, it courts nobody by *smoothness*, it tickles nobody by *petiteness*, it is without either *fal de lal* or *fiddle de dee*, how then can I hope to be popular?"

With the 'Waterloo Bridge',[2] Constable exhibited a very small picture of 'Sir Richard Steele's Cottage, Hampstead';[3] with two others, 'A Romantic House, Hampstead',[4] and 'Moonlight', and four drawings, among which was the 'Jacques and the wounded Stag'.[5]

When the following note was written, every thought of art was banished from Constable's mind by the sudden illness of his eldest daughter with scarlet fever: "Charlotte Street, June 22nd. My dear Leslie, Thank you for your kind note. I knew you would be anxious, and I regret to say this note of mine will not allay your anxiety. My dear child is alarmingly ill; her pulse to-day is at a hundred and fifty. My hope is this may be the worst day, so Evans hopes also. Mr. Haines says her throat is not worse to-day than yesterday, but God only knows how it will terminate. I have, as you and Mrs. Leslie know, looked to this sweet infant as the hope and comfort of my old age; but hope is futile, and on what joy can we reckon on this side the grave? . . . I am also very anxious about the two other little dears, who must remain at school, it being not advisable to have them home or even away. All our endeavour is to keep this most cruel disorder out of the way of my boys. How providential it was that she was not already at home; she is managed far better where she is, but it is a case of hard necessity, and poor Roberts[6] is crying all day at not being able to administer to the dear darling child's comfort. Poor John

[1] Chapter XV, p. 234.
[2] Now in the collection of Lord Glenconner. See Plate 48.
[3] Formerly in the collection of Sir Leicester Harmsworth.
[4] Probably the painting now in the National Gallery (No. 1246). See Plate 56.
[5] Now in the British Museum (No. 1940–4–13–14). [6] Her nurse.

Dunthorne[1] is getting daily, nay hourly, worse; he cannot long remain to me. I do not contemplate a happy old age even if I should attain it."

"June 24th. My dear Leslie, I send you a packet which I had made up last night for Lucas to take to you, but he did not come. I think I have rather a better account to send you of my little girl; it is not impossible but the worst is past. To-day her pulse is lessened and her throat better, but she is in a fearful state. It is cruel I cannot see her, and it is hard for the other little girls that they cannot come home; but little Emily told Miss Noble that it was not 'near so disagreeable and nasty to stay the holidays as she expected. . . .' "

"June 25th. Dear Lucas, I send you the picture with my best hopes and wishes, and which I assure you are not slight nor disinterested; but I am more anxious for your sake than my own; anxious that your enthusiasm may not be thrown away nor prove unpropitious. My dear little girl is better, God be praised! and with His blessing she may recover. She got some sweet sleep yesterday, but otherwise it was my most anxious day, though the fever was greatest (pulse one hundred and fifty) on Friday. I am full of anxiety about the other two little dears, who of necessity must be left at the school, but apart from her."

The picture mentioned in this note was the 'Cornfield', now in the National Gallery, which Mr. Lucas undertook to engrave at his own risk; the plate was afterwards purchased and published with its companion, the 'Lock', by Mr. Moon.

I received the following letter at Brighton: "July 6th. My dear Leslie, I was much delighted with your letter this morning, and lose no time in replying to it. My dear child, thank God, is wonderfully recovered; I can take her away safely to herself, though not to others, next week. Which to do, I know not, take her to Brighton or Suffolk. I fear most for my boys. Poor dear John Dunthorne is very much worse; he had several doctors with him yesterday, who have relieved him a little, but

[1] Constable's young friend had been for some time suffering from a disease of the heart.

this state of things cannot last long. It makes me sadly melancholy; I shall lose a sincere friend, whose attachment to me has been like that of a son, from his infancy. He is without fault, and so much the fitter for Heaven. I wake in the night about him. . . . Pray make my kindest regards to Mrs. Leslie, and God bless the dear children! I trust you have not thrown the lovely baby into the sea; it has been the ruin of thousands of young infants. . . . Some noble pictures at the Gallery, along with a good deal of rubbish."

"July 9th. My dear Leslie, Our meeting at the Academy was to address the king on his 'happy and providential escape'.[1] The plan of a new house is quite flourishing, and at present there is no obstacle save what may be apprehended from the Commons' House, it being possible it may be filled with *common* minds. K. F—— was with me when your letter was put into my hands. He seemed amused at your mode of life; he, chivalrous man, goes on

'Scorning delights, living laborious days;'

and so far he realises the poet's words, in that he finds 'no guerdon'. He is an excellent fellow. His drawings are now before me, and he certainly sees and feels the grandeur of the great painters in the Gallery. I have presented him with a set of proofs of my work. I shall send my little girl to Brighton as soon as she is able to be removed. Miss Noble will go with her and take charge of her, in a post-chaise, as I should not like any other dear child who might be in a stage-coach to take any harm. To-day I thought she looked like herself; this is only the second time of my seeing her. The other little prisoners are as yet well. . . . Evans is to be married on Saturday. No man deserves more happiness, and so far as we short-sighted mortals can promise it to ourselves, he has every prospect of it; but as Archdeacon Fisher's father's coachman told him, 'It is all a mystery, this same matrimony.' . . . Poor dear John Dunthorne is so very ill that I do fear his time is now short indeed. My visits to him are so melancholy that I do not get over them

[1] A stone had been thrown at the King at Epsom.

all day; still he works a little. A nice friend and relative is now staying with him, and this is a great comfort."

While Constable's mind was agitated by the near prospect of losing John Dunthorne, to whom he had been a useful patron, having assisted to establish and to procure him employment as a picture cleaner, he heard of the death of that friend who had been his own and only patron, when patronage was of the greatest importance to him.

"September 4th. My dear Leslie, You will be grieved to hear that I have lost my dear friend, Archdeacon Fisher. He went with Mrs. Fisher to Boulogne, hoping there to find some relief from a state of long and severe suffering. He was benefited at first, began to take an interest in what was about him, and poor dear Mrs. Fisher was cheered with the prospect of his being speedily restored to health and spirits, when on Friday, August 24th, he was seized with violent spasms, and died on the afternoon of Saturday, the 25th. This sudden and awful event has strongly affected me. The closest intimacy had subsisted between us for many years; we loved each other, and confided in each other entirely, and his loss makes a sad gap in my worldly prospects. He would have helped my children, for he was a good adviser, though impetuous, and he was a truly religious man. I cannot tell you how singularly his death has affected me. I shall pass this week at Hampstead, to copy the 'Winter',[1] for which, indeed, my mind is in a fit state. Evans has returned with his nice bride."

Hoping to amuse Constable, I had sent him a copy of a small picture by De Hooge, of which a sunbeam, and that alone, may be considered the subject; but it shines through a window on the wall of a clean little Dutch room, from which it is reflected on the return of the wall and other objects with extreme elegance, and a degree of truth perfectly illusive.

"September 22nd. My dear Leslie, I came here last evening, and saw the pictures. I am delighted with the copy of De Hooge. How completely has he overcome the art, and trampled it under foot, yet how full of art it is. No painter

[1] By Ruysdael, belonging to Sir Robert Peel.

that ever lived could change a single thing in it, either in place, or light or dark, or colour, warm or cold. Such things are in short quite above the art, and it is a blessing they are done. I must take the De Hooge to Hampstead."

"October 1st. Dear Lucas, . . . I have sad accounts, indeed, of poor John Dunthorne from Suffolk. He will never see London again. He is confined to his bed and cannot write."

"Dear Lucas, I have added a *Ruin* to the little 'Glebe Farm',[1] for not to have a symbol in the book of myself, and of the work which I have projected, would be missing the opportunity. The proof of the new 'Old Sarum' looks well this morning, half-past seven. October 2nd, J. C."

"November 6th. My dear Lucas, I go to Suffolk on Thursday to attend the last scene of poor John Dunthorne; but he 'fought a good fight', and I think must have left the world with as few regrets as any man of his age I ever met with. . . . His fond father, who has been here to-day, is gone back entirely broken-hearted; he was so proud of him, and well he might be. Do not cut the plate of the new 'Old Sarum' yet. I have touched another proof to-day, and it looks so well, I think you may like it, and perhaps adopt it. I did it on seeing poor John Dunthorne's rainbow this morning. . . . They like the 'Stonehenge'. I mean Leslie, and the gentleman who lectured on it, and tried to prove it antediluvian; the thing was ingenious."

"Well Walk, November 14th. My dear Lucas, I returned last night, after seeing the last of poor John; no one can supply his place with me. God's will be done! The text of the sermon of the Rev. D. C. Rowley for poor John was from Isaiah, chap. iv. ver. 2: 'In that day shall the branch of the Lord be beautiful and glorious, and the fruit of the earth shall be excellent and comely for them that are escaped of Israel.' . . . To-day is dear Alfred's birthday, and they have kept me a

[1] This was a plate rejected by Constable, and which its general masses enabled him to turn into a view of Castle Acre Priory. It was not published, though I believe he intended it, with some other plates, to form an appendix to the book.

willing guest. . . . An angry neighbour has killed my fine black cat, who used to call me up in the morning, but she had been naughty, and killed one of his ducks. . . . In the coach yesterday, coming from Suffolk, were two gentlemen and myself, all strangers to each other. In passing the vale of Dedham, one of them remarked, on my saying it was beautiful, 'Yes, sir, this is Constable's country.' I then told him who I was, lest he should spoil it."

The lovely engraving, in the *English Landscape*, called 'Summer Morning',[1] is a view of Dedham vale, very much as it is seen from the high road. Its foreground and sky were greatly altered by Constable while the plate was in progress. The plough, the two cows, and the milkmaid, were introduced in the place of a single figure of a man with a scythe on his shoulder.

"Well Walk, November 20th. My dear Leslie, My man is going from here to Lucas, and I avail myself of the opportunity to return the De Hooge, which has afforded me much pleasure. These mutual communications of study are a great help to the happiness of life. . . . I shall send my god-daughter Bishop Horne's sermon on a kiss when she is a little bigger.[2] I was in Charlotte Street, fortunately, yesterday, when Newton called with his wife, and was pleased to see a lady so genteel and so amiable, and so free from affectation or false pride. . . . It is delightful to see Landseer's unaffected kindness to his sisters."

Constable's eldest son seemed now to have outgrown the ailments that had caused so much anxiety to his parents, and in a note to me, dated December 4th, he says, "This is dear

[1] After 'Dedham Vale', in the Victoria and Albert Museum (No. 132–1888).

[2] In the following year he presented her with the first and best book ever written expressly for children, *Dr. Watt's Songs*. It is illustrated by wood-cuts from Stothard, and Constable not only coloured them very beautifully, but added some designs of his own, as a bird singing over its nest to the song against quarrelling, and a bee settling on a rose to that on industry; while over the lines beginning, 'Let dogs delight to bark and bite', he wrote with a pencil, 'For Landseer'. *Another copy, decorated for his daughter Emily, is now in the Library of the Victoria and Albert Museum.

John's birthday.—Poor dear Maria, if she could see him now!
..."

"Charlotte Street. My dear Leslie, It is long since I have seen
you, or heard of you and Mrs. Leslie; but we have got settled
here after the agony of three days' moving. The first detach-
ment of my forces went off with Roberts, and consisted of all
my boys, and a servant or two besides, and I followed with
my girls and innumerable boxes—ships—dolls—fire engines—
pictures—easels—and other useless lumber; and now we are
all looking round with astonishment at having been so long
away from so comfortable a house as this. I am in possession
of half a doe, which I shall not at all enjoy unless you and Mrs.
Leslie and your sister partake of it. My wish is to entrap
Newton and his bride. I have not been out into the street
since my return, but have finished, or shall to-morrow, a
small wood, and a head, both commissions of long stand-
ing, and so far I secure some peace of mind. As to the
exhibition, the 'House that Jack built' will be enough to
me."

Constable had recently formed an acquaintance with a
gentleman of his own name, though not a relation, Mr.
George Constable of Arundel, and this was the beginning of
a warm friendship which contributed much to the happiness
of the last years of his life. The next letter is addressed to this
gentleman: "Charlotte Street, December 14th. My dear Sir,
I beg to send the copies of my work for your choice. The
proofs that are sealed have had my close inspection; but I
send those you had last evening to compare with the India
ones. I send also the prints, which are equally good, for all are
printed by ourselves.[1] I should feel happy in the belief that my
book should ever remunerate itself, for I am gratifying my
vanity at the expense of my children, and I could have wished
that they might have lived on me, not the reverse. My only
consolation is, that my fortune has not sheltered me in idle-
ness, as my large canvases, the dreams of a happy but un-
propitious life, will prove. Pray forgive the unreserved tone of

[1] Mr. Lucas had fitted up a press in his own house..

this hasty scrawl. I remain, my dear sir, always your obliged servant, John Constable."

He was now engaged on a portrait of Englefield House, Berkshire, for its possessor, Mr. Benyon de Beauvoir; and of which, though the subject was unpromising, he made a beautiful picture. The commission had been obtained for him by the recommendation of Mr. Samuel Lane.

"December 17th. My dear Leslie, I was sadly disappointed at missing you and Mrs. Leslie here on Tuesday. I am glad Bonner showed you what I am about with the house, as it produced your very kind note. It reached me at tea time that day, and before bed time I had made all the cows in the foreground of the house picture bigger, and put in another bigger than all the rest. This has had the effect you anticipated, and sent the house back, and also much recovered and helped to realise my foreground, which indeed this blank canvas wants to aid it; but I must try at one of the elements, namely, air, and if that include light, I ought not to despair. What you say generally of my canvases is too delightful for me to dispute; I ought to be satisfied that you think so; to please *one* person is no joke, nowadays."

1833

Messrs Chalon. The Palette Knife. Mr. Seguier. Mr. Beauchamp's Establishment. Picture of the Cenotaph erected by Sir G. Beaumont to the Memory of Reynolds. Constable visited by a Connoisseur. Lady Morley. Letters to Mr. George Constable. Stothard. Letter to Mr. Thomas Dunthorne. Exhibition at the Royal Academy. Picture of 'Englefield House'. Allusion to the Loss of the *Abergavenny*, Captain Wordsworth. The Author's Visit to America. Constable's First Lecture on the History of Landscape. Captain Cook. Letters to Mr. George Constable. Notes to Mr. Lucas. Picture of 'Waterloo Bridge'.

"My dear Leslie. . . . I called on the Chalons; John's landscape is very promising, one of his best. As to Alfred's 'Samson', it is just what Paul Veronese would have made it, if he could have combined expression with colour; it is full of power, full of splendour. They are both adopting the palette knife, while I have laid it down, but not till I had cut my own throat with it. The Delilah is lovely in her supplicating posture. January 7th, 1833."

The dexterity with which Constable used the palette knife has been mentioned, and when he speaks of having 'cut his own throat with it', he alludes to a recent charge brought against his pictures, that they consisted 'only of palette knife painting'. But if he had now laid the knife down, he very soon took it up again.

"January 11th, 1833. My dear Leslie, . . . I have had a friendly visit from a much greater man than the Duke of Bedford—Lord Westminster—Lord Egremont—the president of the Royal Academy—or even the king himself,—Mr. Seguier![1] He seemed rather astonished to find so good an appearance, or rather, an appearance so far beyond his expectation, and bestowed much praise, such as, 'Did you do this? really! Who made that drawing, you? really! very good indeed.' . . . John Chalon has spread a report respecting myself that has reached me from two or three quarters much to my

[1] Mr. Seguier was supposed to be the principal director of the taste of the nobility and gentry in all that related to pictures. He was a good-natured and honest man.

advantage, namely, that he actually saw four small sable pencils in my hand, and that I was *bona fide* using them in the art of painting. . . . I must give up ——[1] on Saturday morning, as I have much to do to the great 'Salisbury', and am hard run for it. I have written to ——[2] to beg off hearing for the hundredth time that his are the best pictures in the world."

I had introduced Constable to Mr. Beauchamp, to whose manufactory of British plate in Holborn he paid a visit with his sons, of which he gave me the following amusing account: "January 20th. My dear Leslie, I went with John and Charles to Mr. Beauchamp's last evening; their delight was great, not only at the very great kindness of Mr. and Mrs. Beauchamp and their boys, but at the sight of all that was to their heart's content: forges—smelting pots—metals—turning lathes—straps and bellows—coals—ashes—dust—dirt—and cinders; and everything else that is agreeable to boys. They want me to build them just such a place under my painting room; and had I not better do so, and give up landscape painting altogether? Poor Mrs. Beauchamp was suffering with the tooth-ache, but her politeness made her assure me that I succeeded in talking it off.

"I have called on poor ——.[3] I did not think his things were quite so bad. They pretend to nothing but an imitation of nature; but then it is of the coldest and meanest kind. He is immersed in white lead, and oil, and black, all of which he dashes about the canvas without the smallest remorse. All is, thence, utterly heartless."

"Charlotte Street, February 13th. Dear Leslie, . . . May I beg of you to let your servant take the little parcel to Edwin Landseer; it is my first number, in which is the 'Mill' he wanted. I have sent it with the four other prints, which is like getting rid of a bad shilling among half-pence."[4]

★[1] Ludgate, a Suffolk acquaintance and collector, who died later this year.
★[2] The same.
★[3] Lee; i.e. F. R. Lee, R.A. (1798–1875), a protégé of Wells of Redleaf.
★[4] Leslie is mistaken in placing this letter in 1833; the full text, quoted by P. Leslie *op. cit.*, Letter XXXVI, contains a reference to a R.A. election which took place on 10th Feb. 1832, to which year this fragment should be ascribed.

In a note to me, not dated, but written in the early part of this year, Constable says, "I have laid by the 'Cenotaph'[1] for the present. I am determined not to harass my mind and health by scrambling over my canvas as I have too often done. Why should I? I have little to lose and nothing to gain. I ought to respect myself for my friends' sake, and my children's. It is time, at fifty-six, to begin, at least, to know oneself,—and I do know what I am *not*. . . ." He then speaks of the qualities at which he chiefly aimed in his pictures,—"light—dews—breezes—bloom—and freshness; not one of which", he adds, "has yet been perfected on the canvas of any painter in the world."

"April 2nd. Dear Leslie, Do not pass my door if you come to town. I have brushed up my 'Cottage' into a pretty look, and my 'Heath' is almost safe, but I must stand or fall by my 'House'. I had on Friday a long visit from Mr. ——[2] alone; but my pictures do not come into his rules or whims of the art, and he said I had 'lost my way'. I told him that I had, 'perhaps, other notions of art than picture admirers have in general. I looked on pictures as *things to be avoided*, connoisseurs looked on them as things to be *imitated*; and that, too, with such a deference and humbleness of submission, amounting to a total prostration of mind and original feeling, as must serve only to fill the world with abortions.' But he was very agreeable, and I endured the visit, I trust, without the usual courtesies of life being violated.—What a sad thing is it that this lovely art is so wrested to its own destruction! Used only to blind our eyes, and to prevent us from seeing the sun shine—the fields bloom—the trees blossom—and from hearing the foliage rustle; while old—black—rubbed out and dirty canvases take the place of God's own works. I long to see you. I love to cope with you, like Jaques, in my 'sullen moods', for I am not fit for the present world of art. . . . Lady Morley was here yesterday. On seeing the 'House', she exclaimed, 'How

[1] He had begun a picture of the cenotaph erected by Sir George Beaumont to the memory of Reynolds.

*[2] Wells, i.e. Wells of Redleaf.

fresh, how dewy, how exhilarating!' I told her half of this, if I could think I deserved it, was worth all the talk and cant about pictures in the world."

Constable often did himself harm by attempting to set right those whom he might have known, from the very constitution of their minds, it was impossible to set right, in matters of taste. Such strong expressions as those mentioned in the last letter, though easily comprehended by the few who understood his views of art, only gained him the character of a dealer in paradox with those who did not. An affronted taste is very unforgiving, and he not only wasted his time, but too often made enemies by attempting to 'cut blocks with a razor'.

"To Mr. George Constable. April 12th. My dear Sir, I am delighted to hear of the steady improvement of your health, and I most sincerely hope it will continue to improve; the coming season is in your favour. I have always heard of the autumn being the *painter's season*, but give me the spring, though

'With tears and sunshine in her fickle eyes.'

I send the drawing by Varley, and I venture to accompany it with two others; they all belonged to my poor friend ——, who died in the autumn, leaving a widow and dear little girl; the disposal of these drawings would essentially serve them. That by Varley is six pounds, the others two pounds each; they would be pretty accompaniments to the 'Curfew' on a mantel-piece; they are by Ziegler. . . . I beg my best compliments to Mrs. Constable, and believe me, my dear sir, with sincere regards, yours truly, John Constable."

"To Mr. George Constable. April 17th. My dear Sir, Accept my best thanks for your very kind letter which I received this morning, enclosing ten pounds, which with great pleasure I transmitted to Mrs. ——. I feel assured your friend will never repent the possession of those very beautiful drawings. I hear the Exhibition will be excellent; the quantity sent exceeds all precedent; Wilkie and Leslie are strong,

Phillips and the president are strong, Landseer is strong, and so on; but perhaps you wish me to speak of myself; Constable is weak this year. We shall probably all know our fate on Thursday se'nnight, and the public may sabre us at their pleasure on the first Monday in May. . . . I passed an hour or two with Mr. Stothard on Sunday evening. Poor man! the only elysium he has in this world is found in his own enchanting works. His daughter does all in her power to make him happy and comfortable. Lucas has been so busy about the portrait of Sir Charles Clark, that till now he could not take up my appendix, which I shall be happy to present to you when ready. I am, my dear sir, always your obliged friend, John Constable."

"To Mr. Thomas Dunthorne.[1] April 19th. Dear Sir. I was prepared to receive the melancholy account of the death of poor Mrs. Folkard,[2] which Mr. Wright has just told me of. How truly melancholy is the history of all this excellent family! How well I remember the birth of all of them— Ann, James, poor John, and Hannah;—little thinking I should live to lament the death of every one. My poor old friend, the father of this hapless race, must be in a fearful condition. But since the death of poor John I well know he has made up his mind to everything that can happen. He now neither cares to stay or go. He told me he did not care how soon he was laid in the same grave with poor John.[3] There seemed an unsoundness in the constitution of all; from the mother probably. There has been a young lady here to enquire for John, to whom he gave lessons. She wished to know if anything was owing to him, and had he been living, to have had more lessons. . . . With the kindest regards, I am truly yours, J. Constable."

"April. Dear Leslie. I send Pitt to know how you are all getting on. R—— assured me that —— and all of them did all in their power to help me to a change of the place of my

[1] Brother of Constable's early friend, J. Dunthorne, Senr.

[2] A daughter of J. Dunthorne, Senr.

[3] Mr. Dunthorne survived until October 1844.

picture, but could not manage it. They have immense trouble this year, but I am easy now, and they all say it looks very well. But S—— and H—— are so strictly academical that they deny the painter the power of making a picture out of nothing, or out of a subject not to their liking, though they do not deny it to the poet. The frames have annoyed them beyond measure, and the cold-blooded selfishness of —— more than all. The council have written to him two mild letters entreating to change a monstrous piece of gilded wood, as it ruined the hopes of at least five others who only look for the crumbs that fall from the Academic table, while at the same time it spoiled his own picture,—but he would not comply. ——'s frames are shameful, or rather *shameless*. The council are determined to regulate these things next year. My 'Heath' is admired, and is well placed."

"Dear Leslie. I send to know how your dear family and yourself get on. . . . John Chalon has just been here. He is full of anxiety about his picture. I told him I would change places with him at a venture. . . . Thank you, dear Leslie, for your kind note.—One ambition I *will* hold fast. I am determined never to deserve the praise of S——, H——, C——, D——, W—— R——, etc., etc., etc."

Constable's pictures at the Academy, this year, were 'Englefield House, Berkshire, morning';[1] a 'Heath, showery, noon'; 'Cottage in a Cornfield'; 'Landscape, sunset', and three drawings in water colours, namely, 'An old Farmhouse', 'A Miller's House', and 'A Windmill, squally day'.

"May 14th. Dear Lane. Thank you for your admiration of my book; the intention is good. I wish it gave me the same unalloyed pleasure; but the extravagant, useless, and silly expenditure I have been led into distracts me, now that the hour of reflection is come. . . . The *Morning Post* speaks beautifully of my 'House'. S——[2] told me it was 'only a *picture of a house*, and ought to have been put into the Architectural Room.' I told him it was 'a picture of a summer morning, *including a house.*'"

[1] Now in the collection of H. A. Benyon Esq. See Plate 47.
[2] Probably Shee, i.e., Sir Martin Archer Shee P.R.A.

Mrs. Leslie had seen in Charlotte Street a proof impression of the 'Weymouth Bay', in some respects imperfect, but in others very beautiful, and had expressed a wish to have it, to which I objected, thinking it was of value to Constable. He sent it the next day with the following note: "Dear Mrs. Leslie. I have no idea that husbands should control their wives, any more than that wives should control their husbands, at least, in trifles; I therefore make no scruple to send you what is good for nothing. It is, I hope, a sufficient excuse for me that you expressed a wish for it, and I felt at the same time assured that its being useless was the reason of your doing so; thus 'much ado about nothing'. I shall now, to give value to the fragment I send you, apply to it a line of Wordsworth:

'This sea in anger, and that dismal shore.'[1]

I think of Wordsworth, for on that spot perished his brother in the wreck of the *Abergavenny*."

That Constable's next note may be understood, I must mention that I contemplated taking my family to America, with the probability of remaining there.[2]

"June 11th. My dear Leslie. As it may not be ordained that I write to you again on my birthday (at least in England), I cannot omit the occasion, though the pleasure is a melancholy one in every way to me. . . . The loss of you is a cloud casting its shade over my life, now in its autumn. I never did admire the autumnal tints, even in nature, so little of a painter am I in the eye of common-place connoisseurship. I love the exhilarating freshness of spring. My kindest regards to Mrs. Leslie; I hope all your children are well. . . . Remember I play the part of Punch on Monday at eight, at the assembly-room at Hampstead."

'The part of Punch' alludes to his first appearance as a

[1] From 'Elegiac Stanzas, suggested by a picture of Peele Castle, in a storm, painted by Sir George Beaumont.' The death of Captain Wordsworth is also alluded to, in another most affecting poem, by his brother, addressed 'To the Daisy'.

*[2] Leslie was to take up the appointment of Drawing Master at West Point Military Academy. He relinquished the post in the following spring, and returned to England.

lecturer. His subject was 'An outline of the History of Landscape Painting', which he afterwards filled up in a course of four lectures delivered in London.

"June. Dear Leslie. . . . My godchild is a delightful little creature, and I shall be glad to live long, if it is only to cross the Atlantic to give her away. When Captain Cook stood sponsor for a little girl in Barking Church, he said, 'If this infant lives, I will marry her'; he fulfilled his promise, and she was living until lately. Only think of the vicissitudes of life; what may we not hope and almost expect? you may return. Don't separate any ties in this country. Keep your diploma."

"Well Walk, August 16th. My dear Leslie, I have wished much to write to you. I have not thanked you for your long and delightful letter, but I am not now so much master of that *cœur de joie* which used to cheer me, especially when I took pen in hand to write to you. The thought that I am to be deprived of the consolations of your and Mrs. Leslie's society —of such happy hours as you and I have passed together— and of our communications on art, and everything else, weighs heavy on me; so much so, indeed, as to depress my mind, and prevent the enjoyment of even the little that remains of our personal intercourse; this is not right on my part, I know.

"I had a delightful visit into Suffolk. We ranged the woods and fields, and searched the crag-pits for shells, and the bones and teeth of fossil animals for John; and Charles made drawings, and I did nothing at all, but I felt happy to see them enjoy themselves. All my family were very kind to the boys. . . . I have just lost a valuable Suffolk friend, Sir Thomas Ormsby, who would have served me always. He was son-in-law to General Rebow, an old friend of my father's; thus I am almost daily bereft of some friend or other. . . . I am glad you are going to Lord Egremont's;[1] he is really a great patron of art. . . . I can hardly write for looking at the silvery clouds; how I sigh for that peace (to paint them) which this world cannot give (to me at least). Yet well I know 'happiness is to

★[1] i.e. to Petworth.

be found anywhere or nowhere'; but this last year, though, thank God, attended with no calamity, has been most un-propitious to my happiness. To part with my dear John is breaking my heart, but I am told it is for his good."

Constable's two eldest sons were about to leave him for a school at Folkstone.

"To Mr. George Constable. Well Walk, December 9th. My dear Sir. I am grieved at the letter I have received from you. To have had such a serious accident,[1] and at a time, too, when your health was so much improving, is extremely distressing, as it must prevent your general habits of enjoying the air, and of exercise. Gigs are bad things, one is so much at the mercy of the horse. I hope, however, from the almost cheerful tone in which you have dictated your letter, that all will do well with you, and that your next letter will bring satisfactory accounts; at least, that the inflammation is gone, and the bone set. The former is much within the reach of the professors, our friends of the ditches, the leeches. These humble creatures have the power and the will, too, to render mankind essential benefits; and this grateful argument will hold good of everything in nature, more or less. I have been sadly ill, and during the last week particularly so, still I have ventured to embark on a large canvas, and have thus set forth on a sea of trouble, but it is a sea that generally becalms as I proceed; I have chosen a rich subject. . . . To-morrow I pass a long evening at the Academy; the 10th being its anniversary. We give the prizes for all kinds of art. I lament to say we must give away an abundance of our beautiful medals to little pur-pose. How are we to account for this? perhaps as Fuseli once told me, 'as the conveniences and instruments of study in-crease, so will always the exertions of the students decrease.' Now, my dear sir, how can I oblige you, or contribute to your amusement during your sad calamity? Can I send you anything to look at?"

"To Mr. George Constable. Well Walk, Hampstead,

[1] Mr. G. Constable had been thrown out of a gig, and his left arm was broken above the elbow.

December 17th. My dear Sir, I would not have kept you so long in suspense, had it been in my power to do otherwise; but I can't get well. I have been long in a disordered state of health, and my spirits are not as they used to be. I have not an idea that I shall be able to part with the 'Salisbury';[1] the price will of necessity be a very large one, for the time expended on it was enormous for its size. I am also unwilling to part with any of my standard pictures; they being all points with me in my practice, and will much regulate my future productions, should I do any more large works. The picture by Cuyp which you send is agreeable, and its colour and sunshine will no doubt please many; I wish not, however, to add any more old pictures to my stock. If you wish for any information about its money value, I can get some professional friends to see it; of that I am no judge; I only know *good* from *bad* things in art, and that goes but little way in being of use to my friends. I shall greatly rejoice to hear that you are so far recovered as to be out again. I will look for some little matters to return with the Cuyp, when you desire to have it."

"To Mr. John Constable. Arundel, December 18th. . . . I sincerely wish I could prevail on you to take a trip to Arundel, I am sure you would derive great benefit from it. I am from experience quite satisfied that the occasional removal from the monotony of domestic scenes and circumstances is very beneficial both to mind and body. . . . Respecting one of your pictures, I shall certainly do my utmost to possess what I think your best in some respects, the 'Salisbury Cathedral'; but more on this subject when I have the pleasure of seeing you. Could you without much trouble enclose me a bit of your sparkling colour to copy, I should be more than I can express obliged. I am, my dear sir, your sincere friend, George Constable."

"To Mr. George Constable. Well Walk, Hampstead, December 20th. My dear friend. I thank you most sincerely for your kind and friendly letter. I am sadly out of order, but

[1] One of his repetitions of the beautiful picture of the 'Cathedral from the Bishop's Grounds'.

you seem determined that I shall not knock under. I am too unwell to go to town, but my friend Bonner has just set off to Charlotte Street to pack your picture and forward it; it is a beautiful representation of a summer's evening; calm, warm, and delicious; the colour on the man's face is perfect sunshine. The liquid pencil of this school is replete with a beauty peculiar to itself. Nevertheless, I don't believe they had any *nostrums*, but plain linseed oil; '*honest linseed*', as old Wilson called it. But it is always right to remember that the ordinary painters of that day used, as now, the same vehicle as their betters, and also that their works have all received the hardening and enamelling effects of time, so that we must not judge of originality by these signs always. Still your picture has a beautiful look; but I shall not collect any more. I have sent most of my *old men* to Mr. Davidson's gallery in Pall Mall to be sold. I find my house too much encumbered with lumber, and this encumbers my mind. My sons are returned from Folkstone for Christmas. John is delighted with the collection[1] you have sent him; he says they are very valuable indeed, and he highly prizes them. To me these pieces of 'time-mangled matter' are interesting for the tale they tell; but above all, I esteem them as marks of regard to my darling boy, the darling, too, of his dear mother."

Perhaps the following notes to Mr. Lucas, without date, may not be far from their proper place here.

"Dear Lucas. Poor infatuated printer, ——[2] has done nothing for me for three weeks: not a single India copy nor one plain one can I get. But he has sent me a large piece of wedding-cake, and this, too, just as he has been begging assistance to buy bread and butter! The devil undoubtedly finds much fun in this town, or we never should hear of such acts of exceeding folly."

"Dear Lucas. All who have seen your large print[3] like it

[1] Of fossils.

[2] The printer of the letterpress to the *English Landscape*. ★His name was Sparrow. Shirley (*Mezzotints* . . . p. 83) adduces convincing arguments for dating this letter May 1832.

★[3] Probably 'The Lock' (Shirley No. 35).

exceedingly; it will be, with all its grandeur, full of detail. Avoid the soot-bag, and you are safe; Rembrandt had no soot-bag, you may rely on it. Be careful how you etch it, that you do not hurt the detail; but there is time enough. I hope you will not injure your family by so large a print."

"Dear Lucas. I should think the 'Yarmouth' would make by far the best companion to 'Old Sarum'. At the same time 'Old Billy Lott's House', if it could be regrounded at the sides, is a lovely subject. The Lord Mayor's Show, I do believe, is too good a joke to be received into *our* church. Nothing can make it either apostolic or canonical, so uncongenial is any part of this hideous Gomorrah. J. C.—And yet, after all, the 'Waterloo' is a famous composition, and ought to give much pleasure;—but it is the devil,—and I am sore perplexed."[1]

By the 'Lord Mayor's Show' he means the 'Opening of 'Waterloo Bridge' (his lordship's barge being a conspicuous object on that picture).—The reader cannot fail to have observed how uncertain Constable always felt of the success of this composition. In the year 1819, it first entered his mind to paint it; and between that time and 1832 (when it was exhibited) it was often taken up and as often laid aside, with many alterations of hope and fear. The expanse of sky and water tempted him to go on with it, while the absence of all rural associations made it distasteful to him; and when at last it came forth, though possessing very high qualities,—composition, breadth, and brightness of colour—it wanted one which generally constituted the greatest charm of his pictures —*sentiment*—, and it was condemned by the public; though perhaps less for a deficiency which its subject occasioned, than for its want of finish. What would he have felt, could he foresee that, in little more than a year after his death, its silvery brightness was doomed to be clouded by a coat of *blacking*, laid on by the hand of a picture dealer! Yet that this was done, by way of giving *tone* to the picture, I know from the best

*[1] According to Shirley (*Mezzotints* . . . pp. 74–8), these two letters belong to March, 1832.

authority, the lips of the operator, who gravely assured me that several noblemen considered it to be greatly improved by the process. The blacking was laid on with water, and secured by a coat of mastic varnish.

1834–1835

Illness of Constable and his eldest son. Death of Lady Beechey. Constable ill again. Mr. Purton. Pictures at the British Gallery and at the Academy 1834. Visit to Arundel. Mr. George Constable. Petworth. Lord Egremont. Large Picture of 'Salisbury Cathedral'. Lady Dysart. Gainsborough. Ham House. Pictures there. Cuyp. Visit to Petworth. Cowdry Castle. Old Mills. Barns. Farm Houses. Constable's Habits. Conflagration of the Houses of Parliament. Large Picture of 'Salisbury Cathedral'. Wilkie's 'Columbus'. Picture called 'The Valley Farm' exhibited at the Academy, 1835, and purchased by Mr. Vernon. Cozens. Pictures by David. Second Lecture at Hampstead. Attacks on the Academy. Committee of the House of Commons, etc. Charles Constable. Mr. Vernon's Picture. Bryan's *Dictionary*.

"WELL WALK, January 20th, 1834. My dear Leslie. I have been sadly ill since you left England, and my mind has been so much depressed that I have scarcely been able to do any one thing, and in that state I did not like to write to you. I am now, however, busy on a large landscape; I find it of use to myself, though little noticed by others. Still the trees and the clouds seem to ask me to try and do something like them. Poor John has been very ill; walking in his sleep at school, he fell and brought on erysipelas; he was six weeks in bed, and on his return to Hampstead for the holidays, he took a rheumatic fever, and was confined for a month. I do not think I shall send the boys again to Folkestone. Bonner is still with me, and Alfred and Lionel are getting on in their studies with him. . . . I dined with Mr. Bannister, who is much delighted with your print of 'Uncle Toby and the Widow'.[1] . . . Poor Sir William Beechey has lost Lady Beechey; she was taken ill on a Saturday, and died the next day; but so happy a death, it was more like a translation; she said, 'Now I have no more to do or to say. I have done my best for you all here, and I will go and see my three dear children in Heaven'; those she had lost early. . . . The Chalons were here on the Heath for six weeks, and it was

[1] Mr. Bannister sat for the face of Uncle Toby. *Versions of this painting are in the Tate Gallery and in the Victoria and Albert Museum.

delightful weather. I have been busy in making a fly-leaf to each of my prints, and I send a specimen or two that are ready, to know what you think of that plan. Many people can read letterpress who cannot read mezzotinto. I shall send you my *discourse*. They want me to preach again in the same place. I dine with Sir Martin to-morrow; Chalon will be there."

Constable had another, and very painful illness, which is thus described by Mr. Evans in a note addressed to Mr. Wm. Purton of Hampstead: "It was a severe attack of acute rheumatism (or rheumatic fever, as it is usually called), which began in February, and lasted for the greater part of two months. In the early part of this period the suffering was very great; all the joints became the seat of the disease two or three times over, and the pain and fever were of the most aggravated kind. These sufferings he bore with great patience for one of so sensitive a frame; and on the occasion of my visits to him, his cheerfulness was generally restored, and his conversation was of the same delightful character which you know so well. I only wish I could recollect all that I heard from his lips on these and all similar occasions. I think he was never so well after this severe illness; its effects were felt by him, and showed themselves in his looks ever afterwards; so that I think it may be said to have had some share in his removal from us."

Among the most valuable friendships Constable formed during the last years of his life, was that with the gentleman to whom Mr. Evans' note is addressed. Fond of devoting his leisure hours to landscape painting, and wholly uninfluenced by that 'cant of criticism' against which Constable waged unceasing war, Mr. Purton was led by the study of nature alone to form a just estimate of the art of his new friend.

In 1834, Constable exhibited three pictures at the British Gallery, 'A Cottage in a Field of Corn', 'A Heath', and the 'Stour Valley, with Dedham and Harwich in the distance'; these had all been exhibited before. His long continued ill health disabled him from sending any large work to the Academy, where he exhibited drawings only; three in water

colours, 'The Mound of the City of Old Sarum',[1] 'Stoke Pogis Church, the Scene of Gray's Elegy',[2] 'An Interior of a Church', also an illustration of the 'Elegy',[3] and a large drawing in lead pencil, 'A Study of Trees made in the grounds of Charles Holford, Esq., at Hampstead'. I returned to England in time to see this exhibition.

"To Mr. George Constable. Charlotte Street, July 2nd. Your prompt and very kind reply to my dear boy makes us quite happy; he is exceedingly impatient to be with you, and to be introduced to his young friend.[4] I am sorry that a meeting of the Artists' General Benevolent Fund, of which I am a vice-president, will take place on Monday evening. It is for the relief of cases, many of which are of my own recommendation; and if I am not present, it may be materially to their disadvantage; therefore I can't come to you on the day you name; but we have arranged, if it is quite agreeable to yourself and Mrs. Constable, to take a place for John on Saturday, and that I follow him on Tuesday, by which he will get two or three days the start of me in the pleasure of our visit. I am brushing up my 'Waterloo Bridge', and shall make it look like something before I have done with it. The difficulty is to find a subject fit for the largest of my sizes; I will talk to you about one; either a canal or a rural affair, or a wood, or a harvest scene; which, I know not, but I could hardly choose amiss; certainly not, if, as Wilkie says, it could be 'painted well'.[5] I rejoice to hear such a good account of your health."

"Arundel, July 16th. My dear Leslie. In all my walks about this delightful spot I think of you, and how much I should like you to enjoy with me the beautiful things that are continually crossing my path. The chalk cliffs afford John many fragments of oyster shells and other matters that fell from the

[1] Now in the Victoria and Albert Museum (No. 1628–1888).
[2] Sketches which are probably related to this drawing are in the Victoria and Albert Museum and the British Museum.
[3] These beautiful drawings of the church were purchased by Mr. Rogers.
[4] Mr. George Constable's son.
[5] If a young artist consulted Wilkie as to what he should do to a picture, his usual answer was, 'Paint it well'.

table of Adam, in all probability. Our friend, Mr. George Constable, is fond of all matters of science, and he has won John's heart by a present (the arrival of which in Charlotte Street I shall dread) of an electrifying machine. The castle is the chief ornament of this place; but all here sinks to insignificance in comparison with the woods and hills. The woods hang from steeps and precipices, and the trees are beyond everything beautiful. Some parts of the castle, such as the keep and some of the old walls, are as grand as possible, but the more modern part is not unlike a London show place. The Baron's hall is a grand room, though strangely vulgarised by some hideous figures larger than life on painted glass; these ruffian-looking fellows look like drunken bargemen dressed up as Crusaders, and are meant to represent the 'Barons bold', the former lords of the estate, who spread the English name over Palestine; but 'how are the mighty fallen!' you would take them to be the very men who are watering the streets of London this hot weather. These things make true what Horace Walpole says, in speaking of the painters of the middle or *dark* ages, as we call them: 'It would not be easy to know where to go to order a painted window' like one he was describing. The meadows are lovely, so is the delightful river; and the old houses are rich beyond all things of the sort; but the trees are above all, yet everything is beautiful. Only last night I stumbled on an old barn situated amid trees of immense size, like this" (here the writing is interrupted by a sketch); "it is of the time of King John.

"But we have been to Petworth, and I have thought of nothing since but that vast house and its contents. The earl was there; he asked me to stay all day, nay more, he wished me to pass a few days in the house. I excused myself, saying, I should like to make such a visit when you were there, which he took very agreeably, saying, 'Be it so, then, if you cannot leave your friends now;' he came to us two or three times. I had a very kind letter of introduction to him from Phillips."

On his return to London, in a letter of thanks to his amiable host at Arundel, Constable speaks of his visit as one of the

most happy and intellectually delightful he ever paid. "You thought," he says, "of everything you could to make John and me happy, and the same motive actuated every member of your delightful and kind family."

"35, Charlotte Street, July 29th. My dear Purton. Should you have time to look in to-morrow or next day, I should be glad. I have done wonders with my great 'Salisbury';[1] I have been preparing it for Birmingham, and I am sure I have much increased its power and effect; I do hope you will say so. I should much like you to see it, because as you are so good as to look at my things at all, I argue you see something to admire in them, and I have no doubt of this picture being my best now. . . . I am, dear Purton, yours most truly, John Constable."

In September, Constable accepted an invitation to Petworth, where I was at that time with my family, sharing with other guests, among whom were Mr. Phillips, R.A., and his family, Lord Egremont's hospitality.

"My dear Leslie. I was happy to receive your kind letter, and I hope in a few days to avail myself of Lord Egremont's kindness. I have been two days at Ham. Lady Dysart is old, and rather more infirm, but well. You and I must go there together. It seems as if its inmates of a century and a half back were still in existence, and on opening the doors some of them would appear. . . . I shall write when to say I hope to be at Petworth, which, as they want to see me again at Ham on Sunday or Monday, will, I think, be about Wednesday or Thursday. How I long to be again in that house of art where you are. I amused Lady Dysart with the story of the sky-rocket; at all events it proved she had been taught where God was to be found.[2] . . . The Gainsborough was down when I was there.[3] I placed it as it suited me, and I cannot think of it even now without tears in my eyes. With particulars he had

★[1] Presumably 'Salisbury Cathedral from the Meadows'.

[2] Constable alludes to my having told him of the exclamation of one of my children on seeing some fireworks in Petworth Park. As the rockets ascended she said, 'Won't God be shot?'

★[3] i.e. at Petworth, not Ham; cf. P. Leslie *op. cit.*, Letter LXXII.

nothing to do; his object was to deliver a fine sentiment, and he has fully accomplished it; mind, I use no comparisons in my delight in thinking of this lovely canvas; nothing injures one's mind more than such modes of reasoning; no fine things will bear, or want comparisons; every fine thing is unique."

"September 6th. My dear Leslie. I hope nothing will happen to prevent my being with you on Tuesday. Perhaps it is now unnecessary to write to Lord Egremont to say that I am coming, but if you think I ought, write on the receipt of this. You see how awkward I am with the great folks. . . . I wish I had said nothing about pictures in my letter. So much has expression to do with words, that writing and talking are not the same thing. I did not in the least misunderstand you. I should like to have *a keen eye*[1] for myself and for my friends, as a thing I should prize above all the attributes of our profession; only I don't think in that I deserve your good opinion to the degree you believe. How beautifully, how justly does Dr. Johnson somewhere speak of epistolary correspondence;[2] but he cautions the writers against complimenting each other, and warns them of the danger of its self-deception. See what the evangelicals have done to one another in this way, till at last they have forgotten the first principles of Christianity, and treated the rest of the world with contempt. I am going tomorrow to Ham; we must see it together. I expect always, in wandering through the rooms there, to meet either King Charles II, or the Duke of Marlborough, or Addison. It has the art, in portraiture, on its walls, from Cornelius Jansen to Sir Joshua Reynolds, including Hopkins[3] and Cooper in miniature. There is there a truly sublime Cuyp; still and tranquil, the town of Dort is seen with its tower and windmills under the insidious gleam of a faint watery sun, while a horrid rent in the sky almost frightens one, and the lightning descends to the earth over some poor cottages with a glide

[1] I was painting a picture at Petworth for Lord Egremont, and I had said in my reply to Constable's last letter, 'I do not think I shall show you what I am about, as I fear your keen eye.'

[2] He probably alludes to a passage in *The Life of Pope*.

*[3] i.e. Hoskins.

that is so much like nature that I wish I had seen it before I sent away my 'Salisbury'."

"September 8th. My dear Leslie. Calculating from your letter that there was a coach to Petworth every day, I sent for a place for Tuesday, when I found the coach was on alternate days, therefore I have taken one for Wednesday next. I have not thought it worth while to trouble Lord Egremont about this trifling change of a day, and I hope you will set the matter right for me. I have my picture back from Worcester,[1] and my house is now full of old jobs and lumber. My glass is very low, but I hope we may still have fine weather. I shall put off Worcester, as I hope to be better engaged. I have almost determined to attack another canal for my large frame.— How beautiful did old Father Thames look yesterday, scattered over with swans above Richmond! and when they flew over the water, the clapping of their wings was very loud indeed.—How lovely the trees are just now!'"

"To Mr. George Constable. Petworth, September 14th. I am much obliged by your kind letter. If I can see you at Arundel before I leave this, I shall be delighted, but of that, as my time is short, I can say nothing. I am glad you are so well, but how could you send your boys to France? I don't think I could; but I dare say you are right, I act so sadly always on my prejudices.—Leslie has commenced a picture here, a companion to his 'Duchess'.—Mr. Phillips leaves this place in a few days. Mrs. Phillips is going to take me to see a castle about five miles off. Yesterday I visited the river banks, which are lovely indeed; Claude nor Ruysdael could not do a thousandth part of what nature here presents. Yours, my dear sir, always truly, John Constable."

Lord Egremont, with that unceasing attention which he always paid to whatever he thought would be most agreeable to his guests, ordered one of his carriages to be ready every

*[1] Constable had shown a 'Barge on the Stour' at an exhibition at Worcester: in a letter he referred to this as 'The Lock' and added that it had been shown at the R.A. It was presumably the painting of 1824, or its replica: cf. Lord Windsor, *John Constable*, pp. 125–6.

day, to enable Constable to see as much of the neighbourhood as possible. He passed a day in company with Mr. and Mrs. Phillips and myself, among the beautiful ruins of Cowdry Castle, of which he made several very fine sketches;[1] but he was most delighted with the borders of the Arun, and the picturesque old mills, barns, and farm-houses that abound in the west of Sussex. I recollect spending a morning with him, he drawing the outside, while I was sketching the interior, of a lonely farm-house, which was the more picturesque from its being in a neglected state, and which a woman we found in it told us was called 'wicked Hammond's house'; a man of that name, strongly suspected of great crimes, having formerly been its occupant. She told us that in an old well in the garden some bones had not long ago been found, which the 'doctor said were the arm bones of a *Christian*.'—While at Petworth, where Constable spent a fortnight, he filled a large book with sketches in pencil and water colours, some of which he finished very highly.

It was on this occasion only that, as an inmate of the same house, I had an opportunity of witnessing his habits. He rose early, and had often made some beautiful sketch in the park before breakfast. On going into his room one morning, not aware that he had yet been out of it, I found him setting some of these sketches with isinglass. His dressing-table was covered with flowers, feathers of birds, and pieces of bark with lichens and mosses adhering to them, which he had brought home for the sake of their beautiful tints. Mr. George Constable told me that while on the visit to him, Constable brought from Fittleworth Common at least a dozen different specimens of sand and earth, of colours from pale to deep yellow, and of light reddish hues to tints almost crimson. The richness of these colours contrasted with the deep greens of the furze and other vegetation on this picturesque heath delighted him exceedingly, and he carried these earths home carefully pre-

*[1] Some of these are now in the British Museum and the Victoria and Albert Museum: other drawings which can be referred to Constable's stay at Petworth are in the same two Museums.

served in bottles, and also many fragments of the variously coloured stone. In passing with Mr. G. Constable some slimy posts near an old mill, he said, 'I wish you could cut off, and send their tops to me.'

On the 16th of October the Houses of Parliament were burnt; and Constable witnessed the scene from a hackney coach, in which, with his two eldest sons, he took a station on Westminster Bridge. The evening of the 31st he spent with me; and while describing the fire, he drew with a pen, on half a sheet of letter paper, Westminster Hall, as it showed itself during the conflagration; blotting the light and shade with ink, which he rubbed with his finger where he wished it to be lightest. He then, on another half sheet, added the towers of the Abbey and that of St. Margaret's Church,—and the papers, being joined, form a very grand sketch of the whole scene.[1]

He was now again at work on the 'Salisbury from the Meadows'. This was a picture which he felt would probably in future be considered his greatest; for if among his smaller works there were many of more perfection of finish, this he considered as conveying the fullest impression of the compass of his art. But it met with no purchaser. "December 4th. My dear Leslie, I have never left my large 'Salisbury' since I saw you. It would much delight me if in the course of to-day or to-morrow you could see it for a moment. I cannot help trying to believe that there may be something in it that in some measure, at least, may warrant your too high opinion of my landscape in general."

"December 15th. My dear Leslie, I write to beg of you to let me put off our visit to ——[2] for a little. I was all day on Saturday at Ham, and shall be all this day with Wilkie, and I can hardly spare so much of my valueless time, for though my life and occupation are useless, still I trifle on in a way that seems to myself like doing something; and my canvas soothes

*[1] Small water-colours of the Houses of Parliament on fire and after the fire are in the Constable family collection.
*[2] Brompton.

me into a forgetfulness of much that is disagreeable. I could not get on with ——[1]; how could I? you will say. . . ." Constable was at this time disturbed by some transactions with the last person mentioned in this note, and with some other unpleasant occurrences, and which, as it generally happened, his imagination magnified, and he continued: "Every gleam of sunshine is withdrawn from me, in the art, at least. Can it be wondered at, then, that I paint continual storms:[2]

'Tempest o'er tempest roll'd'.

Still the darkness is majestic, and I have not to accuse myself of ever having prostituted the moral feeling of the art. . . . I saw Mr. Bannister yesterday, so well, so happy and more delightful than ever. I told him I had venison in the house, and that I wanted you and Mrs. Leslie to dine with me, if he would but come; he did not say no."

"December 17th. My dear Purton. I am obliged to you for the quotations; the second is excellent,[3] and shall be used in the title-page of my book; but I must take care of being an author, it is quite enough to be a painter. I beg my best respects to Mrs. Purton. I shall like to see what you are doing, and will try to catch a glimpse by daylight, but I am in a terrible turmoil with all my things. I seem foolishly bent on a large canvas. I was at Wilkie's all day on Monday; he has painted a noble picture, Columbus with the monk, when he shows him his plan for overtaking another world."

Constable had been asked by Wilkie to sit for one of the heads in the picture of 'Columbus', that of the physician Garcia Fernandez. Among his papers I found a slight pencil sketch of the whole composition of that fine picture, no doubt made from recollection while describing the subject to some

*[1] Alaric Watts (1797–1864), poet and editor of *The Literary Souvenir*, an illustrated miscellany.

[2] One of the objections made to his pictures by those who could not deny them nature. He was fond of representing the passing shower, but I know of no other instance in his pictures of a storm, and here it is breaking away.

[3] From Crabbe. 'It is the soul that sees;' etc. Constable made use of this in the third lecture he delivered at the Royal Institution.

friend. Wilkie also asked Constable to sit to him for a portrait, and it is much to be regretted that he declined doing so.

The following letter to Mr. Dunthorne accompanied a present of Mr. Lucas's large engravings of the 'Lock', and the 'Cornfield'. "My dear friend. I hope you will receive the prints safe. Mr. Lucas bids me tell you that he shall send two more which he is now about, 'Salisbury' and 'Stratford Mill'. If you can lend me two or three of poor John's studies of the ashes in the town meadow, and a study of plants that grew in the lane below, Mr. Coleman's, near the spouts which ran into the pond, I will take great care of them and send them safe back to you soon. I am about an ash or two now. The prints will come to you from Flatford, as I have sent a pair to Abram. Yours very truly, John Constable. Charlotte Street, February 14th."

"March. My dear Leslie, Our friend Bonner[1] is on his way to bid my children good-bye at Hampstead. He is going to Germany, whence his family originates, and he cannot leave England without shaking you by the hand. I have been wholly shut up, so much so that I do not know what is going on since you have been here. My picture must go, but it is wofully deficient in places. Yesterday Mr. ——[2] called, and though he said, 'perhaps it is a little better', yet he added, 'you know I like to be honest'; but, fortunately for me, I am sure it was not at all to his liking. Mr. Vernon[3] called soon after with the Chalons; he saw it free from the mustiness of old pictures, he liked its daylight, and bought it; it is his, only I must talk to you about it; he leaves all to me. . . ." Constable told me that Mr. Vernon asked him if the picture on his easel was painted for any particular person; to which he replied: 'Yes, sir, it is painted for a *very particular* person,—the person for whom I have all my life painted.'

"To Mr. George Constable. April 8th. Your trips to France

[1] Mr. Bonner had been for some time domesticated with Constable as private tutor to his sons.

★[2] Wells.

★[3] Robert Vernon, whose collection passed to the nation in 1847.

must be delightful, and John bids me tell you that of all things he should like to go with you at some time or other. At present, however, it is impossible, as all his lectures now are in regular course; he is a pupil of Faraday's at the Institution in Albemarle Street on chymistry, he is also a pupil at the London University in surgery and physiology, and he is attending a course of lectures on anatomy in Windmill Street. To all these things he is as regular as a clock; all I pray for is, that his health will continue to bear it; nevertheless, he must take some trips in the summer, and he, as well as I, look with great pleasure to a repetition of our most unalloyed and delightful visit to Arundel. Having spoken of the young chymist and surgeon, let me speak of the old landscape painter. I have got my picture into a very beautiful state; I have kept my brightness without my spottiness, and I have preserved God Almighty's daylight, which is enjoyed by all mankind, excepting only the lovers of old dirty canvas, perished pictures at a thousand guineas each, cart grease, tar, and snuff of candle. Mr. ——[1], an admirer of commonplace, called to see my picture, and did not like it at all, so I am sure there is something good in it. Soon after, Mr. Vernon called, and bought it, having never seen it before in any state."

This beautiful work, a view of 'Willy Lott's House' from an early sketch, had the rare luck, when exhibited, of pleasing even some of the newspaper critics; it was the only picture Constable sent to the Academy this year.[2]

"To Mr. George Constable. Charlotte Street, June 6th. John has declared this morning that, if I defer writing to you any longer, he will never speak to me again. I have had almost every sort of occupation, and if I do not write almost directly to any letter I receive, I am too apt to delay it for a very long time, as you, my dear friend, have so often experienced, and so often been kind enough to forgive. The Exhibition is a successful one, it is profitable and productive; I speak now of

*[1] Presumably Wells: cf. the previous letter to Leslie.
*[2] 'The Valley Farm', now in the Tate Gallery (No. 327). A study is reproduced on Plate 57.

pictures under the line, the large pictures are very so so. . . . But there are some excellent works of art on the walls. 'Columbus and his little Son',[1] the 'Gulliver',[2] the 'Scotch Drovers',[3] and Eastlake's 'Pilgrims'.—Turner's light, whether it emanates from sun or moon, is exquisite.—Collins' skies and shores are true, and his horizons always pretty."

"My dear William Carpenter. Some years ago, a lady got away my copy of Bryan's *Dictionary,* and this has ever since been an inconvenience to me. I want to know when the younger Cozens[4] was born; his name was John, and he was the greatest genius that ever touched landscape. He was the son of Alexander Cozens, drawing-master of Eaton, and John died in 1796, still rather young. I want this for my lecture on Monday to be given at Hampstead. My best regards to your father. Very truly yours, J. Constable. Perhaps Days or Edwards mentions his birth." What Constable here says of Cozens is startling, although all who are acquainted with the beautiful works of that truly original artist will admit that his taste is of the highest order; but the reader must have observed that in other instances Constable speaks in similar unqualified terms of admiration of that which at the moment engaged his attention.

"The longest day. My dear Leslie. 'Tis true we have got you back from America, but you are still too far away, too far for indolent friends like me. . . . Alfred, to my surprise and delight, seems quite happy at Mr. Brooks'. He plays first fiddle there at

★[1] By Wilkie.　　　★[2] By Leslie.　　　★[3] By Landseer.

[4] 'This artist was the son of Alexander Cozens, a Russian by birth, who established himself in London as a landscape painter and drawing-master about the year 1770. He followed the same profession, and with great ability and elegance. He produced some drawings which possessed extraordinary merit, executed in a style which was afterwards adopted and improved by the ingenious Mr. Girtin. He died in 1799.'—Bryan's *Dictionary,* Appendix, vol. ii. p. 680. In an octavo edition of Pilkington's *Dictionary* printed in 1829, speaking of John Cozens, it is said, 'His drawings were sold at Christie's in 1805 for five hundred and ten pounds. He died in a state of mental derangement in 1799.' I think Pyne, in those articles he contributed to *The Literary Gazette* under the title of 'Wine and Walnuts', gave some notices of Cozens. ★ It is now established that J. R. Cozens was born in 1752 and that he died in December 1797. The legend that Alexander Cozens was Russian by birth is now discredited.

everything but his book. But, poor dear boy, his whole life has been one of affliction,[1] which, as well as his drollery, has endeared him to me, perhaps unduly. I have been closely shut up doing—nothing. Lord N——[2] saw my pictures at Tiffin's;[3] he wanted the 'Church', and offered his Hobbema for it. I daresay his Hobbema is good for nothing. All this time the painter is to be had, but they still wait for his quiet departure. . . . I have seen David's pictures; they are indeed loathsome, and the room would be intolerable but for the urbane and agreeable manners of the colonel. David seems to have formed his mind from three sources, the scaffold, the hospital, and a brothel. . . . I give my lecture at Hampstead to-morrow evening at a quarter before eight. I have sent up young Uwins' beautiful copy of Ruysdael; it will be of infinite service to me; also Partridge's 'Peter Martyr'.[4] I have written little, and shall depend most on being conversational. I have got a lovely drawing of young Bone's of Guido's 'Aurora'. . . . I never saw the elder bushes so full of blossom, and some of the flowers, fore-shortened as they curve round, are extremely elegant; it is a favourite of mine, but 'tis melancholy; an emblem of death.''

The pictures by David mentioned in this letter were of 'Buonaparte crossing the Alps', 'Mars and Venus', the 'Death of Marat', and some drawings of revolutionary scenes which were exhibited in Leicester Square; and 'the colonel' was a French gentleman who attended in the room during the exhibition.

Of Constable's second lecture delivered at Hampstead I have preserved no notes; but the reader will find much of it incorporated with what I have been able to preserve of those he gave in London. I remember that the sky was magnificent on the day on which it was delivered; and as I walked across the West End fields to Hampstead, towards evening, I stopped

[1] From ill health. [2] Northwick.
[3] Tiffin, a picture-dealer.
[4] A copy of the famous painting by Titian in SS. Giovanni e Paolo, Venice: it was destroyed by fire in 1867.

repeatedly to admire its splendid combinations and their effects over the landscape, and Constable did not omit in his lecture to speak of the appearances of the day.

Mr. Lucas was now proceeding with his large plate of the 'Salisbury Cathedral from the Meadows', which Constable had commissioned him to undertake, and it is of this the next note speaks: "June 30th. Dear Lucas. I should be glad if you would leave the plate here a day or two. Leslie is so much impressed with the proof, that he would give any money to possess one; so am I, and would give anything to possess two at least. Now would you mind printing a few, five or six? would it hurt the plate? I know you don't like to do so, but I would gladly pay all expenses. It never can nor will be grander than it is now; it is awfully so. You shall be amply paid for this indulgence. I do think with you, it is well to stay your hand with my works when these large ones are all done, and pause for some time; and if you take up a portrait or so, it may be advisable, lest that branch of the art should be shut out from you, and your forming a connection that way be cut off. All this I meant to say yesterday, but you availed yourself of Rembrandt's light and shadow, and were lost."

Mr. Lucas had parted from Constable in a crowded exhibition room containing the drawings by Rembrandt which formed part of the Lawrence collection.

"To Mr. George Constable. 35, Charlotte Street, July 2nd. I had the pleasure of seeing the lady yesterday bearing your note, in which you speak so highly of the services she has rendered your dear children. I can, indeed, well appreciate such benefits, as my own dear girls have received them at the hands of my friend, Miss Noble, for seven, eight, and nine years. I agree with you in its being the least we can do to express our gratitude to such benefactors. This excellent lady introduced herself to me by saying she had 'had two hundred and fifty children'; I was alarmed,—but an explanation soon took place, and I told her the contents of your note. My poor boy John and myself are panting for a little fresh air. He is gone to Hampstead to look for a mouthful, leaving me with

a promise that I write to you this evening, to say that, if it is quite agreeable to yourself and Mrs. Constable he and I will come to you on Tuesday to pass a few days, and if also agreeable, I will bring my eldest girl with me. I long to be among your willows again, and in your walks and hanging woods; among your books of antiquities, and enjoying your society as I did before; without reserve, restraint, coldness, or form. I am much worn with a long and hard winter and spring campaign, though a successful one. I gave my lecture last Monday week at Hampstead, and did it much better this time; I was thanked by the committee; it was all conversational; but all this wears me; and to crown the whole, I was led up to the stake in a court of justice (for it proved one in this instance) to give evidence about a Claude."[1]

"To Mr. George Constable. August 3rd. I have been sadly vexed with myself for not writing to you long ago; but I am sorely perplexed with sundry matters which day after day eat up my time. I have been with Maria to Kingston, and have just brought her home; and now that all my girls and my little boys are safely deposited at school, I begin to breathe, and to recollect that I was a week or two ago at Arundel, passing a most delightful time with my dear friends, and amid most heavenly scenery; or was it a dream? for it seems much like one. John was determined that this day should not pass without my writing to you; his words are, 'Papa, remember how happy you were, and how kind Mr. and Mrs. Constable were.' —I have no news, excepting that the Exhibition was prosperous. But the attacks on the Royal Academy have commenced, and a Mr. Foggo[2] has written a pamphlet, and a committee in the House of Commons are enquiring into our affairs. I

*[1] The case was between two dealers, Pennell and Woodburn: it concerned the authenticity of a painting said to be by Claude. Witnesses for the defence of the attribution included Constable, Linnell and Uwins, and those who contested it included W. Y. Ottley and Haydon. Cf. Whitley, *Art in England 1821–1837*, 1930, pp. 303–4.

*[2] George Foggo (1793–1869) was a painter, lithographer and writer on art. Constable refers to his *Letter to Lord Brougham on the History and Character of the Royal Academy*, London 1835.

should say that the country, ignorant and ungrateful as it is in all liberal matters, does not deserve the Academy.—My picture is in my room; it is going to its destination in Mr. Vernon's great house in Pall Mall."

The thoughts and wishes of Constable's second son, Charles, had been turned towards the sea from his childhood; he seemed, indeed, to have been born a sailor as certainly as his father was born a painter. It cost Constable many pangs to conquer his repugnance to such a destiny for his boy, but he found it fruitless to oppose it, and placed him under the care of Captain Hopkins of the *Buckinghamshire*, East Indiaman.

"Dear Leslie, I send you a proof of the great 'Salisbury' in its pristine grandeur. My poor Charley's time is now very short in the land of comfort. The ship sails this week, and the house has been long in a stir with his outfit. There is no end to his wants. What would Diogenes, or an old sow (much the same thing), say to all the display of trowsers, jackets, etc., by dozens, blue and white shirts by scores, and a supply of rattlin for his hammock, as he expects to be often cut down!—Poor dear boy! I try to joke about him, but my heart is broken at parting with him."

"To Mr. George Constable. Charlotte Street, September 12th. John's return, and so exceedingly well, has made me quite happy; he is delighted with his tour, and with your and Mrs. Constable's great kindness to him. I know not how I can be sufficiently thankful to you and her. It has set up his health, and it is essential to his ensuing winter's studies that he should be strong enough to meet the fag. I have had, as you may suppose, a most anxious and busy time with Charles. I have done all for the best, and I regret all that I have done, when I consider that it was to bereave me of this delightfully clever boy, who would have shone in my own profession,[1] and who is now doomed to be driven about on the ruthless sea. It is a sad and melancholy life, but he seems made for a sailor. Should he please the officers and stick to the ship, it will be more to his advantage than being in the navy,—a hateful

[1] Charles Constable drew and etched beautifully for so young a practitioner.

tyranny, with starvation into the bargain. Barrow told me not long ago that they had twelve hundred midshipmen they did not know what to do with at the Admiralty. In the midst of my perplexities I have made a good portrait, and finished and sold my little 'Heath'. Mr. Vernon has luckily paid me, for it has cost me two hundred pounds to get Charles afloat. My pictures have come back from Worcester;[1] I wish I could get off going there to lecture,[2] especially as C——[3] has been drivelling a parcel of sad stuff in the Worcester paper in the name of Lorenzo; God knows, not Lorenzo de Medici; but it is all about *ideal art*, which in landscape is sheer nonsense, as they put it. Even Sir Joshua is not quite clear in this."

"Charlotte Street, September 14th. My dear Leslie, Nothing but my almost entire occupation within doors by my poor Charley, and various other matters, could have caused me so long to delay writing to you.[4] I have several letters from Charles from the ship, and at length a final one off Start Point, when the ship was leaving the land. He is a true sailor, and makes up his mind to combat all difficulties in calms or storms with an evenness of mind that little belongs to me, a landsman. They have had a rough business of it so far. He says Captain Hopkins is a delightful man. . . . Poor Charles hung about me when I parted from him; Roberts and Alfred were with me; he asked if I could stay in the ship till next day, but I knew we must part, so we shook hands, and I saw him no more. It is a noble ship, the size of a seventy-four. . . . John is returned from France, much pleased and wonderfully strong and well, ready

[1] Lord Windsor (*John Constable*, 1903, p. 126 sqq.) quotes from *Berrow's Worcester Journal*, 23rd July 1835. Three of the paintings exhibited in Worcester are there described: these were 'Harvest Noon: A Lane Scene' (i.e. 'The Cornfield'), 'Valley of the Stour—Morning' (probably the 'Dedham Vale' of 1828) and 'A Water Mill' ('Watermill at Gillingham', Victoria and Albert Museum, No. 1632–1888). A letter from B. W. Leader, R.A., quoted by Lord Windsor (*op. cit.*, p. 137) states that 'Salisbury from the Bishop's Meadows', 'The Glebe Farm' and 'Flatford Mill' were also exhibited at Worcester.

[2] Constable delivered three lectures in Worcester in October 1835. An account of the first two lectures was printed in the *Worcester Guardian*, 31st Oct. 1835, and is quoted by Lord Windsor (*op. cit.*, pp. 130–136).

[3] Carey, i.e. William Carey, picture-dealer and critic.

[4] I was then out of town.

and willing for a winter fag in London, where he enters his course of chymistry, anatomy, and *materia medica*. He was amused with France, but with the food he was annoyed, as he says they put vinegar into everything they eat and drink. I have made a beautiful drawing of Stonehenge;[1] I venture to use such an expression to you.—I called on Mr. Bannister, who is well, but sadly low about the poor young men who were drowned; they were brothers of his son's wife.—The Academy has given Mrs. —— forty pounds, so I hope Parliament will not put it down.—I must go to Worcester, or they will think me shabby and a charlatan. I have got my picture back; they tell me I played first fiddle. John tells me of Lord Egremont shooting three brace of partridges and a hare on the 1st of September; wonderful at his age.

"To Mr. J. J. Chalon. October 29th. I much regret not seeing you last night, but I want most to see you by daylight, as I have been very busy with Mr. Vernon's picture. Oiling out, making out, polishing, scraping, &c., seem to have agreed with it exceedingly. The 'sleet' and 'snow' have disappeared, leaving in their places, silver, ivory, and a little gold. I wish you could give me a look, as it will go in a few days. I am glad you are all on the return, and I was exceedingly glad to hear you are all well."

"To Mr. George Constable. November 11th. We shall be delighted to see your son and any part of your family; John has a bed to spare in his own room. For myself, I only wish to be left to my painting-room. I do not think of much canvas this year; a size smaller will be better, and more of them; such as will suit my friends' pockets; though 'tis too late in life for me to think of ever becoming a popular painter. Besides, a knowledge of the world, and I have little of it, goes farther towards that than a knowledge of art."

"December 1st. My dear Leslie, Will you be so kind as to call in on your way to-morrow, so that we may go to the Academy together, and this will give me a fair opportunity

*[1] Very probably the water-colour now in the Victoria and Albert Museum (No. 1629-1888), exhibited at the R.A. in the following year. See Plate 49.

of begging you to look at Mr. Vernon's picture by daylight. I don't wonder at your working so much on the same picture, now that I see what can be done by it. I want you, of all things, to see it now, for it has proved to me what my art is capable of when time can be given sufficient to carry it home. So much you will take from me."

"December 9th. My dear Leslie, I have had a letter from your sister, with another from Mr. Carey, who has desired me to send him a picture which I have not got, nor ever had. Through the kindness of your sister, he has seen my book, and has taken a liking to the 'Sea Beach',[1] thinking, no doubt, it was done from something more than a sketch. I know not what to say, perhaps you will call on me to-morrow evening, and we will go together to hear Sir Martin. Mr. Vernon's picture is not yet gone to him; he wants it, but it was never half so good before, and I will do as I like with it, for I have still a greater interest in it than anybody else."

"To Mr. William Carpenter. Dear Sir, Accept my best thanks for the book, James' *Italian School*,[2] which I return. The *Dictionary* is a most valuable work, but as I go on referring to it, I occasionally meet with errors; and how can it be otherwise, when the sources from whence the information is derived are so often erroneous? I shall not fail, however, to make memoranda when I meet with them to submit to you. My character of Ruysdael I have not yet found, but I can always write it for you, and better and better.[3]—I have never ceased to work on Mr. Vernon's picture since I saw you; it is at present with him in Pall Mall, but is coming back by the bearer for 'more last words'.—My painter's library is now getting very considerable.—I wrote a long note to you the other day, full of nonsense, which my man lost by the way. '

"To Mr. George Constable. Charlotte Street, December 16th. We shall be delighted to see you and any of your family;

*[1] 'A Seabeach' (Shirley No. 17) was engraved from a sketch, said to have been in the Salting Collection.

*[2] J. T. James, *The Italian Schools of Painting. With Observations on the Present State of the Art*, London 1820.

[3] I regret to say it was not found among his papers.

our own plans are thus. My daughters come home to-morrow, and will go in a few days to their aunt at Wimbledon. John and I have engaged to eat our Christmas dinner at Bergholt, with my own family. We shall leave town on the 24th, and stay a week; in the second week of January, therefore, we shall look for you. Can you bring with you the little Gainsborough, and the sketch I made of your 'Mill'? John wants me to make a picture of it. I had a nice excursion to Worcester, and got on quite well with my sermons; you will see my placards, and how well they are arranged. I would make a book, but I recollect the saying, 'O that mine enemy would write a book!' John is now at the door, by which I know it is exactly ten minutes past four."

1836–1837

Mr. Vernon's Picture. Contemplated Pictures of 'Arundel Mill', and of 'Stoke'. Description of Stoke Church. Engraving of 'Salisbury'. Breakfast with Mr. Rogers. Lectures at the Royal Institution. Exhibition of 1836. Picture of the 'Cenotaph' erected by Sir George Beaumont to Sir J. Reynolds. Drawing of Stonehenge. Constable's two eldest Sons. Clouds and Skies. Death of Westall. Constable Visitor in the Life Academy. Picture of 'Arundel Mill'. Engraving of 'Salisbury Cathedral from the Meadows'. Probable Causes of the decline of Constable's Health. His Death. His Funeral.

"To Mr. George Constable. January 12th, 1836. . . . I have never left my picture till now, when Mr. Vernon has allowed it to go to the British Gallery, and I am glad to get it there in its present state, as you will be able to see it. When you come, will you bring the little sketch of 'Arundel Mill', as I contemplate a picture of it of a pretty good size."

"Charlotte Street, February 6th. My dear Purton. I am sure these dear children would be disappointed were they not to have the pleasure of joining the young folks at your party on Saturday. We all, therefore, gladly avail ourselves of your and Mrs. Purton's kind invitation, and will be with you at four o'clock that day, John, myself, and the sailor; though for myself there is always an uncertainty, I like to be poking about among my lumber, and loathe to go from home. I am glad you encourage me with 'Stoke'. What say you to a summer morning? July or August, at eight or nine o'clock, after a slight shower during the night, to enhance the dews in the shadowed part of the picture, under

'Hedge-row elms and hillocks green.'

Then the plough, cart, horse, gate, cows, donkey, etc., are all good paintable material for the foreground, and the size of the canvas sufficient to try one's strength, and keep one at full collar. Now pray keep to your canvas, and get up a heath scene, to which you are now fully competent, having the

advantage of previous experience of that kind of practice on your large picture.[1] I am happy with these boys about me. My monitor, John, I always give up to, he is always in the right. Charley is a good boy, but a straw will draw him aside, —his character is easily mistaken. He is every other night with his navigation master. Both boys are now reading their studies by my side."

The large picture of 'Stoke' was never painted; but a sketch of the subject furnished a plate for the *English Landscape*.[2] Of his intention in this sketch, Constable says, 'The impressive solemnity of a summer's noon, when attended, as it often is during the heats of the season, by thunder clouds, is attempted to be expressed in this picture; at the same time, the appearance of a noon-day rainbow is hinted at, when the arc it describes is at its lowest.—Suffolk, and many of the other eastern counties, abound in venerable Gothic churches, many of them of a size which cannot fail to strike the stranger with admiration and surprise; and a melancholy but striking characteristic of these churches is their being found in situations now comparatively lonely, some of them standing in obscure villages containing a few scattered houses only, and those but ill according with such large and beautiful structures; but it is thus accounted for: these spots were the seats of those flourishing manufactories once so numerous in these counties, where they had from a remote period been established, and were during the reigns of Henry VII[3] and VIII greatly increased by the continual arrival of the Flemings, who found here a refuge from the persecutions of the Low Countries; as well as afterwards in the reign of Elizabeth, whom the course of events had raised to be the glory and the support of Protestant Europe. The

[1] Constable said to Mr. Purton, 'A large canvas will show you what you cannot do, a small one will only show you what you can.'

*[2] 'Stoke-by-Neyland' (Shirley No. 9). Two distinct oil-sketches can be referred to this engraving: No. 150–1888 in the Victoria and Albert Museum, and No. 1819 in the National Gallery. Leslie's remark that 'the large picture of "Stoke" was never painted' may be incorrect: in the Chicago Museum is a painting (49 × 66 in.) of this subject and of approximately similar composition.

[3] Dedham Church was built by Margaret Tudor, the mother of Henry VII. and bears her initials in many of its ornaments.

vast size of these noble structures, with the charm that the mellowing hand of time has cast over them, gives them an aspect of extreme solemnity and grandeur, and they stand lasting monuments of the power and splendour of our ecclesiastical government, as well as of the piety and skill of our ancestors. Stoke, though by no means one of the largest, certainly ranks with the churches alluded to. It was probably erected about the end of the thirteenth century. The length of the nave, with its continuous line of embattled parapet, and its finely proportioned chancel, may challenge the admiration of the architect, as well as its majestic tower, which from its commanding height may be said to impart a portion of its own dignity to the surrounding country. In the church are many interesting monuments; and here, as well as at Neyland, are many of the tombstones of the clothiers; being mostly laid in the pavement, they are much defaced, but are known to belong to them by the small brasses still remaining.'

"February 15th. My dear Lucas. The 'Salisbury' is much admired in its present state, but still it is too heavy, especially when seen between the 'Lock' and the 'Drinking Boy'. Yet we must not break it up, and we must bear in recollection that the sentiment of the picture is that of solemnity, not gaiety, nothing garish, but the contrary; yet it must be bright, clear, alive, fresh, and all the front seen."

"March 18th. My dear Leslie. I never had such a morning in my life as that which I passed with Mr. Rogers.[1] I long to see you, but the grievous place in which you are[2] cuts off everything. All that know you agree that the spot is fatal to your friendships; you will justly say, 'What are such friendships worth?' But I am angry because I have wanted of late so very much to see you. Mr. Rogers thinks I am in the right road in my pursuit of landscape. He likes my plan of its history, and says, 'nobody can do it so well'; this is encouraging. He

*[1] Samuel Rogers (1763–1855), the poet: he was also a collector of paintings and other works of art.

*[2] Leslie was on the Hanging Committee of the R.A. this year: cf. the next letter.

was pleased with my pointing out the falling or shooting star in his exquisite Rubens.[1] But he is very quiet in his likes and dislikes; a delightful man, all intelligence, all benevolence and justice, and a generous upholder of art, living and dead. What pictures he has got! the best in London; and he has some noble old wood-cuts. It was pleasing to see him feed the sparrows while at breakfast, and to see how well they knew him. But he has some melancholy ideas of human nature. He said 'it is a debt genius must pay to be hated.'—I doubt this in general, but there is something like it in nature. I told him if he could catch one of those sparrows, and tie a bit of paper about its neck, and let it off again, the rest would peck it to death for being so *distinguished*."

"March 26th. My dear Leslie. I send you a few skies, such as we thought might suit your picture. Perhaps a mountain ash among the shepherds might be useful; I send a rough sketch of one I made from a bedroom window where I slept; they are pretty with the berries. . . . I am sorely perplexed with concerns not my own, in the picture way; I have in my house several works supplicating for places in the Exhibition; they are sent to me because it is well known what a fool I am.[2] . . . What stuff I am writing to you, but the worst is, I am really serious in all I ask of you. I enclose a card of the Royal Institution, that you may be convinced of my folly and activity, but I am not yet selling spruce beer in the streets, like ——."[3]

"To Mr. George Constable. May 12th. I am pretty full handed, and sorely perplexed for time, owing to the numerous irons I have put in the fire. I have engaged to deliver four lectures, as the card I enclose will let you see; they will comprehend a pretty full account of the history of landscape. . . . I got up a tolerably good picture for the Academy, not the 'Mill', which I had hoped to do, and which was prettily laid in

[1] A moonlight; a scene of such perfect stillness that the entire orb of the moon is reflected in a pool of water. There is a horse in the foreground, and you seem to hear him cropping the grass.

[2] I was then on the arranging committee at the Academy.

★[3] Constable wrote "one R.A. of my neighbourhood."

as far as chiaroscuro, but I found I could not do both; and so I preferred to see Sir Joshua Reynolds' name and Sir George Beaumont's once more in the catalogue, for the last time at the old house. I hear it is liked, but I see no newspaper, not allowing one to come into my house. I send you a catalogue, and marked, I believe, pretty fairly. The Exhibition is much liked. Wilkie's pictures are very fine, and Turner has outdone himself; he seems to paint with tinted steam, so evanescent and so airy. The public think he is laughing at them, and so they laugh at him in return. The non-members are very powerful: Charles Landseer, Herbert, Partridge, Knight, and Roberts. The President was never better, but his health gives way under his duties. I dined with Wilkie last week, and met Allan, who is very entertaining. Wilkie recommended to me to paint a large picture for over the line next year."

The picture mentioned in the beginning of this letter was of the 'Cenotaph'[1] erected by Sir George Beaumont to the memory of Reynolds. It might seem as if Constable had consulted the taste of his late friend in choosing the autumnal tints for the foliage of a scene taken from Sir George's grounds, but his doing so arose naturally from his having made his studies from it late in the autumn. In this fine picture, every way worthy of so interesting a subject, Constable introduced nothing living, except a deer in the foreground, and a robin red-breast perched on one of the angles of the monument. In describing the 'Cenotaph' in the catalogue, he quoted the lines inscribed on it, written by Wordsworth at Sir George Beaumont's request:

'Ye lime trees ranged before this hallow'd urn,
Shoot forth with lively power at spring's return;
And be not slow a stately growth to rear
Of pillars branching off from year to year,
Till they have learn'd to frame a darksome aisle,
That may recall to mind that awful pile
Where Reynolds, 'mid our country's noblest dead,
In the last sanctity of fame is laid.

[1] Now in the National Gallery (No. 1272). See Plate 53.

There, though by right the excelling painter sleep
Where death and glory a joint Sabbath keep,
Yet not the less his spirit would hold dear
Self-hidden praise and friendship's private tear:
Hence in my patrimonial grounds have I
Raised this frail tribute to his memory;
From youth a zealous follower of the art
That he profess'd, attach'd to him in heart;
Admiring, loving, and with grief and pride
Feeling what England lost when Reynolds died.'

Constable exhibited with this picture a magnificent drawing in water-colours of Stonehenge,[1] of a large size.

He was now wholly occupied in preparing the lectures which he delivered in the summer of this year at the Royal Institution, Albemarle Street, beginning on the 26th of May. The ticket mentioned in the following note was an admission to these lectures.

"Dear William Carpenter, I send a ticket, as you requested, to Mrs. Carpenter; and if your son is, as I sincerely hope, better, he may accompany her and yourself, as both may possibly be included among her friends. Don't trouble yourself about Lanzi any farther, as I have now pretty well done with him.[2] He is an old twaddler, but the labour he spares is immense, and certainly his arrangement, his history, and the marking of the epochs is admirable and very useful. Yours truly, J. Constable."

"To Mr. George Constable. Charlotte Street, September 16th. My dear Friend. It is a very long time since I have written to you, or since I have had the pleasure of hearing from you. I am anxious to know how you and Mrs. Constable and all your family are, and what have been your occupations in the way of the arts, in antiquities, and in natural history. My dear John is always engrossed with some study or other;

*[1] Now in the Victoria and Albert Museum (No. 1629-1888): cf. p. 247 n. 1, and Plate 49.
*[2] Luigi Lanzi (1732-1810). An English translation of his work, entitled *History of Painting in Italy*, was published in 1828.

he is remarkably well, and is wholly devoted to Latin and Greek. I know not, nor does he know himself, exactly, what he will ultimately be, but either a clergyman or a physician. He is brushing up for Cambridge; this I regret, but it is a selfish feeling; I cannot bear to part with him. I live a life of more solitude than you would suspect for the midst of London, and in such a pursuit, so wide a field as the arts. My son Charles is returned from the East Indies; the voyage has been a hard one, but it is all for the best. All his visionary and poetic ideas of the sea and a seaman's life are fled, the reality only remains; and a sad thing the reality is. But in the huge floating mass there is an order, and an habitual good conduct, which must be of advantage to a youth of ardent mind, and one who has never been controlled. Charley is preparing for another voyage, and the ship sails in the middle of November for China. . . . I have not been out of town once this year, but for an hour or two. I dislike to leave home, but enjoy an excursion very much when I am away. I have an invitation to the Isle of Wight, but I daresay I shall not go. I must go into Suffolk, and take my sailor boy with me. John was there this summer for five weeks; he was a great favourite with his aunts and my brothers; indeed, John is sure to win his way, for he never gives offence to any living creature. I have lately painted a 'Heath'[1] that I prefer to any of my former efforts; it is about two feet six, painted for a very old friend, an amateur, who well knows how to appreciate it, for I cannot paint down to ignorance. Leslie was here to-day; he is going to Petworth in ten days. I have never seen such scenery as your country affords; I prefer it to any other for my pictures;—woods—lanes— single trees—rivers—cottages—barns—mills—and, above all, such beautiful heath scenery."

"October 29th. My dear Leslie. It seems a very long time since we met, or that I have heard from you. I should, as you will believe, be delighted to have a letter, if it is only to give me a hint of what is going on at Petworth. I trust you will hardly quit so hospitable a roof till this ebullition of premature

★[1]Probably the painting now in the National Gallery (No. 1275).

XI. STUDY OF FLOWERS. Victoria & Albert Museum

XII. THREE STUDIES. Pencil, 1813. Victoria & Albert Museum

winter is past; the snow is very deep indeed, and all since four o'clock this morning. My boys are very good boys. I have not left home for a day, nor can I till John is at Cambridge and Charley at sea. O what a melancholy, dirty life is a sailor's! but he is going out again with the ship to China. There are to be twelve or thirteen midshipmen, and where they find a pig-hole for so many, I know not. . . . I hear a sad account of poor Mr. Bannister, who will never leave his room again, nor see any more of his friends, nor sing any more of his delightful songs."

"My dear Leslie. . . . My poor Charley has had sad weather in his progress to the Downs, where he is now possibly wind-bound. The frightful gale on Tuesday is well described by him. The ship was anchored by the Nore light, and rode out the storm with little damage; but the wrecks around and within two hundred yards were shocking; one large ship floated past, bottom upwards, and after the gale he saw seven large hulls in tow with steam boats. In their passage to the Downs they saw some on the Goodwin Sands, and some of the beach under the Foreland."

"December 8th. My dear Leslie. . . . Mr. Sheepshanks means to have my 'Glebe Farm' or 'Green Lane', of which you have a sketch; this is one of the pictures on which I rest my little pretensions to futurity. . . . I hope you are all well, and safely returned, and the better for the excursion. Will you come to the last lecture given in the old house? if so, call and dine here. . . . Poor Westall!"[1]

"To Mr. George Constable. December 12th. I return the book which you lent me so long ago. My observations on clouds and skies are on scraps and bits of paper, and I have never yet put them together so as to form a lecture, which I shall do, and probably deliver at Hampstead next summer. I wish I had secured your fine old willow, which you say is now no more (what a pity), for my lecture on trees. If you want anything more about atmosphere, and I can help you, write

★[1] Richard Westall, R.A., died on 4th Dec. 1836.

to me. Foster's[1] is the best book; he is far from right, still he has the merit of breaking much ground. . . . Poor Westall! I went to his funeral on Saturday."

"December 30th. My dear Leslie. I am vexed with myself for having so long delayed to write to you, to thank you for your kind invitation to these dear children. This fearful weather intimidates me, but it seems little likely to change; and all my dreads, and all I can say about the danger of such an *excursion into the country* at such a time, gives no alarm whatever to the children, and they insist on my coming out of my lurking place, where I thought I had lain up for the winter, and so I must accompany them to your house on Monday to keep New Year's Day. Now all this I do, and let them do, only on condition that Mrs. Leslie and you dine with me on Wednesday. We have venison from my old friend, Lady Dysart, and are almost alone; only Mr. and Miss Spedding, very old and esteemed friends of my poor wife. Prithee come, '*life is short, friendship is sweet*'; these were the last words of poor Fisher to me in his last invitation.—My month in the Life School is March. I have concluded on setting the three figures of the 'St. Peter Martyr', for I am determined to sift that picture to the bottom.[2] I have by me a very old print of the subject five years before Titian's picture, done from the one which occupied the same place in the Dominican Church. The picture[3] was by Jacopo del Fiore, or 'Jemmy of the flower'; the flower stands for his name in the print, forming a very expressive figure."

The invitation contained in this letter was Constable's last written one to me. Without attaching to coincidences such as these any superstitious importance, they are too affecting to pass unnoticed. The expression, also, which follows, with

[1] This was *Researches about Atmospheric Phaenomena* by Thomas Forster, first published in 1813. On the whole subject of Constable's relations with the scientific meteorologists, see Kurt Badt, *John Constable's Clouds*, London, 1950.

[2] His lectures, in which he says much of the 'Peter Martyr', will explain this.

[3] It was decided in 1525 to replace this painting, and a competition was held in which Titian was victorious. Palma Vecchio and Pordenone were also competitors.

regard to March, which proved to be the last month of his life, is very remarkable.

In a note to Mr. Lucas, after thanking him for some proofs of the 'Salisbury', and making some remarks on them, he continues: "God preserve your excellent wife, and give her a happy hour; I have not forgotten my own anxieties at such times, though they are never to return. I beg to thank you again and again for the most lovely winter piece I ever saw.[1] You have caused the last of the old year to slip away from me with pleasurable feelings; we have now only a quarter of an hour left of the year 1836! Farewell."

"January 19th, 1837. Dear Lucas. We must keep this proof as a criterion, and get as much of it as we can. The bow is grand whole, provided it is clear and tender. How I wish I could scratch and tear away with your tools on the steel, just as old ——[2] wanted to fly up to Langham Hill, and tear the trees and hedges all up by the roots; but I can't do it, and your quiet way is, I well know, the best and only way."

"To Mr. George Constable. February 17th. . . . I cannot give much account of myself, but we have all been well, and have escaped this sad influenza, which has been the desolation of so many hundreds of all ages. John is the most tender of us all; he works hard, as he wishes so much to get himself fit for Cambridge. I believe he goes in October. As the spring gets up he would be delighted to pass a few days with you; he looks for an hour at his old fishing place near the Black Duck. For myself, I am at work on a beautiful subject, 'Arundel Mill', for which I am indebted to your friendship. It is, and shall be, my best picture; the size, three or four feet; it is safe for the Exhibition, as we have as much as six weeks good. We hold our first general meeting at the new house on Monday, and a

[1] An impression of the 'Salisbury' taken when the plate was imperfectly filled with ink, and which had accidentally the appearance of winter. Mr. Lucas had sent it to Constable as a curiosity.

[2] A farmer who, by his restless grasping disposition having made some of his neighbours as well as himself very uncomfortable, uttered this singular wish.

very noble house it is.[1] I am visitor next month in the Life Academy, which I regret, as it cuts up my time; but I relieve by exchange, Turner. My great 'Salisbury' print is done; I shall call it the 'Rainbow'; you shall soon receive a proof of it. Remember me most kindly to Mrs. Constable, and all your family. Pray write to me soon; I long to know that all is well with you."

"February 25th. My dear Leslie. I know not how to reply to your kind request to come to you on Monday, as I am engaged with my *assassin* on that day, and shall be employed with him all the week; in other words, I commence my visitorship at the Academy, and I shall set Titian's figure of the assassin in the 'Peter Martyr'. I shall turn Fitzgerald into the *fallen saint*, and the remaining figure of the monk I give to Emmet, who is an obliging and well-behaved man, and anxious for a turn at the Academy; will not this flying monk sicken him? I have been sadly hindered, and my picture is not worth anything at present. Roberts was at Hampstead on Thursday. All my little girls are well and happy, and I really believe they cannot be in better hands than with that excellent woman, Miss Noble."

"March 18th. Dear Lucas. Mr. Cook, the Academician, said yesterday that the 'Salisbury' was 'a grand-looking thing'. I hope that obliging and most strange and odd ruffian, your printer, will be allowed to have just his own way in printing the plate, for I now see we must not be too full, otherwise it will, as he says, 'only be fit for a parcel of painters'."

No date. "Dear Lucas. The print is a noble and beautiful thing; entirely improved and entirely made perfect; the bow is noble, and is now a neck or nothing business; it is startling and unique. I have mentioned to your clever and agreeable ruffian, who is in high good humour, two things; the light on the tower under the trees must be made thus" (here a sketch) "instead of thus" (another sketch); "also the little spot

[1] Constable never joined in the popular cry against the architect of the National Gallery, for not building a larger house than the ground given for the purpose permitted.

on the cloud your ruffian will show you, and he pointed out a good way of doing it; half an hour will alter both. Thank you for the pains you have taken with the bow; it is lovely. I hope you are better. I must now dismiss the ruffian, for he is getting too knowing for John and me."

"Dear Lucas. Your man has told me that there is every reason to know that the 'Salisbury' will print both full and rich. Tone, tone, is the most seductive and inviting quality a picture or print can possess; it is the first thing seen, and like a flower, invites to our examination of the plant itself. . . . Your man is a droll fellow. I have given him two shillings, but it was before he had told me that he 'is given to break out of a Saturday night, but it does not last long, and generally goes off on the Sunday morning.' He cannot help it, he cannot even account for it, but so it is. This is his own gratuitous account of himself. What a creature is man, either cultivated or not, either civilised or wild! I offered him some rum and water, and gin and water, all of which he refused almost with loathing; perhaps his hour is not yet come."

"To Mr. Samuel Lane. March. My dear Lane. . . . Pray keep your children within doors this grievous weather; I am told nothing breeds whooping cough so much as such bitter easterly winds as are now prevailing. I am out every evening from five to nine at the old Academy, visitor in the Life."

The recollection that Constable was very sensitive to atmospheric influences, and that his health had many times suffered in the early part of the spring, recalls to my mind the passage from Shakespeare I have most often heard him repeat:

> 'daffodils,
> That come before the swallow dares, and take
> The winds of March with beauty—'

they were, now, indeed, winds of ominous import to him.

He was the last visitor who officiated in the Life Academy within the walls of Somerset House. On the concluding evening of his attendance, he made a short address to the students, pointing out to them the many advantages our

Academy affords, and cautioning them not to be in too great haste to exchange these for instruction in the schools of France, Germany, or Italy. He was of opinion that the best school of art will always exist in that country where there are the best living artists, and not merely where there are the greatest number of works of the old masters. He did not admit that the French excel the best of the English artists in drawing, a point generally conceded to them; and in support of his own opinion he quoted that of Mr. Stothard, who said, 'The French are very good *mathematical* draughtsmen, but life and motion are the essence of drawing, and their figures remind us too much of statues. In the slightest pen and ink sketches of Raphael, however irregular the proportions, you have the real principle of good drawing,—his figures live and move.'

This is but a recollection, at some distance of time, of what Constable told me he said. I wrote to Mr. Maclise, who was then a student in the Life School, to ask if he could help me to anything more, and that gentleman very kindly sent me the following note, enclosing a pencil sketch he had made of Constable in the Academy.

"14, Russell Place. My dear Sir. I cannot call to mind the substance of any particular address of Constable when he was visitor, but I recollect that he constantly addressed us collectively; or rather, whatever observation he had to make, he made aloud; and this was very frequent. Every evening he said something, generally relating to the model he had set, and in favour of certain picturesque accompaniments which he thought might always be introduced with propriety;[1] he

[1] This reminds me of what I have often heard Constable say, that he 'never could look at any object unconnected with a background or other objects', and he thought the students might very advantageously to themselves be taught at an early age to look at nature in this way. For this reason all his figures were set with backgrounds and other accompaniments. A difference of opinion exists as to the expediency of this method of teaching, and it is one of the charges brought against the Academy, that the students are placed under the care of various instructors, who have each their own notions; and yet this may possibly be an advantage, when it is considered that the opinions of any one man can scarcely be right on all points; and also that the Life is the highest

was, with the students, a most popular visitor. The little sketch was made under the disadvantage of my being on the upper and back seat, looking down on him as he sat on the front and lower one in the Life School, and must have been when he set the Eve, although I should not have thought it was so long ago as 1830.—I remain, very faithfully yours, D. Maclise."

"March 29th. Dear Lucas. I am greatly pleased to see how well you are preparing for the new bow;[1] the proof is about what I want; I mean that you took hence. I took from the elder bush a blossom to the left; you will possibly do the same. Go on as you think proper. I go to a general meeting on Thursday, to-morrow evening, and I dine at the Charter House on Saturday. We cannot fail with a proper bow. The ruffian is so delightful that no one would for a moment judge him to be one; so bland, so delighted with John, and John with him; they are both in the room."

This note may, perhaps, be the last Constable ever wrote. The engagement mentioned in it to dine with Dr. Fisher, the father of Archdeacon Fisher, at the Charter House, was for Saturday, the 1st of April, but the dawn of that day he never saw. His constitution was undermined to a degree of which he was not himself aware, far less his friends, for sedentary and irregular as were his habits, he had not the look of a valetudinarian, nor would his age have been easily guessed from his appearance. Not long before the time of which I am writing, I had remarked to him that I should guess him to be younger than he really was, to which he answered,

> 'In my youth I never did apply
> Hot and rebellious liquors to my blood,' etc.

school in the Academy, and that in which the students may be supposed to have arrived at an age to judge in some measure for themselves; and that they are not placed under more than one master until they have entered the Life School.

[1] From the manner in which this is expressed, it would appear that the rainbow had been taken out, and a new one was to be put in, but this was not the case; the 'new bow' was the one with which Constable had before expressed himself so much pleased.

But the reader has seen how far his mind was from being an equable one. In reference to his art, he would sometimes say he 'thanked Heaven he had no imagination', though in reality few men ever had more; and if it heightened all his enjoyments, it greatly deepened all his sorrows. He had fully proved the truth of Burns' lines:

'Dearly bought the hidden treasure
 Finer feelings can bestow;
Chords that vibrate sweetest pleasure
 Thrill the deepest notes of woe.'

Had Constable been even less sensitive, the perpetual activity of a mind that could not rest must have affected his constitution at no very late period. His very amusements consisted of study. I do not think he ever read a novel in his life. It was on no narrow principle that he objected to works of fiction, but they did not interest him. I remember soon after the death of Mrs. Constable, when books were proposed to him as a relief to his mind, he said, 'I should be delighted to read *Tom Thumb* if it could amuse me.' If her loss had been but that of an assistant in his parental duties, and a partaker of the cares of a family, he must have felt it daily; how much more heavy, then, must have been his affliction for the loss of a wife in whom no hope formed by him during the days of courtship had been disappointed, excepting the hope of her longer continuance on earth. His married years were unquestionably the happiest of his existence. In Fisher and the younger Dunthorne, he was also bereft of friends whose places were never supplied to him; and his professional life had been a continual struggle for the estimation which he felt he deserved, but which he had now ceased to expect. If his intimate friends were but imperfectly acquainted with the real state of his feelings, those who knew him but slightly, and who seldom saw him unless surrounded by smiles of his own creating, could not have believed how much he was now a prey to melancholy and anxious thoughts; thoughts, no doubt, in part, both the cause and effect of declining health. The reader will remember a passage in one of his letters to Mr. Fisher, in which he says,

"all my indispositions have their source in my mind. It is when I am restless and unhappy that I become susceptible of cold, damp, heats, and such nonsense."

On Thursday, the 30th of March, I met him at a general assembly of the Academy, and as the night, though very cold, was fine, he walked a great part of the way home with me. The most trifling occurrences of that evening remain on my memory. As we proceeded along Oxford Street, he heard a child cry on the opposite side of the way; the griefs of childhood never failed to arrest his attention, and he crossed over to a little beggar girl who had hurt her knee; he gave her a shilling and some kind words, which by stopping her tears, showed that the hurt was not very serious, and we continued our walk.—Some pecuniary losses he had lately met with had disturbed him, but more because they involved him with persons disposed to take advantage of his good feelings, than from their amount. He spoke of these with some degree of irritation, but turned to more agreeable subjects, and we parted at the west end of Oxford Street, laughing.—I never saw him again alive.

The whole of the next day he was busily engaged finishing his picture of 'Arundel Mill and Castle'. One or two of his friends who called on him saw that he was not well, but they attributed this to confinement and anxiety with his picture, which was to go in a few days to the Exhibition. In the evening, he walked out for a short time on a charitable errand connected with the Artists' Benevolent Fund. He returned about nine o'clock, ate a hearty supper, and feeling chilly, had his bed warmed, a luxury he rarely indulged in. It was his custom to read in bed; between ten and eleven he had read himself to sleep, and his candle, as usual, was removed by a servant. Soon after this, his eldest son, who had been at the theatre, returned home, and while preparing for bed in the next room, his father awoke in great pain, and called to him. So little was Constable alarmed, however, that he at first refused to send for medical assistance; he took some rhubarb and magnesia, which produced sickness, and he drank copiously of warm

water, which occasioned vomiting; but the pain increasing, he desired that Mr. Michele, his near neighbour, should be sent for, who very soon attended. In the meantime Constable had fainted, his son supposing he had fallen asleep; Mr. Michele instantly ordered some brandy to be brought, the bedroom of the patient was at the top of the house, the servant had to run downstairs for it, and before it could be procured, life was extinct; and within half an hour of the first attack of pain.

A post mortem investigation was made by Professor Partridge in the presence of Mr. George Young and Mr. Michele, but strange to say, the extreme pain Constable had suffered could only be traced to indigestion; no indications of disease were anywhere discovered sufficient, in the opinion of those gentlemen, to have produced at that time a fatal result. Mr. Michele, in a letter to me, describing all he had witnessed, says, "It is barely possible that the prompt application of a stimulant might have sustained the vital principle and, induced reaction in the functions necessary to the maintenance of life."

Constable's eldest son was prevented from attending the funeral by an illness, brought on by the painful excitement he had suffered; but the two brothers of the deceased and a few of his most intimate friends followed the body to Hampstead,[1] where some of the gentlemen residing there, who had known Constable, voluntarily joined the procession in the churchyard. The vault which contained the remains of his wife was opened, he was laid by her side, and the inscription which he had placed on the tablet over it,

> 'Eheu! quam tenui e filo pendet
> Quidquid in vita maximè arridet!'

might well be applied to the loss his family and friends had now sustained. The funeral service was read by one of those friends, the Rev. T. J. Judkin, whose tears fell fast on the book as he stood by the tomb.

[1] I cannot but recall here a passage in a letter to Mr. Fisher, written by Constable nearly ten years before his death, in which, after speaking of having removed his family to Hampstead, he says, "I could gladly exclaim, here let me take my everlasting rest!"

Picture of 'Arundel Mill and Castle' exhibited, 1837. Presentation of the Picture of the 'Cornfield' to the National Gallery. Letter from Mr. Andrew Robertson. Constable and Hogarth compared. Traits of Constable's Character described by Mr. George Field. Farther Particulars. Selections from Constable's miscellaneous Memoranda. Note from Mr. Collins. Pictures injured by cutting, enlarging, etc. Forgeries of Constable's Pictures. Recollections of his Sayings and Opinions. The Author's Visit to East Bergholt, in company with Mr. Purton and John Constable, Junior. Mr. Purton's Remarks on Constable's Art. Sketch Books.

By a law of the Royal Academy, works, not before exhibited, of a deceased artist are allowed to appear in the first exhibition, and that one only, which follows his death; and Constable's picture of 'Arundel Mill and Castle'[1] was considered by his friends sufficiently completed to be sent to the Academy. He had begun two smaller pictures, but they were not forward enough to be admitted even as sketches; and the 'Mill' was therefore the only work of his pencil that graced the Exhibition of 1837, the first in Trafalgar Square. The scene was one entirely after his own heart, and he had taken great pains to render it complete in all its details; and in that silvery brightness of effect which was a chief aim with him in the latter years of his life, it is not surpassed by any production of his pencil. It remains in the possession of his children, being one of those reserved from the sale of his works by his eldest son.

Before the property Constable left, in pictures, was dispersed, it was suggested by Mr. Purton that one of his works should be purchased by a subscription among the admirers of his genius, and presented to the National Gallery. He proposed that the large picture of 'Salisbury from the Meadows', should be chosen as being from its magnitude, subject, and grandeur of treatment, the best suited to the public collection. But it was thought by the majority of Constable's friends that the boldness of its execution rendered it less likely to address itself to the general taste than others of his works, and the

[1] Now in the Toledo Museum of Art, Toledo, Ohio. See Plate 54.

picture of the 'Cornfield', painted in 1826, was selected in its stead.—As I felt much interested in this proceeding, I wrote on the subject to those of Constable's friends whom I thought likely to join in it, and from among the replies I received, I trust Mr. Andrew Robertson will forgive the publication of his.

"19, Berners Street, August 21st, 1837. My dear Sir, I have had this day the melancholy gratification, if I may combine such terms, of again visiting the gallery of our lamented friend Constable. The great number of his works left in his possession proves too clearly how little his merits were felt by those who could afford, and ought to have possessed them; and that, unless some such a measure had been adopted as that which, to the honour of his friends, has been carried into effect, it is too probable that his works would have fallen into the hands of artists only, for a mere trifle, and remained comparatively buried, till dug up, as it were, and brought to light in another age. Much, indeed, should I regret to have lost the opportunity of having my name enrolled in the list of those who bear testimony to the merits of genius so original, so English, so alive to the beauties of simple nature, and of whom it may be said so truly that he was

'Nullius addictus jurare in verba magistri.'

He had his peculiarities, but they were not in conception, nor in the way in which he looked at nature; he saw clearly, and not through a glass darkly, nor through other men's eyes. His peculiarities were only in his execution, and in the admirable picture selected for his monument in the National Gallery, we find all his truth of conception, with less of the manner that was objected to, than in most of his later works. I remain, my dear sir, always truly and sincerely yours, A. Robertson."

In some points of Constable's character a striking resemblance may be traced to that of Hogarth. Though their walks of art were wide apart, yet each formed a style more truly original than that of any of his contemporaries, and this, in part, prevented each from enjoying the fame to which he was

entitled.[1] They both incurred the imputation of vanity, perhaps from much vainer men, because they vindicated their own merits.—Hogarth expressed in a witty etching ('The Battle of the Pictures') his sense of the injustice he suffered from the connoisseurs, and Constable spoke his opinions openly of the critics; and with point, truth, and freedom, as did Hogarth, of contemporary artists, and each by so doing, made bitter enemies.—In conclusion, they were both genuine Englishmen; warmly attached to the character and institutions of their country; alike quick in detecting cant and quackery, not only in religion and politics, but in taste and in the arts; and though they sometimes may have carried the prejudices of their John Bullism too far, they each deserved well of their country, as steady opponents to the influence of foreign vice, folly, and bad taste; in which, however, Hogarth's class of subjects enabled him to exert himself with far the most effect.

The object I have endeavoured to keep in view throughout the preceding pages being to give an account of Constable's life and occupations as much as possible in his own words, my extracts from his letters have been necessarily limited to passages relating chiefly to himself; but had not this, and the reserve due to other persons, prevented my quoting these papers more at length, it would be seen that in very many of them his own affairs occupied the least part of his attention. Many indeed of his notes and letters have been entirely unavailable to me on this account, excepting in as far as they have added to the high opinion I had before formed of the kindliness of his nature.

My friend, Mr. George Field,[2] who knew him long and intimately, says, in a letter to me, "Of Constable's benevolent

[1] Hogarth's prints were popular; for his wit, his satire, and his matchless power of expression were felt;—but the taste and richness of his compositions, and the beauty of his colour, in other words *his art*, was not. One circumstance alone proves this,—he could not obtain for the six pictures of the 'Marriage-à-la-Mode', together, more than one hundred and ten guineas.

*[2] George Field (1777?–1854), chemist and author of *Chromatography; or, A Treatise on Colours and Pigments, and of their Powers in Painting* (1835), among other books.

feelings and acts a volume of instances might be recorded, and no better proof of his genuine worth can be adduced than that affluence did not spoil the artist, while it very much improved the man."

In another of his obliging communications to me, Mr. Field says, "At all times of the day, at night, and in all seasons of the year, Constable had inexpressible delight in viewing the works of nature. I have been out with him after all colour of the landscape had disappeared, and objects were seen only as skeletons and masses, yet his eye was still active for his art. 'These were the things,' said he, 'that Gainsborough studied, and of which we have so many exquisite specimens in his drawings.'[1] Constable found undecorated beauties in the nakedness of winter when he lavished admiration on the anatomy of trees, etc. He well knew the *language* of a windmill, and by its expressions could tell you of the winds, and of the skies, and besides this he knew many other tongues that are not written, and are too little studied and understood for the boundless authorities they furnish to artists, to poets, to philosophers, and all true lovers of the wisdom of nature. To this attachment to nature and averseness to factitious studies, he probably owed the originality of thought, expression, and manners by which he was distinguished; which, however sometimes savouring of rusticity and destitute of the artifice and convention of society, were marked by an unrestrained amiableness and real refinement which were his own. This clash of nature and artifice appears also to have given rise to the incessant workings of a humorous satire, by which he continually levelled the pretensions of others, which although not entirely inoffensive was generally just, and few ventured to face it. It subjected him and his peculiarities, however, to assailments from anonymous, injudicious, and pointless criticism, which a less genuine and more courtly carriage might have saved him from, or transformed into praise or fame, patronage or profit. These anonymous attacks served him for

[1] Several very fine sketches by Gainsborough, in black and white chalk, hung in Constable's parlour.

a spur, and his satirical humour for a theme, with which he entertained his friends at the time, although his heart was naturally too affectionate to all the world to be insensible to praise, for affection seeks affection, and praise is love. It is remarkable of our most eminent landscape painters, in common with genius in other shapes, that they have been subjected by this natural independence of thought and action to frequent misprise and neglect during their lives, and the incomparable Wilson was an instance of it. But in him this quality wrought more asperity than in Constable. Was this to be attributed to difference in the circumstances of fortune or of disposition in these great painters?"

These extracts from the letters of Mr. Field contain but a part of the assistance with which he has favoured me.

In the winter seasons, after he could afford it, Constable frequently sent clothes and blankets to be distributed among the poor of his native village; indeed no feature of his character was more amiable than his sympathy with the sufferings of the humbler classes, and his consideration for their feelings in all respects. He possessed that innate and only real gentility of which the test is conduct towards inferiors and strangers; he was a gentleman to the poorest of his species,—a gentleman in a stage coach, nay more,—a gentleman at a stage coach inn dinner.

A mind like Constable's, united to a nervous temperament so sensitive, could not be indifferent to music. In his youth he was a good flute player, but he laid the instrument aside as he found that painting required his whole attention. Preferring simplicity and expression to an ostentatious display of art, I remember that, at a musical party during a trio in Italian, with which his ears were stunned, and which was only fit for the vast area of the Opera House, he whispered to me, 'I dare say it is very fine, for it is very disagreeable; but if these people were to make such a noise before your door or mine, we should send for the police to take them away.'

The following may be placed here as connected with this subject. I found it among his papers in his handwriting; and it

was no doubt a draught of a paragraph inserted by him in a provincial newspaper.

"Died on the 29th ult. at Great Wenham, Thomas Cheverton, aged 48 years, leaving a widow and nine children. This individual, although in the humble condition of a day labourer, may fairly claim some further notice in our obituary from the circumstance of his being gifted with a most extraordinary voice; one of the fullest, richest, and sweetest counter tenors ever, perhaps, heard. He could with ease ascend to D, and even to E in Alt. His knowledge in the science of music was by no means inconsiderable, and his appearance in the humble choirs of the village churches in his immediate neighbourhood was always hailed with silent satisfaction even by the best educated people. He was gentle and affectionate to his family, who are now thrown on a world, too busy, it is feared, to cast a look on beings so humble, or to extend the hand of charity to objects so unobtrusive and friendless. August 1st, 1831."

Among the papers with which I found this, were many separate scraps, containing notes, memoranda, and quotations, many of them, no doubt, intended to assist him in his lectures. The following are selections from them, and from a few of his unpublished letters.

"When young, I was extremely fond of reading poetry, and also fond of music, and I played myself a little; but as I advanced in life and in art, I soon gave up the latter; and now after thirty years, I must say that the sister arts have less hold on my mind in its occasional ramblings from my one pursuit than the sciences, especially the study of geology, which, more than any other, seems to satisfy my mind. November 10th, 1835."

"The difference between power and truth is very material in painting, as it is in other matters of taste. It may be illustrated by an anecdote of Barry and Garrick. Few actors had more power than Barry; indeed he was able for some time to divide the admiration of the town with Garrick. They played Lear in competition fifty nights; but the public were set right by an

epigram, which placed the distinction between them in the proper light, the last line of which was

'To Barry we give loud applause, to Garrick only tears.' "

" 'System can by no means be thrown aside. Without system, the field of nature would be a pathless wilderness; but system should be subservient to, not the main object of, our pursuit.' —WHITE *of Selborne*."

"This imitation of an elegantly touched drawing by Waterloo was one of my earliest instructors.—J. C.—Presented to me by J. T. Smith, 1798."—(Written on the back of a pen drawing.)

"Connoisseurs think the art is already done."

"I have never seen anything in the art yet with which I have been entirely satisfied. The least mannered, and consequently the best pictures I have seen, are some of the works of De Hooge, particularly one of an outdoor subject, at Sir Robert Peel's. His indoors are as good, but less difficult, as being less lustrous."[1]

"The world is wide; no two days are alike, nor even two hours; neither were there ever two leaves of a tree alike since the creation of the world; and the genuine productions of art, like those of nature, are all distinct from each other."

"In such an age as this, painting should be *understood*, not looked on with blind wonder, nor considered only as a poetic aspiration, but as a pursuit, *legitimate, scientific,* and *mechanical*."

"The old rubbish of art, the musty, commonplace, wretched pictures which gentlemen collect, hang up, and display to their friends, may be compared to Shakespeare's

'Beggarly account of empty boxes,
Alligators stuffed,' etc.

Nature is anything but this, either in poetry, painting, or in the fields."

[1] Constable would not have said that such works were the greatest achievements of art; he merely meant that they were the most perfect, in the sense in which some minor poems may be considered more perfect than the *Iliad* or the *Paradise Lost*.

"Barry thought, to be great he must reject the attributes of painting; hence the iron-bound outline and brazen lights of his pictures in the Adelphi."

"The most perfect of all masters of real chiaroscuro are Claude and Ostade. The chiaroscuro of Rembrandt is decidedly an artificial feature in his works; he painted expressly for it; it was his own peculiar language, and used by him to express the sentiment."

"What were the habits of Claude and the Poussins? though surrounded with palaces filled with pictures, they made the fields their chief places of study."

"Cowper numbered it among his advantages as a composer that he had read so little poetry; for 'imitation,' said he, 'even of the best models is my aversion; it is servile and mechanical; a trick that has enabled many to usurp the name of author, who could not have written at all, if they had not written upon the pattern of somebody indeed original.' "[1]

"The folly of imitation is well shown in the fable of 'The Ass and the Lap-dog'."

" 'I hate e'en Garrick when at secondhand.'—CHURCHILL."

"Mr. W—— is conscious of being a great mannerist, and that he is thought so. He was told how much trouble his picture had given the Council on that account, for that it would hang with nothing else; he was hurt, and said, 'manner might be either good or bad'; but Fuseli makes the true distinction between *style* and *manner*."

"Lord Bacon says, 'Cunning is crooked wisdom. Nothing is more hurtful than when cunning men pass for wise.'—This is mannerism in painting. The mannerists are cunning people; and the misfortune is, the public are not able to discriminate between their pictures and true painting."

"Manner is always seductive. It is more or less an imitation of what has been done already,—therefore always plausible. It

[1] The last book Constable had been reading, and on which his attention had probably been engaged little more than an hour before his death, was a volume of Southey's *Life of Cowper*, containing the poet's letters.

promises the short road, the near cut to present fame and emolument, by availing ourselves of the labours of others. It leads to almost immediate reputation, because it is the wonder of the ignorant world. It is always accompanied by certain blandishments, showy and plausible, and which catch the eye. As manner comes by degrees, and is fostered by success in the world, flattery, etc., all painters who would be really great should be perpetually on their guard against it. Nothing but a close and continual observance of nature can protect them from the danger of becoming mannerists."

" 'Is it not folly,' said Mr. Northcote to me in the Exhibition, as we were standing before ——'s picture, 'for a man to paint what he can never see? is it not sufficiently difficult to paint what he does see?'[1]—This delightful lesson leads me to ask, what is painting but an imitative art? an art that is to *realise*, not to *feign*. I constantly observe that every man who will not submit to long toil in the imitation of nature, flies off, becomes a phantom, and produces dreams of nonsense, and abortions. He thinks to screen himself under 'a fine imagination', which is generally, and almost always in young men, the scapegoat of folly and idleness."

" 'Rien est beau que le vrai.'—BOILEAU."

" 'Observe that thy best director, thy perfect guide is Nature. Copy from her.—In her paths is thy triumphal arch. She is above all other teachers; and ever confide in her with a bold heart;—*especially when thou beginnest to feel that there is a sentiment in drawing.*—Day after day never fail to draw something, which however little it may be, will yet in the end be much; and do thy best.' Extracted from Cennino Cennini's book on painting written four hundred years ago, now first printed in 1821, from the manuscript in the Vatican. He was a pupil of Angiolo Gaddi, whose father painted under Giotto twenty-four years."

[1] Northcote's objection did not apply to the *supernatural* in painting, but to the *unnatural*. The picture before which they stood professed to be a real scene, but treated in what the artist conceived to be a poetic manner.

"None of the greatest painters were eccentric in their works. They were too consistent with themselves to merit such an epithet; too sensible of what they were about."

"The rage of what may be called *protégé-ism* among the rich and great, arising from the expectation either of being the first to discover genius in obscurity, or of turning some young man of ordinary talent into a genius, though it may now and then be of use, is far more often prejudicial to the real interests of art, and even to the individual so patronised. Very worthy men, possessed with this vanity, become completely blinded to the injustice they commit to all who have fairly won the field, and whom they would not hesitate to drive from it, to make room for some favourite of their own, who is, by their *instruction* as well as patronage, to be placed on the pinnacle of fame.—Thus, Rasselas, in recalling the visions he had indulged in of a perfect government when he should come to the throne, acknowledges that he afterwards was startled to think with how little regret he had contemplated the death of his father and elder brothers."

"There should be a moral feeling in the art, as well as in everything else, and it is not right in a young man to assume great dash, or great completion, without study or pains."

"There has never been a boy painter, nor can there be. The art requires a long apprenticeship, being *mechanical,* as well as intellectual."

"It was at Rome Claude became the real student of Nature. He came there a confirmed mannered painter. But he soon found it necessary to 'become as a little child', and he devoted himself to study with an ardour and a patience of labour perhaps never before equalled. He lived in the fields all day, and drew at the Academy at night, for after all Art is a plant of the conservatory, not of the desert."

"'D. O. M.[1]

CLAUDIO . GELLEE . LOTHARINGO .

EX . LOCO . DE . CHAMPAGNE . ORTO .

PICTORI . EXIMIO .

QUI . IPSOS . ORIENTIS . ET . OCCIDENTIS

SOLIS . RADIOS . IN . CAMPESTRIBUS .

MIRIFICE . PINGENDIS . EFFINXIT .

HIC . IN . URBE . UBI . ARTEM . COLUIT,

SUMMAM . LAUDEM . INTER . MAGNATES .

CONSECUTUS . EST .

OBIIT . IX . KALEND . DECEMBRIS . MDCLXXXII.

AETATIS . SUAE . ANNO . LXXXII.

JOANN . ET . JOSEPHUS . GELLEE .

PATRUO . CHARISSIMO . MONUM . HOC .

SIBI . POSTERISQUE . SUIS .

PONI . CURARUNT.'

" 'To Claude Gellée Lorraine, a most eminent painter, born in the province of Champagne, who, in painting landscape, represented to admiration the very rays of the rising and setting sun. In this city, where he practised his art, he obtained the highest celebrity among the great. He died the 9th of the Kalends of December 1682 (*i.e.* 23rd of November), aged 82.

" 'John and Joseph Gellée caused this monument to be erected to their beloved uncle, for themselves and their posterity.'

"The above inscription was on the monument of Claude Lorraine (now destroyed) in the church of the Trinità al Monte at Rome. Sir George Beaumont, who had seen it, and again sought for it when there about 1820, informed me that it was mural, and moderately ornamented, having a palette and pencils carved on it. Had he been successful in finding the fragments, it was his intention to have brought them to his

[1] Diis omnibus manibus. 'To all the infernal Gods.' So the ancient Romans inscribed their monuments. This inscription was turned by the Christians into Deo optimo maximo, 'To the good and great God', thus preserving the same initial letters.

seat at Cole-Orton, and put them up in the church or on his grounds."[1]

Constable seldom failed to penetrate the real characters of men through the disguises of manner. In an unpublished letter he says, of one of a class of persons not very uncommon, "More *overbearing meekness* I never met with in any one man."

To these few gleanings from Constable's papers I will add some recollections of his sayings. His manner of talking was perpetually digressive, yet he never lost sight of the subject with which he set out, but would always return to it, though often through a long and circuitous path. This rambling habit made his talk, which was amusing enough in itself, sometimes still more so, but it unfitted him in a great degree for an extemporaneous lecturer. His conversation might be compared to a dissected map or picture, of which the parts, as seen separately, appear to have no connection, yet each is capable of being so placed as to form a complete whole.

In reply to an application to my friend Collins for his assistance in this part of my undertaking, I received the following note:

"Dear Leslie, I have been cudgelling my brains on the subject of the Constable anecdotes, and the result is the recollection of a great number of good things, calculated, alas, only for table-talk among friends. This, as I told you, I feared would be the case. The great charm of our lamented friend's conversation upon art was not only its originality, but its real worth, and the evidence it afforded of his heartfelt love of his pursuit, independent of any worldly advantages to be obtained by it. . . . I mentioned to you his admirable remark upon the composition of a picture, namely, that its parts were all so necessary to it as a whole, that it resembled a sum in

[1] My friend, Mr. T. Uwins, has obliged me with the following account of the destruction of Claude's monument: 'When the French republican troops devastated Italy in 1798, their great delight was to turn out the monks and nuns from the convents and other religious houses, which houses they converted into barracks. This happened to the Church and Convent of the Frati Minori on the Trinità al Monte at Rome, and it was during this barbarous occupation that Claude's monument was obliterated.'

arithmetic; take away or add the smallest item, and it must be wrong. His observations, too, on chiaroscuro were all that could be made on that deep subject. How rejoiced am I to find that so many of the great things he did will at last be got together for the benefit of future students."

The comparison mentioned by Mr. Collins of a picture to a sum in arithmetic was intended by Constable to expose the unpardonable liberties sometimes taken by the possessors of the works of deceased artists, in cutting, enlarging, or otherwise altering them. 'Would you take from or add,' he would say, 'to a physician's prescription? . . .' Another proceeding, perhaps not more justifiable, may be here adverted to,—the employment of artists to finish pictures left incomplete by their predecessors. The best painters know that a work of any value can only be carried through by the head and hand of him who planned it, and consequently, those only undertake to complete unfinished pictures who are the least capable of divining the intentions of their authors.[1] Some of Constable's sketches have thus been *finished* into worthlessness, and what is a still greater injury to his reputation, entire forgeries have been made of his works. Multitudes of these I have seen, and with astonishment that their wretchedness should impose upon purchasers. But they are put forth, in safe reliance on the little real knowledge of his style that, at present, exists among our connoisseurs.

To return from this digression to the more agreeable subject of Constable's conversation, I remember to have heard him say, 'When I sit down to make a sketch from nature, the first thing I try to do is, *to forget that I have ever seen a picture*.'[2] He well knew that, in spite of this endeavour, his knowledge of pictures had its influence on every touch of his pencil, for in speaking of a young artist who boasted that he had never studied the works of others, he said, 'After all, there *is* such a thing as the art.'

[1] I have known some deplorable instances of the *finishing* of Wilkie's incompleted pictures, and many more of works, so left, by Lawrence.

[2] A curious proof of the stillness with which he had sat one day while painting in the open air, was the discovery of a field mouse in his coat pocket.

On hearing somebody say of the celebrated collection of Raphael's drawings that belonged to Sir Thomas Lawrence, 'They inspire,' he replied, 'They do more, they inform.'

The amiable but eccentric Blake, looking through one of Constable's sketch books, said of a beautiful drawing of an avenue of fir trees on Hampstead Heath, 'Why, this is not drawing, but *inspiration*,' and he replied, 'I never knew it before; I meant it for drawing.'

'My pictures will never be popular,' he said, 'for they have no *handling*. But I do not see *handling* in nature.'

He said also, 'Whatever may be thought of my art, it is my own; and I would rather possess a freehold, though but a cottage, than live in a palace belonging to another.'

To a lady who, looking at an engraving of a house, called it an ugly thing, he said, 'No, madam, there is nothing ugly; *I never saw an ugly thing in my life* : for let the form of an object be what it may,—light, shade, and perspective will always make it beautiful. It is perspective which improves the form of this.'

Speaking of the taste for the *prodigious* and the *astounding*, a taste very contrary to his own, he made use of a quotation from the 1st Book of Kings. 'A great and strong wind rent the mountains, and brake in pieces the rocks before the Lord; but the Lord was not in the wind; and after the wind an earthquake; but the Lord was not in the earthquake: and after the earthquake a fire; but the Lord was not in the fire: and after the fire *a still small voice.*'

There were many occasions on which Constable quoted the aphorism of Dr. Johnson: 'That which is *greatest* is not always *best*.'

His fondness for children has been mentioned. I have often heard him say, but as a quotation (I think from Plato), '*Children should be respected.*'

He was asked how soon a relish for the works of Domeni-chino might be acquired, and replied, 'In about the same time in which you may acquire a relish for the works of Homer.'

An artist who undervalued every class of art but the heroic, said in his presence, 'that he could not conceive to what Jan Steen owed his great reputation, unless to the high encom-iums Sir Joshua Reynolds had passed on his style;' 'And could he,' replied Constable, 'owe it to a better authority?'

He was struck with a remark of Dr. Gooch, that he found 'every individual case of disease a new study.' Constable applied this to painting, and said 'In like manner every truly original picture is a separate study, and governed by laws of its own; so that what is right in one, would be often entirely wrong if transferred to another.'

A friend of Constable expressing to him his dissatisfaction at his own progress in art, received (as he told me) the greatest encouragement to proceed he ever met with, in the following answer: 'If you had found painting as easy as you once thought it, you would have given it up long ago.'

He could not easily resist the temptation of making an unexpected reply, and when Archdeacon Fisher, one Sunday, after preaching, asked him how he liked his sermon, he said, 'Very much, indeed, Fisher; I always did like that sermon.' But Fisher had too much wit himself not to relish this; and if he kept any account of such hits with his friend, it was no doubt a fairly balanced one.

If Constable had occasion to find fault with a servant or a tradesman, it was seldom unaccompanied with a pleasantry, though often a sharp one. To the person who served his family with milk, he said, 'In future we shall feel obliged if you will send us the milk and the water in separate cans.'

A picture of a murder sent to the Academy for exhibition while he was on the Council was refused admittance on account of a disgusting display of blood and brains in it; but

he objected still more to the wretchedness of the work, and said, 'I see no *brains* in the picture.'[1]

I regret that among his papers I have not met with the observations on skies and clouds, which he mentions in a letter to Mr. George Constable. I recollect hearing, at different times, remarks by him on atmospheric effects, but I can scarcely recall anything he said with sufficient distinctness to repeat it. I remember that he pointed out to me an appearance of the sun's rays, which few artists have perhaps noticed, and which I never saw given in any picture, excepting in his 'Waterloo Bridge'. When the spectator stands with his back to the sun, the rays may be sometimes see *converging* in perspective towards the opposite horizon. Since he drew my attention to such effects, I have noticed very early in the morning the lines of the rays diminishing in perspective through a rainbow.

I have seen him admire a fine tree with an ecstasy of delight like that with which he would catch up a beautiful child in his arms. The ash was his favourite, and all who are acquainted with his pictures cannot fail to have observed how frequently it is introduced as a near object, and how beautifully its distinguishing peculiarities are marked. I remember his pointing out to me, in an avenue of Spanish chestnuts, the great elegance given to their trunks by the spiral direction of the lines of the bark.

He would never admit of a distinction which is sometimes made between poetry and truth. He felt that the *supernatural* need not be the *unnatural*.[2] Neither did he admit that the *conventional* in art, though it may be found in the works of the greatest masters, was to be considered in any other light than as an evidence of human imperfection. He looked upon the imitation by modern painters of that which is conventional

[1] This recalls to my recollection a saying, still better, which is related of Opie, who, when a young artist asked him what he mixed his colours with, replied, '*Brains*'.

[2] Why do 'the Gods of Homer continue to this day the gods of poetry', but because they are endued with human passions? And for the same reason do the weird sisters, the Oberon, Titania, Puck, Ariel, and Caliban interest us.

in the works of their predecessors, as one great cause of the deterioration of art. 'Raphael and Michael Angelo,' he said, 'would be greatly astonished could they rise from their graves, at the theories on which it has been supposed their works were formed; as, for instance, that the charms of colour, or chiaroscuro, would detract from the intellectual dignity of their inventions.'[1] He has often pointed out to me, even in the imperfect engravings we have from the Sistine Chapel, the admirable conduct of the light and shade; and he told me that Stothard, looking at these things with him, said, 'Michael Angelo always composed for chiaroscuro.' Constable considered that the union of various excellences proposed by the Carracci might not be impossible, but that their failure, where they did fail, was mainly owing to their attention being too much confined to the works of their predecessors. He preferred the advice given by Wilkie when consulted by young artists, '*paint it well*,' to the elaborate recommendations contained in the sonnet of Agostino Carracci.[2] He considered the analogy to hold good in all respects between religion and taste. He told me that one of Sir Joshua Reynolds' discourses had been turned into a sermon, and was found not to require any alteration in the general scope of the arguments.

When the opinions scattered through Constable's letters are compared with those expressed in his lectures, it will not be necessary for me to say that his love of nature did not blind him to the real value of art. I never remember to have stood with him before a fine picture, either ancient or modern, without his directing my attention to some excellence in it which I had not before noticed; and if his intimate acquaintance with nature made him more than usually fastidious in his admiration of pictures, it gave him a relish for the best, of which no mere connoisseur can form the least conception.

[1] Such a theory, it appears to me, may be overturned at once by two remarks of Fuseli: 'The Jeremiah among the Prophets glows with the glow of Titian, but in a breadth unknown to Giorgione and him.' And 'The Eve under the Tree has the bland pearly harmony of Correggio.'

[2] See Fuseli's Second Lecture, ed. R. N. Wornum, London 1848, p. 395.

But the light in which Constable considered works of art was exactly that in which Lord Bacon places the sciences, when he says, 'It is a fatal mistake to suppose that they have gradually arrived at a state of perfection, and then been recorded by some one writer or other; and that as nothing better can afterwards be invented, men need but cultivate and set off what is thus discovered and completed: whereas in reality, this registering of the sciences proceeds only from the assurance of a few, and the sloth and ignorance of many.'—And again, 'As water ascends no higher than the level of the first spring, so knowledge derived from Aristotle will at most rise no higher again than the knowledge of Aristotle. And therefore, though a scholar must have faith in his master, yet a man well instructed must judge for himself; for learners owe to their masters only a temporary belief, and a suspension of their own judgment till they are fully instructed, and not an absolute resignation, or perpetual captivity. Let great authors, therefore, have their due; but so as not to defraud time, which is the author of authors, and the parent of truth.'

Need I mention how very little Constable cared for the usual classifications of art? he judged as all who have taste, and who give their taste fair play, judge of pictures, by their intrinsic merit alone. *Good art* was with him *high art*, however humble the subject; and mediocre art, let the attempt be ever so sublime, was in his estimation *low art*.[1]

In the summer of 1840, I accompanied Mr. Purton on an excursion to Suffolk. We were received at Flatford with the greatest hospitality by Mr. Abram Constable and his sisters, and were accommodated with facilities for exploring what to us was classic ground, in which we had the advantage of

[1] All men of genius have something in common, however dissimilar their productions, but genius and mediocrity have nothing in common; Raphael and Ostade *may* be classed together, but never Raphael and Carlo Maratti. Since this note was first printed, I have met with the following passage in Cunningham's *Life of Wilkie*. Speaking of Raphael and M. Angelo, Wilkie says, 'They have that without which the Venus and Apollo would lose their value, and with which the forms of Ostade and Rembrandt become instructive and sublime; namely expression and sentiment.'

being accompanied by Constable's eldest son, and his nephew, the Rev. Daniel Whalley.

We visited the house in which Constable was born.—It was a large and handsome mansion, at that time untenanted, and has since been pulled down. A view of the back of it forms the frontispiece to the *English Landscape*, with these lines inscribed under it,

'Hic locus ætatis nostræ primordia novit
Annos felices lætitiæque dies:
Hic locus ingenuis pueriles imbuit annos
Artibus et nostræ laudis origo fuit.'

Of which, in one of his sketch books, is the following translation by Mr. Fisher.

'This spot saw the day-spring of my life,
Hours of Joy and years of Happiness;
This place first tinged my boyish fancy with a love of the Art,
This place was the origin of my Fame.'

We found that the scenery of eight or ten of our late friend's most important subjects might be enclosed by a circle of a few hundred yards at Flatford, very near Bergholt; within this space are the lock, which forms the subject of several pictures—Willy Lott's House—the little raised wooden bridge and the picturesque cottage near it, seen in the picture engraved for Messrs. Finden's[1] work, and introduced into others—and the meadow in which the picture of 'Boat-building' was entirely painted. So startling was the resemblance of some of these scenes to the pictures of them, which we knew so well, that we could hardly believe we were for the first time standing on the ground from which they were painted. Of others, we found that Constable had rather combined and varied the materials, than given exact views. In the larger compositions, such as 'The White Horse' and 'The Hay Wain', both from this neighbourhood, he has increased the width of the river to great advantage; and wherever there was

[1] Finden's *Royal Gallery of British Art*, 1845. The painting engraved was the 'View on the Stour' (R.A. 1822).

an opportunity, he was fond of introducing the tower of Dedham Church, which is seen from many points near Flatford. At Stratford we missed the picturesque little water-mill, with which the picture given by Fisher to Mr. Tinney had made us aquainted, in place of which now stands a large brick building. We visited Stoke; and at Neyland, which adjoins it, we saw the altar-piece of the Saviour blessing the elements; we saw, likewise, the altar-piece at Brantham; and visited Langham, where all is so much changed excepting the church, that we could scarcely recognise it as the scene of the 'Glebe Farm'. The appearance of Dedham mill is greatly improved in every picture Constable painted of it, by his showing the waterwheel, which in reality is hidden.

In the education of an artist, it is scarcely possible to foresee what circumstances will prove advantageous, or the reverse; it is on looking back only that we can judge of these things. Travelling is now the order of the day, and it may sometimes prove beneficial,—but to Constable's art there can be little doubt that the confinement of his studies within the narrowest bounds in which, perhaps, the studies of an artist ever were confined, was in the highest degree favourable; for a know-ledge of atmospheric effects will be best attained by a constant study of the same objects under every change of the seasons, and of the times of day. His ambition, it will be borne in mind, was not to paint many things imperfectly, but to paint a few things well.

The impression made on the minds of Mr. Purton and myself by these beautiful scenes was, that Constable being born among them, and being born a painter, was almost of necessity born a landscape painter. As we were leaving them, my companion made some remarks which seemed to me so just and so happily expressed, that I begged he would give them to me on paper, and his kind compliance with my request enables me to add them to this brief account of our excursion.

"In looking," says Mr. Purton, "at such faithful transcripts of nature as are exhibited in the landscapes of Constable, it

would be difficult to point out any one quality or excellence which pre-eminently distinguishes them; and perhaps it will be found that this oneness or individuality constitutes their principal charm: one pervading animus, one singleness of intention runs through the whole; and this, it may be observed, has been pronounced on the best authority the *sine quâ non* in poetical composition:

'Denique sit quidvis simplex duntaxat et unum.'[1]

Whether he portray the solemn burst of the approaching tempest—the breezy freshness of morning—or the deep stillness of a summer noon—every object represented, from the grandest masses to the smallest plant or spray, seem instinct with, as it were, and breathing the very spirit of the scene. His figures, too, seem naturally called forth by, and form part of, the landscape: we never ask whether they are well placed, there they are, and unless they choose to move on, there they must remain. His quiet lanes and covert nooks never serve to introduce a romantic or sentimental episode to divide, not heighten the interest; all is made subservient to the one object in view, the embodying a pure apprehension of natural effect. Hence it is that the true lover of nature admires not at sight the beauty of the lines, or the truth of colouring displayed in his works; his first impulse is, as with Fuseli, to call for his umbrella, or with Bannister, he feels the breeze blowing on his face.[2] I do not presume to point out what high qualities of art he must have attained, or what difficulties overcome, before he could have effected so deep a feeling of the natural; but I imagine that the highest attainments of art, even all his patient study had been vain, had they not been engrafted on

[1] 'In a word, it may be what you will, only let it be simple (or rather single) and one.'—HORACE *on the Art of Poetry.*

[2] The reader will remember Mrs. Fisher's remark on the arrival of the 'White Horse' at Salisbury, that she carried her eye from the picture to the garden, and observed 'the same sort of look in both'; and Lady Morley's exclamation on seeing the view of 'Englefield House', 'How fresh, how dewy, how exhilarating!' It was for those who feel and judge in this way Constable painted; but connoisseurs, and even artists, are not always such judges.

the purest and warmest admiration and affection for the scenes and effects which he represented."

An extremely interesting portion of Constable's works is known only to his intimate friends,—I mean the contents of his numerous sketch books.[1] In these are many complete landscapes in miniature, often coloured, and when not tinted the chiaroscuro is generally given in lead pencil, sometimes with great depth of effect, and always with exquisite taste.— The name of nearly every spot sketched is added, and in looking through these books one thing is striking, which may be equally noticed of his pictures, that the subjects of his works form a history of his affections.—Bergholt and its neighbourhood—Salisbury—Osmington—Hampstead—Gillingham—Brighton—Folkstone (where his boys were at school)—and scenes in Berkshire visited by him with Mr. Fisher. With the exception of his excursion in Derbyshire, and afterwards to the English Lakes, he never travelled expressly for subjects. Chiaroscuro, as I have said, was an all-important thing in his estimation. Many artists see it nowhere, but Constable saw it everywhere, and in all its beauty. Why then should he go in quest of subjects, when the spots endeared to him from his infancy, or from the associations of friendship, had not only in general great attractions of their own, but where they had least of beauty could be elevated by this power to sublimity?

*[1] Three complete sketch-books (belonging to 1813, 1814 and 1835) are in the Victoria and Albert Museum (Nos. 317–1888, 1259–1888 and 316–1888); many of the individual drawings by Constable in the same Museum appear to have come from sketch-books. There are in the Louvre four sketch-books by Constable (three of them c. 1806, the fourth c. 1820).

XIII. STUDIES OF CATTLE.
Pencil, 1813. Victoria & Albert Museum

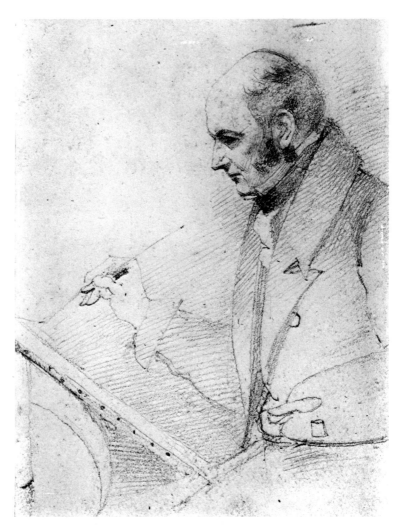

XIV. DANIEL MACLISE: CONSTABLE LATE IN LIFE.
Pencil. National Portrait Gallery, London

Notes of Six Lectures, delivered by Constable, on Landscape Painting.

THE lectures Constable delivered at the Hampstead Assembly
Rooms, at the Royal Institution in Albemarle Street, and at
Worcester, were never written. He had prepared some brief
notes only, but he depended more on a collection of copies
and engravings from the pictures to which he had occasion to
allude, with large placards containing the names of the princi-
pal painters who had contributed to the advancement of land-
scape painting, chronologically arranged. These sufficiently
served to refresh a memory well stored with information on
the subject of his lectures.—Many of his friends urged him
after the delivery of the first discourse to write it, and he
probably intended to amplify the following abstract which was
found among his papers, and which, he says, 'is little more
than a recollection of a discourse delivered at the Hampstead
Assembly Rooms in June 1833.'

"In offering a few observations on the history of landscape
painting to the members of the Literary and Scientific Society
of Hampstead, it will be necessary, before I proceed, to
exonerate the gentlemen forming its committee from blame
for the appointment to this talk of one so inefficient, at least as
a speaker; and perhaps I cannot better excuse their choice, nor
illustrate the position in which both the committee and my-
self are placed, than by the following words of Lord Bacon.

" 'He who questioneth much will learn much; and will
content much; but especially if he apply his questions to the
skill of those whom he asketh; for he shall give them occasion
to please themselves in speaking.'—And again: 'There is
small doubt but that men can write best and most *really* and
sincerely on their own professions; only there is one vice which
accompanies them that write on their own professions, that
they magnify them in excess; but generally it were to be

wished, as that which would make learning indeed solid and fruitful, that active men would or could become writers.' "

"In tracing the history of landscape, although my limits necessarily permit me to give but an outline, I shall endeavour to render it clear, useful, and interesting, by pointing out the *epochs* which mark the development, progress, and perfection of this department of art,—a department than which there is none more efficient, impressive, or delightful,—none that has more completely succeeded in the attainment of its object.— My endeavour shall be to separate it from the mass of historical art in which it originated, and with which it was long connected. Considering, as I do, that landscape has hitherto escaped a distinction to which it is entitled, I propose to trace it to its source, to follow its progress to its final success, to show how by degrees it assumed form until at last it became a distinct and separate class of painting, standing alone, when, from being the humble assistant, it became the powerful auxiliary to that art which gave it birth, greatly enriching the dignity of history.

"If we are to form any opinion of the state of landscape painting among the ancients from the specimens displayed on the walls of Herculaneum, the Baths of Diocletian, and in other places of more recent discovery, it would appear that, although they practised it with much grace and elegance, they merely seemed to consider it as forming a part of their arabesques. Trees, like candelabra, formally spread on a plain blue sky, for instance;—but we have no specimen in their landscape in which we can trace any attempt at chiaroscuro, without which it can never be rendered impressive. Yet if we are to believe Pliny and other ancient writers, chiaroscuro as well as colour was thoroughly understood and practised by the great historical painters.

"All was, however, lost in the general wreck of Europe; and it is hardly to be expected that in the early time of the middle ages anything of so refined a character should reappear. The Bayeux tapestry, which is indeed little better than a Mexican performance, scarcely hints at it. The illuminated

manuscripts and missals, when they represent the agony of Christ, indicate the garden only by a flower, or a flower pot, the rest of the field of the picture being dark. But when historical painting was attempted on a larger scale, and the Passion, the Crucifixion, and the Entombment of our Saviour afforded its most important subjects, landscape, and even some of its phenomena, became indispensable. The cross must be fixed in the ground,—there must be a sky,—the shades of night must envelop the garden (the scene of the agony),—and a more awful darkness the Crucifixion;—while rocks and trees naturally made a part of the accompaniments of the sepulchre. Here, then, however rude and imperfect, we are to look for the origin of landscape. It was first used as an assistant in conveying sentiment, and being found completely successful, was cultivated by succeeding painters, until at length it became a distinct branch of art.

"Pictures are books; and they were especially so considered in the earliest ages of painting in Europe, when so few even of the highest classes could either read or write. The great importance of painting, therefore, as a means of instruction, will account for the whole history of our Saviour being painted on one panel. The artists, very justly, considered themselves engaged in works of piety, and they employed all their powers to tell their stories with the greatest perspicuity. In the first simple ages of painting there was no display of the technicalities of art; they were indeed unknown. The holy truths of Christianity were told with sincerity, in pictures filled with natural expression and purity of sentiment. The works of Cimabue, Giotto, etc., were carried in procession to the churches, there to remain, to enlighten the ignorant, and to add to the fervours of the devout.

"It was fortunate, therefore, for landscape, destined as it was to become so material a feature of the art, that it originated and was in its infancy nursed in the hands of men who were masters of pathos. As early, I believe, as Cimabue, and certainly Giotto, landscape became impressive. I am told that in the Campo Santo at Pisa the frescoes exhibit wonderful

proofs of its use and power. The names of Ghirlandaio, Barnardo, and Paolo Uccello (the first master of perspective), follow. By these artists architecture, vistas, and other materials, were added with great intelligence; so much so as to cause us not to be surprised at the future advance of landscape, as an accompaniment, in the hands of Raphael. In his early pictures, generally holy families, and many of which may be seen in England, it is most beautifully and appropriately introduced; the single leaves of plants, flowers, and that religious emblem the trefoil, in his foregrounds are very elegantly detailed; and the soothing solitudes of his middle distances find a corresponding serenity in the features of the benign and lovely subjects of these works. In the first of the grand series of frescoes with which he adorned the chambers of the Vatican, he has placed the Eucharist on the table in the open air. The low horizon just permits the tops of trees, spires, and gently rising hills to be seen over the altar, and the serenity imparted to the picture by an exceedingly elegant landscape, aids the religious feeling which reigns over the whole. In many of his smaller subjects in the Loggie of the Vatican, the landscape backgrounds are of extreme beauty, and of great importance; and the lovely pastoral scenery of that noble cartoon, the 'Charge to Peter',[1] is probably familiar to all my auditors.

"Thus was landscape cradled in the lap of history, at a time when its grandeur, simplicity, and powers of expression were carried to their greatest perfection by the schools of Italy; and it thus early gained a strength and dignity which has never since wholly forsaken it.

"Although I shall have occasion to notice its obligations at a later period to the German, Dutch, and Flemish colour[2] and delicacy of finish, it may be worth while to advert to what would probably have been the result, had its cultivation at the

[1] One of the seven Raphael Cartoons, on loan to the Victoria and Albert Museum from the Royal Collection.

[2] The exquisite colour of the early Flemish art as seen in the works of Van Eyck, Hemmelinck, etc., is not more surprising than the state of perfect preservation in which the tints of their pictures, some of which are more than four hundred years old, still remain.

time at which we have arrived been carried on by the German and Dutch painters only. In their hands dignity of subject never excluded meanness, and the wretched material introduced into their historical pictures could have led to nothing, or worse than nothing, impressive. The accompaniments even of the Nativity were often, with them, an assemblage of the mean and ridiculous. An owl, seen through a hole in a thatched roof, sitting on a beam just over the head of the Virgin, with a mouse dangling by its tail from his claw; pigs quarrelling at the trough, etc. But Albert Durer and Lucas Van Leyden though they have been guilty of these things, have occasionally rendered a very different account of landscape. The background to the figure of 'Fortune' is a grand exception, as well as those to the 'Prodigal Son' and the 'Armed Knight', and indeed in all Albert Durer's landscape, notwithstanding the objections I have mentioned, there is much that is striking.

"It was, however, at Venice, the *heart* of colour, and where the true art of imitation was first understood, that landscape assumed a rank and decision of character that spread future excellence through all the schools of Europe. Giorgione and Titian, both historical painters, were early disciplined in the schools of the brothers Bellini, where they were taught to imitate nature in what has been termed a servile manner. But it appears to have been the true way of proceeding if we may judge from the result; for afterwards, when those great painters had attained the plenitude of their powers, they never lost their respect for nature, nor for a moment wandered from the materials which were about them, and which they had been taught to copy so admirably, into the vacant fields of idealism. In the Venetian school, landscape formed a very important study, and whether separate or united with history, it was here carried to a degree of perfection it had never before attained.

"In the year 1520,[1] Titian, then in his fortieth year, produced his celebrated picture of the martyrdom of the Dominican Peter, the background of which, although not the model,

[1] Titian's 'St. Peter Martyr' was not painted until after 1525 (cf. p. 258 *n*. 3): it is known to have been completed by 1530.

may be considered as the foundation of all the styles of land-
scape in every school of Europe in the following century. In
this admirable union of history and landscape, the scene is on
the skirts of a forest, and the time verging towards the close
of day, as we may judge from the level and placid movement
of the clouds on the deep blue sky, seen under the pendent
foliage of the trees which overhang the road. The choice of a
low horizon greatly aids the grandeur of the composition;
and magnificent as the larger objects and masses of the picture
are, the minute plants in the foreground are finished with an
exquisite but not obtrusive touch, and even a bird's nest with
its callow brood may be discovered among the branches of
one of the trees. Amid this scene of amenity and repose, we
are startled by the rush of an assassin on two helpless travellers,
monks, one of whom is struck down, and the other wounded
and flying in the utmost terror. At the top of the picture,
through the loftiest branches of the trees, a bright and super-
natural light strikes down on the dying man, who sees in the
glory a vision of angels bearing the emblems of martyrdom;
and illuminating in its descent the stems and foliage, contrasts
with the shadowy gloom of the wood.—The elder bush, with
its pale funereal flowers, introduced over the head of the
saint, and the village spire in the distance, the object of his
journey, increase the interest and add to the richness of the
composition. Admirable also is the contrivance of the tight-
drawn drapery, part of the garment of the martyr, which,
pressed by the foot of the assassin, pins his victim to the
earth.—The noble conception of this great work is equalled,
I am told, by its breadth and its tone, while the extreme
minuteness and variety of its details no way impair the unity
of its impression.

"However justly the historic art of the Bolognese school
may be termed 'eclectic', the landscape of the Caracci and
Domenichino cannot be so considered, as each possesses a
character of its own.—The Landscape of Annibal Caracci,
though severe, is grand and poetic, not to meddle with the
ambiguous term *classic*, and is admirably adapted to the fauns

and satyrs, and other mythological beings with which he peopled it, as may be seen in that most felicitous conception of Pan and Apollo[1] in our National Gallery.

"The Bolognese landscape, although founded mainly on the Venetian, is not wholly so. Denis Calvart, born at Antwerp in 1555,[2] died at Bologna in 1619, having come to Italy as a landscape painter, on purpose to perfect himself in the study of the figure. He learned perspective under P. Fontana, studied at Rome, and left it to set up his school at Bologna, in which Albano, Domenichino and Guido became his pupils.

"The landscape of Domenichino is of the highest order; and although it bears the stamp of composition,. yet we recognise the features and hues of nature in every part of it. His pictures in the National Gallery are poetic, but not of so high a character as the Orleans picture called 'le Batelier', now in the possession of Lord Francis Egerton. The subject is pastoral; sheep flocking to a river, over which a romantic bridge discovers through its lofty arch a wide sheet of water falling into a lake. Two elegant ash trees gently overhang a neighbouring steep. The lake expands in the centre of the picture, on which the boatman is seen, and a group of figures recline on the grass on the near bank. The grandeur of the composition, and the urbanity of tone which pervades it, place this picture in the highest class of landscape.

"In the 'St. Jerome' of Domenichino, the landscape is accessory only, yet most important. The subject of the picture is an aged and decrepit man, dying, attended by the ministers of religion. Through columns and a lofty arch are seen some religious buildings, perhaps often the scene of the dying saint's good works, on a gentle eminence, and overshadowed by a single group of trees. The placid aspect of this simple landscape seems like a requiem to soothe the departing spirit: its effect is like that of solemn music heard from an adjoining apartment. On the serene blue sky, hovering cherubs fill and complete the composition. This noble and pathetic picture,

*[1] Now known as 'Bacchus playing to Silenus' (No. 94).
*[2] 1540 is now the accepted date for Calvart's birth.

if not so startling as the 'Peter Martyr', leaves an impression as lasting.—Yet it was rejected by the authorities of the church for which it was painted, until Nicolo Poussin restored it to the world, and in a public harangue (the lecture of a painter) pointed out its beauties. It is mournful to reflect that neither age, worth, nor transcendent talents could screen the virtuous Domenichino from the bad passions of intriguing contemporaries, who blighted, and it is supposed, ultimately destroyed a life they had long embittered.[1]

"Although no distinct landscape is known by the hand of Guido, yet in a history of this particular branch it may not be improper to notice its immense importance as an accessory in his picture of 'Aurora'.[2] It is the finest instance I know of the beauty of natural landscape brought to aid a mythological story, and to be sensible of its value we have only to imagine a plain background in its stead. But though Guido has placed us in the heavens, we are looking towards the earth, where seas and mountain tops are receiving the first beams of the morning sun. The chariot of Apollo is borne on the clouds, attended by the Hours and preceded by Aurora, who scatters

[1] 'Domenichino was so persecuted and overborne by the partisans of Guido that his picture of the 'Communion of St. Jerome' had been torn from its place in the church of San Girolamo della Carità, and thrown into a garret, where it remained forgotten, until the monks, desirous of having a new altar-piece, requested Poussin to paint one for them, and sent him Domenichino's picture as old canvas to paint it upon. He no sooner saw it, than, struck with its extraordinary merit, he carried it to the church for which it had been painted, and gave a public lecture upon it, in which he dared to compare it with the 'Transfiguration', and called these two, with the 'Descent from the Cross', by Daniel de Volterra, the three finest pictures in Rome. As to the accusation that the composition was a theft, from the sketch by the Caracci on the same subject, he showed that the Caracci had never finished their picture, and that as it was altered and improved in every particular, that was no ground for condemnation; for, far from injuring them by his appropriation of their idea, he had shown what a noble use might be made of it, and from it had composed one of the finest pictures in the world. The public had only to be roused by a steady and right-judging criticism; the elegant but weaker attractions of the rival school gave way, and Domenichino thenceforward was placed in his just rank among the great painters of Italy.'—*Life of Nicolo Poussin,* by Maria Graham, afterwards Lady Callcott. —Domenichino was still living when his picture was restored to its place by Poussin. He died in 1641, it is supposed by poison.

[2] One of the frescoes in the Palazzo Rospigliosi, Rome.

flowers; and the landscape, instead of diminishing the illusion, is the chief means of producing it, and is indeed most essential to the story.

"Every walk of landscape—historic—poetic—classic—and pastoral, were familiar to Nicolo Poussin; and so various were his powers, that each class, in his hands, vies with the rest for preference. He was gifted with a peculiarly sound judgment; tranquil, penetrating, and studious of what was true rather than of what was novel and specious. His best performances are perhaps to be found among what may be called his local landscapes, composed often from the scenery near Rome, such as the 'Snake at the Fountain',[1] and that admirable picture in the National Gallery, erroneously called 'Phocian';[2] and if he did not often reach the lofty energy of the Caracci, or the sentiment and romantic grandeur of Domenichino, yet in the poetry of art his 'Polyphemus'[3] remains unequalled, and in the awful sublimity of the conception of his picture of 'Winter', generally known as the 'Deluge',[4] he has surpassed every other painter who has attempted the subject; nor can there be a greater proof of the effective power of landscape than that this portentous event should have been best told by landscape alone, the figures being few and entirely subordinate.

"My present limits do not allow me to dwell on Gaspar Poussin, although a painter of exquisite taste; his style being for the most part compounded from that of his brother-in-law and Claude Lorraine. Perhaps his best works are his storms, of which we have two noble specimens in the national collection; the 'Dido and Æneas'[5] and its companion.

[1] This is probably the 'Landscape with Snake' acquired by the National Gallery in 1948: the National Gallery painting (No. 5763) was in the collection of Sir Watkin Williams-Wynn at the time of Constable's lecture; it may have been the 'Landscape with Figures' which he lent to the B. I. Old Masters Exhibition in 1816, in which case Constable almost certainly saw it there. No other painting by Poussin so closely fits Constable's title.

[2] Now called 'Landscape: a Man washing his Feet at a Fountain' (No. 40).

[3] Formerly in the Hermitage, Leningrad. [4] In the Louvre.

[5] In the National Gallery (No. 95); the other picture must be 'Landscape: Storm' (No. 36), but it is not strictly speaking a companion-picture to 'Dido and Aeneas'.

"It was reserved for Paul Bril, who arrived at Rome about the end of the sixteenth century, bringing with him from Antwerp a style of landscape peculiarly his own, and less severe than that of the Caracci, to exercise an influence on the art which was destined in the seventeenth century to extend through Bril's pupil, Agostino Tassi, to Claude Lorraine, and to lead to that more minute imitation of particular nature which was the practice of the French and German artists of the time. By thus engrafting a certain portion of Flemish art on that of Italy, a more perfect and beautiful transcript of nature was achieved by the inimitable Claude, and conduced to the production of those exquisite works of his pencil which are wholly without rivalry in the quality which distinguishes them of placid brightness. In his seaviews, his golden sunsets, his wild and romantic shores, and his exquisitely poetic pastoral scenes, the luminous beauties of the painter are so clearly developed as to require less explanation than the qualities of many of the works already referred to. He has been deemed the most perfect landscape painter the world ever saw, and he fully merits the distinction. The characteristics of his pictures are always those of serene beauty. Sweetness and amenity reign through every creation of his pencil; but his chief power consisted in uniting splendour with repose, warmth with freshness, and dark with light.—Although he was a painter of fairyland, and sylvan scenery of the most romantic kind, he is nowhere seen to greater advantage than in his seaports, which, while they possess many of the most charming qualities of his more sequestered landscapes, are full of business and bustle.

"The names of Salvator Rosa and Sebastian Bourdon come next in an account of the art in which they so much excelled. The one, wild and terrific in his conceptions of natural scenery formed his mind amid the savage recesses of the Abruzzi, and painted subjects which best accorded with its character. The other, equally romantic, but more visionary, selected as the materials of his pictures solitudes among rocks, waterfalls, and solemn-looking buildings which he peopled with monks and hermits.

"In following the art to Flanders we find the magnificent Rubens, with his numerous followers, Vadder, Fouquieres, Artois, Huysman, Van Uden, etc. In no other branch of the art is Rubens greater than in landscape;—the freshness and dewy light, the joyous and animated character which he has imparted to it, impressing on the level monotonous scenery of Flanders all the richness which belongs to its noblest features. Rubens delighted in phenomena—rainbows upon a stormy sky,—bursts of sunshine,—moonlight,—meteors,— and impetuous torrents mingling their sound with wind and wave. Among his finest works are a pair of landscapes,[1] which came to England from Genoa, one of which is now in the National Gallery.

"In Holland, Rembrandt's 'Mill'[2] is of itself sufficient to form an epoch in the art. This is the first picture in which a sentiment has been expressed by chiaroscuro only, all details being excluded.—Nor must the names of Ruysdael and Cuyp be overlooked as distinguished from numerous other painters by traits peculiarly their own.

"On the death of these great men Landscape rapidly declined; and during almost the whole of the succeeding century, little was produced beyond mannered and feeble imitations of their art,—the painters of this period adding nothing to the general stock, as their predecessors had done by original study, but referring always to the pictures of their masters instead of looking to the aspects of nature which had given birth to those pictures. From this degraded and fallen state it is delightful to say that landscape painting revived in our own country, in all its purity, simplicity, and grandeur, in the works of Wilson, Gainsborough, Cozens, and Girtin.

"It is a striking feature in the history of all the arts and sciences, though it has not perhaps been noticed in ours, that the great names by which they have each been supported are about equal in number in any given space of time. The names

★[1] These are 'The Château de Steen' (National Gallery No. 66) and 'The Rainbow Landscape' (Wallace Collection No. 63).
★[2] In the National Gallery of Art Washington.

of the painters I have mentioned and which have become points marking the epochs of landscape, correspond numerically with those of the eminent men who have materially enlarged the boundaries of each of the other departments in art, literature, and science. It will not be easy to add to those I have enumerated, as forming the fixed stars in the hemisphere of art, and although others of great talent crowd in, 'Thick as autumnal leaves', to fill the interstices, yet they all emanate from, or converge into those which form the great points, and my limits do not permit an account of them here. Should, however, at any future time my humble services be employed in any further inquiry of this kind, they must in justice be brought forward, as each brings in his hand a flower snatched by himself from the lap of nature.

"I shall conclude with a brief allusion to a certain set of painters who, having substituted falsehood for truth, and formed a style mean and mechanical, are termed mannerists. Much of the confusion of opinions in art arising from false taste is caused by works of this stamp, for *if the mannerists had never existed, painting would always have been easily understood.* The education of a professed connoisseur, being chiefly formed in the picture gallery and auction room, seldom enables him to perceive the vast difference between the mannerist and the genuine painter. To do this requires long and close study, and a constant comparison of the art with nature. So few among the buyers and sellers of pictures possess any knowledge so derived, that the works of the mannerists often bear as large a price in the market as those of the genuine painters. The difference is not understood by picture dealers, and thus, in a mercantile way, has a kind of art been propagated and supported from age to age, deserving only to be classed with the showy and expensive articles of drawing-room furniture. To this species of painting belong the works that have marked the decay of styles and filled the intervals between the appearances of the great artists. They are the productions of men who have lost sight of nature, and strayed into the vacant fields of idealism; sometimes, indeed, with talent, and even with

power, as in Wouvermans,[1] Berghem, Both, Vernet, Zuccherelli, and Loutherbourg; but oftener with feebleness and imbecility, as in Jacob Moore, Hackert, etc."

Previously to the delivery of Constable's lectures in London, the following card was printed:

"ROYAL INSTITUTION OF GREAT BRITAIN.

ALBEMARLE STREET, 23RD APRIL, 1836.

SYLLABUS

OF

A COURSE OF LECTURES,

ON

THE HISTORY OF LANDSCAPE PAINTING,

BY

JOHN CONSTABLE, ESQ., R.A.

TO BE DELIVERED ON THURSDAY, MAY 26TH, AND THE THREE FOLLOWING THURSDAYS AT THREE O'CLOCK.

"Lecture 1st, May 26th. The Origin of Landscape—Coeval in Italy and Germany in its rise and early progress—Farther advanced in Germany in the Fifteenth Century—Albert Durer—Influence of his Works in Italy—Titian impressed by them; in *his* hands Landscape assumed its real dignity and grandeur, and entitled him to the appellation of the *Father of Landscape*—The 'St. Peter Martyr'.

[1] The great merit of Wouvermans only makes it the more important that the wide departure from nature in his highly-wrought works should be pointed out. No perfection of execution can atone for inky foregrounds, slaty trees and distances, and leaden skies; but it may well be doubted whether that execution should be called perfect which reduces every object to a Lilliputian scale. They are exactly such painters as Wouvermans, so near excellence in the minutiæ of a picture, and at the same time so false in the whole together, of whom Constable has well said, 'had they never existed, painting would always have been easily understood.'

There is a class of the Dutch painters of familiar life, men of much talent, ingenuity, and patience, at the head of which Gerard Dow may be placed, whose works call forth the wonder of ignorance rather than the admiration of taste, though from their scarcity they often command higher prices than the pictures of Jan Steen, Ostade, Terburgh, Metzu, De Hooghe, and Nicholas Maas, the great masters of familiar life of the Dutch School, and in some of whose best works is perhaps to be found the most perfect art the world ever saw.

"Lecture 2nd, June 2nd. Establishment of Landscape—The Bolognese School. By this School Landscape was first made a separate Class of Art—The Sixteenth and Seventeenth Centuries—The Caracci—Domenichino—Albano—Mola—Landscape soon after perfected in Rome—The Poussins—Claude Lorraine—Bourdon—Salvator Rosa—The 'Bambocciate'—Peter de Laar—Both—Berghem—The Deterioration of Landscape—Its Decline in the Eighteenth Century.

"Lecture 3rd, June 9th. Landscape of the Dutch and Flemish Schools—Emanates from the School of Albert Durer, forming distinct branches—Rubens—Rembrandt—Ruysdael—Cuyp—The marks which characterise the two Schools—Their decline, also in the Eighteenth Century.

"Lecture 4th, June 16th. The decline and revival of Art. Imitation of preceding excellence opposed to original study, the main cause of the decline—The Restoration of Painting takes place in England—Hogarth—Reynolds—Wilson—Gainsborough—West—When Landscape at length resumes its birthright, and appears with new powers."

May 26th

"I AM here on the behalf of my own profession, and I trust it is with no intrusive spirit that I now stand before you; but I am anxious that the world should be inclined to look to painters for information on painting. I hope to show that ours is a regularly taught profession; that it is *scientific* as well as *poetic*; that imagination alone never did, and never can, produce works that are to stand by a comparison with *realities*; and to show, by tracing the connecting links in the history of landscape painting, that no great painter was ever self-taught.

"The art of painting may be divided into two main branches, history and landscape; history including portrait and familiar life, as landscape does flower and fruit painting.

"Landscape is the child of history, and though at first inseparable from the parent, yet in time it went alone, and at a later period (to continue the figure), when history showed signs of decrepitude, the child may be seen supporting the parent, as in the works of Pietro da Cortona. Although it was in the school of the Caracci landscape first stood quite alone, yet as early as the year 1546 there were distinct landscape painters in Germany." Constable showed an enlarged drawing from an engraving of a landscape by Albert Durer, in which a cannon, placed on an eminence overlooking an extensive country, forms a foreground object. He pointed out the grandeur of this work, and said, "There can be no doubt but that Titian had received early and deep impressions from the works of Albert Durer and other Germans."

"The writers on art employ the word *School* to denote a similarity of feeling and practice in many individuals arising from the example of one powerful mind, yet by no means implying a want of originality in the rest. The greatest masters were largely indebted to their predecessors. Each sprang from, and in turn founded, a school; but in the complicated art of painting so many avenues to excellence are open,

that every painter, in every school, whose fame has outlived his age, is distinguished from all the rest by some perfection which is to be found with himself only."

Near the commencement of this lecture, Constable exhibited a drawing from a very grand and simple composition by Paolo Uccello, of Noah and his family kneeling round an altar, while the birds and beasts are leaving the ark, the whole arched by the rainbow.[1] "Uccello was either the inventor or the perfector of parallel perspective, and this new art is beautifully shown in the flight of the birds. Titian's Cornaro family[2] somewhat resembles this picture."

In speaking of the 'Peter Martyr' of Titian, he said, "The monk, afterwards canonised as St. Peter, was a general of the Dominicans and an inquisitor. In the zeal displayed by him in the last of these offices he had given great offence to a powerful family, who employed an assassin to waylay and murder him. In the representation of this subject Titian has brought together a rich assemblage of picturesque objects producing a felicitous combination of the two most important walks of art,—history and landscape; and contrasting them so as to enhance the sentiment of each. We see a deed of horror perpetrated with the utmost energy of action, in a scene, hitherto one of stillness and repose." Constable then spoke of the probable manner in which Titian proceeded with the composition of the picture, and whether in every respect he guessed rightly or not, he accomplished his principal object, which was to show that the greatest works of genius are not thrown off as if by inspiration, but on the contrary, are the result of patient labour, and often undergo many changes of plan during their progress. He showed an old print bearing the name of Titian, in which the saint is looking down and writing with his finger on the ground the word *credo*, while the assassin who holds him by his drapery is about to strike a death blow with his sword. "This", he said, "was

[1] One of the frescoes in the Chiostro Verde, Santa Maria Novella, Florence.

[2] 'The Vendramin Family' (previously called 'The Cornaro Family') in the National Gallery (No. 4452).

possibly a mode in which it was suggested by the monks that
the subject should be treated, and the engraving may have been
made from a first design. But Titian could not rest contented
with the unnatural incident of a man writing while in the
grasp of an assassin, and he therefore turned the face of the
victim towards the murderer, and afterwards still more so,
with an expression of great horror." Constable here showed a
copy of an original sketch by Titian (one of the Lawrence
collection), in which the saint has the outlines of three heads
drawn one over the other, the first looking down, the others
more and more turned up, and said,—"still this made the
subject nothing more than a common murder by the roadside,
and it wanted the dignity of a martyrdom. The composition
was then heightened, the vision of angels introduced, and the
head of the saint again altered, so as to look up to the glory
that now beamed down on him." Several sketches supposed
to be by Titian seemed to confirm these conjectures, and by
these it also appeared that the tall tree on the right of the pic-
ture, with small round leaves, was an after-thought, and made
necessary by the additional height given to the picture ; it is
not in the sketch of the landscape alone. " It is striking," said
Constable, " to observe with what consummate skill the
painter, like a great musician, has varied his touch and
execution from slow movements to those of extreme rapidity.
Thus the quick and vivid sparks of light near and upon the
assassin's arm, hand, and sword, give inconceivable energy to
his action, and contrast finely with the solemn quiet of the
retiring forest.[1]

"Reynolds has censured Count Algarotti[2] for admiring the
minute discrimination of the leaves and plants in the fore-
ground, but Sir Joshua was swayed by his own practice of
generalising to such a degree that we often find in his fore-

[1] The murderer has the shirt sleeve stripped from his right arm, as in the old
pictures of decapitations by the sword the right arm of the executioner is
bared. This circumstance which makes the figure more picturesque, aids the
story by showing that the crime was premeditated. In the earlier design of the
subject, the assassin is entirely dressed.

*[2] Reynolds, 11th *Discourse*, ed. by Roger Fry, London 1905, p. 307.

grounds rich masses of colour, of light and of shade, which, when examined, mean nothing. In Titian there is equal breadth, equal subordination of the parts to the whole, but the spectator finds, on approaching the picture, that every touch is the representative of a reality; and as this carries on the illusion, it cannot surely detract from the merit of the work.

"Mr. West said of the 'Peter Martyr' that '*it had required three hundred years to produce such a work;*' and this will be found to be about the time from the revival of the art in the middle ages to that in which it was painted.

"Titian was by no means high in reputation when he produced this great work, and so inadequate was the remuneration he received for it, and for many others that had preceded it, that he was in a condition little removed from indigence. Albert Durer, who at that time visited Venice, does not mention him in speaking of the most eminent painters there; it was not, indeed, until through the praises bestowed on his works by his friend Pietro Aretino, the poet, he was called to Bologna to paint the portrait of Charles V in 1530, that he became the great idol of popularity in Italy, and indeed, of Europe."[1]

[1] In a note to Mr. Purton, dated May 28th, 1836, Constable says, 'How did I get on? Faraday said it pleased him; Sir Martin and Howard liked it; Phillips did not like my unbigoted mention of Sir Joshua's observation on Algarotti, and said I was wrong: I knew I was quite right. I trust you will follow me through my sermons, and help me in putting them together afterwards. I hope to murder Both and Berghem on Thursday next at a quarter to four o'clock. The rest that come after are not worth murdering."

June 2nd

CONSTABLE began this lecture with the Caracci, in whose school landscape first became *permanently* a distinct branch of the art, and recapitulated what he had said at Hampstead of Domenichino. He characterised also the art of Albano and Mola, but of this part of his discourse I have no notes.

He spoke of Claude Lorraine as "a painter whose works had given unalloyed pleasure for two centuries. In Claude's landscape all is lovely—all amiable—all is amenity and repose; —the calm sunshine of the heart. He carried landscape, indeed, to perfection, that is, *human perfection*. No doubt the greatest masters considered their best efforts but as experiments, and perhaps as experiments that had failed when compared with their hopes, their wishes, and with what they saw in nature. When we speak of the perfection of art, we must recollect what the materials are with which a painter contends with nature. For the light of the sun he has but patent yellow and white lead,—for the darkest shade, umber or soot.

"Brightness was the characteristic excellence of Claude; brightness, independent on colour, for what colour is there here?" (holding up a glass of water.)

"The 'St. Ursula',[1] in the National Gallery, is probably the finest picture of *middle tint* in the world. The sun is rising through a thin mist, which, like the effect of a gauze blind in a room, diffuses the light equally. There are no large dark masses. The darks are in the local colours of the foreground figures, and in small spots; yet as a whole, it is perfect in breadth. There is no evasion in any part of this admirable work, every object is fairly painted in a firm style of execution, yet in no other picture have I seen the evanescent character of light so well expressed.

"Claude, though one of the most isolated of all painters, was still legitimately connected with the chain of art. Elsheimer

*[1] 'Landscape: Embarkation of St. Ursula' (No. 30).

and Paul Bril opened the way to him, coming after the
Caracci, with a softer and richer style than theirs.—Could the
histories of all the fine arts be compared, we should find in
them many striking analogies. Corelli was to Handel what
Elsheimer and Paul Bril were to Claude. Claude (as he is)
could not have existed without them. He was, therefore, not
a *self-taught artist*, nor did there ever exist a great artist who
was so. A *self-taught artist* is one taught by a very ignorant
person.

"Claude neglected no mode of study that was calculated
to extend his knowledge, and perfect his practice. His evenings
were passed at the Academy, and his days in the fields; and
though it is the fashion to find fault with his figures indis-
criminately, yet in his best time they are so far from being
objectionable, that we cannot easily imagine anything else
according so well with his scenes;—as objects of colour, they
seem indispensable. Wilson said to a friend who was talking
of them in the usual manner, 'Do not fall into the common
mistake of objecting to Claude's figures.'—In the little picture
of 'Cephalus and Procris',[1] the expression of the former is very
touching; and, indeed, nothing can be finer than the way in
which Claude has told that affecting story throughout.
Procris has come from her concealment to die at the feet of
her husband. Above her is a withered tree clasped by ivy, an
emblem of love in death,—while a stag seen on the outline of
a hill, over which the rising sun spreads his rays, explains the
cause of the fatal mistake. Claude's own figures always accord
better with his scenes than those sometimes introduced for
him by other artists. Painting does not readily admit of
partnership.

"But of Claude it may be proper to remark that his style
and mode of execution, and even of thinking, varied much
at different periods of life. Of his very early manner we know
little; in middle age he appeared in the most perfect state, and
from which he fast declined, so much so that the dates of his
pictures (which can for the most part be ascertained) will

[1] 'Landscape: Death of Procris', in the National Gallery (No. 55).

serve as a criterion of their merit. Between the ages of forty and sixty he produced most of those works in which are seen his peculiar attribute, *brightness*, in its greatest perfection. Some of his best pictures are in the National Gallery—the 'Narcissus',[1] painted at forty-four, the 'Hagar' at forty-six, and the 'St. Ursula',[2] under sixty. Those of his latter time are cold, heavy, and dark, though stately,—for he seemed as if trying to make up by grandeur of subject and conception for the loss of that excellence which, in the decline of life, and in the absence of his former habits of incessant observation of nature, was now departing from him. It is in these last pictures that his figures are defective in their proportions; and though it must be admitted that some of his most important works (as the 'Doria' and the 'Altieri'[3]) were painted in his old age, still with all their grandeur, they are in his black, his cold, or his green manner. There are undoubted productions of his pencil, however, so destitute of his distinguishing excellence, that it may be said purchasers are not always buying *a Claude* when they are buying a picture painted by him.[4]

"The landscapes of Sebastian Bourdon are all poetry; visionary, romantic, abstracted. Sir George Beaumont said of this imaginative painter that 'he was *the prince of the dreamers, yet not without nature.*' "—Constable showed a drawing of some pine trees from nature, of peculiarly wild and eccentric forms, and compared them with trees extremely like them in an engraving after Bourdon, to prove that the latter were not imaginary.—He spoke of 'The Return of the Ark [5] in the National Gallery as a very fine specimen of the style of this painter.

"The circumstances attending the life and education of

[1] Dated 1644.

[2] Infra-red light has since revealed that this painting is dated 1641.

[3] The 'Altieri Claudes' are dated 1668 and 1675.

[4] The story so often repeated of Claude's apprenticeship to a pastry-cook rests on no foundation whatever. The best account of the little known of his early life is given by Mr. Smith, in his *Catalogue Raisonné* of the works of the Dutch, Flemish, and French painters.

[5] No. 64.

Salvator Rosa were peculiar, and show how his character and that of his art were formed, or rather *confirmed*. He was first placed with Francesco Francanzani, and he then became one of the *desperate* school of Anniello Falcone, a battle painter, who formed the 'Company of Death' at Naples, in the revolt with Masaniello. He was afterwards for a short time in the school of Spagnoletto[1];—thus he had *savages* for his masters in painting, and he painted *savage* subjects. Salvator Rosa is a great favourite with novel writers, particularly the ladies; and it has lately been attempted to show that he deserved the reputation to which he always aspired, of a great historical painter. But there is a meanness in all his conceptions of history which must ever exclude him from its first ranks, and Fuseli, with true judgment, admits him to be a great genius only in landscape.

"A class of artists now appeared, in all respects the reverse of the last, and whose style Salvator has satirised in one of his sonnets with more justice than when he presumed to censure Michael Angelo.

"Peter de Laar, who travelled from Holland into Italy, and was there surnamed 'Bamboccio', probably from the class of subjects he painted, which were the various sports of the populace and the transactions of vulgar life, gave rise to a school called by the Italians, 'The Bambocciate'. Of this school were Both and Berghem, who, by an incongruous mixture of Dutch and Italian taste, produced a bastard style of landscape, destitute of the real excellence of either. In their works, all the commonplace rules of art are observed; their manipulation is dextrous, and their finish plausible; yet their pictures carry us in imagination only into their painting rooms, not as the pictures of Claude and Poussin do, into the open air. They rarely approach truth of atmosphere. Instead of freshness they give us a clean and stony coldness, and where they aim at warmth they are what painters call *foxy*. Their art is destitute of sentiment or poetic feeling, because it is factitious, though their works being specious, their reputation

[1] i.e. Jusepe Ribera.

is still kept up by the dealers, who continue to sell their pictures for high prices.[1] Landscape was afterwards still farther debased by Vernet, Hakert,[2] Jacob Moor, and the English Wooton, the last of whom, without manual dexterity, left it in unredeemed poverty and coarseness, until Hogarth and Reynolds aroused the minds of our countrymen, and directed them to nature by their own splendid examples; then, with Wilson and Gainsborough, the high and genuine qualities of landscape appeared in England at a time when they were utterly unknown in any other part of the world.

"The deterioration of art has everywhere proceeded from similar causes, the imitation of preceding styles, with little reference to nature. In Italy, the taste was for the beautiful, but the beautiful in the hands of the mannerists became the insipid, and from that descended to the unmeaning. In Germany a clumsy imitation of Italian art, and particularly of M. Angelo, produced inflation and bombast, as in the works of Goltzius and Sprangher; while in Flanders and Holland, the taste for the picturesque, when colour, chiaroscuro, and execution were gone, left only the coarse and the mean.

"The decline of history was parallel with that of landscape. What is termed the 'French taste' (as opposed to good taste), and which may be characterised as *romantic hyperbole*, began with Lucatelli, a pupil of Pietro da Cortona, who died about 1717.[3] He was an Italian, and practised his art chiefly in Rome; but his style soon spread itself in France, where it destroyed whatever may have remained of the influence of Poussin, Le Sueur, or Sebastian Bourdon. He painted chiefly historical subjects for churches, and was like his master, a compendious painter—a mannerist—a self-worshipper; he preferred forms of his own imagination to those of nature. In his works may be seen the beginning of that prettiness which soon afterwards

[1] After this lecture, one of Constable's auditors, a gentleman possessing a fine collection of pictures, said to him, 'I suppose I had better sell my Berghems,' to which he replied, 'No, sir, that will only continue the mischief, *burn them*.'

[2] Not Hackaert, a Dutch painter, born in 1635, but Hakert, a Prussian, born a century later.

*[3] Lucatelli died in 1710.

in Marco Ricci, Paulo Panini, and Zuccherelli, and Vernet in landscape, displayed itself so offensively. In history, Mengs, Cipriani, Angelica Kauffman, etc., followed this emasculated taste, to the exclusion of all that is found in art.

"But the climax of absurdity to which the art may be carried, when led away from nature by fashion, may be best seen in the works of Boucher. Good temper, suavity, and dissipation characterised the personal habits of this perfect specimen of the French School of the time of Louis XV, or the early part of the last century. His landscape, of which he was evidently fond, is pastoral; and such pastorality! the pastoral of the opera-house. But at this time, it must be remembered, the court were in the habit of dispersing into the country, and duchesses were to be seen performing the parts of shepherd-esses, milkmaids, and dairymaids, in cottages; and also brew-ing, baking, and gardening, and sending the produce to market.[1] These strange anomalies were played off on the canvases of Boucher. His scenery is a bewildered dream of the picturesque. From cottages adorned with festoons of ivy, sparrow pots, etc., are seen issuing opera dancers with mops, brooms, milk pails, and guitars; children with cocked hats, queues, bag wigs, and swords,—and cats, poultry, and pigs. The scenery is diversified with winding streams, broken bridges, and water wheels; hedge stakes dancing minuets—and groves bowing and curtsying to each other; the whole leaving the mind in a state of bewilderment and confusion, from which laughter alone can relieve it.[2]—Boucher told Sir Joshua Reynolds 'that he never painted from the life, for that nature put him out.'

"It is remarkable how nearly, in all things, opposite ex-

[1] Vagaries like these were practised by Madame de Pompadour at the Parc-aux-cerfs to amuse Louis XV, and afterwards by Marie Antoinette at the Petit Trianon to amuse herself.

[2] Watteau reconciles us by his natural grace and expression, and his exquisite colour, to an ideal union of the pastoral and the fashionable, and to which he alone gives an air of probability. The manners he painted were French, but his art is essentially Flemish, being founded on Rubens, whose 'Garden of Love', no doubt, suggested a class of subjects in which Watteau has excelled all other painters. Boucher is Watteau run mad,—bereaved of his taste and his sense.

tremes are allied, and how they succeed each other. The style I have been describing was followed by that which sprung out of the Revolution, when David and his contemporaries exhibited their stern and heartless petrifactions of men and women,—with trees, rocks, tables, and chairs, all equally bound to the ground by a relentless outline, and destitute of chiaroscuro, the soul and medium of art."

Constable spoke of the want of sense in David's large picture, in which the Romans and the Sabines are about to join battle, stark naked, but with helmets on their heads, and shields and spears in their hands. "What," he said, "would be the impression of a spectator of such a scene, but that he saw before him a number of savages who had accidentally found and snatched up these weapons and accoutrements?"

June 9th

"I SHALL consider four works as marking four memorable points in the history of landscape, and all by historical painters. The 'Peter Martyr' by Titian—'The Deluge' by Poussin—'The Rainbow' by Rubens—and 'The Mill' by Rembrandt."

Having spoken of the 'Peter Martyr', Constable showed an engraving of the 'Deluge', and said, "Towards the end of the life of Nicolo Poussin, he was employed by Cardinal Richelieu to paint four pictures, each to represent a season. For the spring, he chose the terrestrial Paradise; for the summer, the story of Boaz and Ruth; for the autumn, the two Israelites bearing the bunch of grapes from the promised land; and for the winter, the deluge. This picture, though small, and with little contrast of light and shadow, and almost no colour, stands as much alone in the world as the 'Magdalen' of Correggio. The good sense of Poussin, which was equal to his genius, taught him that by simplicity of treatment, the most awful subjects may be made far more affecting than by overloading them with imagery. In painting the 'Deluge', he has not allowed his imagination to wander from the Mosaic account, which tells us of rain only.[1] Human habitations, rocks, and mountains are gradually disappearing, as the water rises undisturbed by earthquakes or tornadoes; and the very few figures introduced, interest us the more deeply from the absence of all violence or contortion of gesture. But of this picture Fuseli says truly, 'It is easier to feel than to describe its powers. We see the element itself, and not its image. Its reign is established, and by calm degrees ingulfs the whole. It mocks the food it feeds on. Its lurid haze has shorn the sun of his beams. Hope is shut out, and nature expires!'

[1] Poussin seems to have reasoned as Coleridge did, who said, 'I think it absurd to attribute so much to the deluge. An inundation, which left an olive-tree standing, and bore up the ark peacefully on its bosom, could scarcely have been the sole cause of the rents and dislocations observable on the face of the earth.'—COLERIDGE's *Table Talk.*

"By the Rainbow of Rubens, I do not allude to a particular picture, for Rubens often introduced it; I mean, indeed, more than the rainbow itself, I mean dewy light and freshness, the departing shower, with the exhilaration of the returning sun, effects which Rubens, more than any other painter, has perfected on canvas."—Constable described the large picture in the National Gallery, in which a fowler is seen watching a covey of partridges, as a fine specimen of Rubens' power in landscape, and lamented that it was separated from its companion, "which had doubtless been painted to give more effect to it by contrast." He said, "When pictures painted as companions are separated, the purchaser of one, without being aware of it, is sometimes buying only half a picture. Companion pictures should never be parted, unless they are by different hands, and then, in general the sooner they are divorced the better.

"The art of Rubens and Teniers[1] is essentially Flemish, and though it is usual to speak of the Dutch and Flemish schools as one, they are no more so than are the Lombard and Venetian schools. The Dutch art is more influenced by chiaroscuro, the Flemish by colour, by brightness, and hilarity.

"Rembrandt's 'Mill'[2] is a picture wholly made by chiaroscuro; the last ray of light just gleams on the upper sail of the mill, and all other details are lost in large and simple masses of shade. Chiaroscuro is the great feature that characterises his art, and was carried farther by him than by any other painter, not excepting Correggio. But if its effects are somewhat exaggerated by Rembrandt, he is always so impressive that we can no more find fault with his style than we can with the giant forms of Michael Angelo. Succeeding painters have sometimes in their admiration of the 'Mill', forgotten that Rembrandt chose the twilight to second his wishes, and have fancied that to obtain equal breadth, they must leave out the

[1] It must have been from inadvertence that Constable omitted any further mention of the younger Teniers, whose landscape compositions form a distinct and very beautiful class of art. Had these lectures been written, a paragraph would, no doubt, have been devoted to this delightful painter.

[2] A windmill on an eminence overlooking a stream.

details of nature in broad daylight; this is the danger of mistaken imitation.

"Chiaroscuro is by no means confined to dark pictures; the works of Cuyp, though generally light, are full of it. It may be defined as that power which creates space; we find it everywhere, and at all times in nature; opposition, union, light, shade, reflection, and refraction, all contribute to it.[1]

[1] All effects of light and dark are but modifications of reflection and refraction, with the exception of the appearances of things self-luminous, as fire, the sun, etc., which occasion what we call lights on other objects by being reflected from or refracted through their surfaces; leaving, where such reflections or refractions are interrupted by intervening bodies, the reflections of inferior lights from other objects, which being less powerful appear as shadows.

It has been said that water receives no shadow; but this is either equally true of all other bodies, or not true of water, which is undoubtedly subject to effects that we can no otherwise describe than by the word shadow.—When, for instance, the sun is shining on the sea, were it possible that the water could be as smooth as a mirror, we should see his disc exactly reflected and once only, the surface of the water in other places giving an inverted image of the sky; but as such perfect stillness never occurs, the light of the sun is spread on the surface by innumerable reflections of his disc from the waves and refractions through them,—the spaces between each of these *lights* (as we call them) reflecting the sky,—where again the upper parts of the clouds reflect the sun, and other portions the blue sky, or the sea. The blue of the sky is occasioned by still more minute reflections and refractions of the sun from particles of vapour more subtle than those that compose the clouds, and but for which in place of the azure there would be a void of utter darkness. Where clouds or other objects intercept the reflections of the sun from the waves, the reflection of the sky remains, causing those patches of shadow which, seen from a low point, stripe the sea with long lines of blue.—The effects are exactly similar on a meadow; the light of the sun being reflected from or refracted through every blade of grass, and where intercepted leaving the reflection of the sky; and on a road, the light is spread by reflection from every particle of sand, gravel, or clay.—Again, if we look close at a polished ball of metal we find a picture of every surrounding object, and this at a distance forms that appearance of light and shade that gives it rotundity to the eye. Let the ball be dimmed or roughened and the same general appearance of light and dark is left,—equally, though not so palpably, caused by reflection, the forms and colours of the objects pictured on the ball being more or less blended as its surface is more or less dimmed.

Of what consequence, it may be said, is it that the artist should know this if he copy faithfully what he sees? To which the reply is, that it may enable him to see better what he copies.—All good colourists have, no doubt, recognised the results I have spoken of in nature whether or not they investigated the principle,—and the purity and evanescence of their colouring has been in proportion to their perception of these results. Paul Veronese saw nature thus

By this power, the moment we come into a room, we see that the chairs are not standing on the tables, but a glance shows us the relative distances of all the objects from the eye, though the darkest or the lightest may be the farthest off— It has been said no man has enough of certain qualities that has them not in excess, so Rembrandt, of whose art chiaroscuro is the essence, certainly carried it to an extreme. The other great painters of the Dutch school were more artless; so apparently unstudied, indeed, are the works of many of them, for instance, Jan Steen and De Hooge, that they seem put together almost without thought; yet it would be impossible to alter or leave out the smallest object, or to change any part of their light, shade, or colour, without injury to their pictures,—a proof that their art is consummate.

"The landscapes of Ruysdael present the greatest possible contrast to those of Claude, showing how powerfully, from

with a truer eye than did Rubens, and a perfect sense of the influence of reflections constitutes that extraordinary charm in the works of De Hooge which we scarcely find elsewhere, on canvas, excepting in the best pictures of Claude.—An investigation of these principles will protect the young artist from the danger of many unfounded aphorisms that he is likely to hear from his elders, and meet with in books, as that *shadow is colourless—that lights should be warm and shadows cool, or shadows warm and lights cool,* etc. A knowledge of these laws will explain, what his eye will soon perceive, that the tones both of lights and shades are infinitely varied according to circumstances;—that as perspective alters every line to the eye, so reflection and refraction change more or less every colour,—harmonising the crude and giving variety to the monotonous;—and that shadow, as far as regards painting, can never be colourless, for it is never solely the result of the absence of light excepting in situations with which the painter can have nothing to do, the interior, for instance, of a cave to which every opening is closed.

I am glad to be able, in support of these conclusions, to quote so high an authority as that of my friend Mr. George Field, whose valuable works on the philosophy of colour are known to most artists, and should be to all. In his *Chromatography* Mr. Field says, 'Colour, and what in painting is called transparency, belong principally to shade; and the judgment of great authorities by which they have been attached to light as its properties merely, has led to error in an art to which colour is pre-eminently appropriate; hence the painter has considered colour in his practice as belonging to light only, and hence many have employed a uniform shade tint, regarding shadows only as darkness, blackness, or the mere absence of light, when in truth shadows are infinitely varied by colour.'* George Field, *Chromatography: or a Treatise on Colours and Pigments* . . . London 1835.

the most opposite directions, genius may command our homage. In Claude's pictures, with scarcely an exception, the sun ever shines. Ruysdael, on the contrary, delighted in, and has made delightful to our eyes, those solemn days, peculiar to his country and to ours, when without storm, large rolling clouds scarcely permit a ray of sunlight to break the shades of the forest. By these effects he enveloped the most ordinary scenes of grandeur, and whenever he has attempted marine subjects, he is far beyond Vandervelde."

Constable showed a copy of a picture of this class by Ruysdael. "The subject," he continued, "is the mouth of a Dutch river, without a single feature of grandeur in the scenery; but the stormy sky, the grouping of the vessels, and the breaking of the sea, make the picture one of the most impressive ever painted.

> 'It is the Soul that sees; the outward eyes
> Present the object, but the Mind descries.'

We see nothing truly till we understand it. An ordinary spectator at the mouth of the river which Ruysdael has here painted, would scarcely be conscious of the existence of many of the objects that conduce to the effect of the picture; certainly not of their fitness for pictorial effect.

Constable pointed to a copy of a small evening winter-piece by Ruysdael. "This picture," he said, "represents an approaching thaw. The ground is covered with snow, and the trees are still white; but there are two windmills near the centre; the one has the sails furled, and is turned in the position from which the wind blew when the mill left off work, the other has the canvas on the poles, and is turned another way, which indicates a change in the wind; the clouds are opening in that direction, which appears by the glow in the sky to be the south (the sun's winter habitation in our hemisphere), and this change will produce a thaw before the morning. The occurrence of these circumstances shows that Ruysdael *understood* what he was painting. He has here told a story; but in another instance he failed, because he attempted to tell that

which is out of the reach of the art. In a picture which was known, while he was living, to be called 'An Allegory of the Life of Man' (and it may therefore be supposed he so intended it)—there are ruins to indicate old age, a stream to signify the course of life, and rocks and precipices to shadow forth its dangers;—but how are we to discover all this?

"The Dutch painters were a *stay-at-home people*,—hence their originality. They were not, however, ignorant of Italian art. Rembrandt had a large collection of Italian pictures and engravings, and Fuseli calls the school of the Bassans the 'Venetian prelude to the Dutch school.' We derive the pleasure of surprise from the works of the best Dutch painters in finding how much interest the art, when in perfection, can give to the most ordinary subjects. Those are cold critics who turn from their works, and wish the same skill had been rendered a vehicle for more elevated stories. *They* do not in reality feel how much the Dutch painters have given to the world, who wish for more; and it may always be doubted whether those who do not relish the works of the Dutch and Flemish schools, whatever raptures they may affect in speaking of the schools of Italy, are capable of fully appreciating the latter; for *a true taste is never a half taste*. Whatever story the best painters of Holland and Flanders undertook to tell, is told with an unaffected truth of expression that may afford useful lessons in the treatment of the most sublime subjects; and those who would deny them poetic feeling, forget that chiaroscuro, colour, and composition, are all poetic qualities. Poetry is not denied to Rembrandt, or to Rubens, because their effects are striking. It does not, however, the less exist in the works of many other painters of the Dutch and Flemish schools who were less daring in their style."

June 16th

OF Constable's fourth lecture, I regret to find that even less is preserved than of the preceding ones. He recapitulated the history of landscape since the revival of the arts, comprising a space of about six hundred years, Titian's 'Peter Martyr' forming a central epoch.

He showed engravings from Patel of imitations of Claude, and from Vernet of imitations of Salvator Rosa, and pointed out the inferiority.

"The absurdity of imitation," he remarked, "is nowhere so striking as in the landscapes of the English Wooton, who painted country gentlemen in their wigs and jockey caps, and top-boots, with packs of hounds, and placed them in Italian landscapes resembling those of Gaspar Poussin, except in truth and force. Lambert, another English imitator of Italian art, but even below Wooton, is now remembered only as the founder of the 'Beef Steak Club'.

"The art of painting was in all its branches in the most degraded state, not only in England but throughout Europe, when Hogarth and Reynolds appeared, and thought and studied for themselves. Burke has said that Reynolds 'was the first Englishman who added the praise of the elegant arts to the other glories of this country'. But he forgot that Hogarth was born twenty-six years before Sir Joshua, and had published his engravings of the 'Harlot's Progress' when Reynolds was but eleven years old; or it may be he was influenced by the common opinion of that time which we find echoed by Walpole, that Hogarth was *no painter*. It is, however, to Reynolds that the honour of establishing the English school belongs. Hogarth had no school, nor has he ever been imitated with any tolerable success."

Among the engravings Constable exhibited at this lecture, he placed Sir Joshua's lovely group of the three Ladies

Waldegrave[1] under the Ugolino,[2] and remarked, "how great must be the range of *his* genius, who could fill the space of art included between two such subjects; Romney, when some of his friends thought to please him by disparaging Reynolds, said, 'No, no, he is the greatest painter that ever lived, for I see an exquisite beauty in his pictures which I see in nature, but not in the works of any other painter.'[3]

"To Wilson, who was ten years the senior of Reynolds, may justly be given the praise of opening the way to the genuine principles of Landscape in England; he appeared at a time when this art, not only here, but on the Continent, was altogether in the hands of the mannerists.[4] It was in Italy that he first became acquainted with his own powers; and no doubt the influence of the works of Claude and the Poussins enabled him to make the discovery. But he looked at nature entirely for himself, and remaining free from any tincture of the styles that prevailed among the living artists, both abroad and at home, he was almost wholly excluded from any share of the patronage which was liberally bestowed on his contemporaries. Barrett, and the Smiths of Chichester, whose names are now nearly forgotten, accumulated wealth while Wilson might have starved had he not been appointed librarian to the Royal Academy. Stothard used to relate an anecdote of Wilson which showed how much he was disposed

*[1] In the collection of Mrs. Yerburgh, London.

*[2] In the collection of Lord Sackville, Knole.

[3] This is true, in a greater or less degree, as Constable has himself remarked in the first of this course of lectures, of every original painter; indeed it is evident that this is the only test of originality.

[4] The biographers of Wilson attribute his leaving portraiture for landscape, to the suggestion of one of these mannerists, Zuccherelli; and of his obligations to another, Allan Cunningham gives this account. 'One day, while sitting in Wilson's painting-room, Vernet was so struck with the peculiar beauty of a newly-finished landscape that he desired to become its proprietor, and offered in exchange one of his best pictures. This was much to the gratification of the other; the exchange was made, and, with a liberality equally rare and commendable, Vernet placed his friend's picture in his exhibition room, and when his own productions happened to be praised or purchased by English travellers, the generous Frenchman used to say, 'Don't talk of my landscapes alone when your own countryman Wilson paints so beautifully." '

to turn to nature even in the midst of art. Stothard, when a student, asked Wilson in the library, to recommend something for him to copy. Wilson at the moment was standing at one of the windows, which, as the quadrangle of Somerset House was then unfinished, commanded a fine view of the river. There,' said the librarian pointing to the animated scene, 'is something for you to copy.'

"The landscape of Gainsborough is soothing, tender, and affecting. The stillness of noon, the depths of twilight, and the dews and pearls of the morning, are all to be found on the canvases of this most benevolent and kind-hearted man. On looking at them, we find tears in our eyes, and know not what brings them. The lonely haunts of the solitary shepherd, —the return of the rustic with his bill and bundle of wood,— the darksome lane or dell,—the sweet little cottage girl at the spring with her pitcher,—were the things he delighted to paint, and which he painted with exquisite refinement, yet not a refinement beyond nature. Gainsborough has been compared to Murillo by those who cannot distinguish between the *subject* and the *art*. Like Murillo he painted the peasantry of his country, but here the resemblance ceases. His taste was in all respects greatly superior to that of the Spanish painter."

Constable spoke of Cozens and Girtin as possessing genius of the very highest order, though their works being comparatively few and in water colours chiefly, they are less known than they deserve to be.

"West showed great ability in the composition of landscape, which he sometimes practised for itself, with figures entirely subordinate. His picture of the reception of Telemachus and Mentor by Calypso after their shipwreck,[1] is an extremely beautiful combination of landscape and figures." Constable exhibited a fine engraving of this picture, begun by Woollett, and finished by Pye.

"As your kind attention," he said, "has so long been given to my description of pictures, it may now be well to consider

*[1] Probably the painting exhibited at the R.A. 1801.

in what estimation we are to hold them, and in what class we are to place the men who have produced them.—It appears to me that pictures have been over-valued; held up by a blind admiration as ideal things, and almost as standards by which nature is to be judged rather than the reverse; and this false estimate has been sanctioned by the extravagant epithets that have been applied to painters, as 'the divine', 'the inspired', and so forth.[1] Yet, in reality, what are the most sublime productions of the pencil but selections of some of the forms of nature, and copies of a few of her evanescent effects; and this is the result, not of inspiration, but of long and patient study, under the direction of much good sense.—It was said by Sir Thomas Lawrence, that 'we can never hope to compete with nature in the beauty and delicacy of her separate forms or colours,—our only chance lies in selection and combination.' Nothing can be more true,—and it may be added, that selection and combination are learned from nature herself, who constantly presents us with compositions of her own, far more beautiful than the happiest arranged by human skill. I have endeavoured to draw a line between genuine art and mannerism, but even the greatest painters have never been wholly untainted by manner.—Painting is a science, and should be pursued as an inquiry into the laws of nature. Why, then, may not landscape painting be considered as a branch of natural philosophy, of which pictures are but the experiments?"[2]

[1] 'To say the truth, men do not appear to know their own stock and abilities, but fancy their possessions greater, and their faculties less, than they are; whence either valuing the received arts above measure, they look out no farther; or else despising themselves too much, they exercise their talents upon lighter matters, without attempting the capital things of all. And hence the sciences come to be considered as Hercules' Pillars, which are to bound the desires and hopes of mankind. But as a false imagination of plenty comes among the principal causes of want, and as too great a confidence in things present leads to a neglect of future assistance, it is necessary that we here admonish mankind that they do not too highly value or extol either the number or usefulness of the things hitherto discovered.'—LORD BACON.

[2] Turnbull, whose folio on ancient painting Hogarth sent to the trunk-maker with less justice than the 9999th volume of Politics, which he placed in the same hamper with it, considers landscape painting as belonging to

Constable thanked his audience for the attention with which they had listened to him, and said, "I cannot better take my leave of you than in the words of my friend, Archdeacon Fisher, who, in an address to the clergy, on one of his visitations said, 'In my present perplexity, the recollection comes to my relief that when any man has given an undivided attention to any one subject, his audience willingly yield him for his hour the chair of instruction; he discharges his mind of its conceptions, and descends from his temporary elevation to be instructed in his turn by other men.' "

natural philosophy, and historical painting to moral philosophy. But Constable was not acquainted with Turnbull's work when this lecture was delivered. He first saw it at my house in January 1837. *The reference is to George Turnbull, *A Treatise on Ancient Painting* . . . London 1740.

On the 25th July 1836, Constable delivered a lecture before the Literary and Scientific Institution at Hampstead, on the subject of Landscape generally.

In adding the notes I took on this occasion to the remaining memoranda preserved among his papers, I shall omit passages in which he repeated parts of his previous lectures.

He began by saying, "The difference between the judgments pronounced by men who have given their lives to a particular study, and by those who have attended to that study as the amusement only of a few leisure hours, may be thus illustrated. I will imagine two dishes, the one of gold, the other of wood. The golden dish is filled with diamonds, rubies, and emeralds, —and chains, rings, and brooches of gold; while the other contains shell-fish, stones, and earths. These dishes are offered to the world, who choose the first; but it is afterwards discovered that the dish itself is but copper gilt, the diamonds are paste, the rubies and emeralds painted glass, and the chains, rings, etc. counterfeit. In the meantime, the naturalist has taken the wooden dish, for he knows that the shell-fish are pearl oysters and he sees that among the stones are gems, and mixed with the earths are the ores of the precious metals.

"The decline of painting, in every age and country, after arriving at excellence, has been attributed by writers who have not been artists to every cause but the true one. The first impression and a natural one is, that the fine arts have risen or declined in proportion as patronage has been given to them or withdrawn, but it will be found that there has often been more money lavished on them in their worst periods than in their best, and that the highest honours have frequently been bestowed on artists whose names are scarcely now known. Whenever the arts have not been upheld by the good sense of their professors, patronage and honours so far from checking their downward course, must inevitably accelerate it.

"The attempt to revive old styles that have existed in former ages may for a time appear to be successful, but experience may now surely teach us its impossibility. I might put on a suit of Claude Lorraine's clothes and walk into the street, and the many who know Claude but slightly would pull off their hats to me, but I should at last meet with some one more intimately acquainted with him, who would expose me to the contempt I merited.[1]

"It is thus in all the fine arts. A new Gothic building, or a new missal, is in reality little less absurd than a *new ruin*. The Gothic architecture, sculpture, and painting, belong to peculiar ages. The feelings that guided their inventors are unknown to us, we contemplate them with associations, many of which, however vague and dim, have a strong hold on our imaginations, and we feel indignant at the attempt to cheat us by any modern mimicry of their peculiarities.[2]

"It is to be lamented that the tendency of taste is at present too much towards this kind of imitation, which, as long as it lasts, can only act as a blight on art, by engaging talents that might have stamped the Age with a character of its own, in the vain endeavour to reanimate deceased Art, in which the utmost that can be accomplished will be to reproduce a body without a soul.[3]

"Attempts at the union of uncongenial qualities in different styles of Art have also contributed to its decline." In illustration of this, Constable showed a print from Vernet, the trees

[1] Archdeacon Fisher, in one of his letters that has not been printed, says, "I have just met with the following observation in Leonardo da Vinci, 'One painter ought never to imitate the manner of any other, because in that case he cannot be called the child of nature, but the grand-child.' "—Constable sometimes called imitators 'Poachers on other men's grounds.'

[2] See Fisher's letter on the death of Mrs. Constable, page 169.

[3] Nine years have elapsed since these observations were made and the tendency of taste is still more confirmed in the direction of which Constable speaks. The present age, distinguished as it is by the advance of the other sciences, has become, in all that relates to painting, sculpture, and architecture, little else than an antiquarian age.—It is well, in all things, as we go on, to look behind us,—but what advance can we hope to make with our faces constantly turned backwards?

of which were in a mannered imitation of Salvator Rosa, without his nature and wildness, while the rocks were in the artificial style of Berghem. "In the foreground," he said, "you will perceive an emaciated French dancing master, in a dress something like one of Salvator's banditti, but intended by Vernet for a fisherman. It is thus the art is deteriorated by the mannerists who employ themselves in sweeping up the painting-rooms of preceding ages. Imitators always render the defects of their model more conspicuous. Sir George Beaumont, on seeing a large picture by a modern artist, intended to be in the style of Claude, said, 'I never could have believed that Claude Lorraine had so many faults, if I had not seen them all collected together on this canvas.' It is useful, therefore, to a painter to have imitators, as they will teach him to avoid everything they do.

"The young painter, who, regardless of present popularity, would leave a name behind him must become the patient pupil of nature. If we refer to the lives of all who have distinguished themselves in art or science, we shall find they have always been laborious. The landscape painter must walk in the fields with an humble mind. No arrogant man was ever permitted to see nature in all her beauty. If I may be allowed to use a very solemn quotation, I would say most emphatically to the student, 'Remember now thy Creator in the days of thy youth.' The friends of a young artist should not look or hope for precocity. It is often disease only. Quintilian makes use of a beautiful simile in speaking of precocious talent. He compares it to the forward ear of corn that turns yellow and dies before the harvest. Precocity often leads to criticism,—sharp, and severe as the feelings are morbid from ill health. Lord Bacon says, 'when a young man becomes a critic, he will find much for his amusement, little for his instruction.' The young artist must receive with deference the advice of his elders, not hastily questioning what he does not yet understand, otherwise his maturity will bear no fruit. The art of seeing nature is a thing almost as much to be acquired as the art of reading the Egyptian hieroglyphics. The Chinese have painted

for two thousand years, and have not discovered that there is such a thing as chiaroscuro.[1]

Constable then gave some practical rules for drawing from nature, and showed some beautiful studies of trees. One, a tall and elegant ash, of which he said "many of my Hampstead friends may remember this *young lady* at the entrance to the village. Her fate was distressing, for it is scarcely too much to say that she died of a broken heart. I made this drawing when she was in full health and beauty; on passing some time afterwards, I saw, to my grief, that a wretched board had been nailed to her side, on which was written in large letters, '*All vagrants and beggars will be dealt with according to law.*' The tree seemed to have felt the disgrace, for even then some of the top branches had withered. Two long spike nails had been driven far into her side. In another year one half became paralysed, and not long after the other shared the same fate, and this beautiful creature was cut down to a stump, just high enough to hold the board."

Constable exhibited an outline of the principal figure in Fuseli's 'Lazar house', and showed that the swellings and depressions in the outline of a figure in fine action never occur exactly on the opposite sides, and the same, he said, would be found true of trees when healthy.

He quoted from Thomson's *Seasons* the sixteen introductory lines to the 'Winter' as a beautiful instance of the poet identifying his own feelings with external nature. He noticed also Milton's love of landscape, and how often in his poems the most simple imagery is mingled with the most sublime. "Thus he has compared the army of the Cherubim attendant on the Archangel, while conducting our first parents from Paradise, to an evening mist:

[1] Some of the Chinese painters have lately produced pictures with powerful effects of light and shade, in imitation of European art. Specimens of this kind may be seen in the splendid Chinese Museum, lately opened. Still they are but imitations of art, and are black, heavy and cold; and destitute of the real charm of chiaroscuro. Indeed the earlier works of the Chinese, in which light and shade are not thought of, are more agreeable. *Leslie refers to Mr. Dunn's Chinese Collection, exhibited in a temporary building on the site of the Cannon Brewery (now Albert Gate) 1841–45.

'The Archangel stood, and from the other hill
To their fix'd station, all in bright array
The Cherubim descended; on the ground,
Gliding meteorous, as evening mist
Ris'n from a river o'er the marish glides,
And gathers ground fast at the lab'rer's heel,
Homeward returning.'

Introducing the homely incident of the labourer's return, and calling up all the rustic fireside associations connected with it in the midst of a description of the host of Heaven.

"There has," said Constable, "never been an age, however rude or uncultivated, in which the love of landscape has not in some way been manifested. And how could it be otherwise? for man is the sole intellectual inhabitant of one vast natural landscape. His nature is congenial with the elements of the planet itself, and he cannot but sympathise with its features, its various aspects, and its phenomena in all situations. How beautifully has Milton described the emotions of Adam in the full maturity of mind and perception, his eyes opening for the first time on the wonders of the animate and inanimate world:

'Straight toward Heav'n my wond'ring eyes I turn'd
And gaz'd awhile the ample Sky, . . .
. About me round I saw
Hill, Dale, and shady Woods, and sunny Plains,
And liquid lapse of murm'ring streams; by these
Creatures that liv'd and mov'd, and walk'd, or flew,
Birds on the branches warbling; all things smil'd
With fragrance, and with joy my heart o'erflow'd;
. . . . Thou Sun, said I, fair light,
And thou enlighten'd Earth, so fresh and gay,
Ye Hills and Dales, ye Rivers, Woods, and Plains,
And ye that live and move, fair Creatures, tell,
Tell if ye saw, how came I thus, how here?'

" 'When I behold,' says Martin Luther, 'the beautiful azure vault of Heaven, besprinkled with constellations of shining orbs, the prospect fills my mind, and I feel the highest grati-

fication at such a glorious display of Omnipotence. Melancthon wishes to know where are the pillars that support this magnificent arch.'

"At a time when Europe was agitated in an unusual manner; when all was diplomacy, all was politics, Machiavellian and perfidious, Cardinal Bembo wrote thus to the Pope, who had been crowning the Emperor Charles V at Bologna. 'While your Holiness has been these last days on the theatre of the world, among so many lords and great men, whom none now alive have ever seen together before, and has placed on the head of Charles V the rich, splendid, and honoured crown of the Empire, I have been residing in my little village, where I have thought on you in a quiet, and, to me, dear and delicious solitude. I have found the country above the usage of any former years, from the long serenity of these gliding months, and by the sudden mildness of the air, already quite verdant, and the trees in full leaf. Even the vines have deceived the peasantry by their luxuriance, which they were obliged to prune. I do not remember to have seen at this time so beautiful a season. Not only the swallows, but all other birds that do not remain with us in the winter, but return to us in the spring, have made this new, and soft, and joyous sky resound with their charming melodies.—I could not therefore regret your festivities at Bologna. Padua, April 7th, 1530.'

"Of the good Bishop Andrews it is related by Fuller, 'that he would often profess that to observe the trees—earth—corn—grass—water,—hearing any of the creatures,—and to contemplate their qualities—natures—and uses—was ever to him the greatest recreation—content—and mirth—that could be.'

"Paley observed of himself, that 'the happiest hours of a sufficiently happy life were passed by the side of a stream;' and I am greatly mistaken if every landscape painter will not acknowledge that his most serene hours have been spent in the open air, with his palette on his hand. 'It is a great happiness,' says Bacon, 'when men's professions and their inclinations accord.' "

From these outlines but a faint impression can be formed of Constable's lectures, as he delivered them, and in rooms of which one side was covered with pictures and prints to which he constantly referred. Many of his happiest turns of expression were not to be found in his own notes; they arose at the moment, and were not to be recalled by a reporter unskilled in shorthand;—neither can the charm of a most agreeable voice (though pitched somewhat too low), the beautiful manner in which he read the quotations, whether of prose or poetry, or the play of his very expressive countenance, be conveyed to the reader by words.

SHORT BIBLIOGRAPHY

C. R. LESLIE, R.A. Memoirs of the Life of John Constable, R.A.
First edition 1843, illustrated with 22 mezzotints by David Lucas
after Constable.
Second edition 1845, with additional textual matter, and only
one mezzotint.
Third edition 1896.
Edition revised and enlarged by the Hon. Andrew Shirley, 1937.

C. J. HOLMES. Constable and his Influence on Landscape Painting.
London, 1902.

LORD WINDSOR. John Constable, R.A. London, 1903.

THE HON. ANDREW SHIRLEY. The Published Mezzotints of David Lucas
after John Constable, R.A. Oxford, 1930.

PETER LESLIE. Letters from John Constable, R.A., to C. R. Leslie,
R.A. London, 1932.

While the second edition of C. R. Leslie's *Life* remains the standard
source-book for a study of Constable, it can be supplemented at
various points. Lord Windsor's book includes a considerable amount
of fresh documentary material, based on a collection of MSS. letters,
and Peter Leslie's edition of the Leslie correspondence gives the full
text of most of the letters quoted by C. R. Leslie, as well as others
which were not used in the *Life*. The Hon. Andrew Shirley's edition
of the *Life* draws on these new sources, but is not always accurate. The
association of Constable and David Lucas over the *English Landscape
Scenery* engravings is well documented by the Hon. Andrew Shirley
in his *Published Mezzotints*.

THE PLATES

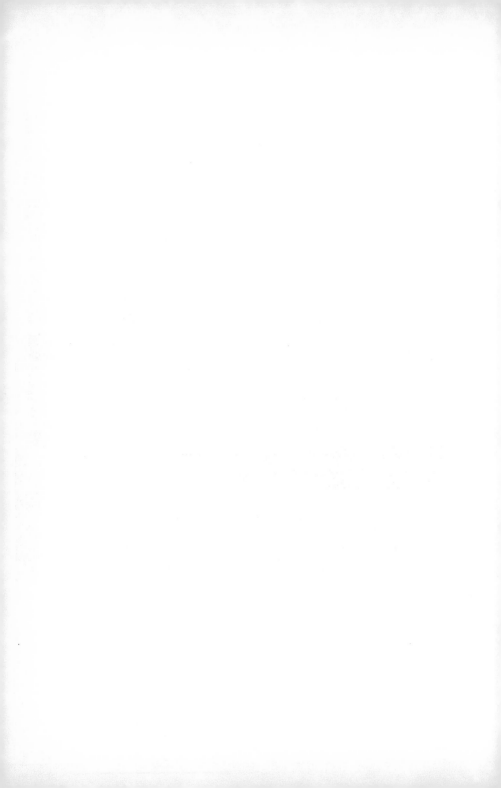

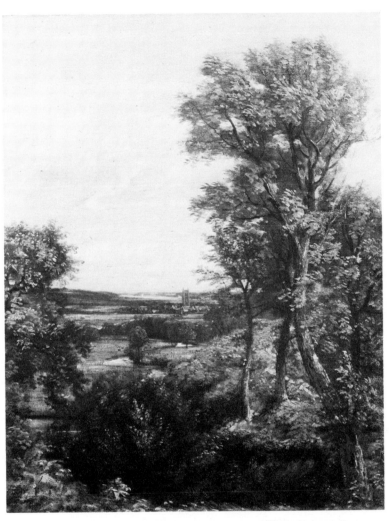

1. DEDHAM VALE. 1802. Victoria & Albert Museum

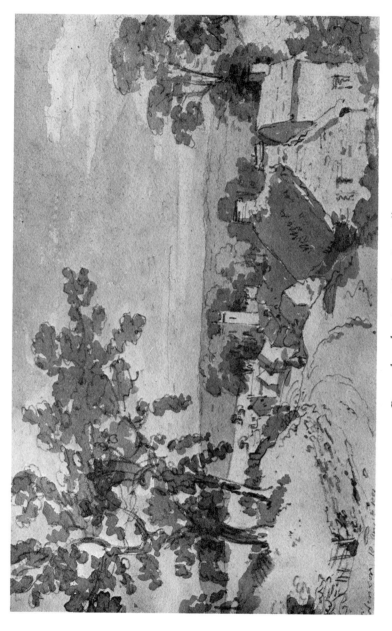

2. EDENSOR. Pen and wash. 1801. Victoria & Albert Museum

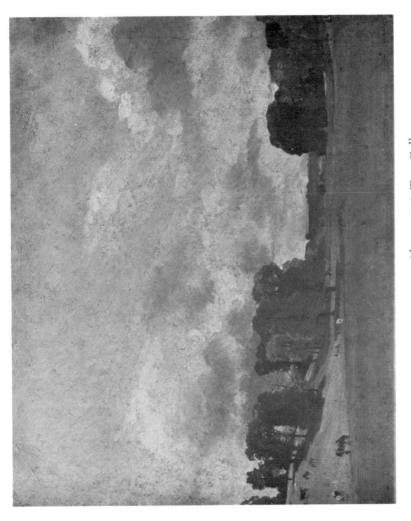

3. VIEW AT EPSOM. About 1808. Tate Gallery

4. BORROWDALE. Water-colour. 1806. Victoria & Albert Museum

5. KESWICK LAKE. About 1807. National Gallery of Victoria, Melbourne

6. MALVERN HALL. About 1809. National Gallery, London

7. GOLDING CONSTABLE'S HOUSE AT EAST BERGHOLT. About 1811. Victoria & Albert Museum

8. VIEW FROM GOLDING CONSTABLE'S HOUSE. Pencil, about 1814. Victoria & Albert Museum

9. BARGES ON THE STOUR. About 1811. Victoria & Albert Museum

10. LOCK AND COTTAGES ON THE STOUR. About 1811. Victoria & Albert Museum

11. DEDHAM VALE. 1811. Collection Major R. G. Proby

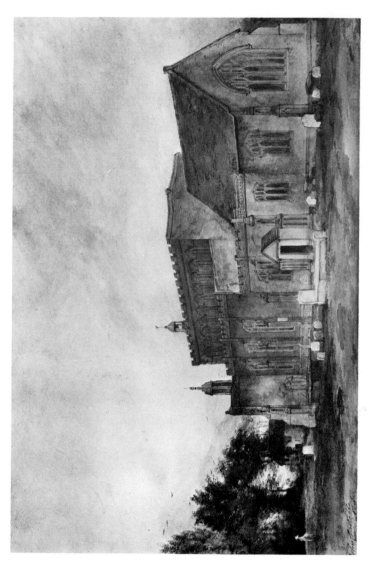

12. EAST BERGHOLT CHURCH. Water-colour, 1811. Lady Lever Art Gallery, Port Sunlight

13. WEYMOUTH BAY. About 1816. Victoria & Albert Museum

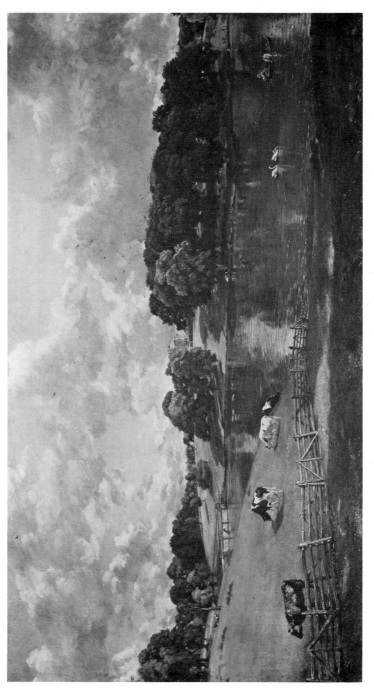

14. WIVENHOE PARK, ESSEX. 1817. National Gallery of Art, Washington (Widener Collection)

15. WEYMOUTH BAY. About 1816. National Gallery, London

16. BOAT-BUILDING NEAR FLATFORD MILL. Pencil, 1814. Victoria & Albert Museum

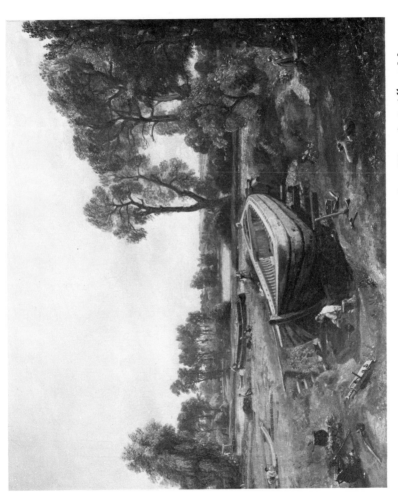

17. BOAT-BUILDING NEAR FLATFORD MILL. 1815. Victoria & Albert Museum

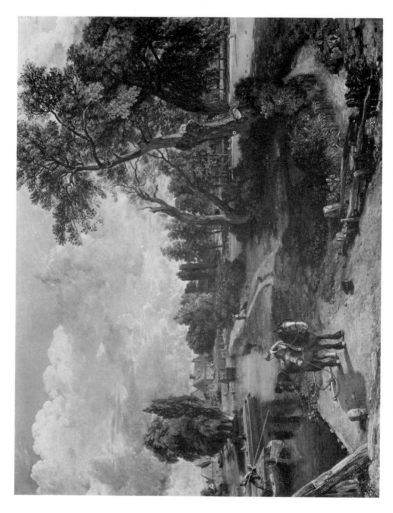

18. FLATFORD MILL. 1817. National Gallery, London

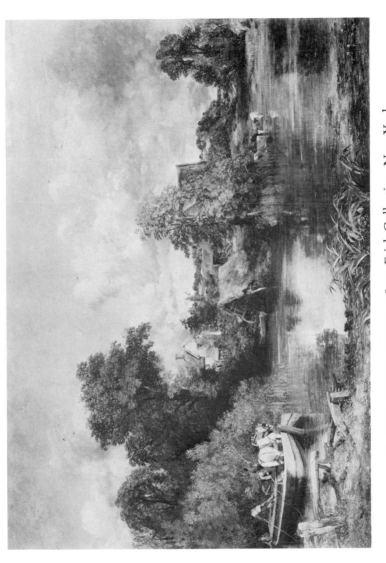

19. THE WHITE HORSE. 1819. Frick Collection, New York

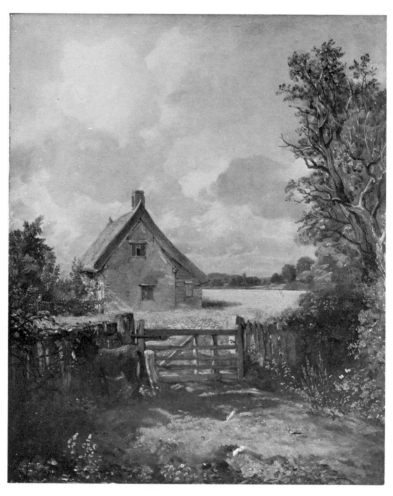

20. THE COTTAGE IN THE CORNFIELD.
About 1817. Victoria & Albert Museum

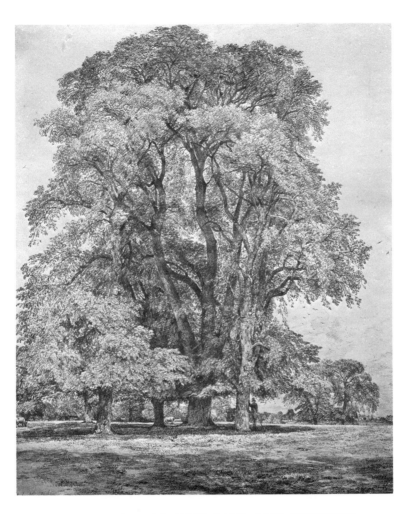

21. TREES AT OLD HALL PARK, EAST BERGHOLT.
Pencil, 1817. Victoria & Albert Museum

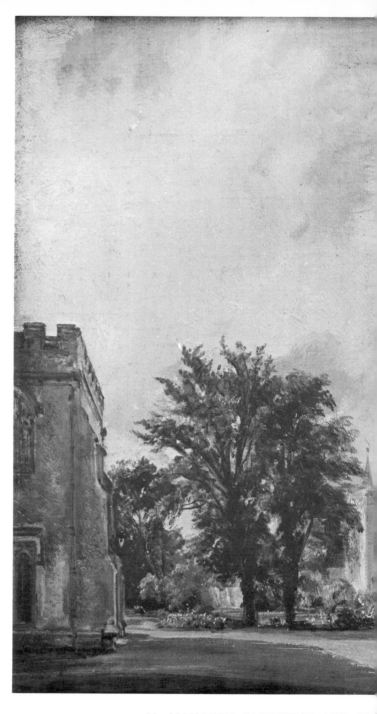

22. SALISBURY CATHEDRAL AND CLO

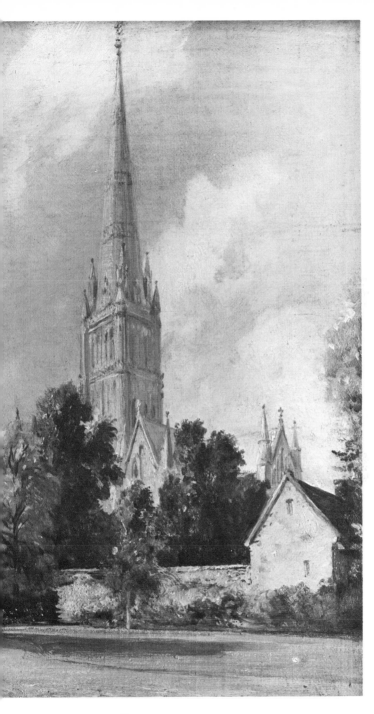

out 1820. Victoria & Albert Museum

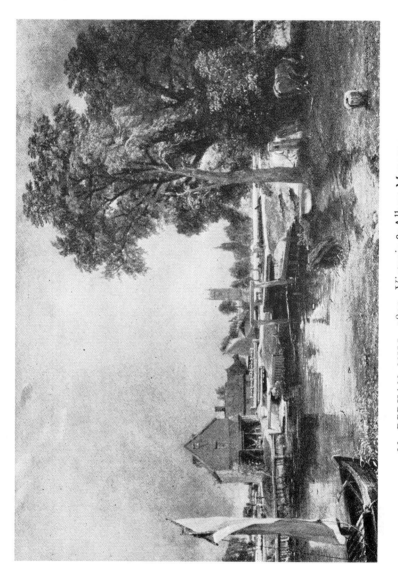

23. DEDHAM MILL. 1820. Victoria & Albert Museum

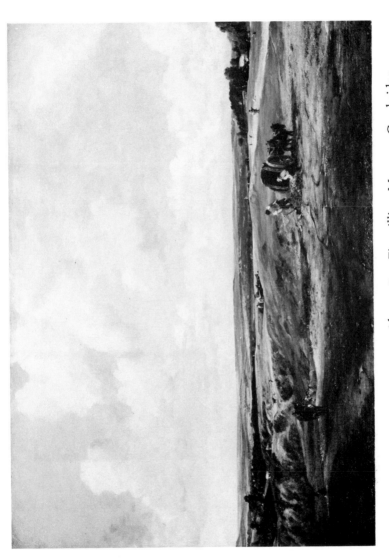

24. HAMPSTEAD HEATH. About 1820. Fitzwilliam Museum, Cambridge

25. STUDY FOR 'SALISBURY CATHEDRAL FROM THE BISHOP'S GROUNDS'.
About 1823. Collection T. W. Bacon

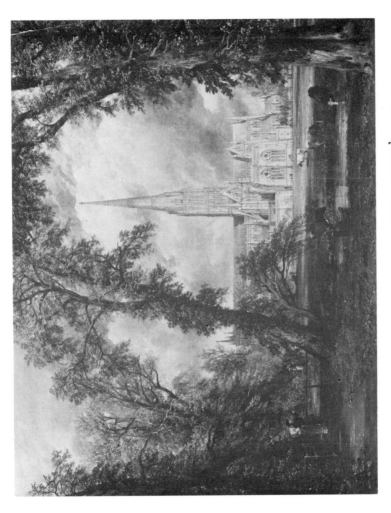

26. SALISBURY CATHEDRAL FROM THE BISHOP'S GROUNDS.
1823. Victoria & Albert Museum

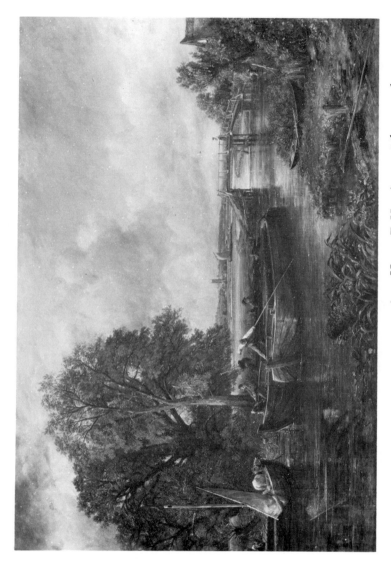

27. VIEW ON THE STOUR. 1822. Henry E. Huntington Library and Art Gallery, San Marino, California

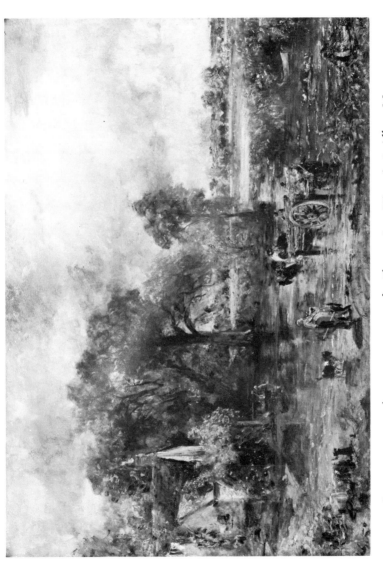

28. STUDY FOR 'THE HAY WAIN'. About 1821. Victoria & Albert Museum

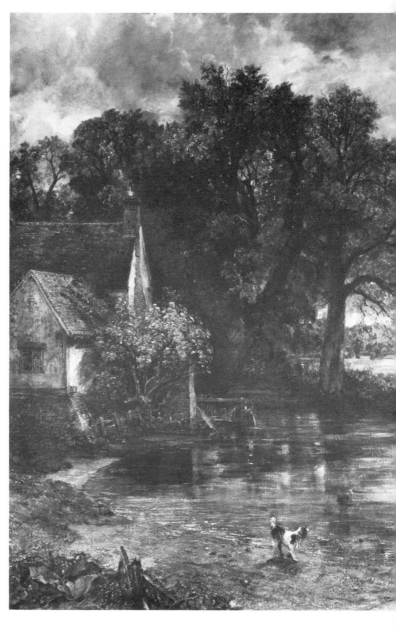

29. THE HAY WAIN. 18

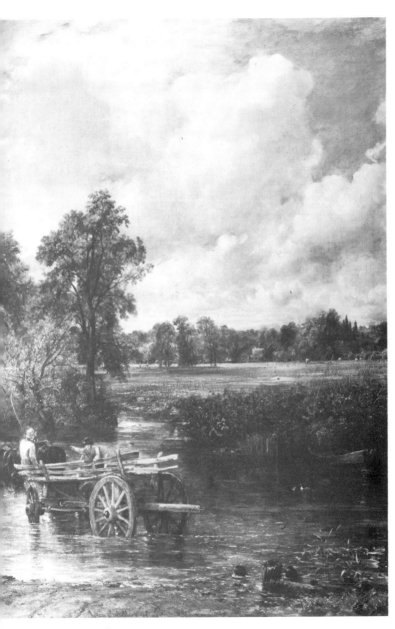

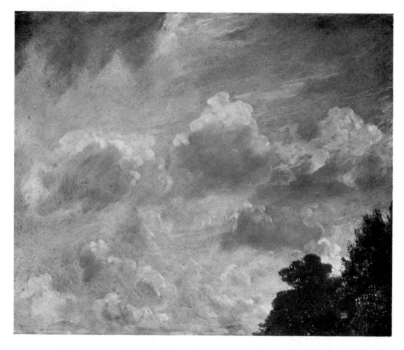

30. STUDY OF CLOUDS AND TREES. 1821. Royal Academy

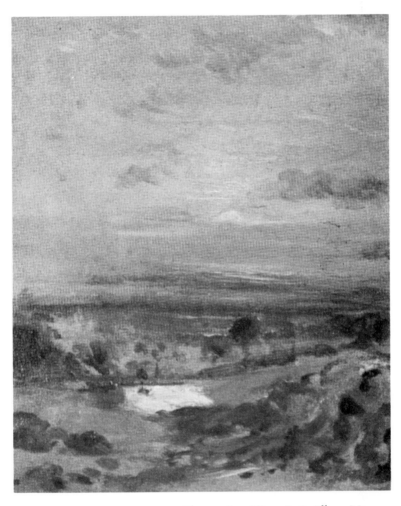

31. HAMPSTEAD; EVENING. About 1822. Victoria & Albert Museum

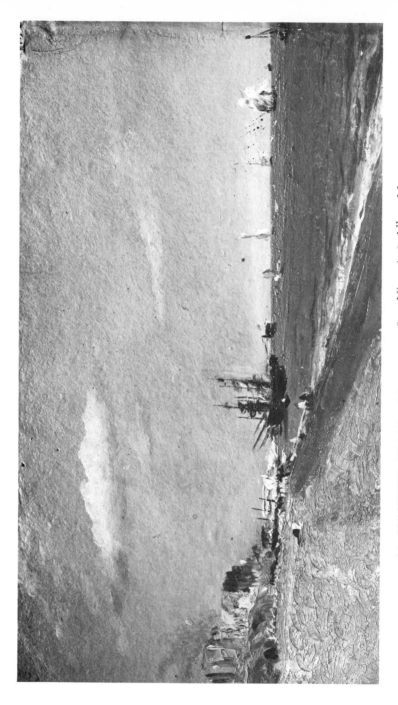

32. BRIGHTON BEACH; COLLIERS. 1824. Victoria & Albert Museum

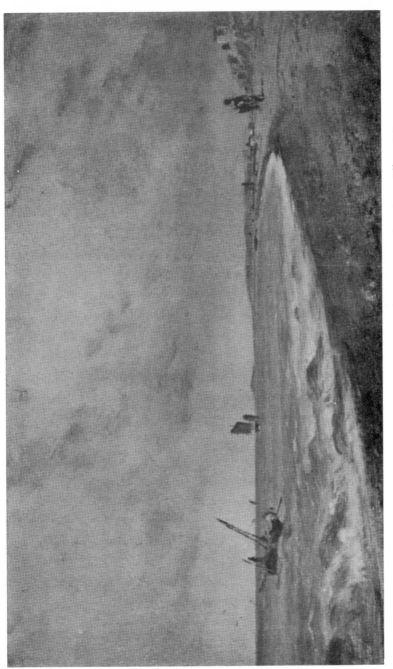

33. COAST SCENE WITH FISHING BOATS. About 1824. Victoria & Albert Museum

34. STUDY OF TREES; EVENIN

823. Victoria & Albert Museum

35. A BOAT PASSING A LOCK. 1826. Royal Academy

36. STUDY OF SKY AND TREES. 1821. Victoria & Albert Museum

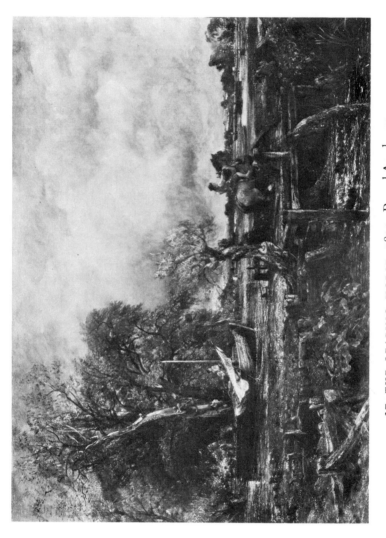

37. THE LEAPING HORSE. 1825. Royal Academy

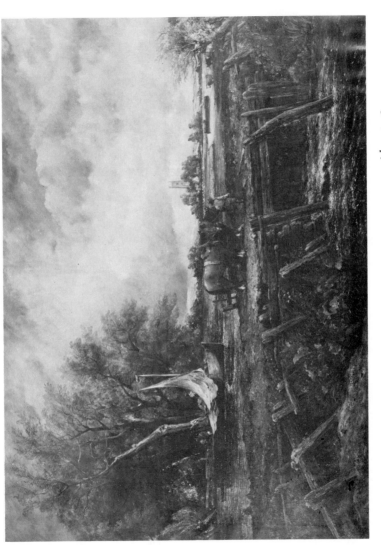

38. THE LEAPING HORSE—VARIANT VERSION. About 1825.
Collection Major R. M. P. and the Misses Willoughby

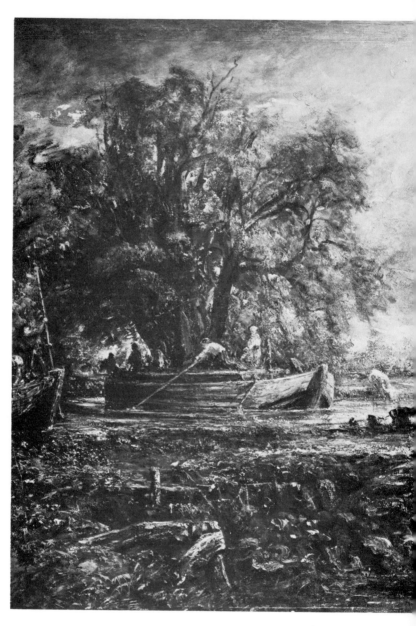

39. STUDY FOR 'LEAPING HORSE

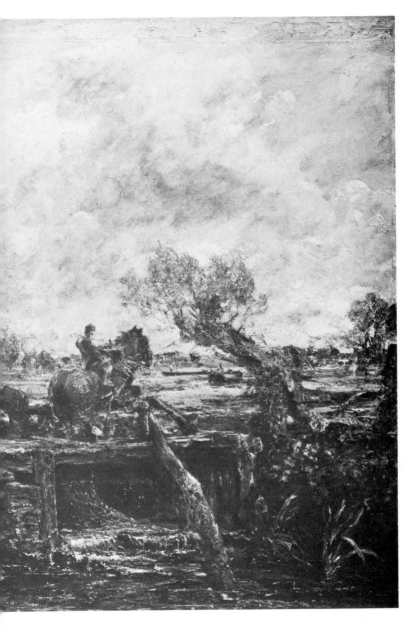

bout 1825. Victoria & Albert Museum

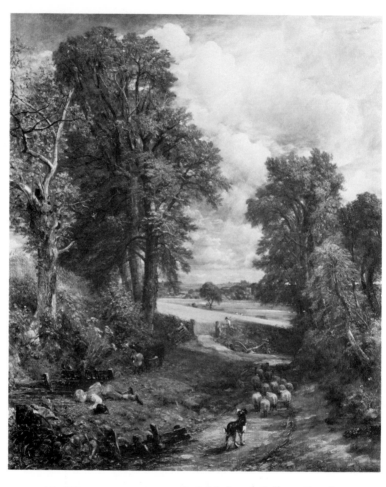

40. THE CORNFIELD. 1826. National Gallery, London

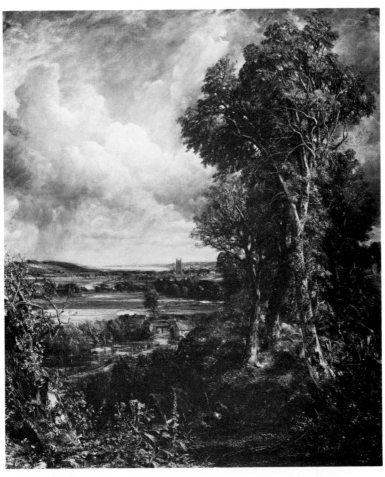

41. DEDHAM VALE. 1828. National Gallery of Scotland, Edinburgh

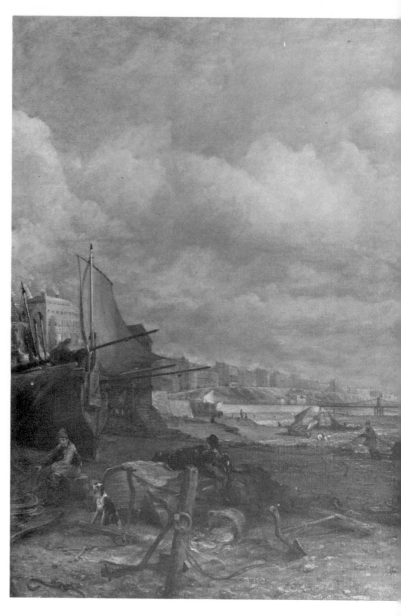

42. MARINE PARADE AND CHAI

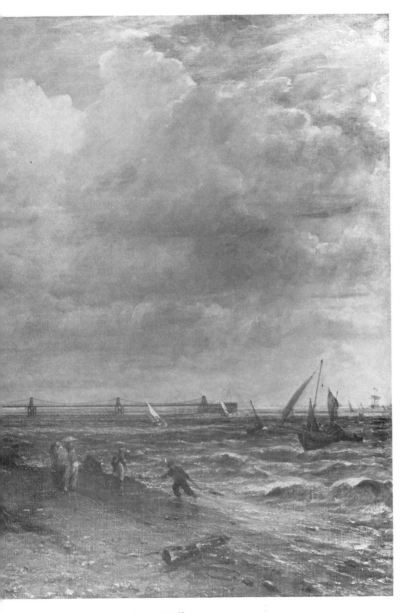

ER, BRIGHTON. 1827. Tate Gallery

43. SALISBURY CATHEDRAL FROM THE MEADOWS. 1831.
Collection Lord Ashton of Hyde

44. SALISBURY CATHEDRAL FROM THE RIVER. About 1827. National Gallery, London

45. STOKE-BY-NAYLAND. Wash, about 1830. Victoria & Albert Museum

46. STUDY OF TREE STEMS. About 1830. Victoria & Albert Museum

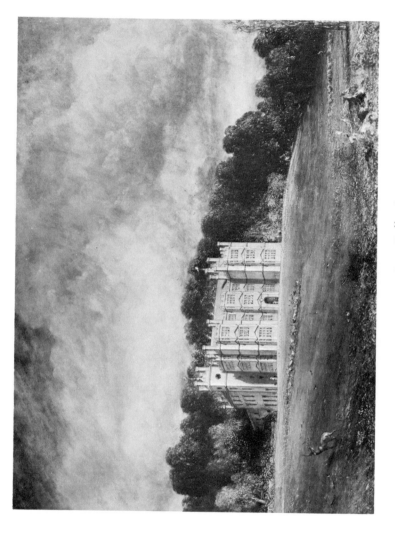

47. ENGLEFIELD HOUSE. 1833. Collection H. A. Benyon

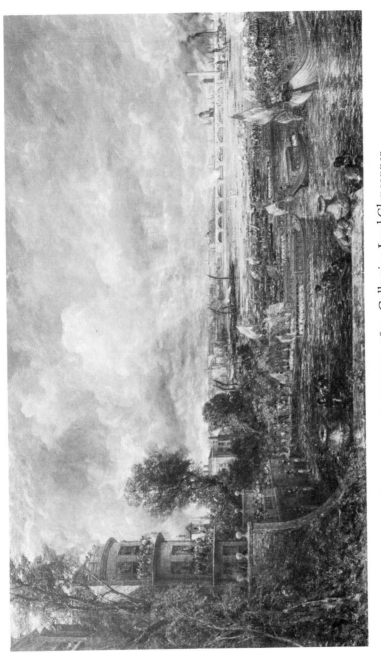

48. WATERLOO BRIDGE. 1832. Collection Lord Glenconner

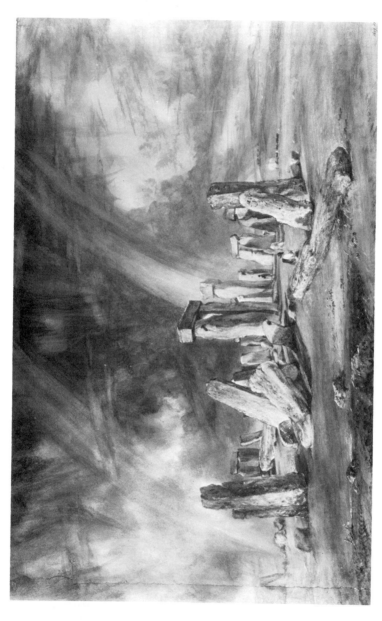

49. STONEHENGE. Water-colour, 1836. Victoria & Albert Museum

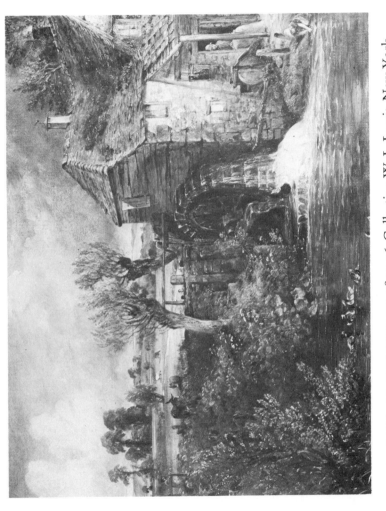

50. MILL AT GILLINGHAM. 1824–26. Collection W. L. Lewis, New York

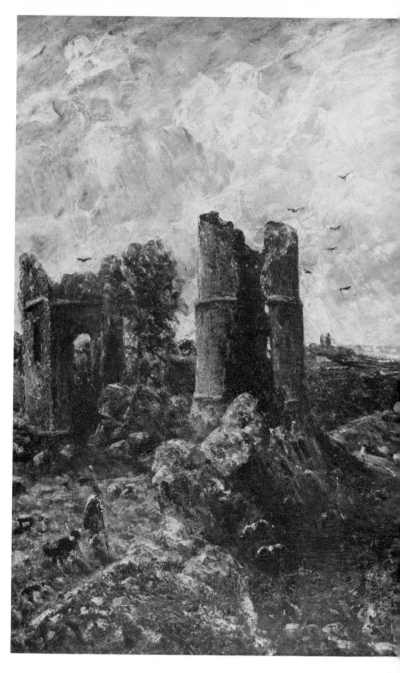

51. HADLEIGH CASTLE. Ab

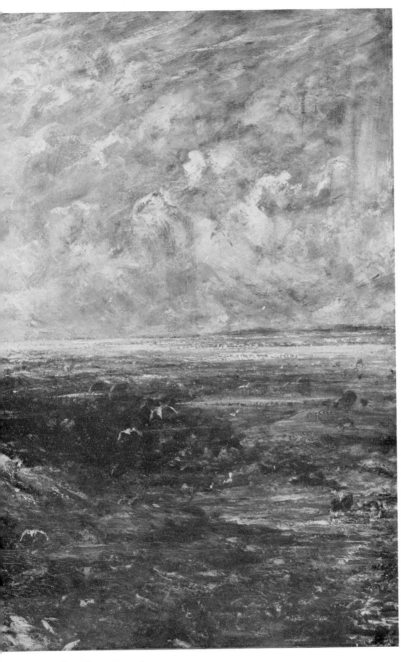

9. National Gallery, London

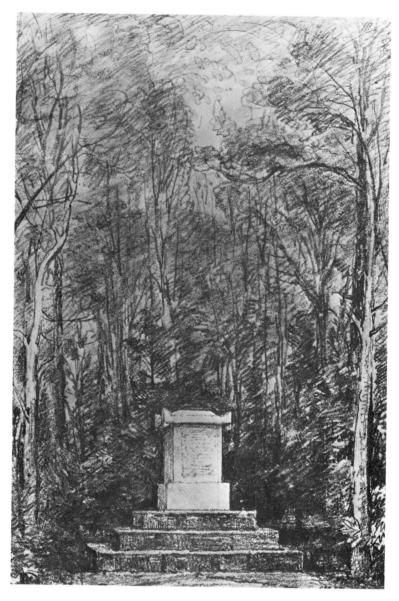

52. THE CENOTAPH. Pencil, 1823. Victoria & Albert Museum

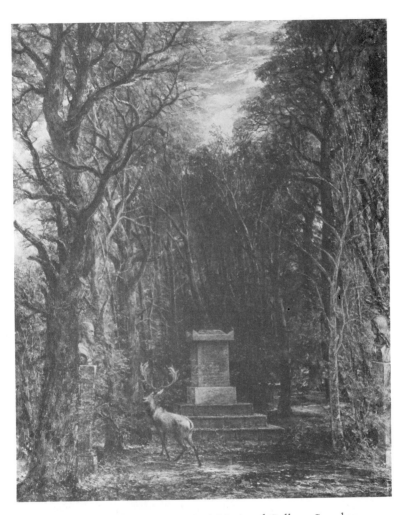

53. THE CENOTAPH. 1836. National Gallery, London

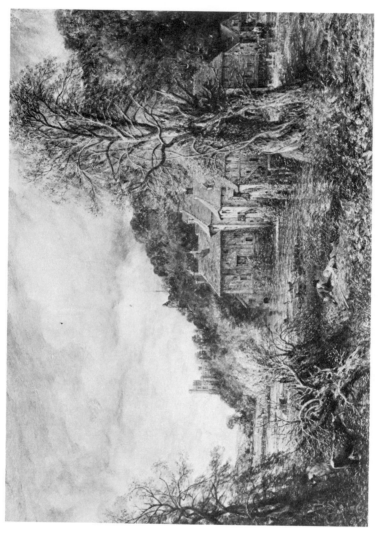

54. ARUNDEL MILL AND CASTLE. 1837. Toledo Museum of Art, Toledo, Ohio

55. COUNTRY ROAD AND SANDBANK. About 1835. Victoria & Albert Museum

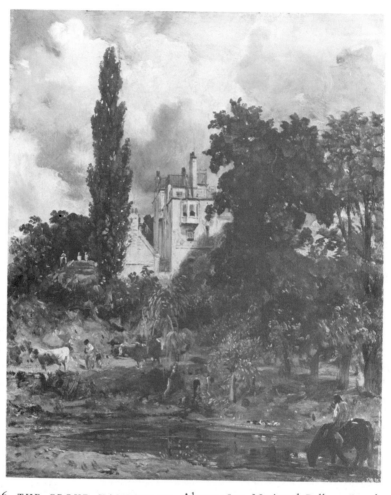

56. THE GROVE, HAMPSTEAD. About 1832. National Gallery, London

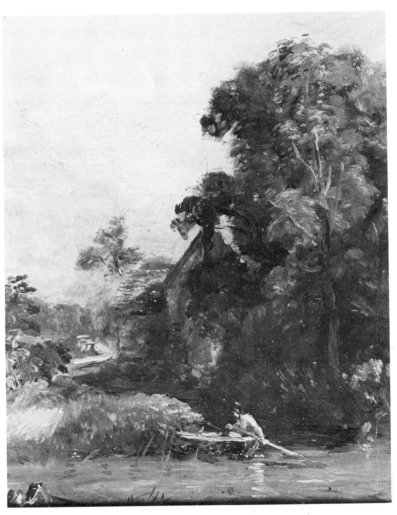

57. STUDY FOR 'THE VALLEY FARM'.
About 1835. Victoria & Albert Museum

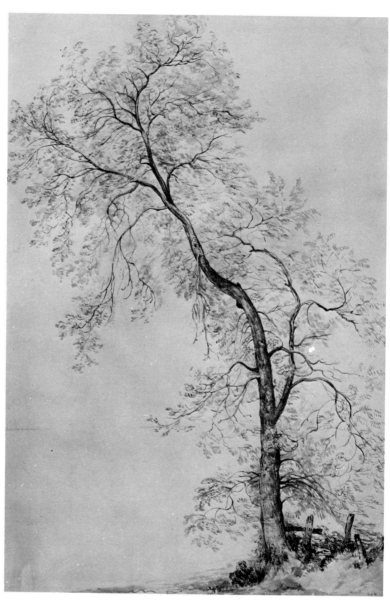

58. STUDY OF A TREE FOR 'THE VALLEY FARM'.
Water-colour, about 1835. Victoria & Albert Museum

NOTES ON THE ILLUSTRATIONS

★

WORKS EXHIBITED BY CONSTABLE

★

INDEX

★

NOTE ON THE ILLUSTRATIONS

The great majority of paintings by Constable in the Victoria and Albert Museum were given or bequeathed by Isabel Constable, the painter's daughter, in 1888: this is true of all those whose official reference-numbers contain this date. In the case of other works in the Victoria and Albert Museum, or of works in other collections, the name of the donor or previous owner is given only when it seemed relevant.

In connection with engravings by David Lucas after works by Constable, the name 'Shirley' followed by a number refers to the Hon. Andrew Shirley's catalogue in his Published Mezzotints.

NOTES ON THE ILLUSTRATIONS IN THE TEXT

FRONTISPIECE. SELF-PORTRAIT.

> Dated 1806. Pencil, $7\frac{1}{4} \times 5\frac{1}{2}$ in.
> *Collection Colonel J. H. Constable*

I. JOHN CONSTABLE, by Daniel Gardner (1750–1805)

> Tempera on canvas, 23×18 in.
> *Victoria and Albert Museum* (No. 589—1888)

A lithographic reproduction of this painting was one of the illustrations to the 1845 edition of Leslie's *Life*, where it was stated to represent the painter in his twentieth year.

II. ANN AND MARY CONSTABLE, THE PAINTER'S SISTERS

> Oil on canvas, $15 \times 11\frac{1}{2}$ in.
> *Collection Colonel J. H. Constable*

III. A GIRL IN A RED CLOAK

> Oil on millboard, $12\frac{3}{4} \times 6\frac{1}{2}$ in.
> *Collection Colonel J. H. Constable*

Family tradition identifies this portrait study with Maria Constable, the painter's wife; it may however represent his sister, Mary.

IV. CONSTABLE PAINTING MRS. HARDEN, by John Harden
 Pencil, $4\frac{5}{8} \times 4$ in.
 Collection A. S. Clay

John Harden and his wife entertained Constable at their home at
Brathay during his tour of the Lake District in 1806. Harden was an
accomplished amateur draughtsman, and other drawings by him, as
well as some by Constable, commemorate this occasion. For further
details and reproductions, cf. Beryl and Noel Clay, 'Constable's Visit
to the Lakes in 1806', in *Country Life*, 16th April 1938.

V. TWO VIEWS OF GOLDING CONSTABLE'S HOUSE AT EAST BERGHOLT
 Pencil, $4\frac{1}{4} \times 3\frac{1}{4}$ in.
 Victoria and Albert Museum (No. 437—1888)

This drawing is on a page from a dismembered sketch-book. The
moonlight view is dated 2nd Oct. 1814, and the daylight view 3rd
Oct.
Another view of this house, in which the painter was born, is repro-
duced on Plate 7, and a view of the garden on Plate 8.

VI. MRS. CONSTABLE WITH TWO OF HER CHILDREN
 Oil on panel, $6\frac{1}{2} \times 8\frac{1}{2}$ in.
 Collection Colonel J. H. Constable

It is not known which two of the painter's children are represented in
this group.

VII. ARCHDEACON JOHN FISHER
 Oil on canvas, 14×12 in.
 Collection Edward Fisher

Exhibited R.A. 1817.

VIII. STUDY OF CLOUDS
 Oil on paper, $4\frac{1}{2} \times 7$ in.
 Victoria and Albert Museum (No. 784—1888)

Most of Constable's cloud-studies were made in 1821–22 (cf. Leslie,
pp. 85, 94), and this example, though undated, can be referred to
this period. For a full discussion of Constable's 'skying' and for
reproductions of somewhat similar studies by Luke Howard, the
meteorologist, and by two foreign painters, J. C. C. Dahl and K. F.
Blechen, cf. Kurt Badt, *John Constable's Clouds*, London 1950.

IX. HEAD OF A GIRL
 Oil on canvas, $13 \times 12\frac{1}{2}$ in.
 Victoria and Albert Museum (No. 1255—1888)

To judge by the style and the coiffure, this study was painted *c.* 1830;
it is not known whom it represents.

X. AN UNKNOWN WOMAN

Oil on canvas, $35\frac{1}{4} \times 27\frac{1}{2}$ in.
Tate Gallery (No. 4954)

Painted *c.* 1810.

XI. STUDY OF FLOWERS

Oil on canvas, $19\frac{3}{8} \times 12\frac{3}{4}$ in.
Victoria and Albert Museum (No. 581—1888)

Another of Constable's flower-studies in the Victoria and Albert Museum (No. 582—1888), to which this is similar in style, is said to have been dated 26th July 1804 (?); the date is no longer visible. No clearly dated examples of flower-studies by Constable are known.

XII. THREE STUDIES

Pencil, $3\frac{11}{16} \times 4\frac{7}{8}$ in. Page from a sketch-book.
Victoria and Albert Museum (No. 317—1888, p. 61)

This sketch-book is one of the three now in the Victoria and Albert Museum, cf. p. 288 and *n.* It was in use from July to October 1813. One of the three studies reproduced here bears the date 31st Aug. 1813. The subjects of the landscapes have not been identified.

XIII. STUDIES OF CATTLE

Pencil, $3\frac{11}{16} \times 4\frac{7}{8}$ in. Page from a sketch-book.
Victoria and Albert Museum (No. 317—1888, p. 56)

From the same sketch-book as the page reproduced on Plate XII. The present page is dated 22nd Aug.

XIV. CONSTABLE LATE IN LIFE, by Daniel Maclise, R.A. (1806–70)

Pencil, $5\frac{1}{2} \times 4\frac{1}{4}$ in.
National Portrait Gallery (No. 1458)

It has been thought that this drawing represents Constable at the Life Class of the R.A., at which he was visitor in 1831 and 1837; if this is so, it might be the drawing sent by Maclise to Leslie after Constable's death (cf. Leslie, pp. 262-3). There is no precise evidence for this, however. The drawing does not seem to fit Maclise's description (*loc. cit.*), and it was formerly in the Constable family collection, not in the Leslie collection which might have been expected if the identification were correct.

NOTES ON THE PLATES

1. DEDHAM VALE

Dated at the back, Sept. 1802
Oil on canvas, $17\frac{1}{4} \times 13\frac{5}{8}$ in.
Victoria and Albert Museum (No. 124—1888)

Shirley has pointed out the interesting connection between the composition of this painting and that of Claude's *Hagar and the Angel* (National Gallery No. 61), which was then in the collection of Sir George Beaumont. Constable made a copy of the Claude in 1799 (Leslie, p. 10), and a copy—probably a later one, judging from the price it fetched—was in his posthumous sale.

2. EDENSOR, DERBYSHIRE

Inscribed with title, and dated 18 Aug. 1801
Indian ink and wash, $6\frac{7}{8} \times 10\frac{3}{8}$ in.
Victoria and Albert Museum (No. 247c—1888)

One of a series of drawings made by Constable on his Derbyshire tour in 1801 (cf. Leslie, p. 11). There are nine of these drawings in the Victoria and Albert Museum, most of which are dated; from them the following itinerary can be reconstructed; Mam Tor (12th Aug.)—Haddon Hall (15th Aug.)—Chatsworth (17th Aug.)—Edensor (18th Aug.). Farington recorded in his diary that he met Constable at Dovedale on 19th August: the passage in question is as follows:—'At 9 o'clock we entered Dovedale. I made a sketch of the first appearance of the entrance, and while I was so employed Mr. Constable came up to me, He having come a 2d time to make studies here. He was accompanied by a Mr. Whaley, who lives near Newcastle in Staffordshire.' 'Mr. Whaley' was perhaps a connection of Constable's sister whose surname was now Whalley.

3. VIEW AT EPSOM

Oil on millboard, $11 \times 13\frac{1}{2}$ in.
Tate Gallery (Vaughan Bequest: No. 1818)

Painted *c.* 1808.

4. BORROWDALE

Dated 4th Oct. 1806
Water-colour, $7\frac{1}{2} \times 10\frac{3}{4}$ in.
Victoria and Albert Museum (No. 187—1888)

The scene has been identified as looking toward Gate Crag with Castle Crag to the left. The old Keswick road is seen on the shoulder of the hill on the right. This is one of the many water-colour draw-

ings made by Constable on his tour of the Lake District in the autumn of 1806. Cf. Leslie, p. 18.

5. KESWICK LAKE
Oil on canvas, $9\frac{1}{2} \times 16\frac{1}{2}$ in.
National Gallery of Victoria, Melbourne (No. 140)
Perhaps the picture exhibited at the R.A. in 1807. Cf. Leslie p. 19.

6. MALVERN HALL, WARWICKSHIRE
Oil on canvas, $20\frac{1}{4} \times 30$ in.
National Gallery (Salting Bequest: No. 2653)
There is some doubt about the date of this painting. Constable exhibited a *Malvern Hall, View of the Terrace* at the R.A. 1822, and on the basis of a dated drawing of a different view of the subject, he may be presumed to have visited Malvern Hall in 1820. There is reason however to believe that the present sketch was made in 1809: an old inscription on the back of the stretcher gives a date of 1st Aug. 1809: and a letter to Constable from his mother, of 17th July 1809, suggests that a visit to Malvern Hall was at that time contemplated. Finally, the style of this sketch is quite in accordance with Constable's style in 1809. It should be added however that another, more finished version, based on this sketch, was painted not earlier than the end of 1819. For a full discussion of the problem, cf. Martin Davies, *National Gallery Catalogue, British School* (1946), pp. 34–6.

7. GOLDING CONSTABLE'S HOUSE
Oil on canvas on panel, $6\frac{3}{4} \times 19\frac{1}{2}$ in.
Victoria and Albert Museum (No. 583—1888)
Probably painted *c*. 1811.
A view of his father's house at East Bergholt, Suffolk, where Constable was born. The house was still standing, though untenanted, in 1840 when Leslie visited it (cf. p. 285), but it had been demolished by 1845 when the second edition of Leslie's *Life* was published. See also plates 8 and v.

8. VIEW FROM GOLDING CONSTABLE'S HOUSE AT EAST BERGHOLT
Pencil, $11\frac{3}{4} \times 17\frac{1}{2}$ in.
Victoria and Albert Museum (No. 623—1888)
Drawn *c*. 1814.

9. BARGES ON THE STOUR
Oil on paper on canvas, $10\frac{1}{4} \times 12\frac{1}{4}$ in.
Victoria and Albert Museum (No. 325—1888)
Painted *c*. 1811
Dedham Church can be seen in the distance.

10. LOCK AND COTTAGES ON THE STOUR

Oil on canvas, 10 × 12 in.
Victoria and Albert Museum (No. 135—1888)
A similar sketch at Burlington House is said to be dated 1811.

11. DEDHAM VALE

Signed, and dated 1811
Oil on canvas, 31 × 51 in.
Collection Major R. G. Proby
Exhibited R.A. 1811: cf. Leslie, pp. 21-2. An oil sketch is in the T. W. Bacon collection.

12. SOUTH-EAST VIEW OF EAST BERGHOLT CHURCH

Signed, and dated 1811
Water-colour, 16 × 24 in.
Lady Lever Art Gallery, Port Sunlight
Inscribed on a label at the back: 'South-East View of East Bergholt Church in County of Sussex (sic)—a Drawing by J. Constable, Esqur., and presented in testimony of Respect to the Revd. Durand Rhudde, D.D., the Rector. February 25, 1811.'
This is presumably the drawing mentioned by Leslie on p. 54.

13. WEYMOUTH BAY

Oil on millboard, 8 × 9¾ in.
Victoria and Albert Museum (No. 330—1888)
Perhaps painted in 1816, when Constable and his wife were spending their honeymoon at Osmington with his friend, Archdeacon Fisher (cf. Leslie, p. 69). Constable exhibited a painting of *Osmington Shore near Weymouth* at the B.I. in 1819, which may have been related to this sketch.
The mezzotint by Lucas (Shirley No. 13) has affinities both with this and with the sketch of the same subject in the National Gallery (see Plate 15).

14. WIVENHOE PARK, ESSEX

Oil on canvas, 21¼ × 39¼ in.
National Gallery of Art, Washington (Widener Coll.)
Exhibited R.A. 1817: cf. Leslie, p. 71.

15. WEYMOUTH BAY

Oil on canvas, 21 × 29½ in.
National Gallery (No. 2652)
Perhaps painted in 1816: cf. note on Plate 13.

16. BOATBUILDING, NEAR FLATFORD MILL
 Dated Sept. 7, 1814. Wednesday
 Pencil, $3\frac{3}{8} \times 4\frac{3}{8}$ in.
 From a Sketch-book
 Victoria and Albert Museum (No. 1259—1888)
The sketch-book in which this drawing is contained was in use in
Essex and Suffolk about 1st Aug. to 23rd Oct. 1814.

17. BOATBUILDING, NEAR FLATFORD MILL
 Oil on canvas, $20\frac{1}{4} \times 24\frac{1}{2}$ in.
 Victoria and Albert Museum (No. FA 37)
Exhibited R.A. 1815. According to Leslie, Constable stated that he
painted this picture entirely in the open air: cf. Leslie, p. 49.

18. FLATFORD MILL, ON THE RIVER STOUR
 Signed, and dated 1817
 Oil on canvas, 40×50 in.
 National Gallery (Isabel Constable Bequest: No. 1273)
Exhibited at the R.A. 1817 ('Scene on a navigable river'), probably at
the B.I. 1818, and at Worcester in 1835. Farington, who visited Con-
stable on 2 Jan. 1817, noticed 'a large Landscape composed of the
Scenery about Dedham, in Essex', which is certainly this painting. It
was the first of the series of large canvases which Constable exhibited
at the R.A. A drawing dated 14th Aug. 1814 in one of the sketch-
books at the Victoria and Albert Museum (No. 1259—1888, p. 61) is
closely related to the right-hand portion of the picture.

19. THE WHITE HORSE (A SCENE ON THE RIVER STOUR)
 Signed, and dated 1819
 Oil on canvas, 51×73 in.
 Frick Collection, New York
Exhibited R.A. 1819, B.I. (special exhibition) 1825, Lille 1826.
Bought by Archdeacon Fisher, and delivered to him in April 1820
(cf. Leslie, pp. 73–5): subsequently bought back by Constable and
sold at his posthumous sale in 1838. Engraved by Lucas (Shirley
No. 21).
The central part of the composition is based on a pencil-drawing in
the Sketch-book of August–October 1814 (Victoria and Albert
Museum No. 1259—1888, p. 66): this drawing is followed fairly
closely in an oil-study which was with Messrs. Tooth, Spring 1950.
Other studies exist, and what may be another version, or a full-size
study, was lent by J. Pender to the Old Masters Exhibition of 1872;
its present whereabouts is unknown.

20. THE COTTAGE IN THE CORNFIELD

Oil on canvas, $24\frac{1}{2} \times 20\frac{1}{4}$ in.
Victoria and Albert Museum (No. 1631—1888)

This painting has been generally supposed to be that exhibited by Constable at the R.A. 1817 and B.I. 1818. However, the measurements given in the B.I. catalogue (1 ft. 7 in. × 1 ft. 5 in. including the frame) seem to preclude this. Nevertheless, Leslie's description (p. 72) fits exactly as far as it goes, and on grounds of style the painting seems to belong to the year 1817–18. A small pencil sketch for this painting is also in the Victoria and Albert Museum (No. 828—1888).

21. TREES AT OLD HALL PARK, EAST BERGHOLT

Signed, and dated 22 Oct. 1817
Pencil, $23\frac{1}{2} \times 19\frac{1}{2}$ in.
Victoria and Albert Museum (No. E. 3237—1911)

Probably the drawing exhibited at the R.A. 1818 under the title 'Elms': cf. Leslie, p. 71.

22. SALISBURY CATHEDRAL AND CLOSE

Oil on canvas, $9\frac{3}{4} \times 11\frac{3}{4}$ in.
Victoria and Albert Museum (No. 318—1888)

Painted *c*. 1820.

23. DEDHAM MILL

Signed, and dated 1820.
Oil on canvas, $21\frac{1}{4} \times 30$ in.
Victoria and Albert Museum (Sheepshanks Gift: No. F.A. 34)

Studies for this painting are in the Victoria and Albert Museum (No. 145—1888) and in the Tate Gallery (No. 2661). Other finished versions exist.

24. HAMPSTEAD HEATH

Oil on canvas, $21\frac{1}{4} \times 30\frac{1}{4}$ in.
Fitzwilliam Museum, Cambridge

Similar in style to a view of Hampstead Heath in the National Gallery (No. 1236) which is datable *c*. 1820: also similar in style and dimensions to a *Hampstead Heath* in the Victoria and Albert Museum (No. F.A. 36) to which it may have been intended as a companion-picture.
A pencil-drawing for part of this picture is also in the Fitzwilliam Museum, Cambridge.

25. STUDY FOR 'SALISBURY CATHEDRAL FROM THE BISHOP'S GROUNDS'
Oil on canvas, 24 × 29 in.
Collection T. W. Bacon
See note on Plate 26.

26. SALISBURY CATHEDRAL FROM THE BISHOP'S GROUNDS
Signed, and dated 1823
Oil on canvas, 34 × 43½ in.
Victoria and Albert Museum (Sheepshanks Gift: No. F.A. 33)
Exhibited at the R.A. in 1823: painted for Bishop Fisher.
At least seven versions of this subject are recorded, of which this appears to be the prototype. Apart from the preliminary study (Plate 25), these are:
1. In the Laing Art Gallery, Newcastle.
2. In the Frick Collection, New York (signed, and dated 1826).
3. In the Metropolitan Museum, New York.
4. In the possession of the descendants of the Mirehouse family.
5. In the Martin Collection, Montreal.
6. With Messrs. Leggatt, London (in Oct. 1950).
In his journal of 25 Nov. 1825, Constable refers to 'three "Cathedrums"' (Leslie, p. 150).
A related drawing is in the Victoria and Albert Museum (No. 292—1888).

27. VIEW ON THE STOUR, NEAR DEDHAM
Signed, and dated 1822
Oil on canvas, 51 × 74 in.
Henry E. Huntington Library and Art Gallery, San Marino, California
Exhibited R.A. 1822, Paris Salon 1824. Constable refers to it in his letter of 13th April 1822 (Leslie pp. 89-90) in the passage starting: 'I have sent my large picture to the Academy. . . .' A full-size study is in the Royal Holloway College Gallery, Egham: the mezzotint by David Lucas (Shirley No. 19) is based on the study and not on the finished picture.

28. STUDY FOR 'THE HAY WAIN'
Oil on canvas, 54 × 74 in.
Victoria and Albert Museum (Vaughan Bequest: No. 987—1900)
The full-size study for the painting exhibited at the R.A. in 1821: see Plate 29 and note.

29. THE HAY WAIN
Signed, and dated 1821
Oil on canvas, 51¼ × 73 in.
National Gallery (Vaughan Gift: No. 1207)

Exhibited R.A. 1821 and B.I. 1822: one of the three paintings by Constable exhibited at the Paris Salon in 1824.

Several sketches and studies exist which are related to this painting: by far the most important of these is the full-size oil-study in the Victoria and Albert Museum (Plate 28). The details of this study were followed with remarkable closeness in the finished painting. The figure on horseback to the right of the dog in the study was at first present in the painting: Constable then removed it and substituted a barrel, which was removed in its turn, leaving the foreground as we now have it. Cf. Leslie, p. 79; cf. also Martin Davies, *National Gallery Catalogue: British School* (1946), pp. 23–6, and Sir Kenneth Clark, *The Hay Wain* (Gallery Book No. 5, London, n.d.).

30. STUDY OF CLOUDS AND TREES

Dated on the back, 11 Sept. 1821
Oil on millboard, $9\frac{3}{4} \times 11\frac{3}{4}$ in.
Royal Academy, Diploma Gallery

The full inscription on the back is as follows:—'Hampstead / Sept 11 1821 10 to 11 Morning / Clouds silvery grey on warm ground / Light wind to the S.W. / fine all day—but rain / in the night following'.
On this type of study, cf. Leslie, p. 94.

31. HAMPSTEAD; EVENING

Oil on paper, $8\frac{7}{8} \times 7\frac{1}{2}$ in.
Victoria and Albert Museum (No. 339—1888)

Painted *c.* 1822. On the reverse is a sky-study.

32. BRIGHTON BEACH, COLLIERS

Dated at back, 19th July 1824
Oil on paper, $5\frac{3}{4} \times 9\frac{3}{4}$ in.
Victoria and Albert Museum (No. 591—1888)

The full inscription on the back is as follows:—'3d / tide receding / left the beach wet—Head of the Chain Pier / Beach Brighton / July 19, Evg., 1824 / My dear Maria's birthday / Your Goddaughter— / very lovely Evening— / looking Eastward—Cliffs / & light of a dark gr(ey?) effect—b . . .-ground—very / white & golden (?) light.'
It is also inscribed, 'Colliers on the beach'.
It was in 1824 that Constable paid his first visit to Brighton.

33. COAST SCENE WITH FISHING BOATS

Oil on paper, 12×19 in.
Victoria and Albert Museum (No. 129—1888)

Painted *c.* 1824. The view was probably taken from Hove beach.

34. STUDY OF TREES, EVENING
 Dated at back, 4th Oct. 1823
 Oil on paper, $9\frac{3}{4} \times 12$ in.
 Victoria and Albert Museum (No. 152—1888)
Probably painted at Hampstead.

35. A BOAT PASSING A LOCK (Diploma Picture)
 Signed, and dated 1826
 Oil on canvas, $40 \times 49\frac{1}{2}$ in.
 Royal Academy, Diploma Gallery
This painting, presented to the R.A. by Constable in 1829 on his
election as an Academician, is related to 'The Lock' (R.A. 1824), but
is not, as it has often been called, a replica. It is a flat, rather than an
upright, rectangle: the trees are different, as are the figure and the
position of the barge. The Diploma Picture is closely based on a
drawing (formerly in the P. M. Turner collection, now Fitzwilliam
Museum), and a full-size oil-study ($40\frac{3}{4} \times 51$ in.) was recently bought
for the National Gallery of Victoria, Melbourne.

36. STUDY OF SKY AND TREES
 Dated on the back, 2nd Oct. 1821
 Oil on paper, $9\frac{3}{4} \times 11\frac{1}{2}$ in.
 Victoria and Albert Museum (No. 168—1888)
The full inscription on the back is as follows:—'Oct 2d 1821. 8 to 9—
/ very fine still morning, / turned out a may (?) day. / Rode with
Revd. Dr. White / round by Highgate, Muswell / Hill, Coney Hatch.
Finchley, by / Hendon, Home.'

37. THE LEAPING HORSE
 Oil on canvas, $53\frac{1}{2} \times 71$ in.
 Royal Academy of Arts
Exhibited R.A. 1825. There are two drawings for this composition
in the British Museum, and a full-size oil-study in the Victoria and
Albert Museum (Plate 39). There are several significant differences
between this study and the finished painting, which will be apparent
from the reproductions. Some alterations were carried out after the
painting had been exhibited—for example the willow-stump which
appears to the right of the horse in the study, and which was also
present in the painting when exhibited, was removed from the paint-
ing in September 1825 (Leslie, p. 145). Cf. Leslie, pp. 139, 142; cf. also
Charles Johnson, *The Growth of Twelve Masterpieces* (London 1947),
pp. 83–90.

38. 'THE LEAPING HORSE'—variant version
 Oil on canvas, $51\frac{1}{2} \times 70\frac{1}{4}$ in.
 Collection Major R. M. P. and the Misses Willoughby

This hitherto unrecorded full-size variant of 'The Leaping Horse' has several points of difference from the studies and from the finished painting. Chief among the differences is the fact that there are two horses, neither of which is leaping. The willow-stump, which in the final painting was removed, is here somewhat further to the right than in the full-size study.

This variant has been in the possession of its present owners' family since 1833.

39. STUDY FOR 'THE LEAPING HORSE'

Oil on canvas, 51 × 74 in.
Victoria and Albert Museum (Vaughan Bequest: No. 986—1900)

The full-size study for the painting exhibited at the R.A. in 1825: see Plate 37 and note.

40. THE CORNFIELD

Signed, and dated 1826
Oi lon canvas, $56\frac{1}{4} \times 48$ in.
National Gallery (No. 130)

Exhibited R.A. 1826, B.I. 1827, and at Worcester in 1835.
There is an oil study in the T. W. Bacon collection.
The scene was described by C. G. Constable, in 1869, as 'the lane leading from East Bergholt . . . to the pathway to Dedham across the meadows, a quarter of a mile from East Bergholt Church, and one mile from Dedham Church, as the crow flies. The little church in the distance never existed . . .' (*The Art Journal*, April 1869, p. 118).
This was the first painting by Constable in the National Gallery, being presented by a body of subscribers after his death in 1837: cf. Leslie, pp. 152-3, 267-8.

41. DEDHAM VALE

Oil on canvas, $55\frac{1}{2} \times 48$ in.
National Gallery of Scotland (No. 2016)

Exhibited R.A. 1828, and probably at Worcester in 1835. This painting was evolved with elaborations and some changes of detail from the small painting in the Victoria and Albert Museum (No. 124—1888), dated 1802 (Plate 1).

42. THE MARINE PARADE AND CHAIN PIER, BRIGHTON

Oil on canvas, $49\frac{1}{4} \times 71\frac{1}{2}$ in.
Tate Gallery (No. 5957)

Exhibited at the R.A. in 1827. Two oil-studies ($23\frac{3}{4} \times 38\frac{1}{2}$ in. and 13 × 24 in.) are in the Philadelphia Museum of Art (Wilstach and Johnson Collections); the larger of these is reproduced on Plate 90 of

the Redgraves' *Century of British Painters* (Phaidon Press 1947). A pencil-drawing is said to be in a private collection in the U.S.A.

43. SALISBURY CATHEDRAL FROM THE MEADOWS

Oil on canvas, $59\frac{3}{4} \times 74\frac{3}{4}$ in.
Collection Lord Ashton of Hyde

Exhibited R.A. 1831. Constable's last visit to Salisbury was in 1829; a drawing in the Lady Lever Art Gallery which is closely related to an oil-sketch of this subject in the National Gallery, London (No. 1814), bears that date: there is another drawing in the collection of L. G. Duke, which sketches the general composition and is probably of similar date. A painting in the Guildhall entitled 'Crossing the Ford' is an almost full-size study for the completed picture: a repaint over the Cathedral spire of the Guildhall painting has recently been removed, revealing a close correspondence.
Engraved by Lucas (Shirley No. 39): the smaller plate of this subject by Lucas (Shirley No. 30) has many important differences, and was probably based on one of the sketches.
Cf. Leslie, p. 191 and the National Gallery Catalogue on No. 1814 for further references.

44. SALISBURY CATHEDRAL FROM THE RIVER

Oil on canvas, $20\frac{3}{4} \times 30\frac{1}{4}$ in.
National Gallery (Salting Bequest: No. 2651)

Probably painted before August 1827, when Dunthorne had completed a painting which seems to have been based on this sketch: cf. Leslie, p. 163 and note.

45. STOKE-BY-NAYLAND, SUFFOLK

Wash, $5 \times 7\frac{1}{4}$ in.
Victoria and Albert Museum (No. 261—1876)

Drawn *c.* 1830. There are two drawings in a similar style in the Victoria and Albert Museum (Nos. 249, 250—1888), one of which bears the water-mark 1829.

46. STUDY OF TREE STEMS

Oil on paper, $9\frac{1}{2} \times 11\frac{1}{2}$ in.
Victoria and Albert Museum (No. 323—1888)

This sketch is usually dated *c.* 1830, and there are some grounds for supposing it to be a late work—for example its fresh, pale colour and its original composition. So far as technique is concerned, however, it could be ten years earlier than this.

47. ENGLEFIELD HOUSE

Oil on canvas, $40\frac{1}{2} \times 51\frac{3}{4}$ in.
Collection H. A. Benyon

Exhibited R.A. 1833. Commissioned by the owner of the house, Mr. Benyon de Beauvoir (cf. Leslie, p. 215). Some sketches which Constable made in the summer of 1832 are in the Victoria and Albert Museum (Nos. 255, 345 and 1258 to 1258b—1888). Mr. de Beauvoir objected to the cattle which Constable painted in the foreground, and traces of these can still be seen under the more imposing herd of deer which was substituted. Cf. Leslie, pp. 218, 221 and Shirley, *The Rainbow* (London 1949) pp. 189–92.

43. WATERLOO BRIDGE FROM WHITEHALL STAIRS, JUNE 18TH, 1817

Oil on canvas, $50\frac{1}{2} \times 79\frac{3}{4}$ in.
Collection Lord Glenconner

Exhibited R.A. 1832. Constable had a painting of this subject in mind over a long period: the earliest sketch is probably the pencil-drawing in the Victoria and Albert Museum (No. 290—1888): the next recorded sketch is that mentioned in a letter of 17th July 1819, and this was probably the 'painted sketch' which Farington criticized on 11th Aug. 1819 on the grounds that it was 'so much a bird's eye view'. Perhaps this was the oil-sketch now in the Diploma Gallery of the R.A. On 21 Nov. 1820 Farington saw 'a new begun picture of "A View on the Thames" . . .' and recommended Constable to submit something more corresponding to his last successful picture (i.e. 'Stratford Mill') to the R.A. next year. In a letter of 18 December 1832, Constable told Fisher that he planned to paint a *Waterloo* for the R.A. 1824, and in a letter of 22 Jan. 1824 he refers to his 'little *Waterloo*, a small balloon to let off as a forerunner of the large one': this is probably the oil-sketch in the Victoria and Albert Museum (No. 322—1888). Later in the same year (18 July 1824) he told Fisher that he had no inclination to continue with the painting. References in his journal to his wife and in a letter to Fisher (12th Nov.) show that he was working on a picture of the subject in October–December 1825, and that he proposed to have it ready for the R.A. Exhibition of 1826 'saving only the fatalities of life'. Leslie notes (p. 152) that Constable laid aside the *Waterloo* in the early months of 1826, but in a letter of 7th July 1826 Constable refers to it again. Thereafter, it is not mentioned until Sept. 1831, when Constable wrote to Lucas 'I fear that we must now engrave the *Waterloo*.' It was completed in time for the Exhibition of 1832.

A pen and ink drawing in the Victoria and Albert Museum (No. 604—1888) is perhaps related to the oil-sketch in the same Museum. A large oil-study is in the collection of Lord Fairhaven. A closer and

entirely different view of the subject is in the collection of Lord Camrose.

49. STONEHENGE, WILTSHIRE

Water-colour, $15 \times 23\frac{1}{2}$ in.
Victoria and Albert Museum (No. 1629—1888)

Exhibited R.A. 1836. There is a small pencil-drawing of the subject dated 18th July 1820 in the Victoria and Albert Museum (No. 309—1888): two water-colour-studies, in the Victoria and Albert Museum (No. 800—1888) and the British Museum (No. 22a) are even closer, and include the double-rainbow.

Constable refers to the water-colour as finished in a letter of 14:h Sept. 1835.

50. WATERMILL AT GILLINGHAM, DORSET

Oil on canvas, $19\frac{3}{4} \times 23\frac{3}{4}$ in.
Collection W. L. Lewis, New York

Exhibited R.A. 1826 ; thereafter in the Hand, Fry, Barton, Joel and Eckstein collections. Constable refers to this painting in his letter to Fisher of 14 Jan. 1826 (p. 151). A smaller study in oil ($9\frac{7}{8} \times 11\frac{7}{8}$ in.), agreeing in most details, is in the Fitzwilliam Museum, Cambridge; it is dated 1824 in a contemporary inscription.

51. HADLEIGH CASTLE: THE MOUTH OF THE THAMES

Oil on canvas, $48\frac{1}{4} \times 66$ in.
National Gallery (No. 4810)

The study for the painting exhibited at the R.A. in 1829. A quotation from Thomson's *Summer* was attached to the entry in the R.A. catalogue. Constable visited Hadleigh in June/July 1814 (cf. Leslie, p. 48) and there is a closely related drawing of the castle of this date in the Victoria and Albert Museum (No. D.234—1888).

The present whereabouts of the completed picture is not known, but two engravings from it by Lucas (Shirley Nos. 11 and 34) suggest that it followed the study fairly closely in composition and much of its detail.

52. THE CENOTAPH AT COLEORTON, IN MEMORY OF SIR JOSHUA REYNOLDS

Pencil, $10\frac{1}{4} \times 7$ in.
Victoria and Albert Museum (No. 835—1888)

At the back are an inscription in ink, *Coleorton Hall—Novr. 28, 1823,* and a commemorative poem by Wordsworth on Reynolds beginning *Ye Limetrees ranged* ... (cf. Leslie, pp. 254-5). See Plate 53 and note.

53. THE CENOTAPH AT COLEORTON, IN MEMORY OF SIR JOSHUA
REYNOLDS

Oil on canvas, 52 × 42¾ in.
National Gallery (Isabel Constable Bequest: No. 1272)

Exhibited R.A. 1836. Constable visited Sir George Beaumont at
Coleorton in the autumn of 1823. He refers to the Cenotaph in a
letter dated 2nd November of that year. Leslie states (p. 114) that he
made a drawing of the subject while at Coleorton; this is almost
certainly the drawing reproduced on Plate 52.
Constable first refers to the painting in a note to Leslie of the early
part of 1833 (Leslie p. 218): apart from this reference and the fact that
it was ready for exhibition in 1836, there is no further information
concerning its execution.

54. ARUNDEL MILL AND CASTLE

Oil on canvas, 39⅝ × 28⅝ in.
Toledo Museum of Art, Toledo, Ohio

Exhibited R.A. 1837, after Constable's death (cf. Leslie, p. 267).
Constable refers to it in a letter of 17 Feb. 1837 to George Constable,
and it was the last work which he brought near completion. It is
based in detail on a pencil-drawing dated 9th July 1835 which is in
the Victoria and Albert Museum (No. 260—1888): this is perhaps the
'little sketch' mentioned in a letter of 12th January 1836 to George
Constable. Constable had at first intended to have the picture ready
for the R.A. Exhibition of 1836, but he laid it aside in favour of
'The Cenotaph' (cf. Leslie pp. 253-4).

55. COUNTRY ROAD AND SANDBANK

Oil on paper, 6⅞ × 8⅜ in.
Victoria and Albert Museum (No. 327—1888)

Painted *c*. 1835.

56. THE GROVE (OR ADMIRAL'S HOUSE) AT HAMPSTEAD

Oil on canvas, 14 × 11¾ in.
National Gallery (Isabel Constable Gift: No. 1246)

Probably the painting exhibited at the R.A. 1832, called *A romantic
house at Hampstead*. Other views of this house by Constable are in the
National Galerie, Berlin, and in the Victoria and Albert Museum
(No. 137—1888).

57. STUDY FOR 'THE VALLEY FARM'

Oil on canvas, 10 1/16 × 8¼ in.
Victoria and Albert Museum (No. 140—1888)

A study for the painting exhibited at the R.A. in 1835, which is now in the Tate Gallery. Leslie states (p. 240) that the 'Valley Farm' was taken from 'an early sketch', by which he may mean the sketch here reproduced, or another and closely related sketch in the Victoria and Albert Museum (No. 143—1888). In style however these two sketches seem to belong to the period of the picture. A pencil-drawing, which suggests the composition with some exactitude, is in the 1813 sketch-book in the Victoria and Albert Museum (No. 317—1888, p. 31): it may be to this that Leslie refers.

58. STUDY OF A TREE, FOR 'THE VALLEY FARM'

Water-colour, 40 × 26¾ in.
Victoria and Albert Museum (No. 1249—1888)

This large water-colour is one of a pair in the Victoria and Albert Museum; both are squared for transference and seem to be related to 'The Valley Farm' (R.A. 1835). The present example is based in careful detail on a pencil-drawing in the same Museum (No. 252—1888).

WORKS EXHIBITED BY CONSTABLE
AT THE ROYAL ACADEMY

1802 19 A Landscape
1803 59 A Study from Nature
 694 A Study from Nature
 724 A Landscape
 738 A Landscape
1805 148 A Landscape: Moonlight
1806 787 His Majesty's Ship *Victory*, Capt. E. Harvey, in the memorable battle of Trafalgar, between two French ships of the line
1807 52 View in Westmoreland
 98 Keswick Lake
 150 Bow Fell, Cumberland
1808 52 Winander-meer Lake
 100 A Scene in Cumberland
 103 Borrowdale
1809 26 A Landscape
 28 A Landscape
 183 A Landscape
1810 74 A Landscape
 116 A Church-yard
1811 71 Twilight
 471 Dedham Vale: Morning
1812 9 A Water-mill
 72 Landscape: Evening
 133 Landscape: A recent shower
 372 Salisbury: Morning
1813 266 Landscape: Boys fishing
 325 Landscape: Morning
1814 28 Landscape: Ploughing scene in Suffolk
 261 Landscape: The ferry
1815 20 View of Dedham
 146 Landscape: A sketch
 215 Boat Building
 268 Village in Suffolk
 310 Landscape
 415 A Drawing

1815 446 A Drawing
510 A Drawing
1816 169 The Wheat field
298 A Wood: Autumn
1817 85 Wivenhoe Park, Essex, the seat of Major-General Rebow
141 A Cottage
216 Portrait of the Rev. J. Fisher
255 Scene on a navigable river
1818 11 Landscape: Breaking up of a shower
34 Landscape
142 Landscape: A Study
304 Landscape: A study
446 A Gothic Porch
483 Elms
1819 251 A Scene on the River Stour
1820 17 Landscape
148 Harwich Lighthouse
1821 89 Hampstead Heath
132 A Shower
135 Harrow
339 Landscape: Noon
1822 111 Hampstead Heath
183 View on the Stour, near Dedham
219 Malvern Hall, Warwickshire
295 View from the Terrace, Hampstead
314 A Study of Trees from Nature
1823 59 Salisbury Cathedral from the Bishop's Grounds
179 Study of Trees
244 A Cottage
1824 180 A Boat passing a Lock
1825 115 Landscape
186 Landscape
224 Landscape
1826 122 A Mill at Gillingham in Dorsetshire
225 Landscape
1827 48 Mill, Gillingham, Dorset
186 Chain Pier, Brighton
290 Hampstead Heath
1828 7 Landscape
232 Landscape
1829 9 Landscape

1829 322 Hadleigh Castle. The mouth of the Thames—morning, after a stormy night

1830 19 Dell Scene, in the park of the Rt. Hon. the Countess of Dysart at Hatmingham (sic), Suffolk
 94 Landscape
 248 A Heath

1831 123 Yarmouth Pier
 169 Salisbury Cathedral from the Meadows

1832 147 Sir Richard Steele's Cottage, Hampstead
 152 A Romantic House at Hampstead
 279 Waterloo Bridge, from Whitehall Stairs, June 18th, 1817
 286 Moonlight
 492 Jaques and the wounded stag
 632 A Church
 643 A Mill
 644 Farm-house

1833 34 Englefield House, Berkshire, the seat of Richard Benyon de Bouvoir, Esq.—morning
 94 A Heath, showery—noon
 344 Cottage in a Cornfield
 402 Landscape—sunset
 639 An Old Farm-house
 645 A Miller's House
 647 A Windmill—squally day

1834 481 The Mound of the City of Old Sarum, from the south
 548 Study of Trees, made in the grounds of Charles Holford, Esq., at Hampstead
 582 Stoke Pogis Church, near Windsor, the scene of Gray's Elegy—also where he was buried
 586 From Gray's Elegy, stanza 11

1835 145 The Valley Farm
1836 9 Cenotaph to the memory of Sir Joshua Reynolds, erected in the grounds of Coleorton Hall, Leicestershire, by the late Sir George Beaumont, Bart.
 581 Stonehenge
1837 193 Arundel Mill and Castle

WORKS EXHIBITED BY CONSTABLE
AT THE BRITISH INSTITUTION

The measurements, which are quoted from the B.I. Catalogues, include the frame in each case. They are given in feet and inches.

Year	No.	Title	Dimensions
1808	380	A mountainous scene in Westmoreland	3·4 × 4·0
	480	Moonlight: a Study	1·11 × 1·8
1809	80	Windermere Lake	1·2 × 1·4
	248	Borrowdale	2·7 × 2·3
	260	A Cottage scene: a Study	2·1 × 1·10
	282	Keswick Lake	1·10 × 2·5
1811	288	A Church Porch	2·1 × 1·10
1813	104	Landscape: a scene in Suffolk	3·7 × 5·2
1814	98	Landscape: a Lock on the Stour	4·1 × 4·1
	216	Martin Cats	3·0 × 4·4
1815	115	Landscape	2·8 × 3·5
1817	132	A Harvest Field: Reapers, Gleaners	2·9 × 3·6
1818	91	Scene on the Banks of a River	4·10 × 5·8
	129	A Cottage in a Cornfield	1·7 × 1·5
1819	44	Osmington Shore, near Weymouth	3·4 × 4·0
	78	A Mill	3·3 × 3·11
1822	197	Landscape, Noon	5·8 × 7·7
1823	35	Landscape	5·8 × 7·6
	148	Yarmouth Jetty	1·8 × 2·3
1824	46	Salisbury Cathedral from the Bishop's Grounds	3·0 × 4·9
1827	101	Landscape, Noon	5·10 × 5·3
	314	The Glebe Farm	2·7 × 3·1
	321	A Mill at Gillingham, Dorset	2·6 × 2·10
1828	64	The Beach at Brighton, the Chain Pier in in the distance	5·8 × 8·3
1829	38	Landscape and Lock	4·10 × 5·7
	348	Landscape, a cottage scene	3·4 × 4·3
1833	155	Salisbury from the Meadows	6·6 × 7·8
	156	Dell Scene	3·2 × 3·10
1834	128	A Cottage in a field of corn	2·10 × 2·6

1834	174	A Heath scene, showery day	2·8 × 3·6
	329	The Stour Valley, which divides the Counties of Suffolk and Essex; Dedham and Harwich Water in the distance	6·0 × 5·3
1836	43	The Valley Farm	6·1 × 5·3

INDEX

Aberdeen, Earl of, 41, 182
Abernethy, Dr., 130
Abingdon, 81
Adelaide, Queen, 194
Albano, 295, 307
Algarotti, Count, 305, 306
Allan, Sir W., 254
Allnutt, John, 46, 47
Andrews, Bishop, 330
Angerstein, J. J., 82, 132
Antwerp, Academy at, 123
Appleton, Mr., 127
Aretino, Pietro, 306
Arnott, Miss, 150
Arrowsmith, Mr., 118, 120, 121, 125, 147
'Artists' General Benevolent Fund', 231, 265
Artois, Jacques, 299
Arundel, 231-2, 244
Arundel Mill and Castle, 86, 249, 250, 253, 259, 265, 267, Pl. 54
Ashby, 110
Autumnal Sunset, 181, 184

Bacon, Lord, 284, 289, 323, 327, 330
Baillie, Dr., 99
Balmanno, Mr., 150
'Bambocciate, The', 310-11
Bannister, Jack, 149, 150, 163, 186, 193, 229, 238, 247, 257, 287
Barges on the Stour, Pl. 9
Barker, T. E., 17
Barnardo, 292
Barret, George, 321
Barrow, 246
Barry, James, 274
Barry, Spranger, 272
Bassani, the, 319
Bayeux tapestry, 290
Beauchamp, John, 217
Beaumont, Dowager Lady, 5, 174
Beaumont, Sir George, 5, 10, 15, 23, 33, 77, 81, 82, 98, 104, 107-14, 117-18, 126, 127, 133, 146, 183, 222, 254, 277, 309, 327
Beauvoir, Benyon de, 215
Bedford, Duke of, 216
Beechey, Sir William, 190, 229
Bellini, the brothers, 293
Bembo, Cardinal, 330

Berghem, Nicolas, 301, 306, 310, 327
Bicknell, Charles, 25, 26, 43, 53, 58, 62, 63, 66, 69, 70, 147, 157, 166
Bicknell, Maria (*see also* Maria Constable), 24-45, 48-70
Bicknell, Mrs., 52, 55
Bigg, W. R., 103, 106, 146, 147, 188, 204
Bigg, Miss, 150
Billy, Master, 146, 150
Birmingham, 233
Blake, William, 280
Blenheim Palace, 81
Boat-building, 49-50, 56, 285, Pl. 16, 17
Boat passing a lock, Pl. 35
Bognor, 34, 35
Bone, H. P., 242
Bonner, Charles, 215, 226, 229, 239
Borrowdale, 19, Pl. 4
Both, Jan, 301, 306, 310
Boucher, Francois, 312
Bourdon, Sebastian, 298, 309, 311
Bourgeois, Sir Francis, 17
Bow Fell, Cumberland, 19
Bradford, Lord, 43
Brantham, 18, 20, 21
Bridgman, Rev. G., 43
Brighton, 51, 123, 151, 210
Brighton Beach: Colliers, Pl. 32
'Brighton Gazette,' 158, 159, 161
Brighton: The Marine Parade and Chain Pier, 162, 163, 170, Pl. 42
Brill, Paul, 298, 308
British Institution, 19, 21, 40, 44, 46, 71, 73, 74, 90, 95, 97, 126, 128, 137, 143, 162, 179, 230, 250
British Museum, 107
Brockedon, William, 132
Brookes, Joshua, 12
Brooks, Mr., 241
Brougham and Vaux, Lord, 194, 195
Brown tree, Sir George Beaumont's, 114
Bryan, Michael, 11, 241
Burgess, Bishop, 152, 160, 161
Burke, Edmund, 320
Burnet, John, 163
Burns, Robert, 94, 264
Burton, L. Archer, 76
Byron, Lord, 41, 57, 123

Callcott, Dr., 37
Callcott, Sir A. W., 47, 100, 154, 156, 175, 206
Calvart, Denis, 295
Canaletto, 207
Canterbury, Archbishop of, 199
Carey, Mr., 248
Carey, William, 246
Caroline, Queen, 76
Carpenter, James, 46, 147
Carpenter, William, 241, 248, 255
Carr, Rev. W. H., 193, 203
Carracci, Agostino, 283
Carracci, Annibale, 10, 107, 294-5
Carracci, the, 283, 294, 296, 297, 298, 303, 307, 308
Cennini, Cennino, 275
Cenotaph, The, 114, 218, 254, Pl. 52, 53
Chalon, A. E., 127, 172, 184, 206, 216, 229, 230, 239
Chalon, J. J., 1, 127, 172, 216, 217, 221, 229, 239, 247
Chantrey, Sir Francis, 156, 166, 177
Charlotte, Queen, 145
Chatham, 16
Cheverton, Thomas, 272
Chiaroscuro, 207, 290
Chinese painting, 327-8
Choiseul, Duc de, 138
Choiseul Gallery, 137
Church Porch, 20, 21, 182, 204
Chymist and Alchymist, 7
Cicero, 140
Cimabue, 291
Claude, 5, 10, 74, 75, 82, 83, 85, 94, 95, 96, 98, 101, 103, 106, 107, 108, 109, 110, 111, 112, 114, 117, 132, 167, 177, 178, 203, 235, 244, 274, 276, 277, 297, 298, 307-9, 310, 317, 318, 320, 321, 326, 327
Clint, George, 91
Clouds, Study of, Pl. VIII
Clouds and Trees, Study of, Pl. 30
Coast Scene with fishing boats, Pl. 33
Coleman, Mr., 239
Coleorton Hall, 107-14, 117, 278
Coleridge, S. T., 82-3, 180, 314
Collins, F., 126
Collins, William, 81, 125, 154, 241, 278, 279
Colnaghi, Dominic, 167
Commons, House of, 210
Conroy, Mrs., 50
Constable, Abram (brother), 4, 45, 129, 165, 239, 284

Constable, Alfred (son), 203, 204, 205, 212, 229, 241, 246
Constable, Ann (sister), 65, Pl. II
Constable, Archibald, 133
Constable, Charles (son), 217, 223, 245, 246, 250, 251, 256, 257
Constable, Emily (daughter), 209
Constable, George, 214, 219, 223, 225, 226, 231, 232, 235, 236, 237, 239, 240, 243, 244, 245, 247, 248, 250, 253, 255, 257, 259, 282
Constable, Golding (father), 1, 2, 3, 25, 28, 33, 60, 61, 62, 63, 64, 65
Constable, Hugh (great-grand-father), 2
Constable, John (son), 71, 99, 170, 190, 213, 217, 223, 224, 226, 229, 231, 232, 233, 240, 243, 246, 247, 249, 250, 251, 255-6, 257, 265, 266, 285
Constable, Lionel Bicknell (son), 165, 204, 229
Constable, Maria (wife—see also Maria Bicknell), 71, 73, 81, 84. 106, 107, 108, 110, 111, 112, 113, 114, 117, 124, 134, 146, 147, 148, 149, 151-2, 155, 161, 165, 166, 167, 168, 214, 264, Pl. VII
Constable, Mary (sister), 28, 30, Pl. II
Constable, Minna (daughter), 74, 150, 166, 178, 183, 200, 201, 208, 209, 210, 244
Constable, Anne (mother), 5, 8, 21, 26, 34, 38, 50, 51, 53, 54, 55
Cook, Captain, 223
Cook, Richard, 260
Cooper, Astley, 104
Cooper, Samuel, 234
Cornfield, The, 142, 152, 153, 156, 162, 179, 209, 246, 252, 268, Pl. 40
Cornfield with reapers, 13
Correggio, 88, 89, 102, 107, 314, 315
Cortona, Pietro da, 303, 311
Cottage, A, 71, 101, 175
Cottages, 7
Cottage in a Cornfield, A, 71-2, 218, 221, 230, Pl. 20
Country Road and Sandbank, Pl. 55
'Courier, The', 102
'Coutts, The', 16
Cowper, William, 33, 34, 274
Coxe, Peter, 45, 166, 172
Coxe, William, 37, 88, 102, 107, 166, 167
Cozens, Alexander, 241

Cozens, J. R., 22, 74, 82, 109, 241, 299, 322
Cumberland, 18
Cumberland, Scene in, 19
Curtis, Sir William, 102, 104
Cuyp, Aelbert, 225, 234, 299, 316

Danbury, 48
Danby, Francis, 178
Dante, 155
Darby, Francis, 143, 148
David, Louis, 96–7, 242, 313
Davidson, Mr., 226
Davis, Dr., 189, 190
Dawe, George, 55, 56
Dawson, Benjamin, 198
Dayes, Edward, 241
Deal, 16
Dedham, 115
Dedham Mill, 180, Pl. 23
Dedham Vale, 21, 22, 166, 230, 246, Pl. I, II, 41
Demosthenes, 140
Derbyshire, 11, 12
'Diorama', 106
Diploma Picture, 150, Pl. 35
D'Israeli, Isaac, 130
Dodsworth, Mr., 96
Dolci, Carlo, 89
Domenichino, 281, 294, 295–6, 297, 307
Dover, 16
Drew, Mr., 190
Driffield, Rev., 48, 67
Dunn, Mr., 328
Dunthorne, John, sen., 3, 8, 9, 11, 12, 15, 45, 212, 220, 239
Dunthorne, John, jun., 45, 124, 126, 128, 129, 130, 144, 149, 150, 152, 154, 156, 158, 159, 163, 167, 208–12, 220, 239, 264
Dunthorne, Thomas, 220
Dürer, Albrecht, 293, 303, 306
Dysart, Countess of, 105, 120, 145, 167, 175, 193, 233, 258
Dysart, Earl of, 11, 19, 33

East Bergholt, 1, 2, 7, 12, 15, 25, 29, 33, 50, 54, 56, 57–62, 65, 71, 74, 167, 249, 285
East Bergholt Church, 54, Pl. 12
Eastlake, Sir Charles, 241
Edensor, 11, 12, Pl. 2
Edwards, Edward, 241
Egerton, Lord Francis, 295
Egremont, Lord, 204, 216, 223, 233, 234, 235, 247

Elsheimer, Adam, 307, 308
Emmet, 260
Englefield House, 214, 215, 218, 221, Pl. 47
English Landscape, 2, 45, 90, 121, 129, 159, 178, 179, 180, 181, 185, 187, 188, 189, 190, 194, 196, 205, 212, 214, 221, 285
Epsom, 30, 195
Epsom, View at, Pl. 3
Essex, Lord, 193
Etty, William, 156, 187, 188
Euripides, 140
Evans, Dr., 168, 170, 171, 175, 177, 199, 202, 208, 210, 211, 230
Eyck, van, 292

Falcone, Aniello, 310
Farington, Joseph, 6, 29, 30, 36, 88, 91, 92, 146
Farmhouse, An Old, 221
Feering, 48
Ferrars, Lord, 110
Ferry, A, 48
Field, George, 269, 270, 271, 317
Finden's *Gallery of British Art*, 90
Fiore, Jacopo del, 258
Fisher, Bishop, 14, 15, 29, 32, 38, 42, 75, 78, 79, 92, 95, 99, 118, 125
Fisher, Dr., 263
Fisher, Conrad, 50
Fisher, John, 31, 32, 37, 38, 42, 50, 68, 69, 71–9, 81–6, 88–90, 92–6, 99–108, 115, 118–23, 125, 128–34, 136–40, 143–5, 150–6, 158–70, 172, 174–8, 180, 192, 205, 210, 211, 264, 281, 285, 324, 326, Pl. VII
Fisher, J. K., 187, 204, 210
Fisher, Mrs. John, 69, 99
Fitzgerald, 260
Fitzwilliam, Lord, 125
Flatford, 45, 49, 165, 285
Flatford Mill, 29, 246, Pl. 18
Flaxman, Thomas, 41
Flowers, Study of, Pl. XI
Foggo, George, 244
Folkard, Mrs., 220
Fontaine, Old, 145
Fontana, Prospero, 295
Fonthill, 105
Forbin, Comte, 133
Forgeries, 279
Forster, Captain, 93
Forster, Thomas, 258
Fouquières, J., 299
Francanzani, Francesco, 310

Fuller, Thomas, 330
Fuseli, Henry, 73, 100–1, 224, 274, 287, 314, 319, 328

Gainsborough, Thomas, 9, 22, 33, 142, 179, 203, 204, 233–4, 249, 270, 299, 311, 322
Gandy, J. M., 200
Gardner, Daniel, Pl. I
Garrick, David, 272, 274
Geology, 272
Gessner, Salomon, 7, 65
Ghirlandaio, 292
Gillingham, 105, 106, 115
Gillingham Mill, 151, 152, 156, 162, 246, Pl. 50
Giorgione, 293
Giotto, 291
Girtin, Thomas, 5–6, 22, 299, 322
Glebe Farm, The, 159, 162, 212, 246, 257, 286
Glover, John, 80, 83, 108, 193
Godfrey, Peter, 1
Golding Constable's House, 2, 285, Pl. 7, 8, V
Goltzius, Hendrik, 311
Gooch, Dr., 99, 104, 111, 281
Gothic Porch, A, 71
Grace Dieu, 110
Gravesend, 16
'Green Highgate', 93
Greenwich, 64
Greuze, J. B., 193, 200
Grimwood, Dr., 3
Grosvenor, Lord, 191
Group of Elms, A, 71
Grove, The, Pl. 56
Gubbins, Miss, 76
Gubbins, Richard, 145–6
Guercino, 101
Guido Reni, 242, 295, 296

Hackert, J. P., 301, 311
Hadleigh, 48
Hadleigh Castle, 173, 174, 176, 177, 179, 181, 184, Pl. 51
Haines, Mr., 208
Ham House, 105, 175, 233, 234, 237
Hamlet, Mr., 145
Hampstead, 72, 76, 161, 162, 164, 173, 200, 211, 212, 222, 229, 242, 289
Hampstead, Lady, 146
Hampstead Literary and Scientific Society, 289, 325

Hampstead, A Romantic House, 208, Pl. 56
Hampstead; Evening, Pl. 31
Hampstead Heath, 72, 79, 92, 143, 162, 166, 185, 205, 218, 221, 230, 246, 256, Pl. 24
Hampstead, Sir Richard Steele's Cottage, 208
Hampstead, View of the Terrace, 92
Hand, Mr., 151
Hand, Mrs., 126
Harden, John, Pl. III
Harrow, 79
Harvest-field, 71
Harwich Lighthouse, 77
Haydon, B. R., 109, 244
Hayley, William, 34
Hay Wain, The, see Landscape: Noon
Heathcote, Lady, 29, 31, 36, 43
Heem, David de, 103
Helmingham, 11, 184, 185, 186
Helmingham Park, 184, 185, 186
Henderson, Mr., 36
Herbert, J. R., 254
Hobbema, Meindert, 131, 203, 242
Hofland, T. C., 95
Hogarth, William, 179, 268–9, 311, 320, 323
Homer, 140
Hoogh, Pieter de, 211, 212, 213, 273, 317
Hopkins, Capt., 245, 246
Hoppner, John, 31, 33
Horace, 140
Hoskins, J., 1, 234
Hottentots, the, 81
Howard, Henry, 193, 306
Huysman, Cornelis, 299

Irving, Edward, 204
Irving, Washington, 125, 129–30

Jackson, John, 20, 81, 89, 125, 154, 166, 175, 177, 188, 191
'Jack the Giant-killer', 161
James, J. T., 248
Jansen, Cornelius, 234
Jaques and the Wounded Stag, 185, 208
'John Bull', 130
Johnson, Dr., 171, 234, 280
Jones, George, 172, 204
Judkin, Rev. T. J., 102, 266

Kauffmann, Angelica, 312
Kean, Edmund, 158
Kemble, J. P., 29

Keswick Lake, 19, Pl. 5
Kneller, Sir Godfrey, 102
Knight, J. P., 254

Laar, Peter de, 310
Lambert, George, 320
Lambert, Mr., 67, 136, 137
Landscape, Ancient, 290
Landscape: A Lock on the Stour, 46
Landscape: A Scene in Suffolk, 40
Landscape: Boys Fishing, 40
Landscape: Breaking up of a Shower, 71
Landscape: Morning, 40
Landscape: Noon (The Hay Wain), 77, 78, 79, 81, 82, 90, 103, 104, 118, 119, 134, 285, Pl. 28, 29
Landseer, Sir E. H., 183, 193, 200, 213, 217, 220, 241
Landseer, Charles, 254
Lane, Samuel, 88, 154, 165, 167, 185, 215, 221, 261
Langham, 159, 181
Lavenham, 2
Lawley, Francis, 205
Lawrence, Sir T., 29, 30, 44, 82, 102, 117, 125, 131, 137, 145, 154, 156, 166, 173, 175, 182, 183, 185, 186, 191, 196, 243, 279, 280, 323
Lanzi, Luigi, 255
Leaping Horse, The, 136, 139, 142, 145, Pl. 37, 38, 39
Lectures at Hampstead (1833), 222–3, 289–301, (1835) 242, 244, (1836) 325–31
Lee, F. R., 217
Leicester, Sir John, 101
Lennard, Lady, 40
Lennard, Sir Thomas, 43
Leonardo da Vinci, 28, 326
Leslie, C. R., 71, 125, 127, 129–30, 145, 157, 168, 170–1, 173, 177, 181–3, 185–8, 191–5, 198–206, 208–23, 229, 231, 233–9, 241–3, 245–8, 252–3, 256–8, 260, 262, 265, 284–6
Le Sueur, Eustache, 311
Leyden, Lucas van, 293
'Library of the Fine Arts', 191
Life Academy, 187, 202, 258, 260, 261–3
Lille, 145, 149, 151
Linnaeus, 101
Linnell, John, 244
Linwood, Miss, 12, 108
Liston, John, 158

Lock, The, 115, 118, 120, 121, 122, 134, 141, 142, 150, 153, 179, 226, 235, 252
Lock and Cottages on the Stour, Pl. 10
Loutherbourg, Philip de, 301
Louvre, Musée du, 123, 133, 137, 138, 171
Lucas, David, 77, 142, 179–81, 183–5, 188–90, 196, 198, 200, 209, 212–14, 220, 226–7, 243, 252, 259–61, 263
Lucatelli, Pietro, 311
Ludgate, Mr., 217
Luther, Martin, 329
Lyttelton, Lord, 195–6

Maclise, Daniel, 262–3, Pl. XIV
Malden, 48
Malvern Hall, 92, Pl. 6
Manners, Lady Louisa, 31, 33
Maratti, Carlo, 97
Martin Cats, 44
Martin, John, 79, 81, 178
Matthews, Henry, 78, 80, 83
Melancthon, Philip, 330
Mellon, Miss, 146
Mengs, A. R., 312
Mere Church, 151
Mermaid Inn, 171
Michelangelo, 162, 188, 283, 310, 311, 315
Michele, Mr., 266
Mill, A., 73, 217
Miller's House, A, 221
Milton, John, 101, 106, 155, 175, 176, 328, 329
Mirehouse, Mr., 118, 147, 149
Mola, P. F., 307
Moon, Mr., 209
Moonlight, 208
Moore, Jacob, 301, 311
Morland, George, 147
Morley, Lady, 218
'Morning Post, The', 221
Morrison, Charles, 121, 125
Murillo, B. E., 322

National Gallery, 97, 152, 193, 203, 209, 267, 268, 295
Nayland, 20, 167
Neave, Sir Digby, 126, 195–6
Newbury, 81
Newton, G. S., 127, 166, 183, 186, 213, 214
Noble, Miss, 209, 210, 243, 260
Northcote, James, 91, 134, 146, 161, 175, 192, 275

Northwick, Lord, 193, 242

Old Hall Park, Trees at, Pl. 21
Old Sarum, 196, 197–8, 212, 227, 231
Ormsby, Sir Thomas, 223
Orwell, View on the, 196
Osmington, 68, 92
Osmington Shore, near Weymouth, 73
Ostade, Adriaen, 137, 274
Ottley, W. Y., 126, 127, 244
Owen, William, 30, 126, 191
Oxford, 81

Palette knife, 207, 216
Paley, William, 139, 330
Pannini, Paolo, 312
Panoramas, 17
Parham, Matthew, 148
Paris, 90, 132, 133, 134, 137, 141
Parliament, Houses of, 237
Partridge, John, 242, 254
Partridge, Professor, 266
Patel, P., 320
'Paul Pry', 157
Peel, Sir Robert, 273
Pembroke, Lord, 157
Pennell, 244
Perne's Mill, 148
Petworth, 202, 223, 232, 233, 235, 236, 256
Phillips, Henry, 124, 152, 153, 158
Phillips, Thomas, 154, 175, 220, 232, 233, 235, 236, 306
Pickersgill, H. W., 175, 187
Pindar, 140
Pitt, 220
Pliny, 290
Ploughing Scene in Suffolk, A, 48
Pope, Alexander (poet), 102
Pope, Alexander (actor), 158
Poussin, Gaspar, 11, 17, 80, 95, 108, 114, 193, 274, 297, 320, 321
Poussin, Nicolas, 84, 151–2, 274, 296, 297, 310, 311, 314, 321
Powell, Peter, 204
Purton, William, 230, 233, 238, 250, 267, 284, 286–7, 306
Putney Heath, 57, 58, 66, 67
Pye, John, 322

Quintilian, 327

Radnor, Lord, 37
Raphael, 5, 95, 187, 262, 280, 283, 292
Read, 96

Reading, 81
Rebow, General, 35, 66, 67–8, 74, 223
Reform Bill, 198, 199
Regent, the Prince, 41, 59
Reinagle, R. R., 10, 17
Rembrandt, 82, 98, 193, 227, 243, 274, 299, 315–17, 319
Reynolds, Sir Joshua, 15, 19, 31, 33, 34, 40, 41, 80, 85, 109, 114, 167, 183, 204, 234, 246, 254, 281, 283, 305, 306, 311, 312, 320–1
Reynolds, S. W., 134, 141, 142
Rhudde, Rev. Dr., 1, 25, 29, 34, 54–5, 56, 61, 62, 63, 70
Ribera, Jusepe, 310
Ricci, Marco, 312
Richardson, Jonathan, 101
Richmond, 33, 44
Ripley, Mr., 93, 147
Roberts, David, 254
Roberts (nurse), 208, 214, 246, 260
Roberts, Mrs., 1, 12
Robertson, Andrew, 173, 268
Rochard, S. J. or F. T., 127
Rochefoucault, 158
Rochester, 16
Rochford, 48
Rodney, Lord, 204
Rogers, Samuel, 252, 253
Romney, George, 321
Rosa, Salvatore, 85, 298, 310, 320, 327
Rowley, Rev. D. C., 212
Royal Academy, 8, 9, 12–15, 19–21, 29, 40, 41, 44, 49, 64, 71–5, 77, 79, 82, 83, 89, 100, 120, 140–2, 155, 156, 161, 166, 171, 173, 174, 176, 177, 182, 183, 185–9, 191, 192, 199, 200, 206, 210, 216, 219, 221, 224, 230, 240, 244, 245, 247, 252–4, 260–2, 264, 267, 281, 321
Royal Institution, 98, 253, 255, 289, 301–24
Royal Scottish Academy, 149
Rubens, Sir P. P., 37, 97, 103, 114, 193, 253, 299, 315, 319
Ruin, A, 212
'Ruysdael House', 72
Ruysdael, Jacob, 7, 8, 10, 74, 83, 94, 103, 131, 161, 211, 235, 242, 248, 299, 317–19

Salisbury, 27, 76, 87, 105, 175, 177
Salisbury Cathedral and Close, Pl. 22

Salisbury Cathedral from the Bishop's Grounds, 93, 95–6, 100, 101, 118, 125, 138, 147, 148, 149, 150, 159, 225, Pl. 25, 26

Salisbury Cathedral from the Meadows, 179, 191, 217, 233, 235, 237, 243, 245, 246, 252, 259, 260, 261, 263, 267, Pl. 43

Salisbury Cathedral from the River, Pl. 44

Salisbury, View of, 29

Sass, Henry, 188

Savage, Mrs., 174

Scene on a Navigable River (Flatford Mill), 71, Pl. 18

Scene on the River Stour, see *The White Horse*

Schlegel, A. W., 168

Schroth, Mr., 118, 143

Scott, Sir Walter, 119

Seabeach, A, 248

Seguier, William, 216

Shaftesbury, Lord, 84

Shakespeare, William, 86, 94, 107, 132, 161, 261, 273

Shee, Sir Martin Archer, 154, 183, 193, 220, 221, 230, 248, 254, 306

Sheepshanks, John, 257

Shower, A, 79

Siddons, Mrs., 41

Sketch-books, 288, Pls. XII, XIII

Skies, 85, 94, 253

Sky and Trees, Study of, Pl. 36

Smith, J. T., 6, 7, 8, 9, 273

Smith, W. R., 90

Smiths of Chichester, the, 321

Socrates, 168

Southend, 48

Southey, Robert, 111, 115, 116, 274

Spedding, Mr. and Miss, 258

Spencer, Lady, 59

Spilsbury, Mr., 55

Sprangher, B., 311

Spring, 4, 181

Stafford, Marquess of, 33, 41

Stanfield, Clarkson, 254

Steele, Richard, 22

Steen, Jan, 281, 317

Sterne, Lawrence, 121, 128

Stoke-by-Nayland, 183, 185, 250, 251, Pl. 45

Stoke Church, 181

Stoke Poges Church, 231

Stonehenge, 247, 255, Pl. 49

Stothard, Thomas, 32, 33, 57, 78, 80, 90, 147, 188, 207, 220, 262, 283, 321, 322

Stratford Mill ('The Young Waltonians'), 77, 125, 126, 128, 137, 143, 179, 286

Strowger, Samuel, 13, 14

Strutt, Mr., 150

Study of Trees, 101

Summer, Afternoon after a Shower, 129

Summer Evening, 183, 184

Summerland, 184

Summer Morning (Dedham Vale), 213

Swanevelt, Herman, 34, 109

Tabley, Lord de, 163

Tacitus, 140

Talbot, 148

Tassi, Agostino, 298

Teniers, David, 315

Theeluson, Vicomte de, 124

Thomond, Marquess of, 33

Thomson, James, 30, 131, 176, 198, 328

Thucydides, 140

Thurtell, 118

Tiffin, 242

Tinney, William, 76, 79, 81, 82, 84, 92, 103, 104, 106, 107, 115, 125, 126, 128, 137, 143

Titian, 85, 95, 242, 258, 260, 293–4, 303, 304–6, 314, 320

Tollemache, Mrs. Charles, 145

Tomkison, Mr., 187

Torin, Captain, 16

Travis, Mr., 64

Trees at Hampstead, 231

Tree Stems, Study of, Pl. 46

Trees, Study of, Pl. 34

Turnbull, George, 323–4

Turner, J. M. W., 30, 42, 44, 155, 156, 166, 172, 175, 187, 202–3, 241, 254, 260

Turner, Sharon, 140, 162

Twilight, 21

Uccello, Paolo, 292, 304

Uden, Lucas van, 299

Uwins, T., 242, 244, 278

Vadder, L. de, 299

Valley Farm, The, 239, 240, 247, 248, 250, Pl. 57, 58

Vanbree, Mr., 123

Vanderheyden, Jan, 119, 138

Vanderneer, Aert, 84

Vandervalde, Willem, 95, 131
Varley, John, 115, 194, 219
Vaughan, 198
Vernet, C. J., 301, 311, 312, 320, 321, 326–7
Vernon, Mrs., 145
Vernon, Robert, 239, 240, 245, 246, 247, 248, 250
Veronese, Paolo, 97, 193, 216, 316
Victory, H.M.S., 16, 18
View of Dedham, A, 56
View on the Stour, 83, 89, 90, 92, 285, Pl. 27
Village in Suffolk, A, 56
Virgil, 140, 161
Voltaire, 138
Volterra, Daniele da, 296
Vris, C. de, 103

Wakefield, Priscilla, 6
Walpole, Horace, 232
Ward, James, R.A., 154
Ward, James, 192
Waterloo, A., 17, 127, 156, 273
Waterloo Bridge, Opening of (White-hall Stairs), 74, 115, 118, 120, 122, 129, 147, 148, 149, 150, 152, 157, 181, 196, 205, 207, 208, 227–8, 231, 282, Pl. 48
Watteau, A., 192, 312
Watts, Alaric, 238
Watts, Ann, 2
Watts, David Pike, 18, 19, 27, 36, 38, 40, 46, 58, 61, 65, 127
Weight, Mr., 36
Wellington, Duke of, 76, 199
Wells, William, 193, 200, 218, 239, 240
West, Benjamin, 14, 15, 21, 29, 30, 40, 44, 117, 306, 322
Westall, R., 156, 257, 258
Westminster Abbey, 194
Westminster, Lord, 216
Westmoreland, 18
Westmoreland, View in, 19
Weymouth Bay, 222, Pl. 13, 15
Whalley, Alicia, 108

Whalley, Mrs. Martha, 10, 64, 65, 108
Whalley, Rev. Daniel, 285
Wheat Field, A, 65
Wheatley, Francis, 147
White, Gilbert, 79, 80, 273
White Horse, The, 73, 75, 76, 77, 137, 143, 145, 151, 159, 285, Pl. 19
Whooping-cough, cure for, 163
Wight, Isle of, 256
Wilkie, David, 14, 20, 31, 81, 100, 109, 125, 145, 171, 175, 188, 219, 237, 238, 239, 241, 254, 279
Willes, Mr., 127
William IV, King, 194, 210
Willis' Rooms, 41
Willy Lott's House, 45, 240, 285
Willy Lott's House, 45, 227
Wilson, Richard, 6, 10, 22, 23, 92, 101, 103, 108, 142, 156, 163, 168, 179, 180, 226, 271, 299, 308, 311, 321, 322
Winchester, 86
Windermere, Lake, 19
Windmill, 45, 221
Windsor, 175, 178
Wivenhoe Park, 67, 68, 74
Wivenhoe Park, 71, Pl. 14
Wood, Alderman, 130
Wood, Autumn, An, 65
Woodburn, Mr., 82, 104, 244
Woodmanstone, 136, 137
Woollett, W., 322
Wootton, John, 311, 320
Worcester, 235, 246, 247, 249, 289
Wordsworth; William, 101, 109, 110, 222, 254–5
Wouvermans, P., 84, 105, 301

Yarmouth, 120
Yarmouth Jetty, 101
Yarmouth Pier, 191
Young, George, 266
Young, John, 96

Ziegler, 219
Zuccarelli, F., 301, 312, 321